THE RESPONSIVE MUSEUM

THE RESPONSIVE MUSEUM

The Responsive Museum
Working with Audiences in the Twenty-First Century

Edited by

CAROLINE LANG
Victoria and Albert Museum, UK

JOHN REEVE
London University, UK

VICKY WOOLLARD
City University, London, UK

ASHGATE

Published by
Ashgate Publishing Limited
Gower House
Croft Road
Aldershot
Hampshire GU11 3HR
England

Ashgate Publishing Company
Suite 420
101 Cherry Street
Burlington, VT 05401-4405
USA

Ashgate website: http://www.ashgate.com

British Library Cataloguing in Publication Data
The responsive museum : working with audiences in the
 twenty-first century
 1. Museums - Collection management - Great Britain 2. Museums
 - Customer services - Great Britain 3. Museums - Great
 Britain - Management
 I. Lang, Caroline II. Reeve, John III. Woollard, Vicky
 069.5'0941

Library of Congress Cataloging-in-Publication Data
The responsive museum : working with audiences in the twenty-first century / edited by
Caroline Lang, John Reeve and Vicky Woollard.
 p. cm.
 Includes bibliographical references and index.
 ISBN 0-7546-4560-6
 1. Museums--Educational aspects. 2. Museums--Philosophy. 3. Museums--Social
aspects. 4. Museum visitors--Educational aspects. 5. Museum techniques. I. Lang,
Caroline. II. Reeve, John. III. Woollard, Vicky.

 AM7.R465 2006
 069'.15--dc22

 2006000102

ISBN 10: 0-7546-4560-6
ISBN 13: 978-0-7546-4560-3

Printed and bound in Great Britain by Antony Rowe Ltd, Chippenham, Wiltshire

Contents

List of Tables

List of Abbreviations

See also Chapter 7 for a full list of ICT-related acronyms and abbreviations.

AAM	American Association of Museums
ACE	Arts Council England
AGO	Art Gallery of Ontario
AHDS	Arts and Humanities Data Service
AHRC	Arts and Humanities Research Council
AIM	Association of Independent Museums
AMA	Associateship of the Museums Association
BBC	British Broadcasting Corporation
Becta	British Educational Communications and Technology Agency
BIG	British Interactive Group
BLF	BIG Lottery Fund
BM	British Museum
CABE	Commission for Architecture and the Built Environment
CCSSC	Creative and Cultural Sector Skills Council
CCTV	closed circuit television
CECA	Committee on Education and Cultural Affairs (ICOM)
CGfL	Community Grids for Learning
CHNTO	Cultural Heritage National Training Organisation
CIE	Common Information Environment
CLMG	Campaign for Learning in Museums and Galleries
DCFW	Design Commission for Wales
DCMS	Department for Culture, Media and Sport
DDA	Disability Discrimination Act
DfEE	Department for Education and Employment
DfES	Department for Education and Skills
DIBAM	Dirección de Bibliotecas, Archivos y Museos
DNH	Department of National Heritage
DPC	Digital Preservation Coalition
eGU	e-Government Unit, Cabinet Office
EPDP	Education Programme Delivery Plan
EU	European Union
GEM	Group for Education in Museums
GLLAM	Group for Large Local Authority Museums
GLOs	generic learning outcomes

HEFCE	Higher Education Funding Council for England
HLF	Heritage Lottery Fund
ICOM	International Council of Museums
ICT	information and communication technology
ILfA	*Inspiring Learning for All*
IMTAE	International Museum Theatre Alliance for Europe
INSET	In-Service Education for Teachers
IT	information technology
ITT	Initial Teacher Training
JEM	*Journal for Education in Museums*
JISC	Joint Information Systems Committee
LEA	local education authority
MA	Museums Association
MEO	Museum Education Officer
MGC	Museums and Galleries Commission
MGLI	*Museums and Galleries Lifelong Learning Initiative*
MICHAEL	Multilingual Inventory of Cultural Heritage in Europe
MLA	Museums, Libraries and Archives Council
MP3	Mpeg layer 3 computer system
NEMLAC	North East Museums, Libraries and Archives
NESTA	National Endowment for Science, Technology and the Arts
NGfL	National Grid for Learning
NIACE	National Institute for Adult and Continuing Education
NMDC	National Museums Directors' Conference
NMGW	National Museum and Galleries of Wales
NML	National Museums Liverpool
NMM	National Maritime Museum
NOF digitise	New Opportunities Fund digitization programme
NQT	newly qualified teacher
PSI	Policy Studies Institute
OCG	*On Common Ground*
QCA	Qualifications and Curriculum Agency
RCMG	Research Centre for Museums and Galleries, Leicester
RFID	radio frequency identification device
RFO	regularly funded organizations
RSA	Royal Society of Arts
SWMLAC	South West Museum, Libraries & Archives Council
UKOLN	UK Office for Library Networking
UNESCO	United Nations Education, Scientific and Cultural Organization
VAGA	Visual Arts and Galleries Association
V&A	Victoria and Albert Museum
WEA	Workers' Educational Association

List of Contributors

The Editors

Caroline Lang is Learning Centre Project Manager at the Victoria and Albert Museum. She is also a museums consultant, an adviser to the HLF, and a visiting lecturer on MA courses, including that at the Institute of Education, University of London. She was Senior Policy Adviser for Access and Audience Development at MLA (formerly Resource) from 1999 to 2003. From 1995 to 1999 she assisted David Anderson in preparing the report *A Common Wealth*. Before this she was head of Extension Services at the Passmore Edwards Museum, and has worked for a number of other museums and heritage sites in London.

John Reeve was Head of Education at the British Museum from 1982 to 2003. He is now a Visiting Fellow at the Institute of Education, University of London, teaching on MA courses including 'Museums and Galleries in Education' (created jointly by the IoE, BM and V&A). He is also a museums consultant, working most recently in India, Qatar and Brazil, and an adviser to the HLF, WMF (World Monuments Fund) and the Helen Hamlyn Trust. His publications include *Behind the Scenes at the British Museum* (with Andrew Burnett), 'Japanese Art in Detail', two guidebooks and numerous articles.

Vicky Woollard is a Senior Lecturer in the Department of Cultural Policy and Management at City University, London, with a particular interest in education in the cultural sector. Vicky had 18 years' experience as an Education Officer in three London Museums before becoming a consultant. She has co-directed three British Council international courses on museum education, which led to co-editing and contributing to *Museum and Gallery Education: A Manual of Good Practice* with Hazel Moffat (1999). She is currently a Director of the Group for Education in Museums (GEM) and a Councillor for the Museums Association and convener of their Professional Development Committee.

Chapter Authors

Ian Blackwell was until recently at North East Museums, Libraries & Archives Council NEMLAC (now MLA North East), where he built an Access and Learning Team with a national reputation for pioneering and inclusive work. As one of

NEMLAC's senior managers he led a range of regional and national initiatives, whilst maintaining a keen awareness of the needs and issues for NEMLAC members. In summer 2005 Ian returned to Devon to work freelance with Sarah Scaife as Red Hen.

Dr Caroline Dunmore studied the history and philosophy of mathematics, and taught mathematical logic. She worked in the financial services sector for several years in a variety of organization development roles (including Head of Learning and Development at Prudential Property Investment Managers), and has gained experience of e-learning in both the commercial and the higher education sectors. Caroline is currently dividing her time between running the Designation Scheme for museums at the Museums, Libraries and Archives Council and studying at the Courtauld Institute of Art.

Eithne Nightingale is Head of Access, Social Inclusion and Community Development at the Victoria and Albert Museum where initiatives to promote cultural diversity in innovative ways have been successful in broadening audiences. She previously worked in adult and community education in Hackney, North London, and thus has brought a different perspective and experience to this work in museums.

Kate Pontin has been a consultant since 2000, having previously worked as an education officer for the London Borough of Hillingdon and for Leicestershire Museums, Arts and Records Service. Kate's consultancy work focuses on education and evaluation work, supporting museums and other heritage organizations to develop visitor services through policy and strategy development, and through evaluation. Recent projects include *Front End* (evaluation for the Natural History Museum) and work as evaluation adviser for the South East Museum Hub's evaluation of their education programme. She is also an associate tutor for the University of Leicester. Her research is largely related to informal learning in museums and in particular the types of methodology used for such visitor research. Kate is currently chair of the Visitor Studies Group.

Rick Rogers is a writer and journalist, researcher and adviser on the arts and education. He was part of the *Spaces for Learning* team. As a journalist, he has worked for *The Guardian*, *The TES*, *New Statesman* and Thames Television. His current work spans the art forms with reports on the state of music and of art and design provision in schools, and of teacher training in the arts. He advises on learning strategies with national arts institutions such as the British Library, Royal Academy of Arts, Tate Modern and the Theatre Museum. His books include *Managing the Arts in the Curriculum*.

Sarah Scaife has worked in the museums sector since 1993 in volunteer, salaried and freelance roles. Her range of experience includes small museums, heritage sites, Local Authority museums and the independent sector. She received the

Yorkshire Museums Council Individual Access Award in 1998 for her work. Her freelance client list includes Tyne & Wear Museums, the South West Museums Hub, NEMLAC (now MLA North East), the British Library and her local volunteer-run museum in a Devon market town. She now works with Ian Blackwell as Red Hen.

Phyllida Shaw has been a freelance researcher, writer and facilitator, working with arts organizations, the arts funding system and the higher education sector since 1988. She is a trustee of Arts Research Limited (which publishes *Arts Research Digest*), Fabrica (a gallery in Brighton) and the recently formed London Centre for International Storytelling. She is chair of the steering group of Ignite, a project of the National Endowment for Science, Technology and the Arts, and chair of the Creative Centre advisory panel of the Roundhouse.

Michael Tooby is Director of the National Museum and Gallery, Cardiff, home to the National Museums and Galleries of Wales' collections of art, archaeology and natural sciences. Previously he held curatorial positions to a number of prestigious arts organizations including Tate Gallery St Ives and the Barbara Hepworth Museum and Sculpture Garden, Kettles Yard Cambridge and Mappin Art Gallery. He has been also the chair of *engage*, the national association for visual arts education in museums, galleries and public art.

Nick Winterbotham is currently Chief Executive Officer of Thinktank and Millennium Point in Birmingham. He was previously a museum education officer in Norfolk and Nottingham, Director of Tullie House Museum, Carlisle, Director of Eureka! in Halifax, deputy head of the National Railway Museum in York, and head of museums and galleries in Leeds.

Response Authors

Christopher Bagot is a director of Softroom, an architecture and design practice based in Central London.

Antonia Byatt is Director of The Women's Library, which is part of London Metropolitan University.

Alec Coles is Director of Tyne & Wear Museums.

Nico Halbertsma is Senior Lecturer in Learning and Visitor Services, The Reinwardt Academy, Amsterdam.

Roy Hawkey is a freelance education consultant and Visiting Research Fellow at King's College London.

Caitlin Griffiths is the Museums Association's Adviser on Professional Issues.

Izzy Mohammed is the Community Access Officer on the HLF *Connecting Histories Project* led by Birmingham City Archives.

Susan Potter is Project Manager of *Vital Communities,* a longitudinal action research project measuring the impact of young children's participation in the arts.

Jane Samuels is Access Officer in the Department of Learning and Information, The British Museum.

Janet Vitmayer is Director of the Horniman Museum in South London.

Preface

Caroline Lang, John Reeve and Vicky Woollard

This book has emerged from our experience of working in museums through a period of dramatic transformation. Our professional careers have taken us into working in museums, cultural policy and management, in schools and adult education, training museum professionals and teaching postgraduates at universities in the UK and abroad. This is an attempt to make our own meaning from the complex and ever-evolving and changing relationship between museums and their audiences. We aim to capture what we think are the significant drivers for this change; gathered from a burgeoning literature and a rapidly developing policy scene, drawing on the expertise and experience of colleagues, while it is still relatively recent and relevant. This seemed a good moment to take stock and to reflect.

This is not a tract by museum educators addressed to themselves, but includes contributions by directors and managers as well as journalists, learning advocates and others from varied backgrounds. This book is aimed at students on museum studies and allied courses as well as professionals and policy makers, and not just in the UK. We have included examples from all over the world, but inevitably there is a strong UK bias. In many ways the last 15 years have been one long and often rather bumpy experiment in bringing museums and audiences closer together. This book is about the varieties of embrace that have resulted. Readers in other countries may wish to note some of the lessons that emerge.

From the outset there have been a number of underlying principles:

- To have varied voices, mixing theory and policy with practice: the chapter authors bring a diversity of experiences from different organisations and professional pathways. Some have written more from a personal perspective, drawing on their own experiences; others take a more objective stance, observing and analysing what they see happening around them.

- In order to encourage a forum for debate, we invited other practitioners to respond to each chapter in Parts 2 and 3. Some offer alternative views while others expand on a particular point. We firmly believe that this book is about questioning and challenging perceptions, and hope that readers will be stimulated to carry on the dialogue.

- To be a resource for tutors and students, by providing an introductory framework, political, theoretical and professional, for current debates; recognising that in no way could we be comprehensive in including all initiatives, policies and practice, but through examples tease out the underpinning issues.

- To provide a useful resource for students by providing contextual information in the appendices to complement the issues raised in the chapters, and by giving links to further resources, text or web-based. Again for teaching and training purposes, we have tried to make each chapter independent.

In order to examine what makes a responsive museum, we have decided to separate out three main areas for investigation: external drivers, internal leadership and management, and the methods by which museums engage with their publics.

Part 1, written by the editors, surveys the context for this period of rapid change. It looks first at the combination of theory, new thinking and research, and how these have influenced museum professionals in their practice on learning, access and audience development. Equally important has been the impact of government, both instrumental and interventionist: we review the UK government policies and agendas over the last decade, such as public accountability, public access, audience development and social inclusion and the tensions these have created with the museum and gallery sector.

Part 2 looks at developing audiences: new means to do so, how to work effectively with new audiences and to sustain the relationship. But first who are they and what are their needs? No museum can give each audience full attention all of the time, so management decisions have to be made to prioritise one group and the necessary resources to support that group. The content of exhibitions, their interpretation and the supporting public programme, can demonstrate to new and diverse communities that museums and their collections are relevant to a far wider public than previously considered. But just putting on such activities is not sufficient: evaluation, networks and partnerships are crucial at all stages of the process to improve practice and to ensure that needs and expectations are met. New technologies, particularly the Web, offer the opportunity for museums to look afresh at how they can provide opportunities to engage and include audiences in researching and investigating the collections.

Part 3 seeks to identify the management and organisational components of a responsive museum. Each museum will be different in the way it reacts to and incorporates external pressures and in the choices the senior management team makes in deciding how the organisation will move forward. The style and focus of leadership, the content and integration of policy, and the nature of funding will together determine the allocation of resources, the recruitment and training of staff, and the interpretation of and access to collections. From the perspective of the public, the crucial test is: 'Where is the visitor in all of this?'. To what extent is the visitor welcomed in to a partnership where interests are ignited, knowledge and expertise are shared, and many voices are spoken and heard?

The conclusions pull out strands from the preceding chapters and identify what are the elements required to make a museum responsive, and then assess progress and ask what still has to be done.

In writing and editing this book our mood has oscillated, often significantly, from optimism to pessimism, and that reflects mainly on its subject and the task of catching it on the wing. We are enormously grateful to all our contributors for finding time to write while also running, advising and training for responsive museums. We would also like to thank Hazel Moffat for her critical advice on the book, Alison Hill for her help with editing, Professor Patrick Boylan and Professor Ian Stephenson for supporting us in the early stages. Finally we thank our families for living with our responses to producing this book, and to our colleagues at Ashgate: Dymphna Evans and Suzie Duke.

We expect there will be many different responses to what follows, and hope that it will be a useful tool, inspiring, informative, provocative and cautionary by turn.

PART I
Understanding Audiences:
Theory, Policy and Practice

Introduction to Part 1

UK society and culture changed almost out of recognition from the 1960s onwards. Museums and galleries were slow to respond and remained, on the whole, part of a deferential, expert-led culture that was increasingly under attack. Certainly there was change: new kinds of art exhibition for example at the Victoria and Albert Museum (V&A) and Royal Academy, and new kinds of interactive display and customer care at the Science Museum and Natural History Museum. These attracted more middle-class and school and college visitors, but not usually new kinds of audiences. Local and regional museums, often the real innovators with audiences, were vulnerable (during the 1980s in particular) to funding cuts, with major inherited problems of infrastructure and conservation. Urban riots in the 1980s helped put inner city regeneration (for example in Liverpool) on even the Conservative government's agenda. It took a Labour government, however, from 1997, to bring culture and museums right up the agenda and into the world of major social policy, and with this came compliance with detailed targets for the first time.

This section explores how far the profession was ready for the challenge of developing audiences: how had its thinking and practice evolved? What had learning in museums to offer a new agenda? How have the power relationships within museums and also those between museums and government developed? Are museums and the other cultural industries now being expected to deliver too much? What new expectations have there been from audience groups such as families, teachers, ethnic minority communities and people with disabilities, and can these be fulfilled and sustained?

Finally, an example to show how far the map has been redrawn. In the summer of 2005, The Ulster Museum, Belfast, announced its plans for renewal, costing £11.5 million. Nearly half of the funding came from the Heritage Lottery Fund (HLF) which will now fund projects only if there is a strong audience case as well as a compelling heritage one. The announcement leads with audience:

> It will greatly enrich the museum experience for visitors. Innovative learning and outreach programmes, associated with dynamic new exhibitions and interactive displays, will make its diverse collections visually and emotionally stimulating and intellectually meaningful for visitors of all ages and backgrounds. The programme is based on the philosophy that the Museum should have a central role in the life of the Northern Ireland community, that it should be accessible to everyone and that it should encourage participation in a wide range of activities and events that meet the needs and interests of all sections of our rapidly changing society ('Opening Up the Ulster Museum' press release, July 2005).

Part 1 explores how this new philosophy has become so deeply embedded in museums that it appears irreversible, but also asks whether this is really so.

Chapter 1

Influences on Museum Practice

John Reeve and Vicky Woollard

Introduction

Over the past 50 years there has been a major shift in the relationship between museums and their audiences. In the 1960s the relationship could have been considered simple and one-dimensional; the museum was all-powerful and the uncontested authority. The museum staff saw their public as a reflection of themselves; knowledgeable about the actual and symbolic meaning of the collections and the obvious 'value' they held for society. Thus museums believed the public to be those who visited regularly and understood the rules and definitions by which the collections were collected and interpreted.

The shift over the past three decades has been towards museums recognizing that the public is made up of many diverse groups who are keen to articulate their needs and make their views known, even through choosing not to visit. Equally, museums have come to appreciate, though not fully, the complex relationships that can be formed with the thousands of individuals who have taken an active role in contributing to the overall activities of the museum; through volunteering, acting as trustees, attending events or providing information on the collections as experts and enthusiasts. This chapter introduces a number of influences that have contributed to these changes. These influences are beyond government intervention yet have helped to raise the debate about audience interests and the role museums have to play in engaging with those interests.

Audiences or Consumers?

A closer look at the terminology used to describe all those who use and contribute to museums will uncover a number of key ideas, individuals and texts that have either directly or indirectly influenced the change in the museum/audience relationship.

Museum audiences will be described in a number of ways throughout this book: audiences, customers, consumers, participants, the public, stakeholders, users, spectators and visitors. 'Audience' and 'spectator' indicate the method by which the individual is actively engaged.[1] 'Visitor' is the more familiar term for those who

1 'Audience', coming from the Latin *audientia*, is used for museums, although it is more appropriate for the theatre and concert hall; whereas 'spectator' is derived from the

enter museums and galleries, and 'virtual visitor' is used increasingly for museum websites.[2] Other combinations such as 'actual' and 'potential' visitor are used to identify sub-groups. Visitor figures are required by the UK government as opposed to audience figures. However, some data is collected, as for example the number of visits as opposed to the number of visitors, as they are likely to be higher. It is interesting to note that the term 'non-users' or 'non-attenders' is used rather than 'non-visitors'. This inconsistency may indicate a previous lack of interest and research into this important group.

Participants are visitors who take part in activities such as workshops and gallery events, while those attending lectures are identified as an audience. The marketing terms 'customer' and 'consumer' indicate participation in the financial sense, either by paying for an entrance ticket or by purchasing items at the café or shop. The former has been a more accepted term since the 1990s, when an emphasis on customer rights and services meant that the museum was obliged in some way to provide customer assistance. The term 'consumer' is often used in a derogatory way when discussing capitalism, mass consumption and the consumer society. The implications of selecting one word over another are revealing: museums must recognize that they continually offer products for consumption such as exhibitions, events, gifts, membership schemes, yet for most museum professionals, using the term 'consumer' places museums alongside shopping malls and the high street.

The final words to be explored are 'public' and 'stakeholder'. These terms encapsulate people who do not necessarily visit or engage with museums but are recognized as significant. The term 'stakeholder' makes it clear that these individuals have a vested interest in the aims of the organization and how they are delivered. The interest of the public as stakeholder is primarily that of financial investment, through local or national taxes. The majority of the world's museums and galleries receive funding (all or part) from income raised through public taxes. Therefore the public quite rightly needs to see how these funds are spent.

Therefore the use of these terms (such as audience, visitor, consumer and stakeholder) signifies different relationships between the museum and its public. 'Audiences' may be thought to be more passive than 'participants', the term 'visitor' seems to have less authority and be less demanding than 'customer'. Perhaps from this one could extrapolate that the preferred term for museums is 'visitor' as in 'visitor services' rather than 'customer services', for institutions may wish to keep the power balance in their control rather than that of the customers. The possible change in balance may lead to the dominance of the consumer, which would totally change the rationale of the museum as a cultural institution.

Latin *spectare*, to gaze at, or to observe and is used for those attending shows, but more likely events, particularly sporting events (Oxford Dictionary of English, 2003).

2 The Oxford Dictionary of English (2003) mentions that 'visit' and 'visitor' include a social element, as in visiting friends, but also identifies the tourist element in terms of taking a view, from the Latin *visare*.

Postmodernism and Museums

Museums and galleries were identified early on as one of the battlegrounds for postmodernism; the traditional museum being seen as another repressive, disciplinary institution controlling visitor behaviour and both physical and intellectual access to art, history and other cultures, while providing grand narratives from a position of uncontested authority (Araeen *et al.*, 2002; Crimp in Foster, 1985; Duncan, 1995; Foucault in Rabinow, 1984; Hall, 1997). Others, such as the sociologist Pierre Bourdieu, have examined the motives for visiting art galleries, for example the middle class hoping to acquire cultural capital. Like economic or social capital, cultural capital is something that can be accrued, can give advantage and status, and can possibly be exchanged or converted. It also implies a need for art to remain exclusive (Bourdieu and Darbel, 1990). Their research showed 'museum visiting increases very strongly with increasing levels of education and is almost exclusively the domain of the cultivated classes' (Bourdieu and Darbel, 1990, p 15). They think that schools can only be effective if the family had already inculcated the attitudes and behaviour patterns. Conservative voices are also invoked, such as Adorno, who disapprovingly coined the term 'culture industry' (Adorno and Horkheimer, 1944). In the museum world the voice of American museologist Stephen Weil has repeatedly cautioned against claims that museums can change the world (Weil, 1995).

In this new context, museums and the world of cultural theory have enjoyed a healthy relationship (a useful introduction to the latter is Mirzoeff, 1998). New and close attention has been paid to the related histories of museums, collecting and systems of thought (Bennett, 1988, 1995; Duncan, 1995; Hooper-Greenhill, 1992; Preziosi and Farago, 2004) and to the traditional practices of curators and museum managers. Art historians, archaeologists, anthropologists, historians and scientists have all been through major conceptual and philosophical changes in their respective fields and this has impacted not only on curatorial practice but also on the relationship (or lack of it) between higher education and museums and galleries. Meanwhile in many art galleries the 'high priests of modernism' carry on as before, though with greater acknowledgement of audiences and public agendas (Serota, 1995). Contemporary art remains the most problematic area for learning and access, because of its innate newness and the often exclusive behaviour of its advocates, both curatorial and educational (engage, 2004b). This is another area, along with archaeology, that has benefited from increased media attention in order to attract enthusiastic new audiences.

Cultural Democracy/Democratizing Culture

These two terms denote a major shift in the perceptions of culture; whose culture and what culture is it? Democratizing culture refers to public accessibility of culture, through price, location and education; there should be no barriers to prevent individuals participating in culture, as the UN Declaration of Human Rights states. Cultural democracy describes the desire for every culture to be respected equally,

without hierarchy. Many factors have contributed to challenging traditional white, male, Western ruling class histories and unquestioned curatorial practices, including Marxism and Social History, and the wider debates about heritage and the heritage industry (Boswell and Evans, 1999; Dicks, 2003; Kavanagh, 1996). Feminism has encouraged critiques of collecting, interpreting, colonialism and management (Carnegie, 1996; Morton, 2003; Porter, 1998). The Multiculturalism of the 1960s and 1970s now campaigns under the banner of Diversity (Cummins, Crew, Merriman and Poovaya-Smith in Kavanagh (ed.), 1996; Simpson, 2001). Edward Said and other postcolonialist scholars have made sure that non-European collections do not sit uncontested in Western museums. The semiotics of display and museum language has also been fruitfully explored in museums and galleries (Araeen *et al.*, 2002; Ashcroft and Ahluwalia, 1999; Coxall in Durbin (ed.), 1996 and Hooper-Greenhill (ed.), 1997; Hall, 1997; Loomba, 1998; Morton, 2003). New approaches to museology include initiatives in Asian, Pacific and North American museums and many reassessments of 'heritage' (Dicks, 2003; Kreps, 2003; Stanley, 1998). These have lessons for museums and galleries in the 'West' also, particularly those emerging from Communism with new narratives and relationships to forge. For the situation under Communism, and for a whirlwind tour of museums worldwide in the 1980s, see the writing of Australian sociologist Donald Horne (1984, 1986).

Marketing

As we have seen above with the words 'customer' and 'consumer', since the 1980s the role of marketing theories and the growth of marketing departments has had a significant influence on how museums regard their audiences (Mclean, 1997; Runyard and French, 2000). Due to diminishing or stand-still budgets, and under pressure to deliver bigger and better services, museums have had to raise income from a number of sources. This income generation can be carried out through the shop, café, tours, educational services, loans, copyright fees, corporate entertainment or even from providing venues for weddings. Marketing's principal role in this is to generate ideas, seek out potential need, inform potential buyers/customers of these opportunities through advertising and promote the organization, goods and services by making them appealing and appropriate to the different markets. Computer databases can now be used to collect and store information on customers and their buying habits (shop or online ticket sales) and draw lifestyle conclusions (Byrnes, 2003).

Marketing professionals would also argue that marketing theory and practice can be equally important in developing the overall vision and forward planning of the museum by allowing the organization to research and debate what its significant attributes are and how these should be matched to the needs and interests of its audiences. Philip Kotler has been a major influence in placing marketing at the centre of the arts in *Standing Room Only: Strategies for Marketing the Performing Arts*

(1997),[3] and with his brother Neil Kotler in *Museum Strategy and Marketing* (1998). Although both books are centred on US practice, they are relevant to the UK and other countries as they emphasize that building and sustaining audiences is crucial to the museum's success and development. The Kotlers expound the need for a strategic market planning system[4] (SMPS) in order to orientate the organization towards its consumers.[5] This system involves four steps: analysing the various contexts in which any marketing plan must operate; examining internal resources through a SWOT[6] analysis; creating a mission and goals; and formulating a strategy (1998, p 60). The purpose of this system is to research and produce new 'products' that will meet the (perceived) needs of current and new audiences, hence encouraging greater numbers of new and returning visitors.

The Kotlers' SMPS can provide valuable information about the public and specific details on current visitors by segmenting the market in terms of demographics, attitudes, lifestyles, interests and needs (Kotler and Kotler, 1998, pp 125–33). This information should and does complement knowledge gathered by education practitioners about learners and the learning environment; for example current visitors, their visiting patterns and what attracts them to the museum/gallery. Market research on non-visitors is valuable in identifying attitudes and perceptions towards cultural institutions. However, despite such obvious overlap, there have been tensions between marketing departments and education teams where the language used is not necessarily shared and understood. Rogers (1998), Maitland (1997) and Owens (1998) have discussed these tensions which can divert energies and effort from the main aims of the organization. The difference between marketing and education is in the rationale and purpose of the activities each undertakes. Education is on the whole focused on the needs of the individual; how that individual will best engage with the collections/exhibitions; and what transferable skills and knowledge can be developed to be used in other situations and environments. Marketing in Owens' terms is focused on the needs of the organization by increasing promotion which will in turn increase audience numbers. However, 'audience development' tends to be considered a marketing term, when in reality the activities of both groups of professional are integral to the development of their audiences.

Education and Learning

Because museum educators have traditionally worked as entrepreneurs between institutional frameworks, and have often been marginalized as a result, certain educational and social theorists have been especially attractive. Informal education,

3 The co-author was Joanna Scheff.

4 See Chapter 3 in *Museum Strategy and Marketing* (1998) by N. Kotler and P. Kotler.

5 The word 'consumer' is used to highlight the relationship between the individual and the museum; with 'customer' there is a real or implied exchange of goods or services.

6 Strengths, Weaknesses, Opportunities and Threats: a method of reviewing the activities of an organization.

de-schooling and work out of the classroom were potent ideas of the 1960s and 1970s (Freire, 1972; Holt, 1976; Illich, 1973; Illich *et al.*, 1977; Taylor, 1993; Ward and Fyson, 1973) whether in inner-city Europe or in the countries of South America where a new kind of education needed to be forged, and where museums at a local level could contribute (see the work of Lucia Astudillo in Ecuador, and also eco-museums there). Informal lifelong learning by adults is now on the agendas of most developed countries (Chadwick, 2004; Chadwick and Stannett, 2000).

A number of other learning theorists are regularly used by museum educators: see Dierking (1992) for a useful introduction. The most influential are Howard Gardner (1983), George Hein (1992, 1998) and Mihaly Csikszentmihalyi (1990, 1991 and 1997). Gardner paved the way for other work on multi-modal learning (Kress and Van Leeuwen, 2001; Kress, 2003) from the 1960s onwards. Hein argues convincingly that as individuals we construct our own realities and meanings rather than there being an external world to which we are introduced and which we accept. Csikszentmihalyi has been developing his flow theory, which is the need to balance the challenge of a task with the skills and knowledge to accomplish it. Among psychologists, Richard Gregory has not only changed our view of perception but put it into practice with the Bristol exploratory science centre (Gregory, 1997). Still influential from earlier generations and from the world of art education are Dewey (1934, 1938), Vygotsky (1971, 1978) and Eisner (1998). Falk and Dierking (1992, 2000) are the most common source for visitor studies; for Kolb and others in this field see Durbin (ed.), 1996; Hooper-Greenhill (ed.), 1999; Kolb, 1984.

Visitor Studies

In the section above on marketing it is noted that precise information on actual and potential museum visitors is crucial to the work of the organization. The rise in the 'science' of understanding visitors has grown in line with the need to match visitors' expectations with improved services and exhibitions. Hooper-Greenhill provides an excellent introduction to visitor studies in *Museums and their Visitors* (1994 – Chapters 3 and 4 are particularly relevant). The US has been very much the leader in this field, having set up the American Visitors Studies Association in 1988, primarily focusing on the visitor experience and trends in science centres and 'exploratoriums'. Authors Falk and Dierking have written extensively from their visitor research to develop a contextual model of learning (1992, 2000 and 2002).[7] Both general and specific published texts have been written to guide practitioners, such as Borun and Korn's *Introduction to Museum Evaluation* (1999), Dufresne-Tassé (1998, 2002) and various papers by McManus (2000b, 1998, 1994). Following

7 See the paper 'Contextual Model of Learning' on the Institute for Learning Innovation website at <www.ilinet.org/contextualmodel.htm>, accessed 15 August 2005.

the US,[8] Australia[9] and the UK[10] have also set up professional groups to explore and discuss new methodologies and, importantly, the ethics involved in evaluation and research (see Chapter 8). Specialist professionals/consultants and, in the case of the national museums in the UK, staff have been taken on to look specifically at visitor studies and evaluation, thus ensuring this aspect is integrated into the museum's long-term planning.[11]

Internal Professional Debate and Advocacy

Professional groups include those mentioned above and others such as the ICOM International Committee on Education and Cultural Action (CECA), The Museum Education Round Table[12] and in the UK, GEM,[13] engage,[14] British Interactive Group (BIG)[15] and the International Museum Theatre Alliance for Europe (IMTAE).[16] These groups help the sector debate with governments and other professionals on learning and access issues and are key providers of training and professional development. However, the concern for audience needs, interests and motivations varies with each group: some are interested in the form of delivery (for example, BIG and IMTAE), while others are much more concerned with the audience/visitor experience. There

8 The Visitors Studies Association was set up in 1988; see <www.visitorstudies.org>.

9 See <www.amol.org.au/evrsig> for the Evaluation and Visitor Research Special Interest group.

10 Visitor Studies Group at <www.visitors.org.uk> and the Arts Marketing Association at <www.a-m-a.co.uk>.

11 In 2005, National Museums Liverpool, National Museums of Science and Industry, Victoria and Albert Museum.

12 The American organization 'dedicated to enriching and promoting the field of Museum Education'. See <www.mer-online.org/>.

13 Group for Education in Museums. For its history, see V. Woollard (1998), '50 years: The Development of a Profession', *JEM* (*Journal for Education in Museums*) 19. It promotes education as a core function of museums, encourages the exchange of information, ideas and research relating to the practice of museum education, fosters the highest standard of educational practice, promotes the role of museums in formal and informal learning, and promotes professionalism in the educational work of museums. See its website at <www.gem.org.uk>, accessed 20 June 2005.

14 engage promotes access to, enjoyment and understanding of the visual arts through 'gallery education' – projects and programmes which help schoolchildren and the wider community become confident in their understanding and enjoyment of the visual arts and galleries. See its website at < www.engage.org>, accessed 20 June 2005.

15 BIG is the organization for people involved in interactive education projects in the UK See its website at <www.big.uk.com>, accessed 20 June 2005.

16 See its website at < http://imtal-europe.org>, accessed 20 June 2005.

are also regional audience development agencies, set up in 2002 by Arts Council England.[17]

The biggest recent influence on museums as learning organizations has to be David Anderson's report *A Common Wealth: Museums in the Learning Age*. First published in 1997 (with the subtitle *Museums and Learning in the United Kingdom*), and updated and reissued in 1999, this report has done a great deal to influence the debate about museum and gallery education and to set agendas. Aimed at policy and decision-makers in the cultural sector, it has been used to guide and develop policy and strategy, to lobby for support and funding and to put museum learning onto the agenda at national, regional and local levels. In order to produce the report, a UK-wide survey was carried out in 1994, followed by a more detailed look at key services. This was complemented by 14 colloquia on different subjects, held throughout the UK.

Over 200 museum professionals and representatives from other related fields, such as education and local government, debated what were seen as the key issues for the future development of museums and galleries. The main findings of the report were that education provision was a patchwork and that there was no underlying rationale or strategic approach to enable museums to make an effective contribution to public learning. Nearly half of museums offered no education services and only one in five had a professional educator on their staff. The report proposed 12 targets for development, and recommendations designed to enable the museum sector to achieve them. The key thrust of the recommendations was that museums should focus more on their users. For the first time a case was being made to government for strategic development, and an agenda proposed.

Following the success of the report, Anderson ensured that the debate around the role of museums, and placing visitors and their learning at the centre, remained alive. He helped to instigate the Campaign for Learning in Museums and Galleries (CLMG) in 1998 which, alongside the Campaign for Learning, Museums Association, The RSA and others, continued to raise the profile of the benefits of engaging with collections. Through dialogue with various trusts and foundations, but principally with the DCMS/DfES, museum education has received well over £25 million since 1999.

A Decade of Change

The issues discussed above are a development of those discussed by Eilean Hooper-Greenhill in her book *Museums and their Visitors* (1994). Hooper-Greenhill is a major contributor to debates around education and learning in museums. Through her many publications, she has conceptualized the context in which museums operate and hence create dialogues with their audiences. *Museums and their Visitors* is still

17 Audiences London, Audiences Central, Audiences Yorkshire, and AMH (for the South East) all receive core funding to help organizations and individuals with audience development.

relevant to today's practice, focusing on 'making connections with visitors with an emphasis on the methods of communications', yet the small range of audience groups it covers reflects the interest of museum education practitioners at the time.[18] Ten years on, in 2004, Hooper-Greenhill describes new projects which involve museums working with non-school attendees, teenage mothers, asylum seekers and specific minority groups, as well as schools.[19]

However, there is one issue that has remained constant from 1994 to the present and that is the lack of accurate and detailed information on number, type and frequency of visitors and visits made to museums and galleries in the UK. Despite having a government department dedicated to the arts and culture (DCMS) there is currently no centralized data collection for the cultural sector as a whole. Several authors (Babbidge, 2005; Selwood, 2002, 2001, 1999; Wright, 2001) have argued for a comprehensive approach to data collection that is transparent, consistent and on nationally agreed criteria. The importance of good quality data, especially in showing longitudinal trends, can help museums to place the rise and fall of their audience numbers into a local, regional and national context. The distribution, geographically, socially and in terms of gender and age, informs not only the museums but also their funders, particularly central and local government whose policies may prioritize the development of one audience segment over another through performance targets. The annual figures will show funders and museums whether their actions have been successful or not. The next chapter will look specifically at the role of government and how it has brought about significant change through policy and legislation, incentives and directives for museums to move towards greater social inclusion.

References

Adorno, T. and Horkheimer, M. (1993) [1944], *The Culture Industry: Enlightenment as Mass Deception in 'Dialectic of Enlightenment'*, New York: Continuum. Originally published as *Dialektik der Aufklarung*, 1944.

Anderson, D. (1997), *A Common Wealth: Museums in the United Kingdom*, London: DNH. (2nd ed., 1999, published as *A Common Wealth: Museums in the Learning Age*, London: Stationery Office.)

Araeen, R., Cubitt, S. and Sardar, Z. (eds) (2002), *The Third Text Reader on Art, Culture and Theory*, London: Continuum.

Arnheim, R. (1954), *Art and Visual Perception*, Berkeley CA: University of California Press.

Arnheim, R. (1969), *Visual Thinking*, Berkeley CA: University of California Press.

18 In the chapter 'Responding to visitor needs', the groups selected for discussion and advice were families, educational groups and people with disabilities – there are also some minor references to other groups such as ethnic minority, community groups, but in terms of non-museum visitors (Hooper-Greenhill, 1994: pp 64–8).

19 Publication based on an evaluation of the impact of DCMS/DfES Strategic Commissioning 2003–2004 National/Regional Education Partnerships.

Ashcroft, B. and Ahluwalia, P. (1999), *Edward Said*, London: Routledge.

Babbidge, A. (2005), '40 Years On', *Cultural Trends* 53, 14: 1, 3–66.

Bennett, T. (1988), 'Useful Culture', in D. Boswell and J. Evans (eds) (1999).

Bennett, T. (1995), *The Birth of the Museum*, London: Routledge.

Bochynek, B. (2004), 'Cultural Treasures as Gateways to the "Treasure Within": The Role of Museums in Lifelong Learning', in engage (2004a).

Borun, M. and Korn, R. (eds) (1999), *Introduction to Museum Evaluation*, Washington DC: American Association of Museums.

Boswell, D. and Evans, J. (eds) (1999), *Representing the Nation: A Reader in Heritage and Museums*, London: Routledge.

Bourdieu, P. and Darbel, A. (1990) [1969], *The Love of Art – European Art Museums and their Publics*, translated by C. Beattie and N. Merriman (1990), Cambridge: Polity Press.

Byrnes, W. J. (2003), *Management and the Arts*, 3rd ed., Oxford: Focal Press.

Carnegie, E. (1996), 'Trying to be an Honest Woman', in G. Kavanagh (ed.) (1996).

Chadwick, A. (2004), 'Lifelong Learning in Museums: An Overview with Reference to Museums and the Post-School Sector', in engage (2004a).

Chadwick, A. and Stannett, A. (eds) (2000), *Museums and Adults Learning: Perspectives from Europe*, Leicester: NIACE.

Csikszentmihalyi, M. and Robinson, R.E. (1990), *The Art of Seeing: An Interpretation of the Aesthetic Encounter*, Los Angeles: J. Paul Getty Museum.

Csikszentmihalyi, M. (1991), 'Notes on Art Museum Experiences', in A. Walsh (ed.) (1991).

Csikszentmihalyi, M. (1997), *Finding Flow: The Psychology of Engagement with Everyday Life*, New York: Basic Books.

Davies, S. (2005), 'Still Popular – Museums and their Visitors 1994–2004', *Cultural Trends* 53, 14: 1, 67–106.

DCMS (Department for Culture, Media and Sport) (2004), *Culture at the Heart of Regeneration*, London: DCMS.

DfES (Department for Education and Skills) (2002), *Learning Through Culture. The DfES Museums and Galleries Education Programme: A Guide to Good Practice*, Leicester: RCMG.

Dewey, J. (1934), *Art as Experience*, New York: Capricorn.

Dewey, J. (1938), *Experience and Education*, New York: Macmillan.

Dicks, B. (2003), *Culture on Display – The Production of Contemporary Visibility*, Buckingham: Open University Press.

Dierking, L. (1992), 'Historical Survey of Theories of Learning' and 'Contemporary Theories of Learning', in G. Durbin (ed.) (1996).

Dufresne-Tassé, C. (ed.) (2002), *Evaluation: Multi-purpose Applied Research*, Paris: ICOM-CECA.

Dufresne-Tassé, C. (ed.) (1998), *Evaluation and Museum Education: New Trends*, Paris: ICOM-CECA.

Duncan, C. (1995), *Civilizing Rituals – Inside Public Art Museums*, London: Routledge.

Durbin, G. (ed.) (1996), *Developing Museums for Lifelong Learning*. London: Group for Education in Museums (GEM), Stationery Office.

Eisner, E. (1998), *The Enlightened Eye: Qualitative Inquiry and the Enhancement of Educational Practice*, Englewood Cliffs NJ: Merrill.

engage (2004a), *Museums and Galleries as Learning Places*, London: engage.

engage (2004b), *Encounters with Contemporary Art – Schools, Galleries and the Curriculum*, London: engage.

Evans, G. and Shaw, P. (2004), *The Contribution of Culture to Regeneration in The UK: A Report to the Department for Culture, Media and Sport*, London: Metropolitan University.

Falk, J. and Dierking, L. (2002), *Lessons without Limit: How Free-Choice Learning is Transforming Education*, Walnut Creek CA: AltaMira.

Falk, J. and Dierking, L. (2000), *Learning from Museums: Visitor Experiences and the Making of Meaning*, Walnut Creek CA: AltaMira.

Falk, J. and Dierking, L. (1992), *The Museum Experience*, Washington DC: Whalesback.

Foster, H. (ed.) (1985), *Postmodern Culture*, London: Pluto.

Freire, P. (1972), *Pedagogy of the Oppressed*, Harmondsworth: Penguin.

Gardner, H. (1983), *Frames of Mind: The Theory of Multiple Intelligences*, London: Fontana.

Gregory, R. (1997), *Eye and Brain: The Psychology of Seeing*, 5th ed., Oxford: Oxford University Press.

Hall, S. (ed.) (1997), *Representation: Cultural Representations and Signifying Practices*, London: Sage.

Hein, G. (1992), 'Constructivist Learning Theory', in G. Durbin (ed.) (1996).

Hein, G. (1998), *Learning in the Museum,* London: Routledge.

Holt, J. (1976), *Instead of Education*, Harmondsworth: Pelican.

Hooper-Greenhill, E. *et al*. (2004), *Inspiration, Identity, Learning: The Value of Museums*, London: Department for Education and Skills.

Hooper-Greenhill, E. (ed.) (1999), *The Educational Role of the Museum*, London: Routledge.

Hooper-Greenhill, E. (ed.) (1997), *Cultural Diversity: Developing Museum Audiences in Britain*. Leicester: Leicester University Press.

Hooper-Greenhill, E. (1994), *Museums and their Visitors*, London and New York: Routledge.

Hooper-Greenhill, E. (1992), *Museums and the Shaping of Knowledge*, London: Routledge.

Horne, D. (1986), *The Public Culture – The Triumph of Industrialism*, London: Pluto.

Horne, D. (1984), *The Great Museum – The Re-presentation of History*, London: Pluto.

Illich, I. (1973), *Deschooling Society*, Harmondsworth: Penguin. Republished by Marion Boyars.

Illich, I. *et al.* (1977), *Disabling Professions*, London: Marion Boyars.

Kavanagh, G. (ed.) (1996), *Making Histories in Museums*, Leicester: Leicester University Press.

Kolb, D. (1984), *Experiential Learning: Experience as the Source of Learning and Development*, Englewood Cliffs NJ: Prentice-Hall.

Kotler, N. and Kotler, P. (1998), *Museum Strategy and Marketing*, San Francisco: Jossey-Bass.

Kotler, P. and Scheff, J. (1998), *Standing Room Only: Strategies for Marketing the Performing Arts*, Boston MA: Harvard Business School.

Kreps, C. (2003), *Liberating Culture – Cross-cultural Perspectives on Museums, Curation and Heritage Preservation*, London: Routledge.

Kress, G. (2003), *Literacy in the New Media Age,* London: Routledge.

Kress, G. and Van Leeuwen, T. (2001), *Multimodal Discourse: The Modes and Media of Contemporary Communication, Cheltenham:* Arnold.

Loomba, A. (1998), *Colonialism/Postcolonialism*, London: Routledge.

Macdonald, S. and Fyfe, G. (eds) (1996), *Theorizing Museums*, Oxford: Blackwell.

Mclean, F. (1997), *Marketing the Museum, London:* Routledge.

McManus, P.M. (ed.) (2000a), *Archaeological Displays and the Public*, 2nd ed., London: Archtype Books.

McManus, P.M. (2000b), 'Written Communications for Museums and Heritage Sites', in P.M. McManus (2000a), pp 97–114.

McManus, P.M. (1998), 'Preferred Pedestrian Flow: A tool for designing optimum interpretive conditions and visitor pressure management', *Journal of Tourism Studies* 9: 1, 40–50.

McManus, P.M. (1994), 'Families in Museums', in R. Miles and L. Zavala (eds) (1994), pp 81–97.

Maitland, H. (1997), *A Guide to Audience Development*, 2nd ed., London: ACE.

Merriman, N. and Poovaya-Smith, N. (1996), 'Making Culturally Diverse Histories', in G. Kavanagh (ed.) (1996).

Miles, R. and Zavala, L. (eds) (1994), *Towards Museums of the Future*, London: Routledge.

Mirzoeff, N. (ed.) (1998), *The Visual Culture Reader*, 2nd ed., London: Routledge.

Morton, S. (2003), *Gayatri Chakravarty Spivak*, London: Routledge.

Owens, P. (1998), *Creative Tensions*, Washington DC: British American Arts Association.

Porter, G. (1998), 'Seeing through Solidity: Feminist Perspectives on Museums', in S. Macdonald and G. Fyfe (eds) (1996).

Preziosi, D. and Farago, C. (eds) (2004), *Grasping the World. The Idea of the Museum*, Aldershot: Ashgate.

Rabinow, P. (ed.) (1984), *The Foucault Reader*, London: Peregrine.

Rogers, R. (1998), *Audience Development: Collaboration between Education and Marketing*, London: ACE.

Runyard, S. and French, Y. (2000), *Marketing and Public Relations Handbook for Museums, Galleries, and Heritage Attractions,* Walnut Creek CA: AltaMira Press.

Selwood, S. (2002), 'Measuring Culture', Spiked-Online, <http://www.spiked-online.com/Printable/00000006DBAF.htm>

Selwood, S. (ed.) (2001), *The UK Cultural Sector: Profile and Policy Issues*, London: Policy Studies Institute.

Selwood, S. (1999), 'Access, Efficiency and Excellence: Measuring Non-economic Performance in the English Subsidised Cultural Sector', *Cultural Trends* **35**, *87– 141.*

Serota, N. (1995), *Experience or Interpretation: The Dilemma of Museums of Modern Art*, London: Thames and Hudson.

Silva, E. and Edwards, R. (undated), 'Operationalizing Bourdieu on Capitals: A discussion on the "Construction of the Object" ' at <http://www.open.ac.uk/ socialsciences/sociology/research/ccse/index.html>, accessed 5 July 2005.

Simpson, M. (2001), *Making Representations: Museums in the Post-Colonial Era*, London: Routledge.

Stanley, N. (1998), *Being Ourselves for You: The Global Display of Cultures*, London: Middlesex University Press.

Taylor, P. (1993), *The Texts of Paulo Freire*, Buckingham: Open University Press.

Vygotsky, L.S. (1978), 'Mind in Society: The Development of Higher Psychological Processes', in H. Gardner (1983).

Vygotsky, L.S. (1971), *The Psychology of Art*, Cambridge MA: The MIT Press.

Walsh, A. (ed.) (1991), *Insights: Museums, Visitors, Attitudes, Expectations: A Focus Group Experiment*, Santa Monica CA: Getty Center for Education In the Arts and J. Paul Getty Museum.

Ward, C. and Fyson, A. (1973), *Streetwork. The Exploding School*, London: Routledge and Kegan Paul.

Weil, S. (1995), *A Cabinet of Curiosities. Inquiries into Museums and their Prospects*, Washington DC: Smithsonian Institution Press.

Wright, M., Selwood, S., Cresser, C. and Davies, J.E. (2001), *UK Museums Retrospective Statistics Projects*, Loughborough: LISU.

Rozwadowski, and Franz, F. (2000). *Alternative Dispute Resolution Handbook for Insurance Coverage Coverage Litigation*. Walnut Creek, CA: AltaMira Press.

Salacuse, J. (2003). *The Global Negotiator: Making, Managing, and Mending Deals Around the World in the Twenty-First Century*. New York: Palgrave Macmillan.

Schön, D. (1983). *The Reflective Practitioner: How Professionals Think in Action*. New York: Basic Books.

Seligman, M. (2002). *Authentic Happiness: Using the New Positive Psychology to Realize Your Potential for Lasting Fulfillment*. New York: Free Press.

Senge, P. (1990). *The Fifth Discipline: The Art and Practice of the Learning Organization*. New York: Doubleday.

Ury, W. (1991). *Getting Past No: Negotiating Your Way from Confrontation to Cooperation*. New York: Bantam Books.

Watzlawick, P. (1974). *Change: Principles of Problem Formation and Problem Resolution*. New York: Norton.

Weisbord, M. (1991). *Productive Workplaces: Organizing and Managing for Dignity, Meaning, and Community*. San Francisco: Jossey-Bass.

Chapter 2

The Impact of Government Policy

Caroline Lang, John Reeve and Vicky Woollard

Introduction

Anyone studying the place of museums and galleries in society has to understand both politics and government policy at national and local level. The relationship of the government, national and local, with its cultural institutions largely determines their function within the community and the type of service they deliver. Governments may see the role of museums in a variety of ways: as primarily representing a desirable identity for the nation; operating as a public space owned by the wider community; as an instrumental tool for social, economic and educational advancement; and so on.

Each country has a different political framework in which museums and galleries are placed, often formed by historical accident and design. Professional expertise, organizations and international conventions such as those promoted by the United Nations Education Science and Cultural Organization (UNESCO), the International Council of Museums (ICOM) and the European Union can influence the way in which museums and galleries operate ethically. Politics can determine attitudes, standards and levels of service. Since the 1980s many countries have experienced radical changes in the nature and governance of their museums and galleries. Globalization and global concerns about migration and the drive for economic growth have impacted on education and cultural sectors everywhere.

There has been a radical change in the structures of formal education systems in terms of curriculum, practice and funding. Governments and employers expect the education system to provide an effective and flexible workforce, placing an emphasis on lifelong learning, workplace training and continuing professional development. The pressure of populations crossing continents raises issues of social and cultural inclusion and cohesion, and the recognition of cultural diversity alongside integration into the social and economic frameworks of individual nation states. *In from the Margins* (Council of Europe, 1997) argues cogently for the role of culture and cultural institutions in creating a stable and constructive balance between integrating migrant groups and yet at the same time celebrating differences.

In order to examine the influence of government on museums and galleries, four areas of government activity are suggested below, using the UK as a case study. The four areas are: legislation, policy-making, funding responsibilities and administration. They are not intended to be exhaustive and it is accepted that the divisions are necessarily artificial and will overlap, but they have been chosen to help

tease out the ways in which governments can impact on museums and determine the relationship the museums have with their visitors and publics.

Government as Legislator

One example of direct government influence which has shaped museums in England today was the introduction of the Museums Act in 1845, which enabled boroughs with a population of over 10,000 to build and maintain museums of art and science financed from the local rates (taxes) and to charge for admission. This Act was passed in response to pressure from the increasing number of popular local museums being established by learned societies and local institutes, and from radical Members of Parliament who saw them as providing worthwhile adult education. It is interesting for the future funding of museums in England that local authorities were enabled rather than required, as later in Scotland, to set up museums. They were not statutory services, as public libraries were later to be, and this has affected their funding and, arguably, their relative position in many local authority structures. A consequence of this mandatory/statutory provision is shown in more concrete terms: museums in small towns across England are often found situated above the library on the first or second floor, distancing themselves from the very public they are asked to serve. Another example of legislation having a direct impact on museums and galleries has been the introduction of the National Lottery, set up in 1993 to raise funds for 'good causes' including museums, galleries and heritage sites. It has subsequently provided organizations all over the UK with new buildings, education centres, and funds for community and school projects. The monies from the Lottery are shared out by a number of bodies, including Arts Council England and the Heritage Lottery Fund, which believe that education, learning, access and social inclusion are central criteria for the award of grants.

Several pieces of legislation which do not specifically include a remit for museums can still have a major impact on their educational provision, for example the Education Reform Act of 1988 which introduced, for the first time in England and Wales, a national curriculum. Prior to the Act, topic and themed teaching in primary schools was easily supported or initiated by museum or heritage visits, but the new curriculum took control of what was to be taught in the classroom, how often and for how long. These sweeping changes brought with them both opportunities and threats (see Chapter 4 below.) The Education Reform Act also forced local education authorities to cut back on their direct funding and devolve more to individual schools. This resulted in the loss of funding for free museum handling collections and loan services, education posts in museums, advisory staff and financial support for visits. Several services have since been revived but only through introducing charges for schools for teaching sessions and for loans. This has created a barrier for those schools which have lower budgets or which have other funding priorities.

Other legislation relating to equal opportunities and human rights has had a powerful effect in many parts of the world in encouraging museums to embrace

a broader audience. In the UK, for example, the Disability Discrimination Act (DDA) 1995 and race equality legislation have changed museum policy and practice since both put the onus on the service provider to effect improvements. The DDA came into force over a ten-year period to allow for changes to be made. It aims to end discrimination against disabled people and improve access. It also places an anticipatory duty on service providers to find out about the barriers to access that disabled people may face and to make reasonable adjustments to overcome them. This has meant that many of the larger museums have employed access officers (see Chapter 12) to ensure that reasonable adjustments have been implemented in consultation with disability organizations.

The Race Relations Act (RRA) 1976 was amended in 2001 to give public authorities a new statutory duty to actively promote race relations. They are expected to eliminate racial discrimination and promote equality of opportunity and good relations. Some authorities such as schools and colleges also have to meet more specific duties. The act has meant that there is a greater emphasis on providing services that are inclusive of, and often prioritize, people from different backgrounds and cultures (see Chapter 6) and also on employing a diverse workforce. Currently staff profiles in museums and galleries are far from being representative of the diversity of cultures in the UK, particularly at higher levels. One initiative designed to help remedy this, set up in response to the Act, is the *Diversify* scheme run by the Museums Association (see Response to Chapter 14). In 2005, the Minister for the Arts, David Lammy, encouraged museums to better reflect the diversity of culture, background and ethnicity in the UK and said that he considered museums and galleries as crucial to the cultural cohesion of Britain particularly in light of terrorist activities in London.[1]

Government as Policy-Maker

In both Conservative (1979–97) and Labour (1997–) governments of recent years there has been a concern to measure the effectiveness of public services, to ensure that they are of necessary quality and that they demonstrate value for money. There has been an emphasis on the importance of the individual as the recipient of public services; but delivered in different ways. The Conservative governments emphasized the role of consumer, customer and citizen, and this can be seen in several initiatives under John Major (Prime Minister, 1990–97) such as *Investors in People* and *The Citizen's Charter*.[2] Any public service should respond to customer needs and be delivered to high standards. For example, English Heritage was created not only to research and record historic sites but also to increase access through a wide range of interpretive devices and to encourage school visits though education packs and displays. Two reports written by the Department of National Heritage (predecessor

1 David Lammy at the Museums Association Conference, October 2005 – his speech on <www.24hourmuseums> was edited by David Prudames, accessed 13 November 2005.

2 The Citizen's Charter was introduced in 1991.

to DCMS) during this period, *Treasures in Trust* (DNH, 1996a) and *People taking Part* (DNH, 1996b), concentrated on the accessibility of arts and cultural heritage organizations, with a particular focus on marketing, information technology and audience development.

When a new Labour government came to power in 1997 the emphasis changed; access to culture was to be promoted through the mantra 'education, education, education' rather than through marketing and customer services.[3] This government also had a clear commitment to tackling social exclusion. Highlighting the change of approach, when the newly named Department for Culture, Media and Sport (DCMS), the government department with responsibility for museums, carried out its comprehensive spending review later in 1997, four central themes for the department were identified:

- the promotion of access for the many not the few
- the pursuit of excellence and innovation
- the nurturing of educational opportunity
- the fostering of the creative industries.

It stated, crucially, that museums 'are about objects and for people'.[4]

By 1999 DCMS had gone on to publish specific guidance for museums, *Museums for the Many: Standards for Museums and Galleries to Use When Developing Access Policies*, as well as an access policy for their own Department (see Chapter 3). Another important initiative by the government, in terms of its effect on the cultural sector, was to set up a Social Exclusion Unit, which published a report on neighbourhood renewal in 1998. Government departments across Whitehall were asked to look, in an integrated way, at the problems of poor neighbourhoods and at ways they could be tackled. DCMS recommended ways to maximize the effects of government spending on sport and the arts (DCMS, 1999). Policy guidance for museums and archives on tackling social exclusion followed in 2000 and education was seen as one of the most powerful weapons they could use. *Centres for Social Change: Museums, Galleries and Archives for All: Policy guidance on Social Inclusion for DCMS-funded and local authority museums, galleries and archives in England* was published in May 2000. Much of the thinking behind these initiatives in terms of the DCMS's response came from the work of the think tank Comedia,[5] particularly the work of Francois Matarasso. In Matarasso's publication *Use or Ornament? The Social Impact of Participation in the Arts*, he discusses the findings of a large research project which explored the use of social indicators to demonstrate how participation in cultural activities can bring about social change, such as social cohesion, improved self-confidence and health and well-being. These indicators

3 'We will make education our number one priority' – from the Labour Party Manifesto 1997. See <www.psr.keele.ac.uk/area/uk/man/lab97.htm>, accessed 23 October 2005.

4 *DCMS Comprehensive Spending Review*, 1997.

5 See <http://www.comedia.org.uk/pages/home.htm>. Set by Charles Landry in 1978.

were much discussed and DCMS seemed keen to adopt them.[6] However, with a change of minister, priorities have shifted and this has not happened.

For the first time in a century or more the educational and social role of museums was being clearly articulated by government and was influencing policy. Not everyone was converted, but for those not persuaded by the political, philosophical and ethical arguments another powerful force made museums look again at the ways in which they provide for the visitor' s needs – namely hard cash. Grants were set up by the Lottery distributors, including the Heritage Lottery Fund (HLF) as mentioned above. Their revised criteria, in line with government thinking, have had an enormous impact. HLF asks for museums and galleries to put the following in place in order to receive funding: visitor research-based projects that show clear benefits for the public, performance indicators and appropriate policies and strategies.

As noted above, both the Conservative and Labour governments included notions of citizenship within their agendas in terms of their rights and responsibilities. The emphasis on respect and involvement in the community have been a key plank of Labour government thinking. Citizenship has become a compulsory element for secondary schools, and an option for primary schools in the National Curriculum. Organizations such as the British Library, English Heritage and the Museum of London have responded with special programmes and resources, dealing with issues such as 'why preserve the past?', 'how to improve the local environment' and 'what are museums for?'. New museums such as the Galleries of Justice in Nottingham and the Empire and Commonwealth Museum, Bristol, have been especially effective at this. This is an arena where social inclusion, reducing crime, ill-health and truancy, etc., all come together, and Nottingham is a good example (Dodd and Sandell, 1998). Wider implications of the citizenship agenda include encouraging more adults to volunteer, and opening museums up to greater public scrutiny through open meetings, which are being held even by the nationals. A good example of involving the community in an area of museum policy is the decision by Glasgow Museums to return the Native American ghost shirt, following public discussion.

Government and Funding

Governments have, in one way or another, reduced overall funding for the cultural sector and encouraged institutions to seek and develop other financial resources, as already mentioned in Chapter 1. The majority of museums now have plural funding sources. For example, Chile's Ministry of Education has delegated its major responsibilities for national and regional museums to DIBAM,[7] a governmental

6 For further information see a paper by Paola Merli in the *International Journal of Cultural Policy*, 2002, **8**: 1, 107–118. For a response by François Matarasso to this article, see *International Journal of Cultural Policy*, 2003, **9**: 3, 337–46.

7 DIBAM stands for Dirección de Bibliotecas, Archivos y Museos, organismo gubernamental dependiente del Ministerio de Educación de Chile. See <http://www.dibam.cl/>, accessed 23 October 2005.

administrative body, which directly funds and administers 25 museums – three nationals and 22 regionals out of the total of 130 museums across the country. One of the main objectives set for these museums is to gradually gain administrative and financial autonomy and to optimize their resources. They are encouraged to add to their core funding by accessing competitive private and governmental resources, such as the National Fund for Regional Development, the Presidential Commission of Infrastructure, *Fundación Andes,* municipal funds, and FONDART (National Funds for the Arts). Some museums have also developed income-raising strategies by offering assessment services to other museums or cultural institutions and, in a more minor degree, through their modest museum shops and cafes.[8] Elsewhere in South America, banks and foundations take the lead in developing and maintaining museums and securing their collections.

In the UK Margaret Thatcher's Conservative government (1979–90) radically changed the relationship between government, culture and education. Her attack on public services led to a number being privatized; others suffered severely reduced levels of public funding and were scrutinized by the National Audit Office, set up in 1983 to check that there was evident value[9] for taxpayers' money.[10] Museums were told to enhance their core budgets with additional funding from admission charges, sponsorship and sales. Thatcher noted with approval, when opening the Egyptian Sculpture Gallery at the British Museum in 1980, that it had been funded by wealthy philanthropists and foundations such as the Henry Moore Foundation. All subsequent galleries, most exhibitions, and many programmes there and at other national museums such as the Imperial War Museum and National History Museum have also been funded through sponsorship, the Government's grant-in-aid only covering staff costs and basic upkeep of the building. This has led to an enormous increase in time spent on fundraising for most museums in the UK in a way that has always been the norm in North America and many other countries.

In the past the British government has accepted gifts on behalf of the nation[11] or purchased collections[12] which now form a part of the 40 museums and galleries that the Government now funds,[13] but does not manage, directly. These museums are managed by boards of trustees on the government's behalf. They include the

8 Thanks to Caroll Yasky for her help with gathering this information on Chile.

9 The three areas to be considered (known as the 3 Es; economy, efficiency and effectiveness).

10 Example of this were the report *The Road to Wigan Pier* and the report on the Victoria and Albert Museum which have recommendations as to how quick a response to an inquiry should be.

11 As with Sir Hans Sloane's collection of natural specimens, etc., which became the foundation of the British Museum.

12 In 1824 £57,000 was paid to the banker John Julius Angerstein for 38 pictures which were intended to form the core of a new national collection, for the enjoyment and education of all.

13 Wales, Scotland and Northern Ireland have received devolved responsibility for their own museums and galleries funded by their elected body. (Since 2000 Northern

Nationals (for example, the Imperial War Museum, the National Portrait Gallery and the Tate Gallery) and a number of regional museums, such as the National Museums Liverpool, where the principal government department responsible is the DCMS. These institutions have a direct funding agreement in which the individual museums and the DCMS civil servants negotiate a budget linked to agreed performance targets set for three years. These performance targets can include a percentage increase in visitor figures in various categories, increases in the range of visitors, and increases in access to collections through different means such as loans and websites. For example, the Geffrye Museum's target is to increase its overall visitor numbers from 83,000 to 88,000 in three years and to increase its website visits by 20,000 over the same period.[14] These museums are also required to explain how they will help to deliver the DCMS's own public service agreement set by the Treasury.[15] In 2005 this included an increase in the take-up of cultural opportunities by people aged 16 and above from priority groups by 2008.[16]

The DCMS is not the only government department with museums within its remit; the Ministry of Defence funds military museums such as the National Army Museum and the Fleet Air Arm Museum, among others. The Department for Education and Skills has an 'arm's-length' arrangement with English university museums and collections which are funded by the Higher Education Funding Council of England (HEFCE) via the Arts and Humanities Research Council.[17]

Further funding from DCMS comes through the Museums, Libraries and Archives Council (MLA). This is the national development agency working for and on behalf of museums, libraries and archives in England and advising the government on policy and priorities. MLA channels government funding to non-national museums, supports the regional agencies in the nine English regions, and promotes minimum standards through an Accreditation scheme. It also administers specific funds which provide extra resources for designated museums with collections considered to be of particular importance, and for other initiatives which often interpret government priorities (see <www.mla.gov.uk>). Learning, and the provision of a comprehensive service to schools, are also central to *Renaissance in the Regions*,[18] originally a £70-million package of government investment in regional museums over four years

Ireland has returned to direct rule from Westminster.) See <http://www.direct.gov.uk/Gtgl1/GuideToGovernment/DevolvedAndLocalGovernment/fs/en)>.

14 See<www.culture.gov.uk/NR/rdonlyres/81B2D612-9290-4F2F-9BF3-834935C87221/0/GeffryeMuseumFundingAgreement03.pdf>, accessed 23 October 2005.

15 See <www.culture.gov.uk>.

16 See <www.culture.gov.uk/about_dcms/>, accessed 14 October 2005.

17 See a comprehensive overview of the funding system of museums and galleries in the UK on the Department for Cultural Policy and Management, City University website at <www.city.ac.uk/cpm/artspol>.

18 *Renaissance in the Regions* produced by Resource (now the Museums, Libraries and Archives Council) in 2001 was both a report and advocacy document to argue that key regional museums in England needed financial investment to bring them up to the standards of the nationals which are, in the majority, located in London.

from 2002, which makes services to the public a priority. The aims are 'to transfer the quality of services to an expanded body of users' and to 'facilitate modernisation of museums and galleries for a 21st century audience' (Resource, 2001). As discussed in Chapter 14, in return for this investment, the museums involved in the scheme have to reach a target of 100,000 visits made by schoolchildren per year.

Government as Administrator

Although national governments may not directly fund all museums, they can influence the way museums are administered. A government's relationship with, and its philosophy and purpose for, museums and galleries can be shown by the government department or ministry they are placed in. In many countries there is a government ministry dedicated solely to culture, including museums. This is the case in Slovenia where the Ministry of Culture's responsibilities include 'the co-ordination of cultural development, the protection of the cultural heritage, providing suitable conditions for the creation, communication and accessibility of cultural assets and guarantees [of] the special cultural rights of minorities'. The Ministry directly funds a number of organizations and institutions such as the National Technology Museum situated in Ljubljana, the capital. In England, museums are included in the remit of the Department for Culture, Media and Sport (DCMS). This is a relatively new department, set up in 1997, and is small in terms of staff and budget compared with other departments such as Health and Education. In order to have greater influence it has had to ally itself to other departments. A 'partnership' with the Department for Education and Skills (DfES) has led to prioritized funding that directly benefits schoolchildren and the formal education sector. The DCMS on its inception took the opportunity to streamline some of the non-departmental public bodies (NDPBs) for which it had responsibility. This resulted in bringing together the separate bodies which looked after archives, museums and libraries into a single agency initially called Resource, now the Museums, Libraries and Archives Council (MLA).

By contrast, in Finland, museums and art galleries come under the Ministry of Education which 'is responsible for education, science, culture, youth and sports policies. The objective of the Ministry is to provide educational and cultural opportunities for further education and to guarantee the skills needed in the labour market, to strengthen national culture and to promote international cooperation' [sic]. Botswana's approach is to place the national museum, art gallery and archives under the Ministry of Labour and Home Affairs. In the Ministry there are two deputy permanent secretaries, one of whom has the following responsibilities: Culture and Youth; National Library Service; National Archives and Records Services; National Museum, Monuments and Art Gallery; Sports and Recreation and Women/ Gender issues. The components of each of these functions or departments, and their partnerships, will to a greater or lesser extent influence the work carried out by the museums involved. It may dictate a 'pecking order' in terms of budget size: for example, will sports get more than heritage? It may result in the types of partnerships

formed to ensure that government policies are implemented or economies of scale are introduced: for example bringing together museums, libraries and archives under one agency. It may mean that special projects are initiated by the Ministry as a whole which have to be delivered by those museums; such as raising girls' and women's educational standards.

Conclusion

To judge by how governments in most parts of the world fund museums and galleries it may be concluded that they are either not interested in such organizations or feel they are unable to be so. In the world's wealthiest countries the rich are expected to pick up the tab, and so Japanese, American and European museums now often operate in a mixed economy of funding by the state (national or local) and from trusts, foundations, companies and individuals, and through self-generated income (see above and Chapter 1). In Portugal, recent cultural policy has largely been created and funded by foundations such as the Gulbenkian, which funds an art gallery, national orchestra and ballet company.

Where government does intervene directly, it can be to the detriment of the heritage, as in Italy, or have a profound affect on their whole rationale, as in Britain, often negatively under the Conservatives and more positively under Labour governments. Inevitably there are strings attached: the warm embrace of the funder is accompanied by evaluation and the need to prove specific outcomes (see Chapter 8). More 'joined up' thinking within government is increasingly reflected in museum policy and funding in the UK. Rationalization of museums into a national network can be amazingly ambitious, as under Napoleon, or more modestly beneficial, as with the World Museum in Gothenburg, the Flanders Collective in Belgium, or Renaissance in the Regions in England.

References

Council of Europe (1997), *In from the Margins*, Strasbourg: Council of Europe.

Department for Culture Media and Sport (DCMS) (1999), *Museums for the Many: Standards for Museums and Galleries to Use When Developing Access Policies*, London: DCMS. See also <www.culture.gov.uk>

Department of National Heritage (DNH) (1996a), *Treasures in Trust*, London: DNH.

Department of National Heritage (DNH) (1996b), *People taking Part*, London: DNH.

Dodd, J. and Sandell, R. (1998), *Building Bridges: Guidance for Museums and Galleries on Developing New Audiences*, London: MGC. (Reprinted 2000)

Dodd, J. and Sandell, R. (2001), *Including Museums: Perspectives on Museums, Galleries and Social Inclusion*, Leicester: RCMG.

Her Majesty's Government (1976), Race Relations Act, London: HMSO.

Her Majesty's Government (1995), Disability Discrimination Act, London: HMSO.
Hooper-Greenhill, E. (1991), *Museum and Gallery Education*, Leicester: Leicester University Press.
Investors in People (2002), *Investors in People – What does it mean for me?*, London: Stationery Office.
Matarasso, F. (1997), *Use or Ornament? The Social Impact of Participation in the Arts*, Stroud: Comedia.
Reeve, J. (1996), 'Making the History Curriculum', in G. Kavanagh (ed.) (1996).
Resource (2001), *Renaissance in the Regions: A New Vision for England's Museums*, London: Resource.

Websites

<www.culturalprofiles.org.uk/slovenia/Units/3845.html>
<www.minedu.fi/OPM/?lang=en>
<www.gov.bw/government/ministry_of_labour_and_home_affairs.html>

Chapter 3

The Public Access Debate

Caroline Lang

Introduction

Museums have experienced a profound shift of focus in recent years. Stimulated by policy guidance from central and local governments, new funding streams with specific requirements to show public benefits and a more vociferous and demanding public, they are responding to the requirements of their audiences more than ever before. Access has crept steadily up the agenda and there is increasing professional concern internationally for issues such as the representation of diversity and the inclusion of previously marginalized sections of society. This involves making collections accessible to a wide range of people, in an intellectual, physical and cultural sense, meeting targets and performance indicators in areas such as access, inclusion, cultural diversity and public accountability, while continuing to maintain high standards of collections care, research and scholarship.

An influential report to the UK government in 2001, *Renaissance in the Regions*, expressed the underlying principle as follows:

> The collections of museums and galleries belong to everyone ... The mission of museums can be simply expressed. It is to make these collections readily accessible and useful to people today and to preserve them so that they can be used by future generations ... They [museums] are important to society not only because of their irreplaceable collections but also because of their educational, social and cultural value: the contribution that they make to improving people's lives and to the understanding of unfamiliar cultures and viewpoints. (Resource, 2001, p 24)

However a glance at any article about museums in the national and specialist press will demonstrate that there is considerable debate about all of this. On the one hand, some ask how far organizations which essentially collect and assemble material culture and natural specimens can be expected to adapt to new, sometimes political, agendas. Others argue that the museum has historically been associated with reinforcing social inequalities through the partial or biased collecting and arranging of objects to cater for the tastes and interests of an elite minority and it is high time that they responded to the public of the twenty-first century who fund them. Many of these arguments assume that hitherto museums have somehow been politically neutral and are only now being required to take account of what is going on in

society beyond their walls. In fact, although the terminology may be different today, the debate itself is not new.

For many this debate has become polarized; essentially elitism versus popularization or 'dumbing down'. This can be quite sterile and the reality for most museums is far more complex. Organizations are attempting to improve access at various levels, according to their own priorities; for example, the need to contribute to local strategies which may emphasize anti-poverty measures or regeneration, or the need to satisfy a range of specialist stakeholders or to generate income. Each museum will find its own rationale and direction for change which is likely to be affected by a combination of factors. These include the ethical/moral case for being a democratic, public-facing organization; the business case, which includes benefits in terms of increased funding and income, resources and public profile; and legal obligations. UK museums which are open to the public are obliged to comply with a growing body of legislation such as the Disability Discrimination Act (DDA), the Race Relations Acts, the Human Rights Act and the Freedom of Information Act and this is also a trend elsewhere.

Most museums now subscribe to the view that they are above all for people and that they should aim to make their collections more accessible, at least in a physical and financial sense. The practical implications, the definition of exactly what a museum is for, how resources are distributed and decisions are made still provoke considerable debate. However to go beyond these criteria to a position where publicly funded museums are expected to actively contribute to a more inclusive society is positively opposed by many. Tiffany Jenkins of the Institute of Ideas argues that museums will suffer if they are forced to shoulder the responsibility for education: 'Museum directors, curators and marketing assistants cannot solve the social problems of exclusion, mental health or poverty. They cannot resolve the crisis in education. Nor should they be asked to. But they have been running around trying to do so, as if they were social workers or teachers.'

From a different standpoint, the literary critic John Carey questions why entrance to the National Gallery in London should be free of charge. He feels that it is wrong for the majority to have to pay for the artistic pleasures of the educated minority, concluding that, since there is no way of proving that 'high art' can be considered superior to 'mass culture', or that it offers any demonstrable moral or spiritual benefits to society, it is hard to argue that it should be made available at tax-payers' expense (Carey 2005). Others take a different view. David Fleming, Director of Museums and Galleries on Merseyside, might sympathize with Carey's viewpoint but from a completely different perspective. He says that there are four reasons why museums have not been positioned to contribute to social inclusion, 'who has run them, what they contain, the way they have been run and what they have been perceived to be for – to put this last reason another way, for whom they have been run ...' He continues:

> One might think that because traditional museums are publicly funded cultural institutions, they would, by definition, have been institutions run in the interests of the public at large.

Nothing could be further from the truth. All kinds of interest groups and individuals have exerted such pressure that they have subverted the museum's democratic role … Museums have often been founded in a spirit of public good, but the temptation to control the way they operate can be powerful. In any case it would be naïve to suggest that the 'public good' was really any more than 'what's good for the public' (Fleming in Sandell, 2002, pp 213 and 217).

What Do We Mean by Access?

Public access is described largely in terms of opening hours and physical access to collections and staff in the International Council of Museums' (ICOM's) *Code of Ethics* (2002). Advice from the Museums Association (the professional organization for museums in the UK) in their *Ethical Guidelines on Access* (1999) identified two elements, the physical and the philosophical:

> Museums are coming to terms with the first. They ask themselves relevant questions. Are opening times convenient for users? Are entrances welcoming?

> Are there ramps as well as stairs? Are labels legible and toilets available? As important are the philosophical assumptions. Why and how are objects acquired? What criteria are used in documentation and display? What values drive publicity campaigns? How do we select the language of our labels and publications?

From the late 1990s we have seen more of a different kind of terminology. For example, Arts Council England recently stated: 'Access is one of those categories that can mean almost anything, from ramps to jobs. Its breadth is its point, for it is essentially inclusive. It carries with it the assumption of equality'. (ACE, 2004). While access was once seen as an issue relating mainly to opening hours and disability, we have now become accustomed in the cultural sector to using the word to describe wider issues associated with the notion of barriers, borrowed from the social model of disability.[1] These may be intellectual, cultural, attitudinal/social, financial and so on, as well as physical and sensory. This approach attempts to overcome what Mark O'Neill, Director of Glasgow Museums, describes as 'the welfare model of provision with a mainstream that is well provided for alongside some cultural benefits for the less well off' (O'Neill in Sandell, 2002, p 24). In *Museums for the Many*, the approach is summarized by the Department of Culture, Media and Sport in this way:

Barriers to access may be:

- physical and sensory; for example, affecting people with disabilities, older people and those with responsibility for young children;

1 See *Disability Directory for Museums*, from Resource (now MLA) 2001: 'Society disables people by putting barriers in their way. These range from physical and communication barriers to those of attitude'. <www.mla.gov.uk>.

- intellectual; for example, through inadequate display and interpretation of objects;
- Cultural; for example, with collections, exhibitions and events failing to engage people from different cultural backgrounds;
- Attitudinal; for example caused by museums not making all of their visitors feel welcome and valued;
- Financial; for example admission charges, the cost of transport to and from museums and the costs of catering and merchandising.' (DCMS, 1999).

To these we should now add an additional barrier:

- Technological; for example IT, websites and other new media not being available to everyone or in suitable formats.

Building Bridges, an influential booklet written for the (then) Museums and Galleries Commission by Jocelyn Dodd and Richard Sandell, who had worked together at Nottingham City Museums and Art Galleries on developing new audiences, explores issues to consider in relation to these barriers and suggests possible approaches to audience development Here, a further two factors are included:

- access to decision-making – does our museum consult potential new audiences and value the input of external stakeholders?
- access to information – does our publicity effectively reach and communicate with new audiences? (Dodd and Sandell, 1998, p 14).

Also from the late 1990s, largely in the UK as a result of government initiatives, social inclusion and exclusion and social justice started to be mentioned in relation to access issues for museums. The term social exclusion was a relatively new one in British policy debates, although it had been used in Europe for 20 years or more. However the principles of this kind of work in museums have a much longer history, particularly in local authority rather than national museums, and examples are well documented by, amongst others, the Group for Large Local Authority Museums (GLLAM).[2] Definitions are fluid and evolving, but the main implications are that museums should work with the whole community and provide equal access to all citizens as of right (Scottish Museums Council 2000).

Cultural diversity is another area often associated with access and particularly with audience development and changing visitor profiles. Again it is a complicated notion with many different strands. Arts organizations tend to use the term in different ways. Arts Council England, for example, defines it according to the major ethnic minority communities in the UK – Black African and Caribbean, Asian and Chinese – and sees development very much in terms of promoting artists as well as

2 See *Centres for Social Change: Museums, Galleries and Archives for All* (DCMS, 2000); *Museums and Social Inclusion*, (Group for Large Local Authority Museums, 2000); *Including Museums: Perspectives on Museums, Galleries and Social Inclusion*, Jocelyn Dodd and Richard Sandell, (2001).

new audiences.[3] Others take a broader view and include all communities outsid mainstream marginalized by, for example, their ethnic origin, disability or sex orientation. Issues of representation, both in terms of collections and staff profile are also increasingly important for museums (Sandell, 2000)

Changes in Museum Culture

An overall change of culture has certainly been apparent in museums over the past two decades. This is clear from the new definition of a museum adopted by the Museums Association in 1999: 'Museums enable people to explore collections for inspiration, learning and enjoyment. They are institutions that collect, safeguard and make accessible artefacts and specimens which they hold in trust for society' (Museums Association, 1999). Their previous definition was: 'A museum is an institution that collects, documents, exhibits and interprets material evidence and associated information for the public benefit'.

The new definition is closer to that of ICOM, with the emphasis less on the function of the organization and more on its role in society: 'A museum is a non-profit making, permanent institution in the service of society and of its development, and open to the public, which acquires, conserves, researches, communicates and exhibits, for purposes of study, education and enjoyment, material evidence of people and their environment (ICOM, 2002).

Using the UK as an example, this evolution has come about for a number of reasons including changes in society, legislation, government initiatives and new opportunities offered by the rapid development of ICT. First there are fundamental changes taking place in society to which museums are responding. Demographic changes, for example, mean that fewer people identify their place in society in terms of stable, definable communities than ever before. If museums can respond to this challenge, their role in preserving and defining cultural memory can be an important and powerful one. Much greater globalization and fluidity in society and the growth of ethnic minority communities presents a further challenge, as such communities do not see themselves reflected and represented in the cultural 'mirror for society' that museums hold up.[4]

The population is ageing. By 2021 more than one third of the population in the UK will be aged over 65, and this is also a trend in most developed countries such as Japan and most of Europe. Older people are enjoying a longer, healthier retirement and are a significant potential audience. Museums need to be flexible in providing programmes which interest them and an environment which is accessible and

3 See, for example, *Whose Heritage? Conference Report*, Arts Council England, 2000.

4 'Museums are a mirror for society; if you don't see yourself reflected in that mirror you cannot feel that you belong' *Unsettling the Heritage: Re Imagining the Post Nation*. Key note speech by Stuart Hall at *Whose Heritage?* Conference, 1999; report published by Arts Council England 2000.

attractive, when there is considerable competition for the leisure time and disposable income of this group.

There is also an enormous expansion in higher education; in the UK one in three young people are now entering the system. This requires new attitudes to teaching and learning and a more self-directed, personalized approach. Museums are well placed to offer opportunities for personalized learning in rich environments but they have to be able and willing to adapt to learners' own agendas. Research into the different ways in which people learn is of great significance for museums, and work on experiential learning and different learning styles (conducted mainly in the United States by Howard Gardner, George Hein and others) is being applied to museums and is changing our understanding of the kind of information and interpretation which is needed for today's visitors (see Chapter 1). Rapid changes in technology are enabling not only different ways of working and leisure activities but also completely different ways of learning. Increasingly people can now choose when, where and how they wish to access the resources and information they need. (see Chapter 7)

A second factor is legal change. Several pieces of legislation have had an effect on the changing approach of museums in the UK to their visitors. The DDA passed in 1995, was brought in over ten years to allow time for providers of goods and services, employers and owners of premises used by the public to make the necessary adjustments.[5] The Race Relations (Amendment) Act (2001) requires public authorities to promote good race relations and The Human Rights Act (1998) gave legal effect to certain fundamental rights and freedoms contained in the European Convention on Human Rights. One museum, quickly commissioned a sign-interpreted version of a film introducing one of their galleries, for example, when it became apparent that two visitors with hearing impairments had queried why they were unable to access this. Many museums have set up panels or user groups of disabled people and most museums now consult users and potential users from diverse backgrounds when planning new developments. Human Rights legislation applying to many countries also includes cultural entitlement. 'Everyone has the right freely to participate in the cultural life of the community, to enjoy the arts and to share in scientific advancements and its benefits.' (Universal Declaration of Human Rights).

Thirdly cultural provision has always had a political dimension which sometimes results in it being subject to manipulation by those in power. The experience of recent years is no exception as extreme examples such as the fate of the Bamiyan Buddhas in Afghanistan and the library in Sarajevo illustrate. As outlined in the previous chapter, in the UK and elsewhere many museums were founded with an overtly educational and social purpose. In the UK this traditional remit received a powerful endorsement when a new Labour government came to power in 1997, with

5 See *Disability Portfolio*, Guide 5, Resource, 2003 (now MLA). Practical ways to remove barriers to access for disabled people are covered in this portfolio of 12 guides. Their online Access Toolkit helps individual organizations to assess how far all the barriers to access affect visitors. <www.mla.gov.uk>.

an explicit commitment to education, wider access in all areas of public life and to tackling social exclusion. *Museums for the Many: Standards for Museums and Galleries to Use when Developing Access Policies* was published in 1999 (DCMS, 1999). This was the first time for a century or more that the social role of museums had been so clearly recognized by government. Although this guidance was aimed at national museums, which the UK government funds directly through grant in aid, the message was clearly aimed at all museums.

Another key UK government initiative affecting museums was to set up a Social Exclusion Unit in 1997. Its report, *Bringing Britain Together*, set out the need for a National Strategy for Neighbourhood Renewal as an agreed response by government departments to the problems of deprived neighbourhoods. It defined social exclusion as: 'What can happen when people or areas suffer from a combination of linked problems such as unemployment, poor skills, low incomes, poor housing, high crime environments, bad health, poverty and family breakdown' (Cabinet Office 1999). A subsequent report from the Department for Culture, Media and Sport (DCMS) in 2001 made culture and leisure part of the Neighbourhood Renewal process: 'If having nowhere to go and nothing constructive to do is as much a part of living in a distressed community as poor housing or high crime levels, culture and sport provide a good part of the answer to rebuilding a decent quality of life there' (DCMS, 2001).

In a series of documents including policy guidance for museums, galleries and archives, *Centres for Social Change: Museums, Galleries and Archives for All*, the government made its position clear (DCMS, 2000). The common strand in what the present UK government is saying about education, lifelong learning, social inclusion, diversity, access and, more recently, social justice and community cohesion is an emphasis on putting the needs of a wide range of people at the heart of what public organizations are doing. The government requires museums to provide services to as broad a range of people as possible and to contribute to education and social initiatives in partnership with others. This has however provoked fierce debate and a backlash against access developments from those who feel that such a radical realignment of priorities will undermine scholarship and focus attention away from collections: 'We really must ask ourselves why, if we regard knowledge as important, we have progressively demoted specialist curatorship, both in status and salary'(Jones, 2005).

Who Goes to Museums?

Perhaps we should look at this from another perspective. There are many factors which influence who visits museums and who does not. Before even crossing the threshold the uninitiated may feel that the experience is not for them. This feeling is described by Elaine Gurian as 'threshold fear' which is 'physical as well as psychological' (Gurian in MacLeod, ed., 2005). The architecture of museum buildings is often intimidating rather than welcoming. Older buildings have their

steps, columns and ornate grandeur because they were designed to be impressive
and awe-inspiring. However, the famous architects of some of the recent explosion
of iconic new buildings also create imposing spaces of a different kind and can
appear to be concerned more about the statement made by the building than what is
in it and how well it functions (see Chapter 13). This makes it difficult for museums
to become the 'new town square' (Gurian, 2005) or neutral community space that
would enable more people to feel welcome and confident.

In addition, collections, particularly historical ones, inevitably reflect the tastes
and interests of their collectors and were rarely put together with the purpose of being
fully representative. 'It is invariably oneself that one collects' wrote Baudrillard
(1968). As a result, while museums frequently have collections of exceptional quality,
they can seem forbidding to a wider audience. Curators and designers, increasingly
with contributions from educators and other museum professionals, choose what is
displayed and with what purpose or theme in mind. The way in which any selection
of objects is put on display to the public will reflect the thinking of those responsible
for this process and people who work in museums have, although this is changing,
tended to come from a particular social background and to be academic in their
approach. Displays arranged by such people often do not communicate well to a
non-specialist audience. Research at the Victoria and Albert Museum (V&A) carried
out for the Silver Galleries using David Kolb's learning styles, found that most
curators were analytical learners who seek facts and logical theories (Hinton, 1998).
It is not surprising therefore that many exhibitions appeal most to others from the
same background. The V&A went on to design the British Galleries with several
identified audiences and all learning styles in mind, so as to appeal to the widest
possible range of visitors.

Visitors themselves bring their own experiences and perceptions to any
exhibition, constructing varied personal meanings which may be quite different from
the intentions of the exhibition organizers. For example, an exhibition about slavery
may unintentionally reinforce, rather than counteract, prejudices about black people.
Museums need to understand much more about visitors from different backgrounds
in order to display their collections effectively, interpret what are often complex
themes and find new ways to communicate with the public on equal terms.

There is clearly still much to do, statistics show that museums are still
predominantly used by people who tend to be relatively prosperous and well
educated. Figures published in *Renaissance in the Regions* are not encouraging. They
show that on average 55 per cent of UK museum visitors come from ABC1 social
categories although there are significant variations depending upon such factors
as the dominant subject matter and admission charges policy.[6] In eight national

6 Social categories A, B. C1, C2, D and E are often used by UK museums in visitor
research. The categories are based on occupation groups. A = Approximately 3 per cent of
the population. Professional people, senior managers. B =Approximately 20 per cent of the
population. Middle managers, owners of businesses. C1 = Approximately 28 per cent of the
population. Junior managers, owners of small establishments, other non-manual workers. C2

museums surveyed for DCMS in 2001, 89 per cent of visitors were ABC1 and 11 per cent C2DE (Davies 1994; Selwood, 2001). Very few museums have made access and inclusion a mainstream policy priority, with core budgets and other resources allocated in a sustainable way. Tyne and Wear Museums Service, a federation of 11 museums and galleries in the north east of England, is one that has done so and its success can be measured by its changed visitor profile. In 1990, 80 per cent of visitors were categorized as ABC1 and 20 per cent as C2DE. By 2000, after a significant policy change which prioritized access at all levels, 48 per cent were ABC1 and 52 per cent C2DE (Fleming, 2000).

A major survey of visitors to Italian museums in 2000 produced similar findings. Of Italian visitors, 43.7 per cent were graduates and 35.4 per cent had a further degree. A commentator on the survey estimated that some 59.5 per cent of Italians never visited a museum (Detheridge, 2000).

Statistics only give part of the story. The sector still lacks a methodology for measuring its long-term contribution to society and improved quality of life for individuals, and perhaps this is not possible. However there is much anecdotal evidence and everyone who has been involved in promoting access and inclusion can give examples from their own experience to show that museums are capable of making a difference both to individuals and the wider community.

Are Access and Inclusion Here to Stay?

In spite of evidence to the contrary, there is a perception from some that the access agenda has gone far enough. Collections are of course, as a recent UK government report states, 'at the heart of all that museums do' – they are the unique selling point (DCMS, 2005). However there still seems to be a perception that the demands of the public and those of collections are somehow mutually exclusive and that it is time that collections were back in fashion. The most significant factor of all in whether museums and galleries can successfully change their approach to their audiences seems to be leadership, because without this any changes will not be sustainable. Another important factor is organizational or systemic change. Recent research into developing new audiences, *Not for the Likes of You*, was carried out with a range of cultural organizations and showed that for organizations to reposition themselves to engage with a wider audience, support from the top and a change of internal culture is required:

> Successful organizations model internally what they wish to express externally ...The three main ways in which they model openness and inclusion are in:
>
> • the behaviour of the leader

= Approximately 21 per cent of the population. Skilled manual workers. D = Approximately 18 per cent of the population. Semi-skilled and un-skilled manual workers. E = Approximately 10 per cent of the population. People dependant on the state through sickness, unemployment, old age or other reasons.

- the organization's structure and systems; and
- the culture and ethos that is thereby created (Morton Smyth, 2004).

Whether or not museums are able to successfully build new audiences and offer high-quality experiences to a wide range of people in the long term depends largely on whether those who run museums believe that they should be exclusive or inclusive organizations.

References

Carey, J. (2005), *What Good Are the Arts?*, London: Faber.

Department for Culture, Media and Sport (DCMS) (2000), *Centres for Social Change: Museums, Galleries and Archives for All: Policy guidance on social inclusion for DCMS-funded and local authority museums, galleries and archives in England*, London: DCMS.

Resource (2003), *Disability Portfolio*, London: Resource.

Dodd, J. and Sandell, R. (1998), *Building Bridges: Guidance for Museums and Galleries on Developing New Audiences*, London: MGC (Reprinted 2000).

Dodd, J. and Sandell, R. (2001), *Including Museums: Perspectives on Museums, Galleries and Social Inclusion*, Leicester: RCMG.

Hinton, M. (1998), 'The Victoria and Albert Museum Silver Galleries II: Learning Style and Preference in the Discovery Area', *Journal of Museum Management and Curatorship* **17**: 3.

MacLeod, S. (ed.) (2005), *Reshaping Museum Space*, London: Routledge.

Morton Smyth Limited (2004), *Not for the Likes of You*, final report for Arts Council England and Resource, at <www.artscouncil.org.uk> or at <www.newaudiences2. org.uk/downloads/NFTLOY_doc_A.doc>.

Detheridge, A. (2000), 'Les Musées, le Public, Les Medias', in *L'Avenir des Musées*, proceedings of a conference at the Musée du Louvre, Paris, 2000.

Scottish Museums Council (2000), *Museums and Social Justice*, Edinburgh: SMC.

Resource (2001), *Renaissance in the Regions: A New Vision for England's Museums*, London: Resource.

Sandell, R. (ed.) (2002), *Museums, Society, Inequality*, London: Routledge.

Arts Council England (ACE) (2000), *Whose Heritage? The Impact of Cultural Diversity on Britain's Living Heritage*, London: ACE. (Proceedings of the 1999 conference.)

Websites

<www.artscouncil.org.uk>
<www.culture.gov.uk>
<www.mla.gov.uk>
<www.museumsassociation.org.uk>
<www. icom.org>

PART 2
Developing Audiences

Introduction to Part 2

For responsive museums there are many kinds of thinking outside the box. The building, the location, the inherited attitudes, and sometimes areas of the collection, can seem like part of the problem rather than the answer when developing audiences. 'Once buildings, organisations and staff are in place, they tend to displace as the primary focus of concern the objectives they were intended to meet, or the communities they were intended to serve' (DCMS, 1999, p 44).

Chapter 4 examines audiences groups, their needs and interests, and asks how museums have recognized and then prioritized their response to those audiences. In Chapter 5 we look at building capacity for sustainable audience development, based particularly on experiences in northern England and in a regional agency (RA), key engines for change in the museum world today. The Dutch response shows how specific to the UK some of these recent changes have been, although often very influential on practice elsewhere. Targeted programmes for specific ethnic communities are described in Chapter 6, seen from the perspective of an experienced adult and community educator now working in a national museum. Here, the response accepts the initiatives but sets a further challenge.

The focus then shifts to reaching out to audiences. Chapter 7 looks at the framework of policy and funding for what used to be called the 'new technologies' and which are still not fully integrated into learning and access thinking. Writing in 2001, Sara Selwood observed that 'the next ten years will see the emergence of an e-culture, with ... the scope for the personalisation of electronically mediated cultural services. This should encourage access, provide a focus for museums' marketing and enhance the role they can play in lifelong learning' (Selwood, 2001, p 9; see also Robert Hewison in ACE, 2001, p 14).

Chapter 8 is contributed by an evaluator with a background in museum education, and its author looks at the pitfalls and potential of what is now an everyday part of museum work as of every other government-funded activity: seeking to prove the value of the investment of funds, staff time and energy.

At the time of writing (late 2005) it is too early to be conclusive about the impact of *Renaissance in the Regions* in raising the standard of museum provision across the country, but the signs are certainly very promising. That is certainly the view of the Minister for Culture, David Lammy, reflecting in October 2005 on the £147 million so far committed:

> Whereas seven years ago the talk was of decay and decline, that investment is now making a real difference on the ground ... I appreciate there is still some way to go, and I share

the desire of those who want to spread the benefits beyond the Hub museums to the wider museum community' (Lammy, 2005).

References

ACE (Arts Council England) (2001), *Towards 2010: New Times, New Challenges for the Arts*, London: ACE.

DCMS (Department for Culture, Media and Sport) (1999), *Policy Action Team (PAT) 10 – Report on Social Exclusion*, London: DCMS.

Lammy, D. (2005), Keynote address to Museums Association Conference, 26 October 2005. (Available at <www.culture.gov.uk/global/press_notices/archive_2005/lammy_ma_speech.htm>.

Selwood, S. (2001), *Markets and Users*, research paper for MLA, London: MLA. Available at <http://www.mla.gov.uk/webdav/harmonise?Page/@id=73&Document/@id=18601&Section[@stateId_eq_left_hand_root]/@id=4332>.

Chapter 4

Prioritizing Audience Groups

John Reeve

Generally, [Smithsonian] managers saw national collections as embodying a responsibility to serve the public interest, but they differed on the fine points of who comprises the public and what is in the best interests of that public. ... Yet if priorities are not made clear, tensions inevitably result, because not all uses (of collections) are compatible with one another, nor can they all be fully developed within the context of available resources. Failure to identify priorities can lead to an inefficient scattering of attention and resources ... (Smithsonian Institution, 2005, pp 39, 103–4).

Introduction

The definition of audiences and their needs has developed out of all recognition since the 1970s or even early 1980s, when terms like 'the general public' or 'children' were still thought to be useful in defining exhibition audiences; although we do still use some equally vague or problematic terms such as 'tourists', 'communities' and 'families'. The pressures to prioritize audiences pervade this whole book. Behind them lie implicit assumptions that audiences can easily and speedily be prioritized, especially by any museum or gallery seeking more public money. From the museum or gallery's point of view it can seem almost impossible: clarity in determining policy and resources by responding to the latest government or funding priority may be bought at the price of losing as well as gaining both audiences and staff.

Priorities

This chapter identifies audience priorities and asks about demographic, educational, geographical, socio-economic and physical definitions of audience; at the relationships of audience, active or otherwise, to provider or host museum or gallery; and at what happens to old audiences if the new are to be effectively embraced. Even America's all-embracing Smithsonian Institution has found no easy answers here, and in its recent soul-searching review, quoted above, makes it clear that it cannot cope with the current and anticipated future growth in demand, given the scale of its collections and audiences but also its declining level of Government support (Smithsonian Institution, 2005, pp 47–8, 62, 67, 100–101). In the UK, Tate appears

fairly exceptional in maintaining its new identities and new audiences, continuing to attract new funding, and expanding its activities and buildings nationwide.

It is not only museums in Northern Europe and North America that grapple with longer agendas and often lower incomes and fewer visitors. The same is true in Japan, for example, where a young audience is not being successfully nurtured. Elsewhere one visits museums and wonders when the audience will show up – this has been my experience of working in South America, the Middle East and India outside the tourist hotspots.

However, there are many parts of the world where new audiences are being prioritised, often for the first time. There has been a revolution in Spanish museums post-Franco, for example (Holo, 2000). Formerly conservative museum centres like Bern and Vienna have even embraced children's museums, whereas in 1993 in Vienna 'the idea ... was met with reservation and a lack of understanding, especially on the part of politicians. Traditional museums also reacted to the idea with disapproval and distrust' (Haas, 2002). New museum initiatives in, for example, east London, rural Ecuador, Cairo and north-east India all aim to engage and sustain new audiences.

Who Decides?

Audience prioritization is a relatively new issue for museums. In 1990 I was working in a national museum with healthy audience figures (probably of four million or more) where nobody was particularly bothered about audience development apart from the education department and a few curators. There was no marketing department, and very few policies. The major audience factor was the strength of foreign tourism often related to random international events. At that time I saw this balancing act for the British Museum Education Department as prioritizing between poles: young and old; beginner/occasional and experienced/regular adult learner; adult learners and tourists; onsite and offsite provision; mediated and unmediated services; core staff and freelance or volunteer input; core staff working on exhibitions and galleries versus everything else. Ultimately it meant balancing existing demand with helping to create new audiences: directly helping primary teachers with the new National Curriculum meant no longer directly helping most secondary classics teachers and their groups (mainly from independent schools). It is now much more complicated than that, since the government, other funders and audiences themselves have taken such an interest in audience development.

Since prioritizing specific audiences is such a difficult balancing act, who adjudicates and who oversees that decision? Often there is no consensus unless it is provided from above or from outside; that is, from strong direction or from government. Mark O'Neill and David Fleming, Directors in Glasgow and Liverpool, articulate their approach to inclusive audience priorities in Sandell (2002). Fleming's earlier successful re-focusing of the Laing Art Gallery in Newcastle, for the bulk of the local population rather than just for traditional art-lovers, prompted a lively

exchange with, among others, a disapproving art critic from a conservative national paper.

The impact of a truly audience-focused director can be seen at the Walker Art Center in Minneapolis, under director Kathy Halbreich from the early 1990s. She instigated its Long Range Plan which focused on sustained community involvement and working with artists: 'Walker Art Center is a catalyst for the creative expression of artists and the active engagement of audiences' (Walker Art Center, 1999).

In 2005 a new audience-focused Director of Budapest's National Gallery replaced a scholar, as so often happens in more traditional European institutions, although the new Director is an economist by training and it is a political appointment. The Director of the Louvre, a traditional curator, has recently discussed the implications of such a strong focus on audiences. The British Museum too is also attempting to change its audience profile with a new media-friendly director. This is partly in response to critical or inadequate media coverage, as well as government audience and performance indicators. So the BM now prioritizes by season in both audiences and cultures, while offering a reduced portfolio of exhibits and events for old as well as new audiences: its formerly substantial daytime adult programme had already been largely replaced with evening and weekend events, workshops and courses enabling adult learners to progress. This was partly in response to new priorities in lifelong learning and the new facilities on offer in the Clore Education Centre. Most of the daytime adult and tourist programme is currently provided by trained volunteers or professional guides, so that professional educator and curator time can be used most profitably on priorities where their expertise is most needed.

Other kinds of museums have moved away from the restrictive nature of special interest audiences: military and naval museums in the UK have become history museums and art galleries and deal with issues such as the Holocaust and slavery in the absence of a national history museum that does that task. War memorial museums elsewhere have also re-invented themselves, with an audience-facing mission and message at Caen (Memorial) and Ypres (Yper). Traditional decorative art collections are re-invented by merging with multi-ethnic collections to present world cultures at Leicester's New Walk Museum. So a comprehensive policy on audiences pervades everything a museum or gallery does: as David Fleming once told a rather astonished Portuguese museums conference, a museum really needs only one policy – an education policy!

What Kind of Learning?

Prioritizing Multi-modal Learning

Offering choice of media, programme and learning mode to the visitor, and prioritizing, whether by audience or by learning style, may mean a significant change of gear for museum curators and designers, commercial and marketing staff and also for educators. Activating different learning styles (see Chapter 1) is very important

with young children and families and often easier to resource as an occasional offer for families than as a regular part of schools programmes: drama, stories, art, dance and film may figure amongst the choices considered. Handling can be offered all the time, through the use of discovery centres, (as at the ROM (Royal Ontario Museum), Toronto) or volunteer-run handling tables, as (for example) at the Getty, London Zoo or the BM. Online learning can aid multi-modal learning, but it often does not optimize the medium to do so (Hawkey, 2004, pp 24, 34). Museum theatre, as a special offer or as an integral part of interpretation, works for broad audiences and especially families, in science as well as art and history museums, not least in engaging emotions and therefore aiding memory (Hughes, 2002; Bridal, 2004). The fruitful use of storytellers and actors can be seen in the Museum of London and the Natural History, British and Science Museums. Drama opens up issues and ideas, makes history raw again rather than blandly pre-packaged, whether it is slavery at Colonial Williamsburg (Hughes, 2002), a Roman soldier or Mary Seacole, the celebrated black nurse from Victorian London.

If this works so well why do we not prioritize it more? It may involve training opportunities for drama and music students, making use of people such as Holocaust survivors, war veterans, grannies, former miners or traditional craftspeople. The training of actors, educators and artists to work with specific age groups is clearly also an issue here. A more fluid model of employment is needed where museums can share the expertise of teachers, artists and actors and others working part-time in museums and galleries or on secondment, as in the former Inner London and West Yorkshire education authorities, and as proposed again recently to the General Teaching Council and to government. Actors and artists have begun to take tailor-made courses, one of which is the MA in Museum and Gallery Education at the Institute of Education in London.

Online Learning and Information

Online learning is also discussed in Chapter 5 but is part of the priority equation here too. Digital technologies and learning programmes soak up time, money and expertise in museums, but there seems to be consensus about the present and future priority of museum-related online learning. UK government and individual museums have invested huge sums (often sponsored) in making collections and data accessible online, with hugely varying results. Some ambitious international collaborative projects have faltered, such as *Fathom*. In the UK there has been little overall coordination, and too often the medium has appeared to be the massage for policy-makers. In the UK and the US there is great enthusiasm for this medium among museum directors (NMDC, 1999; Jones-Garmil, 1997). There is now a growing literature that details initiatives in Japan and Latvia, Switzerland and Greece, Cleveland and Russia, Edinburgh and Kew (Hemsley, 2005).

But is this an *audience* priority? There still seems to be a limited amount of useful audience research in this medium: learning outcomes appear often to be an afterthought. Too often online projects are led by the technologist and not the curator

and educator together (Knell, 2003). It is often noticeable when a learning advocate is in charge, as Gail Durbin has been at the V&A, where successful new galleries as well as exhibitions and research data are available online, and competitions, special offers and magazine content make the website an event. Tate has also been a pioneer, successfully archiving many of its live programmes, with art students especially in mind. The BM at one time had three separately controlled online strands: the website controlled by Marketing; sponsored educational websites such as 'Ancient Civilisations'; and 'Compass', the curator-driven online collections database. The latter two are now both in the Learning and Information Department where they belong: ICT works across the whole museum, not in isolation.

Families, teachers and tourists plan visits based on online information. Outreach to schools and communities, with a strong online link, has also been successful. In many situations a small programme or display can be enormously enhanced by online links to other collections and resources as with *Moving Here*, which deals with immigration (<www.movinghere.org.uk>) or the collaboration between NMM Greenwich, NMM Liverpool and Bristol Empire and Commonwealth Museum on slavery (<www.nmm.ac.uk/freedom>, and NMM's other sites such as <www.portcities.org.uk>).

Among many new developments in responsiveness and 'personalized learning', handheld PDAs can help tourists to access the information and related visuals they want when visiting the Palazzo Vecchio in Florence, for example. Palmtops (as at Dulwich Picture Gallery, initiated for sixth-form art history and art students) enable students to record their reactions to art and e-mail them back to school or to other schools taking part in the same project. Other innovations include creative use of wireless technology and webcasts at Tate Modern; visitors making their own websites (such as the Science Museum's *Antenna* and the science centre At-Bristol's *Get Connected*) and sharing ideas with other teachers (STEM at the Science Museum) (Hawkey, 2004, pp 19, 25–7, 36, etc.).

Roy Hawkey has surveyed the current scene critically, as a former Head of Education in a national museum (Hawkey, 2004). He quotes ICT guru Steven Heppell on the dangers of schools 'using tomorrow's technology to deliver yesterday's curriculum' and the same clearly applies to museums. Hawkey wonders, however, if 'it is museums that have embraced new technologies and approaches to learning while schools focus on delivering an outmoded curriculum' (*ibid.*, p 2). More provocatively he asks, 'Does learning in museums have a real future – or only a virtual one ...?'(*ibid.*, p 4) and argues that 'the multidimensional and truly multimedia nature of museums invests them with significant advantages over other learning providers, both formal and informal'(*ibid.*, p 11).

In 1999, David Anderson was critical of much digital learning material, seeing it as imaginatively, aesthetically, symbolically and educationally impoverished (Anderson, 1999, p 10). Four years later Geser (2003) is also critical of their efforts so far, which for him are too focused on collections and 'deemed to be useful for "informal" learning in some way or other (i.e. usually not further specified)'. Hawkey stresses the need for online learning to be truly interactive and two-way (2004, pp

21–6). It should be, like any other form of museum learning, a conversation in the same way that Hooper-Greenhill describes a rewarding object-handling session.

Which Audiences?

I will now explore ways of prioritizing audiences with certain key target groups, and ask how far it is possible to meet their needs separately and together. This cannot be a comprehensive guide to museum audiences, but will look at the implications and strategies for doing this.

Children and Families

Young Children

Early years (under-fives) are now a significant audience, as part of the mushrooming of family and community programmes and consumer demands for better provision by campaigners such as journalist and mother Dea Birkett in the UK newspaper, *The Guardian*. They are also a political priority for the current Labour government, which aims to bring all the different children's services together. There are strong educational as well as social arguments for the importance of starting young with the museum experience, and also in beginning to deal with stereotypes and prejudices before they become firmly established. That is one of the aims of the Wereldmuseum in Rotterdam, which has 162 nationalities represented in its population. Children can find out about where the foreign guests in a simulated hotel come from by investigating the clues they have left behind in their rooms: 'they are actively involved, looking, feeling, listening … singing and dancing' (Wartna, 2002, p 14). Even contemporary art centres such as the Zentrum Paul Klee in Bern, which opened in June 2005, have prioritized children over four in their Kindermuseum Creaviva.

One of the issues is whether early years need a separate place or just a special one within a larger museum. Providing for early years certainly requires expert advice and tailor-made facilities. The work of specialist audience advocates (see Chapter 12), such as Jo Graham (formerly at the Science Museum) has borne fruit in The Garden facility there for the under-sixes, the first of its kind in the UK. She is also the Learning Consultant for Discover, one of the Gulbenkian-funded Centres for Discovery and Imagination for young children. Discover is at Stratford in a deprived part of east London, and has forged links, for example, with Sure Start schemes in adjacent boroughs. Sure Start is a government policy priority for children under five and their parents, to deliver 'the best start in life for every child by bringing together early education, childcare, and health and family support'. Discover used artists as enablers in this partnership: they are also a successful component of community programmes. Discover also has a children's forum to advise it, in line with government policies on children. Manchester Museum of Science and Industry decided to prioritize carers and children from the more deprived areas by allocating

50 per cent of places to Sure Start groups in its XPERITOTS facility, free for under-fives (*GEM News* 93, summer 2004).

Another privately funded initiative, Eureka! the children's museum in Halifax, (funded by the Clore Duffield Foundation), has also prioritized under-fives with two new galleries for them, and provides special soft play facilities for babies. Another service to prioritize under-fives as part of a successful bid to develop audiences and be noticed in a challenging environment is the New Art Gallery at Walsall near Birmingham (*JEM* 16, 1995) where, for example, sculpture was installed at the right height for small children to touch. Rural areas have a different kind of challenge in reaching out: North Somerset developed loan boxes aimed at pre-schools, nurseries and childminders with distribution through children's libraries and a minimal charge (*GEM News* 95, winter 2004).

Aiming at under-fives seems therefore to hit a number of targets: social inclusion; family involvement in learning, especially in the sciences; socialization of the very young and building a new audience base for museums. This publicly articulated emphasis on the young continues as children grow up: Thinktank Birmingham has a gallery for under-sevens; the re-displayed Bethnal Green Museum of Childhood in east London is now firmly focused on children under eight, with a greatly reduced number of objects on show, much more to touch, and play areas such as the beach with deck chairs and sand. The Livesey Museum in South London prioritizes under-12s in its exhibitions and services.

As well as the famous examples such as Boston in the US, children's museums can now be found in Greece and the Netherlands, Austria and Switzerland, Moscow, Brussels and Florence (see Wolf and Salaman, 2002). In Florence, actors in Renaissance roles bring to life the Palazzo Vecchio, and Suleiman the Magnificent appears in the Islamic armour gallery of the Museo Stibbert to berate the foul-smelling Christian slaves who have just been brought in (on one occasion a group of European museum educators!).

Families

Museums and galleries can decide not to prioritize early years, but cannot ignore families. Most large museums have family learning officers or make them a priority for a member of the children's team. There has to be a balancing act here between weekday core provision for schools and the bottomless demand at weekends and in the holidays from families, as well as developing new family audiences. This may require a different kind of part-time contract and work off-site. Prioritizing for a large museum can take many forms: the British Museum took its family programme to outer London shopping centres in areas not using the Museum, allocated parts of the holiday programme to play schemes, and offered it to community and ethnic groups, such as local Muslim and Asian families during a Mughal exhibition.

Are we talking about informal learning by all the family members, or targeting the 5–11s with the others as helpers? Even addressing the needs of 5–11s requires enormous flexibility and ingenuity. English Heritage Education Service responded

to this by developing family learning packs, with activities for varied ages, interests and learning styles; V&A's British Galleries have also taken this approach, as have many science centres.

Family programmes are not surprisingly very popular with parents who are educating their children at home (*GEM News* 93, summer 2004). They are also attractive to sponsors, giving a high profile with 'drop in' facilities such as trolleys, art carts, and named facilities, such as the Ford Centre at the British Museum, which is available (when not in use by schools) for families to bring their own lunches, use the facilities and pick up resources and advice for their visit. A parent of a five-year-old and a nine-year-old commented that museums need 'something for all the children, rather than just being good for the older or younger ones'. The same applies on community days where extended families of Bangladeshi or Turkish Londoners may bring everyone from under-fives to grannies.

Family facilities, such as The Den at the Hancock Museum for natural history in Newcastle, help young children to discover the seashore or the jungle, with exhibits developed with children that feature their work. As in American children's museums there is a gallery explainer. Many museum family programmes use students, either paid or as part of work experience, and pay for their police clearance as part of Child Protection policies. Family thinking also means buying in suitable merchandise for the museum shop (*GEM News* 93, summer 2004, p 12) and training friendly attendants and other front of house staff (see Halbertsma in Moffatt and Woollard, 1999, pp 89–98), possibly even as contributors to the programme, as at Colchester.

Schools and Teachers

> In the museum context, programmed education floats like a ship on a sea of self-directed learning' (Anderson, 1999).

The UK National Curriculum, introduced after the 1988 Education Reform Act, has been a major factor in defining and prioritizing the school audience in the UK (Reeve, 1996). The Curriculum has given museums a new, but potentially dangerous, role as an adjunct of the schools system, with the same functional and over-assessed approach to learning that government policies have enforced in schools. English children and their teachers are now the most assessed in the world, and as a direct result museum programmes for schools have to meet precisely what teachers think is required or they are not adopted. Market forces now determine which exhibitions or galleries are 'relevant' and such is the volume of demand and the financial clout of the customer that museums have no choice but to deliver. The curriculum is restrictive both in its view of the world and of learning. Many excellent museum exhibitions and galleries may not appear to 'fit' it and are ignored as a result. ' "Greater flexibility and creativity within the curriculum" is therefore one of the trends hoped for by the London Hub in the new regionalized structure for museum provision instituted by *Renaissance in the Regions*' (Swift in *GEM News* 95, winter 2004).

Primary (Key Stage 1–2) needs have invariably been prioritized over secondary (Key Stage 3 and above) in many museums because of where specific historical and other topics have been allocated, and also for institutional reasons, since visits by under-11s (who usually have one main class teacher) do not disrupt the timetable in the way that visits by over-11s do, with their vastly overcrowded timetable. This is also a problem now with sixth forms (16–18s) because of new exams at 17 as well as at 18.

Sponsorship may be used to promote museum visits to age groups such as secondary schools, where visiting has declined, as at the Museum of London. Schools usually pay for museum programmes and may even have to pay admission for some non-national museums. Innovative charging schemes include the subscription model adopted by Tullie House, Carlisle (see Chapter 11). In order to deal with the insatiable demand, teachers need to deliver more of the special elements of a museum visit themselves: museum educators cannot help everyone. Non-specialist primary teachers still need more INSET (in-service training) than their secondary colleagues think they do. Training in using museums is needed not only as part of Initial Teacher Training (ITT) but for NQTs (newly qualified teachers) and teaching assistants, whom the government sees as part of the solution to delivering its overcrowded curriculum. There is a different relationship in the US, where teachers face licence renewal every three years and so are looking for the kind of continuing professional development that museums and galleries provide (*JEM* 20, 1999).

There is a fragmented curriculum at primary level, where formerly topic and project work brought subject areas together. Museums and galleries have a potentially holistic role therefore. In the UK they may also play a complementary role where the arts or diversity are marginalized in the curriculum, as also in many parts of the US. Africa and Asia are both scandalously neglected in the UK school curriculum, and museums have successfully used family and lifelong learning programmes to push their own curriculum here. Museum educators have been quick to spot other new opportunities in the curriculum, in areas such as citizenship, which is now a compulsory element in the secondary curriculum and an optional one for under-11s. The Galleries of Justice, Nottingham (in a converted law court) and the Bristol Empire and Commonwealth Museum have been pioneers here on issues such as crime and punishment, and slavery (see Hann, *GEM News* 96, spring 2005). The Museum of London has developed excellent online resources on citizenship (Swift in *GEM News* 95, winter 2004). Distance learning materials are also being developed by the Institute of Education that include cultural citizenship and the use of museums, galleries, heritage sites and oral histories. Another new target group is the 'gifted and talented'; for example, summer schools for sixth-formers are organized by museums in coordination with university departments to attract applications. Another initiative with this audience focuses on diversifying the museum workforce.

Although the teacher is now the customer with the budget to spend, museum learning departments do not always agree with teachers on what the priorities should be. This seems to be a problem particularly with contemporary art galleries. There is a need to consult children consistently, as well as parents and teachers, as the National

Museum of Scotland did in planning its new building, and Weston Park Museum, Sheffield, did in developing its new facilities (*GEM News* 95, winter 2004). Recent developments in the UK include a greater emphasis on OSHL (out of school hours learning), pioneered by Birmingham's University of the First Age among others; and on personalized learning, rather than what politicians describe as 'one size fits all'. Inventive uses of ICT have a significant role to play here, as mentioned earlier: 'personalisation is the way forward ...' (Hawkey, 2004, p 39).

Teenagers and Young Adults

From a strategic viewpoint, what does not happen in schools for under-11s may be partly addressed through family and other museum programmes; but what about over-11s? This is a notoriously difficult audience to capture and keep, particularly if their earlier experience on school trips has been unrewarding.

> One of the key things in thinking about your organisation is why it wants to target young people ... is it simply that it is a government objective? But remember: young people can hear the bat squeak of tokenism ... If your entire organisation is not behind it, young people will push off ...' (Ings, 2001, p 34).

The emphasis from those interviewed on the research project just quoted was that simply 'making it funky on your flyer' was not the answer, and that young people needed to be involved and feel some ownership. This may be achieved through focus or membership groups such as Young Tate; opportunities to volunteer; music and fashion events (as at the V&A, with Style Lounge and Friday Late Views aimed at students and young people in the creative industries); and partnerships with radio stations, magazines and promoters.

Paul Willis, guru of youth culture, thinks it is essential to allow young people 'to colonise cultural organisations'. Many museums are not yet ready for that kind of involvement or to share authority, any more than they are with ethnic groups and communities. The initiative often comes from outside and is maintained only with strong partnerships. Orleans House Gallery in south-west London, for example, collaborated with the National Portrait Gallery in a project aimed at teenagers at risk of offending; elsewhere projects have been aimed at teenagers excluded from school. This kind of work is labour-intensive and not a quick fix: smaller museums may find it easier working with local youth and other services (see Dodd and Sandell, 2001). Because of all the connotations of museum buildings that can look like magistrates' courts, prisons or churches, this may be an audience best dealt with through outreach programmes.

Adults and Lifelong Learning

The Third Age of retired or semi-retired people is the fastest ̦
demographic groups. Soon 20 per cent of the population in developed
be in this category (Reeve in Chadwick and Stannett, 2000). Traditio.
museums have catered for this audience as part of the adult education pr͵
often in partnership with WEA (Workers Educational Association), u͵ ͵rsity
extramural departments or local authority provision. Changes in government
priorities and funding have now reduced access for the less well-off to this kind
of opportunity. By prioritizing Basic Skills, government has de-prioritized non-
vocational lifelong learning even further. NIACE (the National Institute for Adult
and Continuing Education) has been an important ally for museums in the UK on
this issue.

This also flies in the face of all the research on the 'wider benefits of learning'
(Schuller *et al.*, 2001) that shows how older people, in particular, stay healthier
longer when engaged in sports, social and learning activities. Many local museums
have a strong base of older users or make it a priority to get one. Sutton House (a
rare Tudor survival in inner-city Hackney, east London) has prioritized over-55s
(especially from the Afro-Caribbean community) as well as prioritizing the under-
11s studying Tudors, plus a small family programme. Adults as volunteers contribute
significantly to museum learning in the UK and North America: they are far less
common elsewhere, although volunteers interpret the city of Stockholm through
their own working and living perspectives. This is a creative approach to making
tourism more inclusive, enjoyable and a collaborative learning experience rather
than an endurance test.

Disabled People

Following the DDA (Disability Discrimination Act, see Chapter 2), this is no longer
an optional audience in terms of physical access: programming is another matter.
This is one of the groups that benefits exceptionally from the museum stimulus,
and from object-based and multi-modal learning (see Chapter12). Disability
activists have been especially successful at pointing this out in the museum and
gallery context and in making their audience a priority (Durbin, 1996, pp 91–106).
American pioneers like Renee Wells have inspired UK museum educators to follow
suit. As she observes: 'Museums are empowering places in the sense that visitors can
express themselves in a very individual way. Unlike a classroom, there is no "right"
or "correct" response. Some people with learning difficulties feel liberated by the
museum environment' (Wells in Pearson and Aloysius, 1994, p 69).

The related project at the BM showed how even autistic children and those with
severe learning difficulties 'may respond to topics more powerfully and emotionally
than mainstream pupils, who may not be concentrating so markedly on the visual
impact of a museum project' (*ibid.*, p 54).

Outreach and Online

Communities

Special collections, exhibits and programmes have been developed to reflect the cultural diversity of Leicester, Bradford, Birmingham and other UK cities. In Chapter 7, Eithne Nightingale shows what can be done by a national museum that prioritizes ethnic communities. Specific ethnic groups have been targeted with posts and programmes at the V&A and at the BM. In each case working with that community in the UK has been just one strand of an intercultural engagement (Burnett and Reeve, 2001).

Beyond individual initiatives there is, as Carol Duncan puts it, 'the much larger question of who constitutes the community and who shall exercise the power to define its identity'. Museums can offer a platform for communities to represent themselves through performance, film and food, as the Museum of London did during *The Peopling of London* exhibition (Merriman, 1993). With communities we are not talking here about just another audience but about issues of control, voice and representation of identities. This may be validating, such as for gays, lesbians, or disabled artists; or problematic, such as when representing blacks in Brazilian museums (Santos, 2005) or in unwittingly reinforcing images of African oppression and low status (Moffatt and Woollard, 1999, p 58).

A museum that prioritizes the community has to listen, share authority and work at sustaining that relationship through thick and thin. All too often it can appear an ad hoc and opportunistic policy of 'slash and burn' – picking up communities and dropping them again once the exhibition or special season has finished. The National Museum of the American Indian in Washington DC opened after three years of consultation with Native Peoples (West, 2002). District 6 Museum recreates a lost community of Cape Town, South Africa (Chakrabarty, 2002) as a community statement about itself. Croydon's Clocktower was built up from objects chosen to represent themselves by the people of Croydon, rather than by using what happened to be in a museum store; it is now being renewed to reflect new generations and needs. Museums have this unusual opportunity to showcase wider community concerns and issues than just those dictated by their collections: the Museum of London, for example, has exhibits on issues as diverse as the problems of highrise living, pollution and the history of gay London.

Museums still do not feature on the radar of many ethnic groups, and the attitudes described by Trevelyan, Desai and Thomas persist. 'What is there for us in the museum?' Museums are seen as 'culturally and socially irrelevant', with reasons ranging from cost, difficulty of getting there, or knowing in advance whether it will be worth it, feeling out of place, and so on.

Geographical Targeting

Napoleon's advisers had a vision of a French national museum grid. Today we talk about 'cultural entitlement' and that applies not just by class, age or ethnicity but also by location, and with reference to collections as well as services. How far is your nearest dinosaur, Greek vase or mummy if you are a KS2 teacher? Working from the top down, how can national museums be truly national? Each has developed its own model in the UK. In France the Louvre is opening an outstation in an unglamorous northern city, after a kind of beauty contest not unlike the one that took the Royal Armouries to Leeds. Devolution and regionalization of culture and museums are part of post-Franco policies in Spain (Holo, 2000). Another approach is the federation of comparable or high-quality collections, as in Sweden to produce World Museum Gothenburg, or in Flanders (vlaamsekunstcollectie of Bruges, Antwerp, Ghent) or pooling of resources to research the histories of slavery in the UK (NMM Bristol, NMM Liverpool).

Rural areas often miss out, such as Lincolnshire, or Worcestershire and Herefordshire, where a mobile museum service has been developed, as earlier in Scotland, and South Yorkshire (Dodd and Sandell, 2001, pp 102–5). Diversity is particularly an issue in the rural 'white highlands' of the UK. The SWMLAC played an important initiating role in supporting cultural diversity programmes in the predominantly white and rural south-west of England. Although audiences fell way short of anticipated, the diversity festival reached even very small museums and small minorities such as Moroccans and Poles in a market town. Encouragingly, many museums in the region plan to continue and build on this first experience (SWMLAC, 2004).

Museums may be part of a Creative Partnership scheme or dealing with its absence; adding to an already targeted area's provision, or finding one that is not but should be. Social deprivation indicators are one way of prioritizing by area, especially in inner cities, such as the Cowgate area of Tyneside, as part of a family health and community project targeting mothers (*JEM* 20, 1999) or in Gosport, a deprived coastal area of Hampshire, with its new Discovery Centre combining library, museum and café.

Much of this expansion in scope and ambition can be mirrored in the education and outreach work of other areas of the creative industries, which are often under less pressure to follow a government line, and where the programme does not have to be limited to works being performed, just as museum outreach does not have to be limited by collections. One of the UK's leading chamber orchestras, the Britten Sinfonia based in Cambridge, works in hospitals and prisons, with nurseries and under-sevens, the same rural secondary pupils over several years, with tiny village schools, in a youth project in an inner city community centre, with adults with disabilities, and with 14–16 year olds excluded from school. Their project to promote the playing of 'endangered' instruments has a clear parallel in the attempt by museums such as the BM to promote interest by sixth-formers and others in 'endangered' university subjects, such as classics and the ancient Near East, and

the related museum work that depends on a supply of graduates in these subjects. Science Museum sleepovers have been aimed at convincing both girls and mothers that science could be for them. Chemistry and physics, for example, currently have difficulty recruiting at UK universities, and there are not enough science teachers. This then is yet another example of the museum's potential role as a public learning forum and motivator.

Conclusions

1. There is a growing consensus on the need to prioritize audiences: 'museums that take a user-centred approach to provision, cater for different preferred ways of learning, and provide access at a range of levels are likely to be more attractive ...' (Swift in *GEM News* 95, winter 2004, p 9).

2. Today in the UK museum priorities appear to be:

- schools and families rather than non-vocational adult learners or tourists;
- active rather than passive learners;
- offsite (including online) learning, either as an adjunct to or substitute for the actual visit.

With ethnic communities, the priority still seems to be targeting an ethnic group related to a specific ethnic collection, rather than truly intercultural programming, or creating other opportunities for that ethnic group once contact has been made (see Hajra Shaikh in Dodd and Sandell, 2001, pp 98–101).

3. Among the least well-served of audiences are:

- people living in rural areas;
- those without the money or mobility to travel into inner cities or heritage sites;
- most tourists;
- those who have fallen through the educational net;
- those who belong to communities with no tradition of museum-visiting and see no point in doing so.

Deprived areas may have deprived museums but will at least now be part of a national provision, although the weakest museums and heritage attractions, in terms of funding and local support, will continue to close.

4. Another priority for the museum's core budget may be what cannot easily be sponsored or economically run by volunteers or freelance staff; at present it may also

mean those audiences, or subjects and cultures, not prioritized by *Renaissance in the Regions*, the curriculum or other government and funding policies.

5. Targeting one group effectively, however, will often mean saying 'no' to another or offering it a slimmer or more pre-packaged service. It does not mean 'the bat squeak of tokenism' or picking up one audience in a blaze of photo opportunities, only to drop it when the next policy initiative or special exhibition comes along. There are lessons to be learnt from marketing: promoting new angles on an apparently unchanging facility can transform public perceptions, even if there is a risk of appearing tokenistic, say by offering special programmes for Black History Month, Eid, Big Draw or Gay Pride, but not at other times. The danger can be averted if it is made clear that this is part of a regular pattern, and there are follow-up resources and displays built in to the programme.

6. Making a difference. Another way of thinking about priorities may be to ask the question 'Where can museum learning make the biggest difference?' or, in jargon, 'Where can most value be added?'. If museums are so successful with the very young and those in special schools for blind, deaf and other disabled children, should they not become major priorities? Both kinds of audience are very labour-intensive, like long-term work with communities or small groups of adults such as the hearing-impaired, and therefore not likely to produce large numbers for the performance indicators. One can also ask what can a museum uniquely do because of its collection or location (for example, the British Museum presenting world cultures to a world audience rather than the story of Britain to a British one).

7. Another implication of prioritizing an audience is to make sure that other audiences do not clash – small children and tourist groups do not go together in the same space, as you can see any termtime day in the Mummy Galleries of the BM. Zoning of the day and of spaces can help, especially with exhibitions. Some gallery designs have built in multi-use (see Chapter 13).

8. It may be easier to prioritize if yours is a smaller museum or a regional museum with a strong local and regional community, rather than a national museum. There has been a considerable increase in the number of posts for learning and access in regional museums: between 1998 and 2003 there was a 61 per cent increase for museums belonging to GLLAM (Group for Large Local Authority Museums), such as Brighton, Leicester, Bristol and Tyne and Wear (GLLAM, 2004). However the majority of museums in the UK still do not have professional educators, so Regional Agencies have an essential role in delivering to schools as a priority audience, the priority in fact of *Renaissance in the Regions*. In the UK, schools will therefore continue to be a priority, even though proportionately their numbers are small for many museums, as other audience groups such as families grow. In some German museums, schools are still the largest audience group, and in India the easiest to target.

9. Whatever size it is, a museum needs focused and inspirational leadership to seriously prioritize audiences and learning. There are now several schemes in the UK that will, it is hoped, provide more of this, run by the Clore Duffield Foundation under former Arts Minister Chris Smith, and others proposed by Arts Council England and MLA (see Chapter 14).

10. Now for the balance sheet. Some audiences require special facilities (under-fives, schools, families, disabled people). Some services can be provided by hiring in (tourists, adult courses, practical workshops) or by using trained volunteers (introductory tours, craft demonstrations, stewarding at special events, accompanying severely disabled visitors, working with communities). Some audience roles require core expertise: policy and programme-making; audience and learning advocacy on gallery, exhibition and online projects; and publishing for young and specialist educational audiences. Some programmes can sustain themselves through charging if key posts are already funded (schools, teachers, tourists, adult education); others need to be free if a museum is to be inclusive as well as responsive (under-fives, families, communities, youth, outreach).

11. Returning to the balancing act described earlier, there is one last polarity to mention in the Seven Ages of Museum Visiting: quantity versus quality. This may be more helpfully seen as progression. If the overall aim is to create new generations of confident, engaged museum and gallery users having a high-quality experience, then resources need to be targeted at a combination of catching them young and making sure they are not put off by a parody of schooling. This must be reinforce by supporting them as parents and by sustaining their interest as adult learners. As these new museum users make use of the improved facilities and the increasing range of learning tools on site and online, the core learning and access teams can then concentrate on the labour-intensive groups and labour-intensive roles. Streamlining for some and targeting for others does not inevitably mean a loss of quality.

References

Anderson, D. (1999), *A Common Wealth: Museums in the Learning Age*, London, Stationery Office.
Bridal, T. (2004), *Exploring Museum Theatre*, Walnut Creek CA: AltaMira Press.
Bridges, D. and McBride, R. (1993), *London Museums Education Unit: An Evaluation*, London: LMEU.
Burnett, A. and Reeve, J. (eds) (2001), *Behind the Scenes at the British Museum*, London: British Museum Press.
Chadwick, A. and Stannett, A. (eds) (2000), *Museums and Adults Learning. Perspectives from Europe*, Leicester: NIACE.
Chakrabarty, D. (2002), 'Museums in Late Democracies', *Humanities Research* **IX**: 1.

Desai, P. and Thomas, A. (1998), *Cultural Diversity: Attitudes of Ethnic Minority Populations towards Museums and Galleries*, London: MGC.

DigiCULT Consortium (2003), *Learning Objects from Cultural and Scientific Heritage Resources*, Salzburg: DigiCULT Consortium. (Available at <www. digicult.info>.)

Dodd, J. and Sandell, R. (1998), *Building Bridges: Guidance for Museums and Galleries on Developing New Audiences*, London: MGC.

Dodd, J. and Sandell, R. (eds) (2001), *Including Museums: Guidance on Museums and Galleries to Use When Developing Access Policies*, Leicester: RCMG.

Durbin, G. (ed.) (1996), *Developing Museums for Lifelong Learning*, London: HMSO.

GEM News – quarterly newsletter of the Group for Education in Museums, published by GEM, UK.

Geser, G. (2003), 'Introduction and Overview', in DigiCULT Consortium (2003).

GLLAM (Group for Larger Local Authority Museums) (2004), *Enriching Lives*, London: NMDC/GLLAM.

Haas, C. (2002), 'ZOOM Kindermuseum, Austria', in W. Wolf and A. Salaman (eds) (2002).

Hawkey, R. (2004), *Learning with Digital Technologies in Museums, Science Centres and Galleries*, Bristol: NESTA Futurelab (also available online).

Hemsley, J. (ed.) (2005), *Digital Applications for Cultural and Heritage Institutions*, Aldershot: Ashgate.

Holo, S. (2000), *Beyond the Prado: Museums and Identity in Democratic Spain*, Liverpool: Liverpool University Press.

Hooper-Greenhill, E. (1994), *Museums and their Visitors*, London: Routledge.

Hooper-Greenhill, E. and Moussouri, T. (2002), *Researching Learning in Museums and Galleries, 1990–1999: A Bibliographic Review*, Leicester: RCMG.

Hughes, C. (2002), 'Telling the Untold Story', keynote address at *Raising the Curtain: First National Forum on Performance in Cultural Institutions*, National Museums of Australia, available at <www.nma.gov.au/events/past_events/2002_ raising_the_curtain/print_index.html>.

Ings, R. (2001), *Funky on your Flyer*, London: ACE.

JEM – Journal of Education in Museums, published annually by GEM, UK.

Jones-Garmil, K. (ed.) (1997), *The Wired Museum*, Washington DC: AAM.

Kavanagh, G. (ed.) (1996), *Making Histories in Museums*, Leicester: Leicester University Press.

Knell, S. (2003), 'The Shape of Things to Come: Museums in the Technological Landscape', *Museum and Society* **1**: 3.

Kress, G. and Van Leeuwen, T. (2001), *Multimodal Discourse: The Modes and Media of Contemporary Communication*, Cheltenham: Arnold.

Mathers, K. and Selwood, S. (1996), *Museums, Galleries and New Audiences*, London: Art & Society.

Merriman, N. (ed.) (1993), *The Peopling of London*, London: Museum of London.

Moffat, H. and Woollard, V. (eds) (1999), *Museum and Gallery Education – A Manual of Good Practice*, London: Stationery Office.

NMDC (National Museums Directors' Conference) (1999), *A Netful of Jewels*, London: NMDC.

Pearson, A. and Aloysius, C. (1994), *Museums and Children with Learning Difficulties*, London: British Museum Press.

Reeve, J. (1996), 'Making the History Curriculum', in G. Kavanagh (ed.) (1996).

Rider, S. (1999), 'Opening the Doors', *Journal of Education in Museums* 20.

Sandell, R. (ed.) (2002), *Museums, Society, Inequality*, London: Routledge.

Santos, M. S. (2005), 'Representations of Black People in Brazilian Museums', *Museum and Society* **3**: 1.

Schuller, T. *et al.*, (2001), *Modelling and Measuring the Wider Benefits of Learning*, London: Institute of Education.

Selwood, S. and Clive, S. (1992), *Substance and Shadow*, London: London Arts Board.

Smithsonian Institution (2005), *Concern at the Core*, Washington DC: Smithsonian Institution.

SWMLAC (South West Museums, Libraries and Archives Council) (2004), *South West Diversity Festival, Final Report*, Taunton: SWMLAC.

Trevelyan, V. (ed.) (1991), *Dingy Places with Different Kinds of Bits: An Attitudes Survey of London Museums amongst Non-visitors*, London: London Museums Service.

Walker Art Center Museum Management Consultants (1999), *Artists and Communities at the Crossroads*, Minneapolis: Walker Art Center.

Wartna, F. (2002), 'Wereldmuseum, The Netherlands', in W. Wolf and A. Salaman (eds) (2002).

West, W.R. (2002), 'American Museums in the 21st Century', *Humanities Research* **IX**: 1.

Wolf, W. and Salaman, A. (eds) (2002), *Playing to Learn? The Educational Role of Children's Museums* (papers from the *Hands On!* Europe conference, 2001), London: Discover.

Chapter 5

Networks and Partnerships: Building Capacity for Sustainable Audience Development

Ian Blackwell and Sarah Scaife

Introduction

This chapter looks at how museums and galleries can address current audience capacity issues while remaining innovative, creative and inclusive. It also discusses key terms, such as audience development and sustainability, and suggests how increasingly demanding expectations can be achieved and how current practice can be enhanced and maintained in the long term.

Relevant Terms

How can museums develop the capacity to support their changing relationship with audiences in a sustainable way? Let us start with the terms used. 'Sustainable', 'audience development', 'building capacity': sometimes the very language is one of the barriers.

Audience Development

This term describes the varied approaches museums and galleries take to understand and expand their user base. A good audience development strategy is one which responds to research (you know your users and potential users), which encourages exploration (by piloting and refining ideas with them), which makes the most of partnership opportunities and which is innovative. Such a strategy needs to recognize the barriers, perceived and real, that confront users and non-users and for the museum and its partners to take measures to overcome them (see Dodd and Sandell, 1998).

Audience development has many facets. These may include visitor profiling and consultation, applying various marketing and selling techniques, the delivery of outreach work, improving services and facilities, targeted exhibitions and programmes, and the development of accessible, new resources (for example online). If ultimately the purpose of all this activity is to increase access to collections as a

source of knowledge, inspiration and enjoyment, then audience development needs to be rooted in the first-class stewardship of collections.

Capacity-building

What about *building capacity*? This term is used commonly nowadays in the UK museums sector to describe, most usually, the creation of the infrastructure which is required to address expansion and improvement agendas, particularly in response to new investment, increased public expectations, local government review (such as the concept of Best Value), increasing/decreasing visitor numbers, etc. So, what we really mean by 'capacity-building' is the finding of ways to strengthen those things which need to be in place for a museum service to be able to grow. Organizations can build capacity in a number of ways. The appointment of new staff or the re-designation of existing posts immediately impact on a museum's ability to take on new work, deal with issues and tackle weaknesses.

In school we may learn that the capacity of a box can be given as a mathematical relationship between its length, width and height. In museums sustainable capacity is derived from a more complex formula involving the relationship between many variables which probably include some or all of the following:

- the latent potential of resources (collections, stories, staff, the building, etc.)
- vision and identity
- plans and organizational context
- networking
- partnership
- dialogue
- skills
- problem-solving approach
- 'appreciative enquiry'[1]
- creativity, flexibility
- capital/investment.

Exact terms may vary, but it seems to us that the same broad list comes up again and again, almost regardless of the source. They appear in published work, are discussed here and elsewhere, and reappear in internal research reports or evaluation of practice. The audience development variables represent both needs and solutions.

There are many examples where a surfeit of one or two items on the list can compensate for a lack of others – lots of financial investment with little dialogue may still provide an apparent increase in capacity for audience development, but

1 This term is borrowed from an approach to leadership and management encountered by Sarah Scaife at Government Office North East. It is used to indicate an approach which is probing and asks questions but in a positive rather than blaming sense.

equally time invested creatively in visioning, dialogue, planning and prioritizing can have fruitful results on shoestring budgets.

Users and Potential Users

We also need to think about these users and potential users. Who are they? What do they gain from engaging with the museum? The answer of course varies with every museum, and probably every 'use'. We might start by trying to identify and understand why people go to museums and how they behave when they get there; and what individual users and potential users will bring to, and indeed expect from, their 'museum experience'. (Falk and Dierking, 1992, is essential reading.)

Underlying current thinking is that audience development is inclusive, collaborative and also a learning process – reflective and evaluative – for the organization. For the user, it creates a ladder to move from a passive (sometimes hostile) mood to one of engagement, loyalty and repeated involvement. It should be collaborative in the sense of sharing skills, views, values and experiences between 'audience' and 'museum'. Once again, terms subliminally shape thought processes and resulting action: notice the effect of the *active* word 'user' compared with the *receptive* word 'audience'. Sustainable audience development must go well beyond increasing numbers of new visitors. Rather it is about forming, maintaining and nurturing relationships which may grow and change over many years. Like any healthy relationship dialogue feeds constant adjustments and readjustments. 'Audience' blurs into 'museum community'.

Capacity-building is also as much about developing the capacity of the audience as the capacity of the museum. This a democratic process which museums are still getting to grips with. In practice this requires museums and audiences (people/ visitors/users) to meet on equal terms. Museums, as gatekeepers, increasingly recognize that until the message has been received by an audience, explored with them and understood by them, it has not been interpreted (nor has any learning taken place). Ultimately it is the audience that does the interpreting not the curator, gallery explainer, education officer or the exhibition itself (these are the media for the messages) (see Jenkinson, 2004). It means museums handing over power, skills and knowledge to the community, and recognizing and valuing the expertise within those communities too.

Sustainability

We would like to reflect on the word 'growth' in relation to sustainable capacity building. A Western model of sustainable organizational growth tends to be focused on size: ensuring bigger capacity means working out how to become physically or financially larger. There are of course other senses of living/organic/ecological sustainable growth. As an individual one might experience a period of emotional growth. There would be no measurable change in physical size, but a change and development is nonetheless taking place. Interestingly, the English language uses

physical size-related metaphors to describe the outcome of this. How would your museum community be if it could walk tall, hold its head up high, take up its full place in the world?

Healthy Growth

Similarly in an organic view of growth one can consider a mature deciduous tree. It is actively growing though it may change little in size. Its growth is expressed in its turning towards the light, bearing fruit, withdrawing to get through winters. Ecologists would also remind us that sustainability can be about reducing in size and focusing on what really matters in the longer term. Arguably a museum service might grow and expand capacity most effectively without actually becoming physically bigger. In a country (UK) where the Heritage Lottery Fund (HLF)[2] is the museum's panacea, we have encountered the 'mezzanine floor' phenomenon; smaller, overstretched museums where paid or volunteer staff feel that all their problems will be solved when they get that lottery bid and can put in a new mezzanine floor. Organizational change, in the meantime, is put on hold. Growing your vision and expanding your horizons can do as much to support change as building extensions; a bonsai is small but perfectly formed.

Practicalities and Tools

So how is building capacity for sustainable audience development achieved on a practical level? There is no need to reinvent the wheel: a substantial body of guidance is already published. In particular there are a number of quite recent well-known toolkits and guides which we, and colleagues at a range of levels, have found practical and helpful to use. Three of these, all available on the Internet, are mentioned here.

Not for the Likes of You (Morton Smyth, 2004) offers museums and the wider cultural sector inspiration, encouragement and tools to boost our relationships with users and potential users. Its authors essentially set out an iterative process for moving towards deep and sustained organizational change which we rather clumsily summarize as follows:

• Discuss your vision; what will it be like when you 'get there'?
• Honestly define the benefits of the status quo. Try to work out what you are prepared to give up to create change.
• Talk to other people in organizations who have made the change.
• Get the support of a 'cheerleader' who will keep in touch and ask how it is going, remind you of your vision, tell you how well you are doing, provide a sounding board and a shoulder to cry on.
• Start with something small, experiment, refine and build on your experience.

2 Heritage Lottery Fund (see <www.hlf.org.uk>, available September 2005).

- Keep doing the above as you build momentum. Look at how far you have come, rather than how far there is to go.
- Do not expect to do it all at once, or get it all right first time.

If you read nothing else on building capacity for sustainable audience development read *Not for the Likes of You*!

HLF has published a useful guide to creating an Audience Development Plan, with a strong emphasis on inclusion (available to download from:<http://www.hlf. org.uk/English/PublicationsAndInfo/AccessingPublications/GuidanceNotes.htm>).

The Museums, Libraries and Archives Council's (MLA's) *Inspiring Learning for All* is also increasingly used as a resource for audience development; for example, the sections on how to analyse visitor feedback and how to consult with communities.

Deep-rooted Change

For many museums, audience development has been a well-tried and highly developed core commitment for many years. However, in terms of numbers of users, museums still suffer from peaks and troughs. Many still find it difficult to increase (even sustain) a share of the market in the face of increasingly predatory or simply better methods elsewhere in the cultural, leisure, travel, media and retail sectors. Other museums are successful in increasing numbers and in engaging a broader audience, but this can be (some argue) at the expense of their infrastructure, their long-term financial security, the care of collections or their ability to offer an enduring high level of service. The response from museums and the UK government has been to invest (especially with Lottery, Designation and *Renaissance in the Regions* funding) in the museum infrastructure, in new skills, in new programming to create more targeted campaigns and in employing professional marketing, outreach and audience development staff.

One side-effect of the *Renaissance* initiative is to remind us of the huge variation in scale of resourcing across the sector. We know from our own work in Yorkshire, the South West and the North East of England that there are substantial variations in resources of all kinds, and in this we include creativity, vision and problem-solving skills, as well as financial capacity. As we have noted, there is not always the expected match between the amount of financial resource and the quality of the museum experience.

Museums are successful not only where they consistently strive to broaden their audience base and to improve the visitor experience, but when they have behind them good management practice, staff (including volunteer) commitment and a range of supporters and partners who share their values. These museums also encourage risk-taking; they share their resources and create partnerships, often surprising ones (see, for example, Maitland, 2000; Morton Smyth, 2004; Dodd and Sandell, 1998; and *Inspiring Learning for All*).

So what is a museum which has built the capacity to reach and involve a range of users ? *Not for the Likes of You* clearly highlighted what makes dynamic, inclusive, audience-focused museums:

> They are exciting to engage with, and their experience is that through repositioning, far from suffering, their product gains new life, vibrancy and meaning. We found that repositioning is as much about attitude and mindset as what you do. Looking at the organisations that have repositioned, and now attract much broader audiences, the most important thing they have in common is a really strong sense of respect and trust for audiences and staff alike ... they also operate on the assumption that people are capable of more than they (or we) think they are. They work on the assumption that everyone is creative and artistic judgement is not the preserve of a chosen few. The most significant finding of the project so far is that successful organisations model internally what they wish to express externally - in other words, to have the best chance of being open and inclusive to audiences you need first to be open and inclusive with staff. You also need to be strong-willed, bold and obstinate. There will be resistance, there will be critics and you need to keep faith – and keep going.[3]

Elsewhere, Ellis and Mishra suggest that: '[In terms of the] management of creative processes and finding an audience or market for the fruits of their labour ... *flexibility*, a *commitment to quality and innovation* and a *strongly branded identity* – all of which require *investment capacity* – would appear to be central attributes of success' (Ellis and Mishra, 2004, our emphasis).

Again we return to our tree metaphor. It is no surprise that trees feature in brand identities – the oak which symbolizes the National Trust, for example; how might one's expectations of the organization change if its symbol were a flowering cherry tree? Once the sector had a resistance to the notion of 'brand' but was freed of its corporate resonance, exploring a museum's branding could be a powerful way to reconsider its vision, values and messages. There is a type of tree suited to each particular environment. Each has its own strengths but cannot be all things to all people. Healthy museums are likely to be those which are adapted to the local environment and conditions and which are nourished, tended and pruned as they grow and take shape over a period of years, strategically as well as physically. They are clear about their own unique identity and purpose and communicate this 'brand' at every level, from their collections policy to their consultation procedures. Arguably, a museum which is comfortable in its own sense of identity and strongly rooted in its communities will be most ready to make good use of any investment opportunities which may arise.

3 From Mel Jennings' keynote presentation from the 2004 Museums and Galleries Marketing Day about the 'Not For The Likes of You' approach.

Strategic Marketing or Strategic Audience Development?

It is useful to remember that the particular character of any museum is the result of a combination of active choices and conscious or unconscious omission over a period of time. Ellis and Mishra take this a step further. They argue that:

> The nature of an economy which deals primarily in symbolic goods, or at least goods where the symbolic aspect is a large part of their value, means that businesses [that is, museums] must not only cater to consumers' desires, but must anticipate and create them … to create a context in which the consumer is willing to be challenged to move beyond his or her set responses and expand the vocabulary of response. [This means there is a need for] marketing that allows the familiar to be a conduit to the unfamiliar … [and] to stimulate the desires and fears to which their products and services are a profitable response (Ellis and Mishra, 2004).

In the UK the current emphasis from the Museums, Libraries and Archives Council (MLA) is to encourage a 'strategic marketing' development approach, suggesting that until now marketing in the heritage sector has tended to be disjointed, reactive and unreflective. Perhaps so. Strategic marketing combines a truthful acceptance of the museum's strengths and potential, as well as its limitations and barriers, coupled with a comprehensive understanding of the audience one does and could serve, set within a longer-term view of where the museum needs to expand its audience base. The museum 'product' is then regularly revised to match both the needs of the museum and of the audience – the success of one is, of course, dependent on the other.

Thriving museums systematically obtain useful and credible data on current users/lapsed users/non-users and exploit this rich source by matching information against the local, regional and national demographics in order to understand audience profiles, needs and reasons for visiting/not visiting. The museum then responds by segmenting the audience and finding meaningful and innovative ways of consistently communicating with these audience segments in ways that are relevant to them. With a strategic marketing approach, the information is analysed, a picture of user and non-user patterns established for the venue(s), an understanding of the needs and drivers of each audience group determined and then a series of inter-related, creative and personalized communication strategies can be employed. It sounds complex but a small museum can be successful by focusing carefully on its relationship with just one audience. An acceptance that it simply may not be possible to reach everyone may be needed before a more strategic approach can be adopted.

Audience development should emphasize a dialogue with the audience, whereas the strategic marketing literature tends towards 'communication'. The difference is slight but the authors regard the most successful and sustainable activities are ones where the *museum* organization learns and experiences a change in attitudes through dialogue with the user. An example of this approach from the North East of England is *Northumbria for All,* established to offer a strategic response to exclusion in the heritage sector (see <www.mlanortheast.org.uk>). This project has been exploring

why many of the region's economically and socially excluded communities do not access heritage-based attractions, and looks at ways in which the sector can improve participation in the heritage by these groups. In an attempt to initiate a genuine dialogue with marginalized groups, *Northumbria for All* involved action research focused on barriers to participation in heritage by delivering activities around a number of cross-cutting themes, and by enabling and supporting individual heritage attractions to tackle exclusion issues in an holistic and strategic manner, with partners and community groups.

The pilot phase of *Northumbria for All*, which ran from January to August 2005, consisted of five projects based at a variety of heritage organizations, each focusing on a key exclusion question; for example, 'What sort of museum marketing material attracts local young people?' or 'Do entry charges matter?' The difference with this approach is that hundreds of people who previously have not given museums a second thought have joined a debate about how museums should operate – the project opened up a dialogue, instead of delivering a promotional campaign.

Unsurprisingly, one of the main outcomes of the *Northumbria for All* project has been to remind museums that, whichever audience they are trying to appeal to, they need to create an offer which secures someone's time amidst a multitude of choices and demands in our lives, and, equally important, that museums convey that offer effectively. This is about creating a museum presence and brand 'where there is a guaranteed offering and, effectively, a partner that the consumer can trust … [in contrast] disappointment of expectations results in a loss of trust' (Curry and Stanier, 2002).

Innovation Through Partnership

Let us return to Ellis and Mishra (2004):

> [Recruiters from large corporations often have the rationale that] it is easier to teach a creative person the practical skills necessary to do a certain job, while reaping the benefits of their fresh perspective on the industry, than to teach a candidate with concrete job-related knowledge how to think creatively. [Inadequate funding however] prevents organizations from being able to take and manage the risk that is inherent in innovation because they do not have the depth of funding required to off-set the risky with the less risky.

There many examples of innovation in museums, from the Galleries of Justice in Nottingham, Tyne & Wear Museums, and the People's Museum in Glasgow, to services in Exeter, Hartlepool and 'conflict management workshops' in County Antrim. The most successful innovation often seems to come out of partnership where the financial risk is spread. Partners may also bring a fresh perspective. What would have looked like odd alliances ten years ago are now being formed on a regular basis. People in the health, youth and community regeneration sectors are beginning to recognize the power of museum resources, the stimulating museum environment and the unique debates that can be had through exhibitions and collections. Of course, the museum sector gets criticized for this approach, but that will pass and

many more people, particularly from outside the sector, increasingly acknowledge the commitment the museum profession is making in continually seeking new and valuable relationships.

One example of innovative partnership in audience development is the 'Max Card' – a simple response to a Department of Health drive to improve local authority care for 'looked-after children'. North East Museums, Libraries and Archives Council (NEMLAC, now MLA North East), working with local authorities in the region, established the Max Card scheme in May 2002 to enable looked-after children, their carers and the carers' children to gain free access to museums, galleries and heritage sites in the North East. This has been achieved through partnership with, and funding from, social services departments. The success of the scheme has been exceptional. Three years on, it now offers 15,000 people free entry to over 50 museums, galleries and heritage attractions across the North East – with schemes also running in Yorkshire and other English regions. Evaluation has shown that the Max Card creates inclusive and positive experiences, fosters a sense of identity and belonging, and builds self-esteem and confidence for looked-after children, disadvantaged young people and their carers (see <www.mlanortheast.org.uk>). The partnership also offers social services budget-holders a cost-effective way to achieve some of their aims.

What Makes a Museum User?

As 'museum professionals' we open the doors to some special engagement with material culture. As parents we sometimes visit museums on a rainy day when we would really rather have taken the children to the beach. The best museums know what motivates, appeals and engages each audience segment, and likewise what deters and irritates them. Museums need to know what distracts the potential user's attention towards another choice of activity. Ask yourself: 'What's the competition? What methods are they employing that are taking our audience away? What can we do to attract people in? What messages and media do they prefer? How do people like their messages packaged?' (Wadeson, 2003), but also 'What can I learn and how can I involve my audience as an equal partner?'

James Bradburne suggests that 'part of the solution seemed to lie in redefining what sort of activity should be happening [in museums] in the first place'. He articulates his experiments (with colleagues) to enhance visitors' engagements with objects in the museums where he has worked. They have moved away from 'creating "exhibits" which *show visitors* ... [and towards] "supports" which helped *structure and sustain interaction between users*' (Bradburne, 2001, p 77).

In the case of mak.frankfurt, Frankfurt's Museum for Applied Art (<www. museumfuerangewandtekunst.frankfurt.de>), this meant

> ... enhancing the features of the Museum which are currently available ... the café/restaurant, playground, the neighbouring park ... and adding new facilities which encourage repeat use, such as a shop, reading tables, portable stools, and ladders for children to see into

high display cases. It also means being open at times when people want to visit, and making an effort to give access to as broad an audience as possible ... (*ibid*).

The Audience Journey

This audience-focused approach will mean that the museum experience does not revolve around the exhibition galleries or the prices in the shop, important though they are. Each aspect of the internal and external spaces, the welcome, the public facilities, the journey to and from the site, the learning and reflective processes each visitor goes through, the interaction with others and the feeling of recognition and inclusion in the coded stories museums create, all impact as much, sometimes more, than the artefacts and exhibits.

This may sound obvious, but many museum professionals still fail to recognize the need to improve the whole museum experience, from the first decision about 'what to do today', to finding the venue and getting near to and onto the site, and out and away again.

Audience development is, therefore, about moving from the internal, museum-centred experience of understanding visitor motivations to one that understands the visitor and shares the complete visitor journey (which is both physical and psychological). By recognizing that the museum visit is an experience which itself is part of a journey, the museum will gain a better understanding of audience needs and motivations (and those of the potential user). What we are talking about is a process of conscious change rooted in dialogue.

The Museum as Community

Putting the audience at the centre of museum interpretation and learning has implications, naturally, on the historic practice of taking objects/collections as the focus. Obviously, objects and collections are the very things that make museums museums; they are the source of people's inspiration, stories and identities. The audience-focused approach does not detract from this at all, indeed it builds on what museums have done for decades, but it does unite the needs and experiences of the audience with the needs and stories held within the collections – and what is so odd about this? Surely our collective cultural heritage is exactly that – a mix of stories and experiences somehow locked up in the remnants of past and present. This democratic version of audience engagement should, therefore, not be seen as a cynical response to New Labour demands and the need to prove our value (Matarasso and Landry, 1999) but as a natural response by people to objects which is mediated through the museum space, the museum staff and the audience.

Importantly, writing in 2001, Bradburne reminds us that when *visitors* become *users*, 'success [can] no longer be measured in terms of numbers of visits, but in terms of repeated, and thus sustained, action' (Bradburne, 2001, p 77). Why then does number of visits or even number of new visitors remain the key performance indicator for many museums, when this should be only the beginning of sustainable audience development?

Let us return to mak.frankfurt:

> Throughout the museum there are chairs – lightweight and elegant portable stools that can be picked up, carried, and left. The configurations in which they are left tell a story of how people stop to chat, to talk with one another, to discuss what they have seen ... What if we believe that the museum is a privileged site for informal learning, not the cognitive learning of the classroom, but the realisation that, as Jonathan Miller says 'the life of the mind is a pleasure'? If we believe that these moments tend to be sustained, social, marked by discussion and exchange – in short, take time – then the chairless museum suddenly begins to look slightly misguided ... The mak.frankfurt experiment is as much about sitting on chairs as it is about displaying chairs (Bradburne, 2005).

This museum's 'lightweight and elegant portable stools' symbolize a great deal. Access need not be ugly, either intellectually or physically. What we are exploring is not the polarization of access and excellence, but rather carefully considered access *to* excellence. Investing in the physical presence of chairs builds the museum's capacity for relationship, changing the emphasis and setting the scene for dialogue at every level. Can we move from the word 'museum' as building to 'museum' as community? It works for 'church'.

Planning for sustainable audience development inevitably involves looking at broad trends. A formal audience development plan is likely to divide up and group audiences in some way; for example, 'woman', 'young person', 'BME',[4] 'single parent', 'professional', 'white', but we need to continue to refine subtly and carefully as we struggle to profile, target and count. Users and potential users seldom have a single identity but rather a portfolio of identities with any one or two coming to the fore in any given context. Sometimes we may feel more of one identity, while being perceived by the categorizing museum to be more of another. For example, as we have already mentioned, one of the authors has visited various museums as a single parent with her 'BME' son, her alter-identity as an experienced museum professional remaining private. If we try to move away from categorizing otherness and towards dialogue and forming relationships with individuals and communities, then thinking from other disciplines – psychology, sociology, community development, for example – becomes a useful resource on which to draw.

Categorizing Identities

One thing which every individual brings to their relationship with the museum is their *sense of self*. A piece heard in 2003 on the BBC Radio 4 programme *All in the Mind* seems to offer intriguing possibilities to apply to audience development in museums. The programme's premise was that our sense of who we are and how we fit into the world is crucial to our health and happiness. Mental health specialists identify one's sense of self as being made up of four elements. To be healthy we need all four:

4 BME = black and minority ethnic.

- *embodiment* – you feel there is a match between who you are and the physical body you live in;
- *unity* – you experience your 'self' as a single and coherent whole;
- *agency* – you are your own agent and you have at least some control over your own life;
- *continuity* – you have *a sense of* your own story as a continuous thread which runs throughout your life.

We, like the other contributors to this book, are 'in' museums because we have had powerful, enjoyable, moving, meaningful experiences in relation to museums and museum objects in our own life and want to share this opportunity with other people. Through museums we have strengthened our sense of self. We are well aware that many people do not share our enthusiasm. For many the expectation or actual experience of a particular museum, or museums generally, is that it will involve being treated as 'other' by staff and that there is little match between their own sense of self and how 'people like them' are presented, represented or indeed absent in the messages of a museum display. It is not surprising that when our sense of self and how we fit into the world is overlooked, undermined or destabilized by a museum visit we do not go back.

References

Bradburne, J.M. (2001), 'A New Strategic Approach to the Museum and its Relationship to Society', Museum Management and Curatorship 19: 1, 75–84.

Bradburne, J.M. (2005), 'Between a Rock and a Hard Place' (date of original publication unknown) from Doors of Perception at <http://www.doorsofperception.com/Features/details/83/?page=5>, accessed 13 June 2005.

Curry, A. and Stanier, R. (2002), 'Filling the Disappointment Gap', paper presented at the Changing Worlds 2002 Conference of the Arts Marketing Association, Cambridge: AMA.

Dodd, J. and Sandell, R. (1998), Building Bridges: Guidance for Museums and Galleries on Developing New Audiences, London: MGC.

Ellis, A. and Mishra, S. (2004), Managing the Creative – Engaging New Audience: A dialogue between for-profit and non-profit leaders in the arts and creative sectors, Background note for a seminar at the J. Paul Getty Trust, 15–16 June 2004, at <www.getty.edu/leadership/downloads/ellis_mishra.pdf>, accessed 20 April 2005.

Falk, J. and Dierking, L. (1992), The Museum Experience. Washington DC: Whalesback Books.

Jenkinson, A. (2004), 'Who are the Interpreters?', Interpretation Journal 9: 1 (Spring), 22–5.

Maitland, H. (2000), Guide to Audience Development, London: ACE.

mak.frankfurt, at <www.museumfuerangewandtekunst.frankfurt.de>

Matarasso, F. and Landry, C. (1999), Balancing Act: 21 Strategic Dilemmas in Cultural Policy (Cultural Policy Note 4), Strasbourg: Council of Europe.

MLA (Museums, Libraries and Archives Council), 'Inspiring Learning for All', at <www.inspiringlearningforall.gov.uk>, accessed September 2005.

Morton Smyth Limited (2004), 'Not for the Likes of You', ACE/MLA/ English Heritage, at <www.newaudiences2.org.uk/downloads/NFTLOY_doc_A.doc>, accessed July 2005.

Wadeson, I. (2003), 'Audience Development – Unpacking the Baggage', paper presented at the November 2003 London Conference of the Arts Marketing Association, Cambridge: AMA.

Audience Development: A View from The Netherlands

Nico Halbertsma

As in the UK examples given in this chapter, there is a new public-centred focus in Dutch museums, involving partnership and collaboration, but it has been slow in developing. In the late 1970s and early 1980s the focus was on 'lowering the thresholds of cultural institutions', which resulted in cheaper special activities and sometimes in bringing art to the people through neighbourhood projects. Lack of money and the not always full-hearted co-operation of the institutions let these initiatives fade out after some years.

Recent Changes

In The Netherlands we are still trying to get a hold on our multi-cultural society, because our ethnic minority groups are in general more socially excluded than other Dutch citizens. In the late 1990s special attention was paid to the larger ethnic minority groups – Turkish, Moroccan and Surinamese. Some of these projects were very successful, such as the special exhibitions in the Amsterdam Historical Museum, where members of these ethnic groups could bring in objects that were of great value to them. The museum extended this to other groups, like gays and prostitutes.

But without good guidelines and real 'pressure' from above, Dutch museums seem to keep making exhibitions and educational programmes for the usual target groups. There is, for example, no law on disabled persons comparable to that of the UK and some other countries.

So it has not been until recently that Dutch museums started to get interested in attracting new audiences: those change arose partly as an urge from within and the growing interest in visitor studies, partly because extra money became available from government and other funders. As a result, at several Dutch museums, the functions of education, marketing, public relations and events have been brought together in one department: 'communication and presentation'. The Reinwardt Academy in Amsterdam, which trains museum and gallery professionals, also changed its emphasis from 'museum communications' to a focus on attracting people into museums, and providing for them, socially, intellectually, economically and physically.

Approaching Audiences

Several museum departments
are involved in thinking about
audiences: marketing and PR,
education, management (fundraising),
maintenance and security, front-of-
house staff and exhibitions: all from
their own point of view with their own
agendas. They all try to develop and
maintain an environment for visitors
in which the latter feel comfortable,
happy, cared for, addressed, taken
seriously and made curious. Dutch
art museums have used television
productively, for example, as in a series
of very short programmes in which a
previous director of the Rijksmuseum
introduced art in a lively way.
Events are another significant form
of marketing as well as of informal
learning. School marketing is also very
important but too often the marketing
department is not really focusing on it,
because school visits cost money and
do not give sufficient monetary return.
So, in some Dutch museums, school
marketing has become part of the
education department's responsibilities.

A very personal and effective way
to approach new audiences is by the use
of 'ambassadors', such as volunteers
who 'sell' their museum to friends and
relatives and who staff stalls at fairs.
For example, during holiday periods,
especially when the weather is not
bright, ambassadors from the Drents
Museum in Assen (a regional history
and art museum) visit campsites and
bungalow parks and give out brochures.
This has a huge effect: it is not the
brochure that brings in the new visitors,
but the very personal, sometimes
enthusiastic and persuasive chat

they have with such an ambassador.
Museums also sometimes work with
school students as ambassadors.
They help the museum in planning
exhibitions, or in the development of
educational materials and activities and
even give guided tours. Thus museums
hope to build bridges between children,
their families and themselves.

Innovation through Partnership

The Dutch Museum Association
recently offered a special training
course for museum educators on
the 'public oriented museum': on
how to arrange that everybody, from
trustees, management and curators
to maintenance staff, really focuses
on visitors and takes them as the
leading principle of their own work.
Everybody in the museum may think
they do a good job that has a positive
effect on the visitor, but generally
this is regardless of colleagues in
other departments. Too often policies
and plans are introduced by museum
management without sufficient
consultation.

Another reason to introduce a
shared, museum-wide, audience policy
is the booming growth of e-learning
and e-culture: all departments are
increasingly involved with this virtual
community.

The Van Gogh Museum in
Amsterdam (with over a million
visitors a year) is a good example
of this new way of thinking about
audiences. All departments have one
goal: 'visitor care' – giving the visitor
the best opportunity to enjoy the works
of art, to feel welcome and to learn

something, if they wish to. This started with cooperation between security and education and now extends from security at the entrance to friendly guards inside, to very competent guided tours, actor-led school sessions, a comfortable information centre and a splendid shop.

The British Galleries of the V&A and their use of learning theories (see Chapter 12) have inspired Dutch Education Officers and resulted in a pilot project in four museums. Two things are very clear from this pilot: visitors stay longer in the exhibition and appreciate it greatly; and members of staff of different departments had to work together to create an exhibition focused on the visitor. This effect on the internal organization of these museums was an unexpected outcome of the pilot projects and of great importance for the Dutch Museum Association. It will therefore be transferred to other museums by seminars and training sessions. Also, currently we see the start of a different approach towards minorities and the projects developed for them. The aim is to make bridges between the different visitor groups instead of putting one in the spotlight. This demands new skills from the museum people involved, new communication tools, new types of learning and a forging of new kinds of partnership.

Chapter 6

Dancing Around the Collections: Developing Individuals and Audiences

Eithne Nightingale

Collections, exhibitions and activities often fail to reflect the diverse backgrounds and cultures of the communities London now serves

(Helen Denniston Associates, 2002).

The Victoria and Albert Museum (V&A) has been developing targeted programmes with and for South Asian and Chinese communities over the last 27 years. This has been mainly but not exclusively in relation to the permanent collections of Asian art in the Nehru Gallery of Indian Art, the T.T. Tsui Gallery of Chinese Art, the Islamic Gallery, related temporary exhibitions and learning and community programmes both within and outside the V&A.

Much of this activity has been highly successful in attracting South Asian, Chinese and other visitors. Temporary exhibitions have been particularly important. According to visitor surveys, of the 119,000 people who visited *The Arts of the Sikh Kingdoms* in 1999 over 60 per cent were Sikh. Of the Sikh visitors over 70 per cent were first-time visitors to the V&A and over 30 per cent had never previously visited a museum or gallery. The group visits brought in an even higher percentage of visitors who had never previously been to a museum or gallery (over 40 per cent). Members of the Sikh community played a key role in bringing new visitors to the V&A. They undertook much of the outreach and many gurdwaras (Sikh temples) from across the country organized free transport for their members, transforming the audience profile of the V&A for the period of the exhibition.

On a smaller scale South Asian[1] and Chinese festivals such as Diwali and Chinese New Year have been very successful in attracting South Asian and Chinese audiences, but have also had a broader appeal for families from all backgrounds. Chinese New Year in 2004 attracted over 17,000 people to a range of events including ballet performances from Beijing Dance Academy, puppeteers from Taipei and kung fu experts from Shaolin Temple. Twenty-three artists came from Taiwan and China to perform or run workshops, alongside a further 27 Chinese artists resident in the UK. These events are always hugely popular as the following visitor comments show:

1 'South Asian' is taken as meaning the Indian subcontinent, thus including India, Bangladesh, Pakistan and Sri Lanka.

'This is fantastic! A wonderful celebration of Chinese culture' and 'A *great* day out. Fabulous that the Lion Dance took place outside and inside the Museum'.

Visitor evaluations for Chinese New Year 2004 show that approximately 25 per cent were first-time visitors to the Museum, approximately 30 per cent were Chinese and a further 30 per cent were of an ethnic origin other than white/British. Other festivals held annually at the V&A, such as the mid-Autumn Festival, attract a higher percentage of Chinese. However the Chinese New Year has established a more universal appeal for both Chinese and non-Chinese.

What is the background and rationale for all this activity targeting both the South Asian community and Chinese UK-based communities? It seems the initiative was originally driven by curators in the Asia department at the V&A who, given the wealth of their collections, considered it an opportunity, or indeed a responsibility, to open up access to collections which they considered would be of relevance to the UK South Asian and Chinese communities. As far back as 1978 Robert Skelton, Senior Curator of Asia, in response to the growing significance and contribution of the Bangladeshi community in the East End, liaised with the Whitechapel Art Gallery to put on the *Arts of Bengal* exhibition. This was followed by initiatives from Deborah Swallow, Senior Curator of the South Asia Department, and Rose Kerr, Senior Curator of the Far Eastern Department, along with David Anderson, Head of Education, to procure funding for dedicated posts to work with South Asian and Chinese communities. The focus of these posts initially was to build new South Asian audiences in relation to the redevelopment of the Nehru Gallery of Indian Art, which opened in 1990, and Chinese audiences for the redevelopment of the T.T. Tsui Gallery of Chinese Art, which opened in 1991. These posts were funded initially by the Hamlyn Foundation for the South Asian post and the T. T. Tsui Fund for the Chinese post, but now are funded from the V&A's core budget. Mr Tsui, a Hong Kong-based businessman and a passionate collector who also funded the refurbishment of the gallery, was clear about one of his key motivations:

> One of Mr Tsui's overriding concerns has been that the Chinese community in Britain should have access to their history and artefacts from their culture. Critical to the achievement of this is the ability to read explanatory museum labelling, and therefore all promotional labelling and literature for the Tsui Gallery are in both English and Chinese
> (Ward and Lawrence, 1991).

The success of both the South Asian and Chinese programmes has largely been due to the imagination and commitment of previous postholders Shireen Akbar and Alice Wong and by the present postholders, Hajra Shaikh and Christine Chin. The scope of the posts has always been to work with the Chinese and the South Asian communities but also the wider community, encouraging all to learn about and engage with the South Asian and Far Eastern collections. Placed within the Learning and Interpretation Department, the support and active involvement of the Asian curators have been key to the programmes' success.

The questions posed by the V&A's approach to broadening access are wide-ranging and complex and of relevance to all museums, irrespective of the nature

of their collections. Have the initial assumptions about the connections between historical collections from Asia and the culture and interests of contemporary UK-based Asian communities been proved valid and sustainable over time? Has the situation changed over the last 27 years, particularly with regard to the younger generation, who might be thought to identify more readily with the diversity and complexity of multi-racial Britain, rather than the rich heritage of Mughal or Ming dynasties? What if there are no existing collections in the Museum of relevance to particular communities that we might wish to target, such as African Caribbean communities, who have been clearly under-represented amongst the V&A audiences? Should we not be developing programmes which encourage people to learn about each other's heritage rather than just their own and to explore commonalities and differences between cultures?

Furthermore, there are those that argue that audiences from black and Asian backgrounds may be as interested or indeed even more interested in European sculpture than in Indian miniatures, Chinese watercolours or African textiles and to do anything else is patronizing. Should we therefore throw out, or at least reconsider, the assumption that there is a necessary link between specific collections and specific communities which has been the rationale for much of the work at the V&A so far? Lastly, in opening up access and broadening audiences, what should be our starting point? Should it be our existing collections or those communities who do not presently engage with the Museum? How do we reconcile or bridge the two? If we step outside the constraints of existing collections in order to bring in new audiences will we then be criticized as 'dancing around the collections'?

All of these questions, views and attitudes have been expressed by colleagues internal or external to the V&A at varying times. I will attempt to explore and review these issues one by one, drawing on examples of programmes at the V&A over the last seven years.

Kindling Interest

How far are the historical Asian collections of interest to both young and old UK-based South Asian communities?

Target audiences for the exhibition, *The Arts of the Sikh Kingdoms*, were the Sikh community, other South Asian audiences and those with a special interest in the Indian subcontinent. In fact the exhibition, whilst very successful in attracting Sikh audiences, was not so successful in attracting other non-Sikh South Asian audiences. It did, however, attract both young and old Sikh audiences and those born in India, in the UK or elsewhere.

The Sikh gurdwaras were instrumental in bringing a large-cross section of ages to the museum, including many older people who could not access the English text. For this reason the V&A had produced a bilingual leaflet with an introduction to the exhibition and text panels in Punjabi. There were specific aspects of the programme in which young people became involved. There was a very active young Sikh student group, for example, who ran a Sikh help-desk on a voluntary basis throughout the

exhibition and who spoke about a resurgence of interest amongst UK-born Sikh youth in exploring and reclaiming their Sikh heritage. Enthusiastic, young male Sikh volunteers assisted the exhibition curator with some of the research in India, helped the Education Department plan the subsequent lecture series and then set up the UK Punjab Heritage Association to promote Sikh heritage, focusing particularly on the involvement of the young. Sikh teenagers gave demonstrations of gatka (martial arts) and bhangra (dance) and groups of Sikh scouts came to the Punjabi storytelling sessions. Neither age nor country of birth, therefore, were a barrier to enthusiasm for this exhibition drawing on historical Asian collections from around the world.

Time and time again the V&A has been successful in reaching specific communities through programmes linked to culturally specific collections. However, this success has usually been underpinned by active partnerships with and involvement of key organizations and individuals from communities. In the case of *The Arts of the Sikh Kingdoms*, Sikh organizations and individuals proposed the initial idea of the exhibition to celebrate the 300th anniversary of the birth of the khalsa (Sikh brotherhood), advised on collections and their display, contributed to the content of the education programme and played a key role in the outreach or marketing strategies for the exhibition. To illustrate the importance of such partnerships and ways of working it is perhaps useful to compare the South Asian Arts Course run within a traditional V&A format and the lecture series following the *Arts of the Sikh Kingdoms* exhibition, which was run in partnership with Sikh communities and individuals. South Asian Arts is a high-quality course which is planned internally, delivered by specialists in Asian art and taps into the general V&A publicity – What's On leaflets are placed within the museum and on the V&A website. It attracts a predominantly white middle-class audience.

In comparison, the lecture series *Sikh Art and Heritage* was planned in partnership with young members of the Sikh community and was part of a strategy to sustain the active involvement of Sikh organizations and individuals after the exhibition had ended. The young Sikhs took over more and more of the responsibility for both developing and running the programme supported by the South Asian Officer. They suggested themes, contacted speakers, helped draft the leaflet and market the programme. A conscious decision was made not to include the lecture series in V&A general publicity in case places became filled by a traditional V&A audience. Instead the leaflet was sent specifically to Sikh organizations and placed on Sikh websites. All sessions attracted an almost completely Sikh audience and were quickly booked up. In fact the series was so popular that the newly formed UK Punjab Heritage Association organized a second series and then successfully applied to the Heritage Lottery Fund for support to run the series in the regions.

Creating Relevance without Material Collections

What about where there are no collections of relevance to a particular culture or community?

It was thought until quite recently that there were no V&A collections of relevance to the African diaspora. This was and still is considered the remit of those museums who have a collection of ethnography, such as the British Museum or the Horniman Museum. From soon after its inception in the mid-nineteenth century, the V&A has collected objects from Islamic North Africa but art from sub-Saharan Africa was 'misunderstood and often contemptuously dismissed by Europeans' (Winch, 2005). This lack of objects of relevance to the African diaspora does not go unnoticed in today's multi-racial Britain. One visitor in 2003 commented: 'I walked around but could not find an African section as a continent whether north, east, west or south of the continent for fairness in arts'.

The fact that there are no specific collections or dedicated gallery in relation to the African diaspora at the V&A has consciously or unconsciously, until recently, been a reason for not developing programmes which targeted the black British African Caribbean communities. This was despite the fact that Mori polls consistently showed black British African communities were an almost invisible percentage of V&A visitors – less than one per cent.

Having previously worked in Hackney, where over 25 per cent of the population and over 40 per cent of schoolchildren are of black British African Caribbean origin, I found the lack of black visitors to the V&A disconcerting. Nor did the lack of an African or Caribbean gallery presence in the national museum of art and design seem to be a justifiable reason for ignoring this specific community or heritage. One aspect of an HLF-funded initiative, *Cultural Diversity and the V&A* (2000–02) therefore, was to explore ways of working with audiences, and in particular black British African Caribbean communities, where there was no specific gallery or collection. There were three inter-related aspects to the initiative. One was to research objects in the V&A of relevance to the African diaspora, the second was to consult both with black British audiences and artists and the third was to develop programmes targeted at black British audiences, testing out the relationship between culturally specific collections and communities where there is no permanent related gallery presence. This initiative was both developed and taken forward almost organically by individuals from across departments – Collections, Contemporary, and Access and Social Inclusion – who were keen to research and develop collections of relevance to the African diaspora and open up the collections to black British communities.

Much to the surprise of many people in the Museum, the initial research by V&A curators Dinah Winch and Mary Guyatt uncovered approximately 3,000 objects of relevance to the African diaspora, including textiles, prints, ceramics, jewellery, silver and sculpture, spanning several centuries. An early example is a beautiful bust of a black woman made in Italy in the sixteenth century in the sculpture collections. More contemporary examples collected by curators Rosie Miles and Mark Haworth-Booth in the department of Prints, Drawings, Paintings and Photographs include works by black artists and photographers such as Lubaina Himid, Chris Ofili, Ingrid Pollard and Maud Sulter. Although the case for collecting these works was that they represented a significant constituency within the British population and that they related in other ways to the historic collections, and British history, persuading other

curators of this significance could be difficult as the necessity for such representation was not perceived across the museum as a whole. Such works were acquired by interested and committed individual curators, mostly in the Photographs and Prints Departments, and the Textiles and Dress Collections. It was by no means an overall V&A policy. As Rosie Miles (Curator of the Word and Image exhibition) recounts:

> Towards the end of the 1980s if I hadn't fully grasped that there was a pretty well developed Black Artists Movement, I had grasped that there was a whole strata of society out there that wasn't being represented in the V&A. I have to confess it was the issue and visibility that pre-occupied me most. I think my Head of Department thought I was a little odd, but she did support me very admirably. I sometimes didn't put forward proposals for fear of being thought obsessed, but with hindsight I can see she was very generous with her support. Every object acquired had to be justified, whoever the artist was, but if you could give a satisfactory reason for acquiring the work and the funds were available you could get it. This was for example how we managed to buy Chris Ofili while he was still a student.

This begs the serious question as to how far collecting of relevance to diverse communities should be left to the individual commitment of curators rather than enshrined within a Museum-wide collections policy.

One particular object illustrates why some of the African diaspora objects have been 'hidden' within the V&A for so long. *Portrait of Francis Williams*, a picture of a free Jamaican poet painted in about 1745, was acquired by the V&A in 1928 because of 'its peculiar value from the point of view of the furniture and other details shown in it, quite apart from the striking story connected with the individual whom it represents'. It hung in the English furniture galleries until it was included in a re-display of eighteenth-century portraiture in the British Galleries, along with a contemporary response to the picture by the poet, Benjamin Zephaniah.

The V&A has tried to overcome some of the limitations of not having a dedicated gallery by putting on small temporary displays of objects related to the African diaspora. The earliest perhaps was the 1993 African Themes, staged by the Prints and Drawings and Photographs Collections as part of their recent acquisitions series. Two years later the same Collections staged a display highlighting their work by artists of African descent, to coincide with the Africa95 festival. In 1996/7 Hogarth after Hogarth included work by Nineteenth and Twentieth century white artists Cruikshank, Frith and Hockney, but also by Lubaina Himid and Tony Phillips. In 2000 The newly launched Contemporay Programme invited Hew Locke and Yinka Shonibare to show in the Main Entrance. Two small displays for Black History Month went up in 2001: one which focused on the representation of black people in European decorative art, the other on work by twentieth-century artists. Rosie Miles, the curator who organized this contemporary display, explores some of the problematic issues surrounding maginalization and pigeonholing of the work of artist from diverse backgrounds, issues that came very much to the fore when the V&A ran a specific focus group with 'black' artists. She said:

We did show Su Stockwell in 2001, but I don't think of her as a 'black' artist. Rather she exemplifies the hybridity of art and artists that is so much of the contemporary art scene, but her work does deal very much with issues of post and neo-colonialism. I was sorry that we had to show her work in Black History Month, but I doubt that at that time we would have been able to show it at any other time of the year. It was Carol Tulloch (curator of Black British Style) who brought her up as a possibility at one of our early meetings and I thought her work was fantastic but at that stage I hadn't met her and didn't know what 'colour' she was – or wasn't!

In 2002 the V&A developed a Museum-wide black history trail which pinpointed collections across the Museum and which included contemporary responses to the objects from artists and others from diverse backgrounds. This again was available during Black History Month.

Alongside these collections-based initiatives, the V&A has developed a range of programmes which have been successful in attracting black audiences. These have included:

- Annual Carnival events with displays, lectures, films, performances, workshops and a procession involving up to 20 Notting Hill Carnival bands;
- *Day of Record: Black British Hairstyles and Nail Art* (2001) with lectures, demonstrations and photo shoots of black hairstyle and nail art of participants for the V&A archives;
- Black History Month, covering a wide range of activities from an illustrated talk by photographers Francis Armet and Neil Kenlock, *Photojournalism on the Front Line,* to a performance by Hackney schoolchildren, *Malcolm X at Mecca,* in the Islamic Gallery;
- *Cultural Revolution in Harlem and Paris,* a day of events alongside the temporary exhibition, *Art Deco*;
- *Black British Style* (autumn 2004) a contemporary exhibition curated by Shaun Cole and Carol Tulloch for the Contemporary Team of the V&A. The exhibition was accompanied by a wide range of events organized by Jonah Albert, Cultural Diversity Officer (African Caribbean) employed on a temporary basis to develop a programme alongside the exhibition.

People from all backgrounds and ages participated in break-dancing, hip hop, graffiti and African head-wrapping demonstrations and workshops. Mental health service users wrote and performed poetry on their take on personal style and fashion. Pensioners reminisced on *Dressing for a Night Out* in the 1950s and 1960s and then danced to the music of country and western, quadrille, reggae and old-time soul traditions in the luxurious surroundings of the Gamble Room of the V&A. For others there were a series of informal talks such as *Changing Fashion in Black Majority Churches* or *Black Dress in the V&A's Collections*. For the more academic there was a two-day conference with a range of speakers including some from the US. Approximately 50 per cent of people visiting the exhibition were black African Caribbean or mixed race and of the 8,000-plus people who attended the education

events, 47 per cent were black or black British or mixed race (white/black African/ Caribbean).

The programme of events alongside *Black British Style* clearly related to the content of the exhibition, focusing on the major themes of clothes for worship, clothes for clubbing and dressing up, and clothes as protest. Another strand was the impact on dress of the first post-war Caribbean settlers who arrived in Britain on the *Empire Windrush* in 1948: the resulting black British communities produced distinctive styles in clothing, which were reviewed in historical context. Similarly, the day's events to celebrate the achievements of the Harlem Renaissance clearly established links with the Art Deco movement and the related exhibition. The relationship between other programmes and V&A collections or exhibitions has not always been so clear cut. Talks on the *West Indian Living Room* by cultural historian Michael McMillan and on *Photography of the Front Line* by photographers Armet Francis and Neil Kenlock are all themes which can broadly fit within the broad remit of art and design, although the events did not draw on any V&A collections.

Carnival, it is argued, is a street artform, and many of the programmes and displays have focused on the art and design aspect of Carnival and even, on occasion, been related to the V&A collections. But what about cake decorating, which was an event organized for Black History Month 2002? Surely the link with the V&A collections is too tenuous and certainly even supportive curators raised their eyebrows at this proposed programme. And yet cake decorating, as I knew from my experience of working in Hackney, is one of the most popular craft forms among Caribbean women attending adult education classes in boroughs such as Hackney and Lambeth, with many courses being heavily over-subscribed. Certainly the cake decorating initiative at the V&A, developed in partnership with Lambeth libraries for Black History Month 2002, did in fact achieve its primary aim of attracting black working-class women who had not previously visited the Museum. Is there not an argument, therefore, for starting with the interests and enthusiasms of the target group and linking this back into the remit and collections of the Museum, no matter how tenuously?

The success of bringing in more black visitors to specific events and exhibitions has highlighted the lack of a significance presence or reference to black heritage in the Museum: 'I think at this museum they should have a lot more things about black people and slavery' (V&A Black History Month evaluation, 2003).

Do such responses mean we should actively start to research the V&A African diaspora objects in more depth, include the acquisition of both historical and contemporary African diaspora objects into our collecting policy and practice and develop a related gallery of the scale of the Nehru Gallery of Indian Art or the T.T. Tsui Gallery of Chinese Art? The V&A is progressing cautiously – we have secured finance to carry out more in-depth research into the African diaspora collections and to develop online resources and related programmes, including the commemoration of the 200th anniversary of the parliamentary abolition of slavery in Britain. There are no plans agreed as yet to actively collect objects of relevance to the African diaspora or to develop a dedicated gallery, although both are presently being discussed within the context of the V&A's Access, Inclusion and Diversity Implementation Plan.

Inter-cultural Interest

Should we not be developing programmes which encourage people to learn about each other's heritage and to explore commonalities and differences between cultures?

Many of the programmes developed to bring in South Asian, Chinese and African Caribbean communities to the V&A attract other audiences. Chinese New Year, Diwali and Carnival are popular with, and accessible to, families from all backgrounds. The V&A has sometimes gone beyond this, however, in the development of programmes whose primary aim is to encourage people to learn about commonalities and differences between cultures.

The inspiration for one such project came from the response of some Sikh visitors to *The Arts of the Sikh Kingdoms* who expressed concern about the lack of emphasis on the Sikh religion and in particular on the significance of the gurus. One visitor expressed it thus: 'The Sikh exhibition was good but we thought a lot more to do with Sikhs could have been on show – paintings of our gurus'.

For the curators this was an exhibition on art, for many members of the Sikh community the distinction was not so clear. In response to this feedback and with the specific intention of sustaining our work with the Sikh community but also wanting to broaden access to other communities, we developed a community-based photography exhibition where diverse faith groups were encouraged to take photographs of sacred spaces within their communities inspired by, or connected to, the sacred objects within the V&A. Coordinated by Marilyn Greene, Project Support Officer at the V&A, the programme involved Sikhs, Buddhists, Jains, Christians, Hindus, Muslims and Jews. The resulting photography display, which showed the links between the V&A's historical objects and objects of religious and everyday significance to diverse faiths, was shown in temples, churches, chapels, schools, museums and prisons up and down the country. Whilst some in the V&A may play down the religious significance of its objects, for others this is a definite hook. The intercultural, interfaith dimension of this programme also captured the imagination and interest of people outside the V&A, concerned to use it as a tool to increase understanding between communities. Participating faith and other organizations were keen for programmes that focused on increasing knowledge, not only of their own faith and culture but also in establishing links with others. Creative engagement was crucial to the success of the programme and to the development of mutual understanding.

Another project with a specific aim of bridging cultures was the World in the East End Gallery at the Museum of Childhood in Bethnal Green which is part of the V&A Museum. Supported by Teresa Hareduke, Community Development Worker at the Museum of Childhood, we trained people from diverse communities – Somali, Bangladeshi, Travellers, Chinese, Vietnamese, East European Jewish and white East End – to collect life stories, objects and photographs which reflected diverse childhoods. This material is now accessible within the Gallery around the unifying themes of travel, rites of passage, festivals and celebrations, play, leisure and work. There are video films of young children travelling across war-torn Rwanda and

transcripts of all communities experiencing poverty and discrimination as well as murals depicting playground rhymes in the many different languages spoken in the East End. The material is regularly used as the basis of art and community projects with diverse audiences from the East End.

Focusing Interest

Should we not start from the premise that audiences from diverse backgrounds may be as interested or indeed even more interested in European sculpture than in Indian miniatures, Chinese watercolours or African textiles?

The focus group with black artists expressed reservations about an approach which focused exclusively on Black History Month, or indeed black heritage, fearing that this reinforced marginalization (although the V&A's Black History Month programmes have been very successful in bringing in a broad cross-section of the black community). For this reason we developed a series of critical debates, *Beyond Identity*, which involved discussions about contemporary practice of artists from very diverse backgrounds. There have been other programmes which have not focused specifically on black heritage but have brought in black audiences. The temporary exhibition on the fashion designer, Versace, is one example which we specifically marketed to the black community. Another is a recent partnership project developed by Laura Elliott, the Social Inclusion Officer with East Potential, which works with young people at risk of homelessness in East London. The young people, mainly female and black, created fashion designs inspired by the V&A collections. After eight months they put on a professional, well-choreographed fashion show which attracted mainly black families, friends and young people from across London. The fashions were influenced by crinolines, Westwood and other top designers but they also integrated such influences with their own street style and African roots.

Beyond the Culturally Specific

Should we therefore throw out or at least reconsider the assumption that there is a necessary link between specific collections and specific communities, which has been the rationale for much of the work at the V&A so far?

The experience of the V&A has shown that culturally specific collections, related temporary exhibitions and targeted programmes can be very successful in bringing in specific communities. This has serious implications for what we collect, how we classify and display objects and how we address gaps in our collections. The African diaspora project at the V&A underlines the need to review, research and display our 'hidden' collections in light of the communities we serve. The *World in the East End* project is an example of involving and drawing on the skills and experience of communities themselves to develop our collections to more closely reflect the heritage of diverse communities.

Sole reliance on this approach is limiting however. In an ever-changing multi-racial community nothing is static. The interests, experiences and motivations within and between communities are multi-faceted. They can be governed by class, education, gender, age, country of birth, residency, as well as a multitude of other factors. We need to be able to create opportunities for people to engage with our existing collections on a multitude of levels and to explore links between the collections and different aspect of their own or other people's lives, exploring commonalities and differences between communities where appropriate.

In the Future

Lastly, in opening up access and broadening audiences what should be our starting point?

Should it be our existing collections or those communities who do not presently engage with the Museum? How do we reconcile or bridge the two? If we step outside the constraints of existing collections in order to bring in new audiences will we then be criticized as 'dancing around the collections?' Some programmes run by the Chinese Education Officer specifically for the Chinese community, like the annual chess competition or the dance festival for UK Federation of Chinese schools, are only loosely related to the collections. However, both Chinese Community and Education Officers have countered these criticisms by arguing that they place the V&A in the minds of the Chinese community and help attract new audiences who would not otherwise come.

Should the starting point be the communities and their engagement with the museum, rather than always focusing on the collections? This has certainly been the case with much of the work with the black British African community at the V&A and with communities of diverse backgrounds at the Museum of Childhood. Sometimes the collections might be the starting point, sometimes diverse communities might be the starting point and sometimes the two will intertwine and be closely inter-related. If this is dancing around the collections then let's dance.

References

ACE (Arts Council England) (2004), *Spotlight on Diversity: Decibel Projects in the NE*, London: ACE.

ACE (Arts Council England) (2003), 'Focus on Cultural Diversity – The Changing Face of Arts Attendance and Participation in England', <www.artscouncil.org.uk>.

Bourdillon, H. (1994), *Teaching History*, London: Routledge.

Dodd, J. and Sandell, R. (eds) (2001), *Including Museums: Perspectives on Museums, Galleries and Social Inclusion*, Leicester: RCMG.

Dodd, J. and Sandell, R. (1998), *Building Bridges: Guidance for Museums and Galleries on Developing New Audiences*, London: MGC.

Greater London Authority, The Mayor's Commission on African and Asian Heritage (2005), *Delivering Shared Heritage*, London: GLA.

Greater London Authority (2004), *The Mayor's Cultural Strategy – London: Cultural Capital – Realising the potential of a world-class city*, London: GLA.

Greene, M. (2003), 'Sacred Spaces', 'Museer for Alle', *Museumformidlere* [Denmark], issue 9, September.

Hall, S. (1997), *Representation: Cultural Representations and Signifying Practices*, London: Sage Publications.

Helen Denniston Associates (2003), *Holding up the Mirror: Addressing Cultural Diversity in London's Museums (A report by HDA for the LMA)*, London: London Museums Agency 2003.

Hooper-Greenhill, E. (2000), *Museums and the Interpretation of Visual Culture*, London: Routledge.

Hooper-Greenhill, E. (ed.) (1997), *Cultural Diversity: Developing Museum Audiences in Britain*, London: Leicester University Press.

Karp, I. and Levine, S. (1991), *Exhibiting Cultures: The Poetics and Politics of Museum Display*, Washington DC: Smithsonian Institution.

Khan, N. (ed.) (2006), *Connections Disconnections – Museums, Cultural Heritage and Diverse Cultures*, proceedings from a conference at the V&A, 22 June 2002, London: V&A.

Littler, N. (2005), *The Politics of Heritage: The Legacies of Race*, London: Routledge.

Macdonald, S.J. (2003), 'Museums, National, Postnational and Transcultural Identities', *Museum and Society* 1: 1, 1–16.

Nightingale, E. and Swallow, D. (2003), 'The Arts of the Sikh Kingdoms: Collaborating with a Community', in L. Peers and A. Brown (eds) (2003).

Peers, L. and Brown, A. (eds) (2003), *Museums and Source Communities*, London: Routledge.

Runnymede Trust (2000), *The Parekh Report: The Future of Multi-Ethnic Britain*, London: Profile Books. Also online at <www.runnymedetrust.org.uk>.

Sandell, R. (ed.) (2002), *Museums, Society, Inequality*, London: Routledge.

Simpson, M.G. (1996), *Making Representations: Museums in the Post-Colonial Era*, London: Routledge. (Second ed. 2001.)

Tulloch, C. (ed.) (2004), *Black Style: Origins, Evolution and Politics*, London: V&A.

V&A (Victoria and Albert Museum) (2003), 'Access, Inclusion and Diversity Strategy at the V&A', at <www.vam.ac.uk>.

Visram, R. (1994), 'British History: Whose History? Black Perspectives on British History', in H. Bourdillon (1994).

Walker, S. (1997), 'Black Cultural Museums in Britain: What Questions Do They Answer?', in E. Hooper-Greenhill (ed.) (1997)

Ward, A. and Lawrence, J. (1991), 'The T.T. Tsui Gallery of Chinese Art', in *Orientations*, July [Hong Kong].

Winch, D. (2005), 'Hidden Histories: Black History in the V&A', in N. Khan (ed.) (2006).

Websites

For information about Sikhs and the arts of the Punjab, see <www.vam.ac.uk/ vastatics/microsites/1162_sikhs>

Response to Chapter 6

Developing the Inclusive Model

Izzy Mohammed

The increasingly complex social and cultural environments within which many museums are situated present an array of difficult but necessary challenges. Unfolding events in our immediate contemporary world have prompted debates about the nature of our society and its constituent groups – about diversity itself. However, whilst there appears to be an appreciation of the need to engage with this diversity, there seem to be few genuinely progressive interventions necessary for meaningful cross-cultural understanding and participation. The Victoria & Albert's (V&A) work with Sikh and other communities, and its efforts to examine how best to engage communities/cultures underrepresented in existing collections demonstrates some of the challenges facing museums today.

The example of work with the Sikh community demonstrates the V&A's conviction to engage communities. This chapter also draws attention to the challenge for the V&A of developing cross-cultural understanding. The exhibition, *Arts of the Sikh Kingdoms*, achieved success in terms of drawing in a particular group – namely the Sikh community – but also groups

already reflected within the visitor profile. However, the existing model of working has generally tended to approach exhibition programming from a mono-cultural perspective. That is to say, exhibition ideas tend to be developed in terms of the representation of a single culture, history or heritage. Within the context of non-represented minority groups this is an alienating practice. In order to engage a broader cross-section of South Asian communities, such an exhibition would need to be able to reflect the range of cultures, heritages and histories these communities also represent. The challenge therefore is to devise a model of practice that is more broadly inclusive and that need not be determined by existing collections.

Chapter 6 has drawn attention to projects that in some part exemplify newer ways of thinking and working (*The World in the East End* project, programmes dedicated to attracting black African Caribbean audiences, and the 'multi-faith photography project') and whilst these appear to be either a little tentative or not broadly inclusive enough they do indicate a gradual learning curve for the Museum. What is required is a robust model of

practice whose underlying principle is to promote cross-cultural understanding through cross-cultural participation. This objective is achievable by considering, in an integrated way, multiple cultures, histories, identities and experiences.

Clear Principles for Future Action

- Given the difficult challenges we face, museums need to adopt a more advanced social role where cross-cultural understanding and participation need to be viewed as fundamental objectives.
- Any exhibition comparing and contrasting a number of cultures – or further still, drawing on common traits, experiences and shared histories – could overcome the wider feeling of 'alienation' engendered when focusing on a single culture or community.
- There must be the 'political will' from within the museum institution in order to validate the newer agendas, otherwise projects will remain tentative, small-scale and tokenistic in appearance.
- This process of engagement would offer a unique chance to develop a forum for cross-community dialogue, with the institution well positioned to develop a body of knowledge reflecting diversity.

References

Birmingham City Archives, Black Pasts and Birmingham Futures, and HLF, 'Connecting Histories', online at <www.birmingham.gov.uk/GenerateContent?CONTENT_ITEM_ID=58944&CONTENT_ITEM_TYPE=0&MENU_ID=10468>.

JCORE, Jewish Forum, Parkes Institute for the Study of Jewish/Non-Jewish Relations at Southampton University, 'Connections Exhibition', online at <www.connections-exhibition.org/index.php?xml=the_project/_/partnerssponsors.xml>.

Manchester Museums, 'Community Advisory Panel' (CAP), online at <http://museum.man.ac.uk/communities/communities.htm>.

Chapter 7

Museums and the Web

Caroline Dunmore

Introduction

The emergence and rise of the Internet and the World Wide Web have been phenomenal. Methods of communicating and publishing information that we had barely heard of a mere ten years ago are now an integral part of our everyday lives. Any organization that has an audience with which it wants to communicate cannot afford to ignore these extraordinarily powerful tools. But, given that museums are all about giving the visitor an experience of the authentic object, to what extent can web-based content play a role in the relationship between the museum and the visitor? The purpose of this chapter is to review what the museum sector has achieved over the past few years in the use of new technologies, and to identify some lessons that can be learned to inform future policy and practice.

An Agenda for Action

In June 1999 the National Museums Directors' Conference (NMDC) published a paper entitled *A Netful of Jewels: New Museums in the Learning Age*. It was an advocacy exercise on the subject of the role of technology in the museum sector, and aimed to define priorities and help establish a framework for policy development. As well as giving cogent arguments for the vital importance of embracing the possibilities offered by new technology, with illustrations of what museums had achieved so far, the paper proposed an agenda for action. There were action points for government, the education sector, the museum sector, local authorities and the private sector. It is significant that this paper emphasized that in the context of technology the museum sector does not and cannot exist in isolation and that any meaningful strategy must take this into account.

Of the range of actions proposed by *A Netful of Jewels*, the following are the ones that are relevant to the present discussion:

- for government, to develop a strategy for a comprehensive national cultural network, and to provide coherent and ongoing funding;
- for the museum sector, to develop a deeper understanding of museums' role in learning, to develop coordinated strategies for creating digital content, and

The Responsive Museum

to provide training for creating and using digital content;
- for the education sector, to establish policies to use the special contribution that museums can make to the national curriculum and lifelong learning, and to work with museums to develop their potential for supplying digital content.

It is noteworthy that the first action for the museum sector and the first action for the education sector are complementary to each other, speaking of a greater collaboration between those two sectors. Also, they both apply to the museum sector's role in education and learning in the wider context, and not just to the use of digital learning resources.

A Netful of Jewels also set some quantifiable targets for what should have been achieved by 2002. One was that all Registered museums should have a website linked to the National Grid for Learning (the Registration Scheme has now been renamed the Accreditation Scheme), and there were other measures of success including percentage of museums having some collections information online, percentage of schoolchildren having used online resources as part of the curriculum, and so on.

When I interviewed Keith Nichol, Head of Museums Education at the Department for Culture, Media and Sport (DCMS) in June 2005, he agreed that government had not yet succeeded in developing a strategy for a comprehensive national cultural network or providing a coherent and ongoing source of funding. He pointed out, however, that the 'short-term-ism' in funding that museums often complain of is an inevitable consequence of the short time-frames to which politicians generally work. In addition he made the following observations. The museum sector needs to become more fluent in speaking the language of funders; it is crucial for museum professionals to understand where funding is available and how to get at it. The Renaissance funding stream is absolutely vital for the sector, of course, but Renaissance money should not be spent where funding is available from other sources; for example, museums need to understand the importance of working with the Learning and Skills Councils.

It is a fact of life in the public sector that the Treasury has to be given evidence of value for money, so the museum sector needs to be able to say something like 'x per cent of schoolchildren have received museum-related curriculum support'. One of the performance indicators that museums are given is numbers of schoolchildren that visit, and so a lot of museums concentrate on getting the numbers in; but with programmes for vulnerable and hard-to-reach audiences, while the unit cost may increase the overall impact also increases. DCMS does need to ensure that its actions are aligned with its rhetoric and it is rewarding the results it wants to see. Information and communication technology (ICT) is certainly vital in the context of museums education, and it is important that museums contribute to Curriculum Online. There has been a lack of consistency in DCMS's involvement with ICT in the past but the importance of DCMS working together with the Department for Education and Skills (DfES) is certainly recognized now. At the time of the interview, Nichol was working on a museums education strategy with DfES. He believes that good strategy

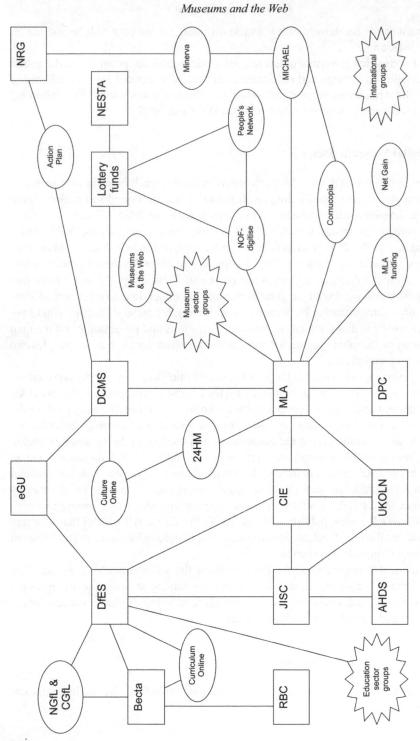

Figure 7.1 The digital museum sector

work must focus on deliverability, and knows that his success will be judged on implementation.

So it seems that government has not yet made significant progress on the action points relating to strategy and investment that NMDC proposed for it in *A Netful of Jewels*. But what about the museum sector and the education sector? The following sections will review progress made between 1999 and 2005.

The Digital Museum Sector

This sector comprises a host of organizations, related to each other in various ways, and a complex network of funding streams and programmes and so on. See Figure 7.1 for a diagrammatic representation of how it looks in 2005. Observe that there are three major groupings: the DCMS–MLA axis, which is central; the DfES–JISC–Becta axis; and the European axis. (As can be seen in the key, MLA = Museums, Libraries and Archives Council, JISC = Joint Information Systems Committee and Becta = British Educational Communications and Technology Agency.) Note that MLA is the component with the greatest number of connections to other components on the map, demonstrating its pivotal role in the digital museum sector. What may seem surprising is that there are so many organizations and programmes on the map that belong to the education sector and not the museum sector, but this is a feature that is highly significant.

The government has invested huge sums in providing kit, connectivity and content. Taxpayers' money paid for the National Grid for Learning, a programme that provided ICT equipment and internet connections for schools. And lottery funding paid for the People's Network, NOF-digitise and the Community Grids for Learning – programmes that provided equipment, Internet connections and content in the community sector. The figures are put at an investment of more than £1 billion in ICT for schools and an investment of £900 million in lifelong learning initiatives. It is vital to understand that the future of the museum sector's use of digital learning resources must be inextricably bound up with the DfES e-strategy (*Harnessing Technology: Transforming Learning and Children's Services*, published March 2005), because it is the DfES that is setting the agenda for the use of technology in education and lifelong learning, and the museum sector must fit in with that agenda.

In the next three sections, we shall examine the achievements of the first few years of the twenty-first century: five initiatives arising at policy level, and then the progress that individual museums have made in using digital resources for the enjoyment and education of their audiences.

Major Developments at the Turn of the Century

This section examines five major developments affecting the digital museum sector:

- the DfES strategy to embed ICT in schools education
- a lottery-funded scheme to develop learning resources for public library users
- the DCMS flagship online programme
- a marketing website for museums and heritage sites
- MLA initiatives to facilitate users' access to online cultural resources.

National Grid for Learning and Curriculum Online

The name 'National Grid for Learning' (NGfL) was based on the idea of the national power grid and was coined to describe a learning utility that people could switch on and off at will. The term originally referred to the government's entire ICT strategy for education and lifelong learning, first outlined in November 1998. It later came to refer to just the schools strand of the strategy, the purpose of which was to provide Internet connectivity and access to online learning resources for all schools in the country. The NGfL website (<www.ngfl.gov.uk>) is a portal to educational resources available on the web that have been quality-assured by Becta.

Curriculum Online is a separate part of the strategy for ICT in schools, officially launched in December 2001. Some observers believe that Curriculum Online was really created to help prop up the UK software development industry after the dot-com collapse, and that it betrays the government's preference for schools content to be developed by the private sector. The Curriculum Online website (<www.curriculumonline.gov.uk>) does offer some free resources as well as resources that schools can buy with their 'e-learning credits', but it is essentially a channel for selling products offered by commercial developers. There is a significant reluctance within the museum sector to get involved, as the procedures are perceived as overly bureaucratic (although MLA has been working to improve this) and there is scepticism about how effective Curriculum Online is in leading users to museum content. MLA argues that it is vital that museums take the long-term view and get involved with Curriculum Online now.

NOF-digitise

The New Opportunities Fund (NOF) digitization programme, which ran from April 2000 to March 2004, was a scheme to create a critical mass of digital learning resources, primarily for the use of adult learners in public libraries. It was part of the People's Network programme, the purpose of which was to create learning centres in public libraries by equipping them with ICT kit and Internet connections and by training staff in how to use the equipment. Nearly 500 public-sector organizations contributed content, which was designed to support learning other than that related to the national curriculum. One hundred and fifty individual websites were developed, and a single portal for them (<www.enrichuk.net>) was launched in March 2003.

The programme, which is generally known as NOF-digitise or EnrichUK, was paid for by £50 million of lottery funding.

Much of the huge amount of digital content that was developed is of high quality, although some of it is not very sophisticated from the point of view of the user's learning experience. The UK Office for Library Networking (UKOLN) and the Arts and Humanities Data Service (AHDS) provided support during the course of the programme and developed technical standards for the projects, the *Good Practice Guide for Developers of Cultural Heritage Web Services*, which now forms part of the EU Minerva project. Becta produced brief guidelines regarding online pedagogy but it is generally acknowledged that they were delivered too late. Apart from the EnrichUK portal, the contributing organizations are responsible for marketing their own websites, and some of them have seen a high take-up, particularly the family history projects. The Big Lottery Fund (under which NOF is now subsumed) has engaged a consultancy to carry out a two-year evaluation programme of the projects and the process, which is due to be completed in 2006.

Culture Online

The purpose of Culture Online (<www.cultureonline.gov.uk>), announced by DCMS in September 2000, is to develop interactive online projects that will engage new audiences not traditionally interested in arts and culture and encourage them to participate. Projects cover both the school curriculum and adult learning, and can come from any part of the cultural sector. Culture Online was awarded £13 million to develop 20 to 30 projects during 2002–04, and an additional £3 million to develop a further ten projects during 2005–06. It is interactivity that is emphasized in Culture Online projects, and in some cases there is not actually very much new digitization of content. The aim has been to develop projects that have quite local remits and that can act as exemplars and be rolled out in other regions.

Rather than making funding agreements with institutions, as is usual with funding streams like this, Culture Online issues contracts as in a commissioning process. Many members of the Culture Online team have been recruited from a broadcasting background and a significant aspect of their approach is that projects are tailored for segmented audiences, like television programmes. No doubt the cultural industry does have a lot to learn from the media industry with regard to the production of digital resources, but there is a feeling among many museum professionals that Culture Online, the DCMS's flagship online programme, has relied too heavily on the media-industry model. It is generally acknowledged that there have been some difficulties in the working relationships, and perhaps this is to be expected when cultural institutions are asked to work in a way they are not accustomed to.

The NOF-digitise programme definitely resulted in a set of supply-led products, with institutions thinking first about what they had that could be digitized, rather than thinking about what audiences they wanted to attract. In contrast, the Culture Online programme has certainly tipped the balance in the other direction by taking a strongly

audience-led approach, although there is in fact no clear evidence of the projects being developed in the light of any overarching audience research. It is surely the proper role of DCMS to invest in the digital cultural sector at the strategic level, and to invest taxpayers' money in activities that will contribute directly to the development of a comprehensive national cultural network. It will be interesting, therefore, to see whether evaluation shows the Culture Online programme to have constituted good value for money for the digital cultural sector's users and non-users.

The 24-Hour Museum

The 24-Hour Museum (or 24HM) (<www.24hourmuseum.org.uk>) is essentially a marketing website for publicly funded museums. Whereas NOF-digitise and Culture Online are both about creating and making available digital resources as an end in themselves, the main purpose of the 24HM, which was set up before NOF-digitise and Culture Online, is to use the Web to encourage people to visit actual museums, galleries and other heritage attractions. The 24HM receives DCMS funding via MLA and top-up MLA funding, along with project funding from a variety of sources. The core funding all goes on staffing; there is no marketing budget but, despite this, the website gets about 200,000 unique visitors per month, making it one of the most visited UK cultural websites.

The editorial content is what sets the 24HM apart from other cultural listings sites. With professional journalists on the staff, the 24HM offers daily arts and museum news stories and exhibition reviews, as well as the more usual venue and events listings, which they describe as 'curating an experience' for the visitor. The 24HM has also developed a free newsfeed service to make its news stories available to other sites. Its searchable database of cultural institutions has a direct data entry function, which means that staff at the institutions can maintain their visitor information themselves. The *City Heritage Guides* were commissioned by Culture Online and present news stories, venue and events information and so on. There is currently one for each of the nine regions of England, with more in the pipeline; and a facility called Storymaker, which enables visitors to write and submit their own stories about their locality. The award-winning children's section, 'Show Me', offers a rich selection of online learning resources designed for children.

Anecdotal evidence indicates that the 24HM is highly regarded in the museum sector. It is important to ensure that DCMS, MLA and the 24HM work together effectively, because the successful 24HM brand could be a vital ingredient in the work the sector needs to do to exploit the benefits that new technology can offer.

The Knowledge Web

In 2004 MLA published a five-year vision statement entitled *Investing in Knowledge*, and the Knowledge Web is one strand of this vision. As discussed earlier, the government invested around £2 billion in embedding ICT in education and lifelong

learning during the period 1999–2005. What MLA is aiming to achieve with its Knowledge Web concept is to maximize the benefit of the investment that has already been made in the provision of Internet access and the creation of digital cultural content by enhancing the public's ability to access the content they want and need. The main components of the Knowledge Web are Cornucopia, MICHAEL and the People's Network Discover Service.

Cornucopia (<www.cornucopia.org.uk>) is an online database of collections held in UK cultural institutions. It holds records for about 6,000 collections held in about 2,000 institutions, using standards for collection-level descriptions developed by UKOLN. It also employs 'web services' technology, which means that external applications can run searches on its contents.

Whereas Cornucopia holds information about physical collections, MICHAEL, the Multilingual Inventory of Cultural Heritage in Europe (<www.michael-culture. org>) is an online database of digital cultural resources. The project is funded by the European Commission and runs from June 2004 to May 2007. The countries involved in the first phase are the UK, France and Italy, with eight other European countries interested in joining the project later. The aim is for each participating country to produce a comprehensive national inventory of digital cultural content. Both material published on the Web (covering the full range from simple online catalogues to rich e-learning resources) and off-line material such as CD-ROMs will be included.

As mentioned earlier, the People's Network (<www.peoplesnetwork.gov.uk>) is a lottery-funded programme, managed by MLA, whose first phase provided all public libraries with ICT equipment and broadband connections. The second phase of the programme is to deliver three online services: Enquire, Discover and Read. The purpose of the Discover Service (PNDS) is to provide access to online resources under five main groupings, of which cultural content is one. It is a facility that works like a search engine, but with technology that allows users to find information from a range and depth of sources not previously available from a single point. Whereas Cornucopia and MICHAEL hold only collection-level information, the PNDS provides access to both collection-level information and object-level information by permitting remote searches of cultural websites and their underlying databases. To enable this to happen, participating institutions make their digital content available to the PNDS according to certain technical standards. For the launch in October 2005, the PNDS is working with about a dozen cultural institutions whose content will be 'surfaceable' by the service.

All institutions in receipt of grants from Renaissance and the Designation Challenge Fund are also obliged by their funding agreements to create their digital content according to the PNDS standards and they will be included in due course. There will be a PNDS-branded website that will serve as an entry point for users to access cultural content, but this is not the main purpose of the PNDS. Rather, it is about enabling cultural institutions to create their digital content and make it available according to certain standards so that it can be easily accessed by users. The aim is to promote multiple points of access, so that a user could start on the

24HM website, or the BBC website, or an individual museum's website and from that starting point access content from many cultural institutions.

Digitization Projects in Regional Museums

An examination of a large number of museum websites has led me to believe that it is helpful to consider museums' use of the Web as following a sort of 'evolutionary scale:

- no web presence
- marketing website – visitor services information, etc.
- access to collections – online catalogues, digital images, etc.
- interpretation of collections – resources for formal and informal learning, etc.
- increasing exploitation of Web technology – interactivity, audiences
- contributing to the content
- website constituting additional museum site.

Note, in particular, that provision of access to collections information, often by simply making an electronic catalogue available on the web, nearly always precedes the provision of specially designed interpretation and education resources. The nationals, of course, are leading the field in exploiting new media. Take a look at <www.tate. org.uk>, <www.nationalgallery.org.uk>, <www.thebritishmuseum.ac.uk> or <www. vam.ac.uk> to see some inspiring ways in which the Web can be used to enhance the relationship between the museum and the visitor. Tate, in particular, aspires to having its website constitute an additional site of the organization.

The regional museums are at various stages on the evolutionary scale, with many making very significant progress in using new technologies to provide access to collections information and learning resources. In autumn 2004 I carried out research into the processes that regional museums follow in their online activity, with a particular focus on project management and evaluation. Museum professionals from a range of institutions were interviewed, with the core of the sample being several museum services in receipt of Designation Challenge Fund (DCF) grants for ICT-based projects: Birmingham; Colchester; Exeter; Fitzwilliam, Cambridge; Museum of London; Natural History, Oxford; Petrie, University College London (UCL) and Tyne & Wear.

On the question of terminology first of all, there is a strong consensus that the term 'e-learning' is not appropriate for the vast majority of what the museum sector is doing with web-based technology. Museum professionals are clear about what e-learning looks like in the commercial and academic sectors, and believe that this is simply not what museums are mostly aiming to provide for their users. As far as targeting audiences is concerned, the reasoning behind defining target audiences for web-based resources is unsurprisingly much the same as that for defining target audiences for actual visits. In many cases, the museum starts by providing an online catalogue, which is useful for researchers, and then moves on to developing richer resources that are aimed at the

general user. There is also a strong focus on providing curriculum-based resources. With regard to the issue of website visits versus actual visits, although the power of the Internet to reach remote users is understood, and is exploited where appropriate, it seems that the vast majority of web-based resources produced by the museum sector are intended to enhance, and not replace, actual visits to the museum.

There seems to be a strong consensus for web-based development projects to be undertaken by cross-disciplinary teams, notably with curatorial and education staff collaborating. There is also a significant reliance on the use of external consultants for Web development work and evaluation. The Telematics Centre at the University of Exeter has developed partnerships with various museums in the south-west and has become an important supplier of web-based learning resources for the museum sector in that region; it could be fruitful to encourage the relevant departments in universities around the country to work with their local museums on the development of web-based learning resources. Most museums do some monitoring of website usage statistics, but there is a need for some guidelines as to how to make the best use of them. It seems that most museums market their websites using traditional marketing methods, as well as by ensuring that they are found successfully by search engines; there is little confidence that Curriculum Online is a useful way of bringing museum websites to the attention of teachers.

Museums are employing a wide variety of methods to evaluate the web-based resources they are providing for their users:

- online feedback forms;
- hard-copy feedback forms – targeted to particular website visitors (for example, by requiring visitors to register to use part of a site); targeted to particular museum visitors (for example, asking teachers who have booked school visits to review part of the site); made available in the museum for users of in-gallery interactives;
- iterative review during the development process – by interested parties such as internal staff; by teachers and pupils; by visitor groups such as disability advisory groups, etc.
- one-to-one observations and interviews;
- group discussions – on paper at very early design stages; of development versions; of finished products;
- surreptitious observation of visitors using in-gallery interactives;
- indirect feedback from facilities such as e-cards and user contributions;
- website usage statistics.

There is a multitude of good design ideas that museums are working on, with the main themes being:

- navigation – user-orientated labels, colour-coding, effective paths into the learning resources
- simple 'low-tech' resources for teachers, to support museum visits

- resources that are cross-curricular or cross-disciplinary
- resources that bring together collections from more than one museum
- rich contextual material (telling stories) about a small selection of objects – allowing the visitor to browse as well as search
- virtual reality models showing objects in context
- content being 'layered' or providing a variety of 'channels' for different users
- resources that mimic the experience of visiting a gallery – things to look at; things to do; things to take away
- interactive resources, such as quizzes, e-cards, e-toys
- enabling users to contribute material and to communicate with each other
- e-guides, bar-coding, radio-frequency ID tags
- developing material at a low level of granularity for re-usability; enabling staff to create online resources about objects as they go along; enabling less well-resourced museums to contribute content to a partnership site.

The interviewees put forward a variety of suggestions for support:

- provision of case studies showing what various museums are doing
- help with evaluation – guidelines and standards for methodology and help with selection of consultants
- guidelines on how to make best use of website usage statistics
- assistance with working with Curriculum Online and provision of information about its effectiveness as a portal
- research into good practice for curriculum-based online learning resources
- research into what users want from museum websites and how web-based resources can enrich visitors' engagement with actual objects
- more training and guidelines on how to use MLA's *Inspiring Learning For All* framework (ILFA)
- good practice guidelines for project management, and research into how project outputs can best be maintained after end-of-project funding
- guidelines regarding technical standards for interoperability
- peer support forums at different levels
- bursaries for training in e-learning
- provision of tools to help users find online learning resources.

Returning to the agenda for action set out in the NMDC paper *A Netful of Jewels* back in 1999, recall that the actions proposed for the museum sector were to develop a deeper understanding of museums' role in learning, to develop coordinated strategies for creating digital content, and to provide training for creating and using digital content. This survey of digitization projects in the regions carried out in autumn 2004 shows that individual museums have been making great progress in their experiments with using new technologies to enhance their audiences' enjoyment of collections.

- See <www.molli.org.uk> for a selection of e-learning offerings developed by the Telematics Centre at Exeter, which are aimed at schoolchildren and employ various types of interactivity.
- See <www.fitzmuseum.cam.ac.uk> for PHAROS, which is a themed guide for the general visitor to the highlights of the Fitzwilliam's collection of art and antiquities.
- See <www.colchestermuseums.org.uk> for a virtual-reality model of Roman Colchester.
- See <www.accessingvirtualegypt.ucl.ac.uk> for a project developed by the Petrie in collaboration with four other museums, which creates a virtual collection of objects excavated by the archaeologist William Flinders Petrie and provides a range of educational resources.
- See < www.twmuseums.org.uk> for the MOO project (Museums Outreach Online), which provides online learning resources for ICT skills acquisition, and developed from an outreach programme aimed at various hard-to-reach audiences.

Even a brief look at the websites of the regional museums reveals a wealth of inventive approaches to online access to collections information and online learning resources. What is not evident, though, is a coherent, sector-wide strategy for the use of new technologies and the development of online learning resources for the museum visitor.

Research into Impact on Audiences

It is clear that the museum sector has not yet carried out sufficient research into how people actually use and want to use its digital resources. Individual museums do undertake perfectly adequate evaluation of individual projects, but there has not yet been a unified approach to developing a pedagogy for museums' digital learning resources. However, one recent piece of research, funded by the Designation Challenge Fund, is certainly worth a mention.

Birmingham Museums and Art Gallery engaged consultants Morris Hargreaves MacIntyre (MHM, <www.lateralthinkers.com>) to carry out an in-depth formative evaluation exercise for their 2004–06 DCF digitization project. In their October 2004 paper, *Learning Journeys: Using Technology to Connect the Four Stages of Meaning-making*, MHM argue that visitors are most usefully categorized not by type (adult, child, etc.) but by behaviour; that is, by the way they make meaning from objects in the museum. They have identified four different types of behaviour:

- browsers – wander randomly until an object grabs their attention, then require explanation (about 50 per cent)
- followers – want the museum to select objects, and require narrative explanations of themes (about 40 per cent)

- searchers – visit the museum to learn about particular objects (about 9 per cent)
- researchers – have expert knowledge and expect specialist access (about 1 per cent).

Putting these findings together with various aspects of visitor engagement with in-gallery interactives, MHM conclude that different types of people need different types of web-based resources to meet their learning needs:

- browsers and followers – need rich contextual explanation about a few objects.
- searchers and researchers – need detailed information about the whole collection.

Given that about 90 per cent of visitors tend to show browser and follower behaviour, it is obvious what sort of design will result in best value for money. The five generic learning outcomes of MLA's *Inspiring Learning for All* framework (ILFA) can easily be mapped onto the four visitor modes: browsers and followers will be seeking enjoyment, not knowledge; searchers and researchers will be the other way around; none of the four will be seeking skills acquisition. But the crucial thing is that visitors can progress from one mode of behaviour to the next as a result of well-designed exhibitions, and MHM are currently developing an evaluation methodology that uses the ILFA generic learning outcomes to measure visitors' progress.

The Way Forward

The overriding conclusion from this survey is that the museum sector needs a national strategy for its use of ICT and digitization. The sector certainly needs the strategy document for museums education that DCMS is currently developing in collaboration with DfES. In addition to this, though, the sector also needs DCMS to develop a strategy for ICT in the cultural sector in the light of the DfES e-learning strategy. With these two items as a basis, a national strategy for the museum sector's use of new technologies could be developed. There is evidence of huge progress being made in the museum sector's knowledge and understanding of what can be accomplished with respect to the use of digital resources, and the existence of a national strategy would surely help to formalize these achievements.

A national strategy would define how the museum sector's contribution to formal education and lifelong learning can be maximized for the benefit of the public. Some of the issues it would need to address are as follows:

- It would need to provide an effective framework for museums to act as content-providers for the national curriculum, one that would be much more successful than Curriculum Online has been.

- It would need to solve the problem of short-term funding streams for digitization projects, perhaps by ring-fencing some element of museums' core funding for online activity.
- It would need to look at the issue of website hosting, which can be a problem for small museums that cannot rely on a local authority or university to provide this service, and to establish consistent standards for website usage statistics.
- It would also need to establish shared technical standards for the creation of digital cultural resources. The good work that has been achieved so far by the NOF-digitise and Minerva programmes and the Common Information Environment needs to be firmly embedded in the sector's online activities, and a national strategy would see to this.

A second observation is that we need to carry out effective evaluation of the impact on users of museums' digital learning resources and to develop a cohesive pedagogy for online museum education. One of the reasons we have not yet seen this is surely that e-learning is intrinsically a hybrid discipline, incorporating both learning theory and technology and, as a result, there are not many people with all the relevant skills. Moreover, both learning theory and technology are relatively immature in the museum sector compared to, say, the higher education sector, and so this discipline that combines them is obviously in its infancy. But there is an enthusiasm to learn. We must hope that the evaluations of the impact of the NOF-digitise and Culture Online projects on learners contribute evidence for the basis of a pedagogy for online museum education. MLA's *Inspiring Learning for All* framework, with its generic learning outcomes, could also be a useful ingredient. And this area is surely fertile ground for partnerships between the museum sector and the higher education sector. Universities could follow the example of the Telematics Centre at Exeter and specialize in developing digital learning resources for museums; and activity on the more theoretical side of things is required, too. At Leicester the programme director for museum studies specializes in new media; and at UCL there is a module on digitization in the museum studies course. All university departments engaged in museum studies should be collaborating with colleagues with new media expertise to contribute to the development of a cohesive pedagogy for online museum education.

A third observation is that we need to provide effective search and discovery tools, with multiple points of entry, to give users easy access to digital learning resources. MLA is making inroads on this, with its Knowledge Web developments. A national strategy would ensure that all funding streams, as well as those managed by MLA, would require adherence to the technical standards necessary for digital cultural resources to be discoverable in this way. This approach to providing access to digital resources is all about putting the user's needs first. No one website could possibly hope to attract all the people the sector wants to reach, so it is right that MLA's aim is to provide effective search and discovery tools so that a user could start on the BBC website, say, and from that starting point access content from many cultural institutions. It will be important for MLA to collaborate closely with the 24HM in particular on this work.

A fourth observation is that we need to provide effective ways of developing the knowledge and skills of museum professionals about the use of digital technologies. There are the obvious things like design principles, technical standards and evaluation, along with aspects of managing digitization projects such as contracts with web developers, intellectual property rights and issues about how project outputs can best be maintained after the end of project funding. Sector membership groups, like the Museums Computer Group and the E-Learning Group, along with organizations like Becta, UKOLN and the AHDS, which provided support for the NOF-digitise programme, could contribute to the delivery of a skills development programme for the sector. Well-researched and well-presented good practice guidelines and case studies are required, which could be published online, of course. With adequate funding, a comprehensive suite of training events designed specifically for the museum sector could be developed and delivered.

The Web is undoubtedly the key to the evolution of the museum's role in the public realm and how the museum manages its relationship with its audiences. Museum professionals have already shown admirable inventiveness in using new technologies as tools for enhancing the services they offer, and a focused government approach to policy and funding would facilitate these developments for the benefit of audiences.

Appendix: Key to Map and Additional Glossary

24HM 24 Hour Museum
<www.24hourmuseum.org.uk>
A website that promotes publicly funded UK museums, galleries and heritage attractions and seeks to develop new audiences for UK culture. Granted the status of 'the UK's national virtual museum'. Set up in 1999 and funded primarily by MLA; based in Brighton.

Accreditation Scheme
Run by MLA; sets nationally agreed standards for UK museums. To qualify, museums must meet clear basic requirements on how they care for and document their collections, how they are governed and managed, and on the information and services they offer to their users.

Action Plan European Action Plan for Digitisation of Cultural Heritage
A plan produced by the National Representatives Group.

AHDS Arts and Humanities Data Service
<www.ahds.ac.uk>
A national service to collect, preserve and promote the electronic resources that result from research and teaching in the arts and humanities. Funded by JISC and the Arts and Humanities Research Council. Based at King's College London.

Becta British Educational Communications and Technology Agency
< www.becta.org.uk>
An organization that works with the DfES on the development and delivery of its ICT and e-learning strategy for schools and the learning and skills sectors. Based in Coventry.

CGfL Community Grids for Learning
A set of separate websites, each with its own local focus, containing information about online and face-to-face learning opportunities for local people.

CIE Common Information Environment
<www.common-info.org.uk>
A group of public-sector stakeholders working together to build a common online information environment. Established in spring 2004. Funded by MLA and JISC; other participating organizations include DfES, Becta and UKOLN.

Cornucopia
< www.cornucopia.org.uk>
An online database of collections held in cultural heritage institutions. Launched in 2000; managed by MLA.

Culture Online
<www.cultureonline.gov.uk>
A series of online cultural projects funded by DCMS and developed by a subsidiary organization reporting to DCMS. Launched in December 2001.

Curriculum Online
<www.curriculumonline.gov.uk>
A portal for online resources designed to support the teaching of the national curriculum. Enables teachers to evaluate and compare resources before buying direct from suppliers; also contains free resources. Set up by the DfES and managed since November 2004 by Becta.

DCMS Department for Culture, Media and Sport
<www.culture.gov.uk>
Central government department.

Designation Challenge Fund
See MLA funding streams.

DfES Department for Education and Skills
<www.dfes.gov.uk>
Central government department.

DPC Digital Preservation Coalition
< www.dpconline.org>
A membership group aiming to secure the preservation of digital resources in the UK and to work with others internationally to secure our global digital memory and knowledge base. Established in 2001 and funded by MLA. Based in York.

Education sector groups
- Centre for Educational Technology Interoperability Standards <www.cetis.ac.uk>
- Digital Curation Centre <www.dcc.ac.uk>
- Technical Advisory Service for Images <www.tasi.ac.uk>

eGU e-Government Unit, Cabinet Office
< www.cabinetoffice.gov.uk/e-government>
Central government unit responsible for formulating ICT strategy and policy, promoting best practice across government and delivering 'citizen-centred' online services.

ICT Information and Communication Technology

International groups
- Cultural Content Forum < www.culturalcontentforum.org>
- DigiCULT – Technology Challenges for Digital Culture <www.digicult.info>
- Dublin Core Metadata Initiative < www.dublincore.org>
- Open Archives Initiative <www.openarchives.org>

JISC Joint Information Systems Committee
< www.jisc.ac.uk>
A body supporting further and higher education by providing strategic guidance, advice and opportunities to use ICT in teaching, learning, research and administration. Funded by all the UK post-16 and higher education funding councils.

Learning and Skills Council
A body responsible for funding and planning education and training for over-16-year-olds in England.

Lottery funds
- Big Lottery Fund (formed by the merger of the New Opportunities Fund and the Community Fund) <www.biglotteryfund.org.uk>
- Heritage Lottery Fund <www.hlf.org.uk>
- New Opportunities Fund <www.nof.org.uk>

MICHAEL Multilingual Inventory of Cultural Heritage in Europe
< www.michael-culture.org>
A Minerva spin-off; a project to establish an international online service, which will allow its users to search, browse and examine multiple national cultural portals from a single point of access. The MICHAEL consortium comprises the ministries of culture of the UK, France and Italy. Managed in the UK by MLA.

Minerva
< www.minervaeurope.org>
A project aiming to establish a network of ministries to harmonize activities relating to digitization of cultural and scientific content, and to create a common European platform and guidelines about digitization, metadata, long-term accessibility and preservation.

MLA Museums, Libraries and Archives Council
<www.mla.gov.uk>
The national agency working on behalf of museums, libraries and archives and advising government on policy and priorities for the sector. Works in partnership with the nine Regional MLA Councils.

MLA funding streams
* Museums ICT Challenge Fund
 Ran for 18 months between 1999 and 2001, providing £500k to 11 collaborative projects that made innovative use of ICT.
* Designation Challenge Fund (DCF)
 Sixty-two non-national museums (or museum services) hold collections that have been designated of national importance. The DCF provides funding for projects relating to collections care and access: £15 million in 1999–2002; £4 million in 2002–04; £4 million in 2004–06. Much of the funding has gone on digitization projects.
* Renaissance in the Regions
 A major programme of investment in the entire regional museum sector via a network of Hubs: £10 million in 2002–03; £10 million in 2003–04; £20 million in 2004–05; £30 million in 2005–06. Referring back to the DCF, 30 of the museums holding designated collections are Hub museums and 32 of them are non-Hubs.

Museum sector groups
* British Interactive Group < www.big.uk.com>
* Computers and the History of Art <www.chart.ac.uk>
* E-Learning Group <www.elearninggroup.org.uk>
* Electronic Museum < www.electronicmuseum.org.uk>
* Museums Computer Group <www.museumscomputergroup.org.uk>mda (formerly the Museum Documentation Association) <www.mda.org.uk>
* National Museums Directors' Conference <www.nationalmuseums.org.uk>. Published the advocacy paper *A Netful of Jewels: New Museums in the Learning Age* in June 1999 in collaboration with MLA and mda.

Museums and the Web
< www.archimuse.com>
An annual international conference run by Archimuse (Archives and Museum Informatics, Canada). The UK Museums and the Web conference is run by the Museums Computer Group.

NESTA National Endowment for Science, Technology and the Arts
< www.nesta.org.uk>
Lottery-funded agency investing in projects that develop new products and services or experiment with ways of nurturing creativity in science, technology and the arts.

Net Gain
A scheme administered by MLA aiming to engender a more cohesive approach to ICT projects funded by *Renaissance* and DCF. Launched in June 2004 with a seminar at the Museum of London.

NGfL National Grid for Learning
<www.ngfl.gov.uk>
A portal for online educational resources on the internet. In a wider sense, the DfES's strategy for embedding ICT in education.

NOF-digitise NOF digitization programme
< www.enrichuk.net>
A programme funded by NOF from April 2000 to March 2004 to develop web-based learning resources, primarily for the People's Network. A portal for the various individual websites, EnrichUK.net, was launched in March 2003. A Technical Advisory Service for the programme was run by UKOLN and the AHDS.

NRG National Representatives Group
<www.minervaeurope.org/structure/nrg.htm>
A group comprising officially nominated experts from each member state of the European Union, which coordinates European digitization policies and programmes, with special emphasis on cultural and scientific resources and on the contribution of public cultural institutions.

People's Network
< www.peoplesnetwork.gov.uk>
A scheme that provided all public libraries with ICT equipment and broadband connections; this first phase ran from 2000 to 2003. Funded by NOF and managed by MLA. Its second phase is to deliver three online services: Enquire, Discover and Read. Discover is a search-engine-type service, but with technology that allows users to find information from a range and depth of sources not previously available from a single point; it can also provide answers that are tailored according to users' interests. Discover Service due to be launched in October 2005.

Renaissance in the Regions See MLA funding streams.

RBC Regional Broadband Consortia
< http://broadband.ngfl.gov.uk>
Consortia of local education authorities established to procure cost-effective broadband connectivity for schools and to promote the development of content for broadband networks. The national RBC Content Development Group enables RBC to develop content with other content providers, particularly in the museums, libraries and archives sector.

UKOLN UK Office for Library Networking
<www.ukoln.ac.uk>
A centre of expertise in digital information management, providing advice and services to the library, information, education and cultural heritage communities. Funded by JISC and MLA; also receives project funding from the European Union. Based at the University of Bath.

References

DfES (Department for Education and Skills) (2005), *Harnessing Technology: Transforming Learning and Children's Services*, London: DfES.

Hawkey, R. (2004), *Learning with Digital Technologies in Museums, Science Centres and Galleries*, Bristol: NESTA Futurelab.

Hemsley, J. (ed.) (2005), *Digital Applications for Cultural and Heritage Institutions*, Aldershot: Ashgate.

Jones-Garmil, K. (1997), *The Wired Museum: Emerging Technology and Changing Paradigms*, Washington DC: American Association of Museums.

MHM (Morris Hargreaves MacIntyre) (2004) *Learning Journeys: Using Technology to Connect the Four Stages of Meaning-making*, unpublished report, commissioned by Birmingham Museums and Art Gallery. MHM website at <http://www.lateralthinkers.com/>.

MLA (Museums, Libraries and Archives Council) (2004), *Investing in Knowledge: A Five-year Vision for England's Museums, Libraries and Archives*, London: MLA.

NMDC (National Museums Directors' Conference) (1999), *A Netful of Jewels: New Museums in the Learning Age*, London: NMDC.

Digital Technologies and Museum Learning

Roy Hawkey

Museums and the Web may be the title of a series of successful conferences (<www.archimuse.com/mw2005>), but it disguises serious misconceptions. Although the Internet is outstanding in its multimedia and interactive capabilities, it is but one of a whole range that includes TV, CD, MP3 player and mobile phone – all more profitably considered as a continuum. And fundamental to the ability of the twenty-first-century century museum to respond to the learning needs of its visitors is an understanding of all forms of ICT.

Learning, too, suffers from traditional associations and models that may no longer be valid. *Inspiring Learning for All* (MLA, 2004) has highlighted the need to celebrate informal learning outcomes – many of them affective – in their own right. Many authors have drawn attention to the parallels between the kinds of lifelong learning encouraged by museums and the approaches to learning facilitated by ICT.

While schools stand accused of 'using tomorrow's technology to deliver yesterday's curriculum' (Heppell, 2001), museums have begun to embrace the fundamentally different approaches that are increasingly available – including some that were impossible prior to the advent of digital technologies. The twenty-first-century exhibit does not require an apparently simple choice between real and virtual, physical or digital; such a dichotomy becomes meaningless as boundaries blur. For example, meta-data can be applied to real objects (using RFID tags) as well as to virtual ones. This obviates any perceived need for museum-specific search tools and makes possible multi-faceted digital interpretation of real artefacts, together with multi-way communication among curators and visitors.

Extensive analysis of the literature (Hawkey, 2004) certainly confirms the need for a coherent pedagogy for museum learning – and not just online. Whatever approach to museum learning is adopted as the century advances – the distinction between formal and informal learning is also becoming a false dichotomy – it is unlikely to depend upon existing paradigms of traditional museum design nor of conventional e-learning. As Prosser and Eddisford (2004) point out: 'Many museums are failing themselves and their users by creating a digital pastiche of the

physical museum, rather than seizing the opportunity to extend and enhance the museum learning experience offered by effective use of ICT.'

One of the principal advantages of digital technologies lies in the degree of choice and control that is given to the learner. Rather than the transmission of knowledge from expert to novice, learning becomes a journey in which the learner becomes increasingly empowered, an active pursuer rather than a passive consumer. Museums provide pathways rather than packages, signposts rather than tracks. Digital archives remove the distinction between temporary and permanent.

As DfES (2005) acknowledges, the future of ICT in education lies in its ability to 'transform teaching [and] learning', to provide 'more motivating ways of learning and more choice about how and when to learn' through an 'open accessible system' 'to improve personalise support and choice'.

Personalization is indeed crucial. Personalization of interpretation will significantly enhance social and intellectual inclusion. Personalization of technology will free both museums and learners from many of the current constraints. Personalization of learning will finally facilitate an escape from the deficit models so prevalent in educational institutions and release untold potential. And the key to personalization lies with the sensitive use of digital technologies by museum educators.

References

DfES (Department for Education and Skills) (2005), *Harnessing Technology: Transforming Learning and Children's Services*, London: DfES.

Hawkey, R. (2004), *Digital Technologies for Learning in Museums, Science Centres and Galleries*, Bristol: NESTA Futurelab.

Heppell, S. (2001), 'Preface', in A. Loveless and V. Ellis (eds) (2001).

Loveless, A. and Ellis, V. (eds) (2001), *ICT, Pedagogy and the Curriculum: Subject to Change*, London: Routledge/Falmer.

Marks, G. (ed.) (2004), *Information Technology in Childhood Education Annual*. Norfolk VA: Association for the Advancement of Computers in Education.

MLA (Museums, Libraries and Archives Council) (2004), *Inspiring Learning for All*, London: MLA.

Prosser, D. and Eddisford, S. (2004), 'Virtual Museum Learning', in G. Marks (ed.) (2004).

Chapter 8

Understanding Museum Evaluation

Kate Pontin

Introduction

This chapter will consider all aspects of current museum evaluation work: how we are using qualitative approaches, why we are doing it and how rigorous each step of the process ought to be. The discussion aims to challenge professional ideas and practice, not just of those who undertake evaluation work, but also of those who read and use it to improve their practice in education, display and visitor services. After all, when reading evaluation reports it is important that we consider who the evaluation was done by, who it was meant for, the questions asked and the methodology that has been undertaken. These factors influence the conclusions drawn.

I shall consider museum evaluation by starting with a review of current practice, move on to consider the key factors needed for a quality approach and then conclude with recommendations for future practice and development. In writing in the first person I am conforming to qualitative principles, which encourage authors to own their writing and provide a context. Thus my background is a long one, starting 20 years ago as a trainee curator. Shortly afterwards, I turned to museum education and have spent the last 14 years researching learning in museums and in particular the methodologies used for this. This research has been based within the qualitative epistemology, which believes that knowledge exists independently of the real world and that when reporting research it is important to represent the findings as fully as possible. It has informed my recent work as a consultant in evaluation and visitor studies.

My hypothesis is that although there is much good practice, as will be described in the following section, there is still considerable progress needed in evaluation technique, use and understanding within museums. A wide range of new evaluation work has been initiated as a result of the development of education in museums, but we need to continue to support this with improvements and new methods. This chapter will consider where and how this improvement could happen.

To do this we need to step back and consider why we undertake evaluation. What is it for? Do we use these studies to prove to government or sponsors that more people are coming to our museum and are fulfilling lifelong learning agendas? Or perhaps it is to help improve our future work? Is it to tick targets in our forward plans? Or to find out what our audiences think? It might even be that we hope it will do a number of these things, if that is possible. This chapter aims to consider these

questions and to stimulate museum and heritage professionals to consider their own practice.

Stepping back even further we can consider the actual tools we use and how these can also impact on the findings. I shall focus on qualitative evaluation, although much of this may be relevant to quantitative approaches, where the focus is also on statistical data. Qualitative analysis is concerned with the quality and texture of experience (Willig, 2001, pp 9–11). It is based on constructivist epistemologies, describes rather than explains, represents the participant view and attempts to offer meaning. It explores processes and asks questions such as, 'What do visitors do and learn when they view a museum display?'

Researchers in the academic discipline of anthropology originally initiated qualitative techniques when they immersed themselves in studies of other cultures and tried to describe them. Other disciplines then adapted the approach to suit their own needs. In the social sciences, qualitative approaches became popular in the 1960s when researchers studied groups within their own society, such as the mentally ill (Goffman, 1968) and the work on 'deviants' (Becker, 1963). These early works illustrated that such research cannot be value free as the researcher and their background inevitably influences the approach, what is 'seen' and what is recorded. Although some have been critical of this approach and still feel safer with numbers, other professionals including many in museums have now adapted these tools.

The approaches used for an evaluation will vary depending on the focus of the researcher, for example a marketing officer will have different background theory, ideas and questions from a museum educator. A publicity officer might want to know where people have come from and their expectations of their visit, while the education officer might want to find out whether accompanying resources are helpful and whether labels need re-writing.

In undertaking a qualitative evaluation study one starts with a hypothesis and researcher-defined categories against which the qualitative data are then checked. For example, if assessing the relevance of an education pack one may have questions in mind concerning the information provided, activities and improvements. Data collected will be linked to these questions to provide answers. In comparison research is much more open-ended which aims to generate theory and meaning (Willig, 2001, p 9).

I offered above a range of possible reasons for evaluating, including improving good practice and proving the worth of museums. Often, though, it is to prove the worth of a project funded either as part of current government initiatives or by independent trusts and foundations. However museum evaluation should do more than just prove to various stakeholders (political and otherwise) and others that we 'fit' their policies. Selwood is critical of the 'tendency to value culture for its "impact" rather than its intrinsic value' (Selwood, 2002, p 1). She is critical of much methodology used by previous researchers such as Matarasso, who used qualitative studies to show the changes seen in users experiencing the arts, and suggests that not only are their approaches flawed but that the need to focus on proving relevance is at the cost of validity. The implications are that government initiatives 'control' our

work and our evaluation, and this 'has resulted in the politicisation of the gathering of data and the state's blurring of the relationship between advocacy and research' (Selwood, 2002, p 2). Do we have to compromise our evaluation methodology to prove our worth? Is our ethical stance and independence being challenged? To consider these questions we need to take a look at current practice and see why and how evaluation is being undertaken.

Evaluation in Museums Today

Funding by the Department for Education and Skills (DfES), the Department for Culture, Media and Sport (DCMS) and the Museums, Libraries and Archives Council (MLA) for initiatives to make education in museums a priority has meant a huge increase in education work with a wide range of different audiences. It has also made evaluation and demonstration of success essential. Such projects have included the DfES programme, *The Museums and Galleries Lifelong Learning Initiative* (£0.5 million invested in 11 museum and gallery projects across England during 2000–03), which is run by the Campaign for Learning through Museums and Galleries (CLMG). They (CLMG) have published a number of evaluation reports (including *What Did We Learn This Time?*) and, more importantly, a more long-term review of learning in *Where Are They Now?* More recent projects include *Inspiring Learning for All*, developed by MLA and run by the Museum Studies Department at the University of Leicester, which aims to inform the profession about accessible and inclusive services and how it can evaluate and achieve best practice. Meanwhile the Heritage Lottery Fund's *Young Roots* programme funds work to attract younger audiences to museums.

The positive results from evaluation can of course encourage further grant funding in the sector and so using data to support political bids has become inevitable in the current climate. However, too often this evaluation lacks critical discussion of weaker aspects of the project, is too short-term, and is limited in its validity. Those involved in the evaluation can be short of skills and understanding of methodological origins and assumptions, and thus are not always aware of the strengths and weaknesses of the approach used. Often evaluation is undertaken by those running the project or by skilled independent consultants who are able to dedicate appropriate time to the study.

Both approaches (using either in-house staff or external consultants) can offer positive outcomes on how to improve practice, but how often are results really used? How often do we read these reports as an initial learning task before starting our own projects? A report written in 2001 (Hawthorne and Pontin) reflects on the experiences of museums in Birmingham and Salford when working with young people, summarizing the similarities within the very different projects in the working processes and providing a number of key success factors. Such reports can help in other projects and when implementing best practice.

Other evaluation work has been undertaken in innovative education departments, such as the Tate (Cox *et al.*, 2000), Walsall (Arts about Manchester, 1998) and Bruce

Castle Museum, London (Pontin, n.d.), to name a few. All these evaluations outline practice and outcomes and suggest ways of improving the service provided. They are based on observations, interviews and questionnaires and provide a description of approaches and a review of the results. However, only a few actually provide information on the evaluation context and its limitations (RCMG, 2001) and (Pontin, 2001).

More recent work by the Research Centre at the Department of Museum Studies, Leicester University has provided a useful structure to illustrate evaluation outcomes and this has been developed with associated theory and practical elements on the *Inspiring Learning for All* website. This approach categorizes learning into a number of different aspects called generic learning outcomes (GLOs), which include skills and knowledge but also development of self-esteem and change in attitudes. It is too early to assess how effective this will be in improving best practice in evaluation or education, but it certainly offers a tool to show the breadth of museum learning. There is a danger that the results can minimalize the data and much may be lost or not visible to the reader. For example, an evaluation report with a table showing that all the generic learning outcomes were seen, with frequencies and a selection of examples for each, does not provide information on validity of original data, or the depth of learning. In a recent report I wrote using GLOs it was very difficult to express the enormity of the impact a museum programme had on the young people. How does one describe or measure the change in a participant who is now volunteering at the museum and starting a training course when once they saw no real way forward in their lives?

Other tools currently being used to quantify or 'reduce' qualitative data include personal meaning mapping (Falk, Moussouri and Coulson, 1998), which assesses the change in language use and extent of knowledge according to a person's own mind-mapping exercises, and the quality of life tool used in the Foyer movement (Kent, 2002), which also attempts to score the change in attitudes and self-esteem of young people. Although all these methods are useful in summarizing outcomes they need to be used and read with caution. There may be no way of checking original data or carrying out validity checks but there is a need to provide a context for the researcher. Extensions to these tools are needed to help show the full picture and give the reader a chance to consider how rigorous and relevant the piece of work is. In exploring new ways to represent qualitative data, we need to develop a range of new approaches.

In developing our own approaches to evaluation, it is worth considering the work of other professions. Action research is a type of evaluation that can help our own practice and development. Teachers and other educationalists have used this approach for a number of years and recent developments in methodology could offer new paths for museum workers to try. Instead of employing others to evaluate a particular aspect of work, the practitioner does it him/herself. There is a range of approaches but action research usually sets out to consider a particular aspect or question (Loughran, 2003, p 181), such as why a specific problem reoccurs, in an attempt to improve practice.

Dadds and Hart (2001) offer a range of approaches in their book for teachers which could easily be adapted for museums, including participant creative writing and the use of models to describe situations. In an effort to keep the 'thick description' of the research, Potter analysed her data by maintaining its completeness and built a model by repeatedly studying the data and 'creat(ing) an imaginary location populated by the participants in my [sic] research' (Potter, 2001, p 31). Others, such as Tripp (1993), have used the study of 'critical incidents' to develop an understanding of classroom practice, where critical incidents are those points at which a lesson either succeeds or 'fails'. In a museum session this might be the point that always inspires children or perhaps more importantly when an aspect of exhibition fails to excite or hold attention. Developing our research approach can result in more confidence in our own experience and knowledge, but also in that of others.

Whatever approach used, we should make sure each part of the evaluation procedure is as rigorous as possible so that our work is thorough and conforms to best practice, from the planning and consideration of the context to the gathering and analysis of data to the reporting of results to others. Such standards can all too often be lost because of finance, commissioning focus or lack of knowledge about methodology. There is also a need to share our results with others and use the support of mentors to help us in our work.

Best Practice in Evaluation

So what is best practice? What should the evaluation process involve? Listed below are the factors which I believe should be included. My approach comes from many years of practical evaluation (and of making mistakes) as well as from reading about research methodology in other professions.

Ethics

Ethical standards are a prerequisite and relate to the consideration of all those involved in data collection. The Museums Association's *Code of Ethics* briefly mention the need to 'use advisory and support groups' and 'not [to] exploit them [but] treat their views with respect and protect their confidences' (MA, 2002, p 12). Personally I feel the need for more guidance than this, especially in the light of recent legislation, with greater rights for individuals and for children in particular. It is important to refer to the codes of other professional communities, for example the Association of Social Anthropologists (<www.theasa.org>), which includes details on personal conduct and confidentiality.

Context and Planning

Evaluation planning should begin with consideration of who is to do it and what the evaluation objectives are to be. If you plan to appoint a consultant, allocate enough

time for the process. GEM's freelance network offers useful advice on appointing a consultant (<www.gem.org.uk>). Remember an evaluation consultant needs experience in the approach and methods that you think will be central to the study, rather than knowledge of the project work being undertaken, although this of course can be helpful too. A feeling of trust and the potential for a comfortable relationship will also be required.

Time taken working together to consider how effectively objectives can be evaluated, and work plans developed, is time well spent. What aspects of the museum environment and local area are relevant? Who is involved in the project? What issues might there be in using particular tools? What feelings does the evaluator have about the project? Keeping an evaluator's diary can highlight the issues that arise throughout the project and can provide assessment for improving evaluation work too.

Collecting Data and Reliability

If we expect qualitative reports to be taken seriously and to be trusted we need to establish strategies to make the data collection reliable. Reliability relates to the way in which we gather our data and is the extent to which data collection is consistent. For example, if a number of people are gathering data it is important to check that they all using the same approach, in the same way, and recording the same things under the same categories. It is useful to test methods through piloting and to check one's own consistency in recording data.

Analysing Data and Validity

'By validity I mean truth; interpreted as the extent to which an account accurately represents the social phenomena to which it refers' (Hammersley, cited by Silverman, 1993, p 149). Validity of data and its analysis is central and depends on the evaluator's ability to base their work on appropriate epistemological theory and to use a number of approaches to 'assess' and 'check' the data. Many workers use triangulation, which requires opportunities to collect data from a number of different sources (such as data source, method, researcher, theory or data type). For example, in an evaluation of young people's experience and learning, feedback was collected from the young people themselves but also from the youth and the museum workers on their perceptions of the change and development of those participating.

Some suggest that triangulation has its limitations and should not be solely depended on. Silverman says that it may be inappropriate to conceive an over-arching reality from data that is gathered in different contexts. Rather, he suggests that it may be useful in providing an 'assembly of reminders' about the situation, but that it should not be used to adjudicate between accounts. In qualitative data we are there to understand not to judge the truth (Silverman, 1993, p 158) and thus if there is conflict between what participants and providers said it would be difficult

to make 'judgements'. However, data that complements each other adds weight to such conclusions.

There are other validity methods that are just as useful and can also become part of the evaluators' box of tools in establishing a more truthful set of results. Validity tools include taking the findings back to the participants being studied to find out whether they feel they have been accurately represented. The testing of any resulting hypothesis or ideas also can be carried out by doing further fieldwork (Miles and Huberman, 1994), either by investigating another similar case study or through a computer programme. Lastly it is important to compare our own results with those of others to see how they differ and why, and then check the meaning of any anomalous data, or 'outliers', as they are known. All rely on the evaluator having an understanding of the context in which the data was collected, their own bias and weaknesses (see *Reflexivity*), the environment, specific issues on the day of collection and the methods that were used.

Reflexivity

This is the awareness of our own contribution to the construction of meanings throughout the evaluation process (Willig, 2001, p 10). Our personal values, experiences, beliefs and the like, shape the evaluation and epistemology chosen. Thus when undertaking or reading about evaluation we need to consider, 'how has the design of the study and method of analysis 'constructed' the data and the findings?' (Willig, 2001, p 10). How might it have been done differently, and what different understandings would have been created as a result? How has the researcher impacted on the process? As part of this reporting of evaluations we need to communicate our approach, epistemology and background so that readers may see the context in which the work was done.

Margot Ely (Ely *et al.*, 1994, p 122) believes that we need to recognize our own myths and prejudices but also a greater self-knowledge 'can help us to separate our thoughts and feelings from those of our research participants'. However, 'confronting oneself is one of the most difficult and thought provoking aspects' in qualitative research to do and takes time to develop, but it is also one of the most important.

Writing Up and Reporting

Writing up the findings provides an opportunity to reflect again on the context and the evaluation itself, and can also help develop ideas further. In fact many researchers find the moving backwards and forwards from the data to the writing an effective part of the analysis. In some cases it can be useful to write a number of different reports for different audiences, so that both the qualities of the project and the learning for the future can be fully expressed. It is also important that unpublished material is made available via Web pages for example, so that learning can be across the profession.

So what does this all mean in practice? A project evaluated in Birmingham, called *Represent*, may offer a useful case study. This project was an early attempt to attract young people from deprived areas of Birmingham and to develop their individual skills and self-esteem. Project work included opening their eyes to cultural heritage in general through visits to carnivals and other museums, as well as workshops in video, DJ-ing and the development of a graffiti exhibition.

Planning of the evaluation only started after the project had already got going. Despite the handicap of not helping to establish evaluation objectives we discussed these and the potential evaluation approaches and realized the need for the evaluator to be part of the project, attend sessions and meetings and to hear about problems and issues as well as successes. This meant that I needed to spend time developing relationships with team members and more importantly the participants so that a sense of trust and friendship was developed.

The project was a completely new experience for the participants (and the staff!) and it took a great deal of time for them to develop the self-belief to become more proactive in management and evaluation. If there had been more time these skills would have been stronger and the evaluation process more in control of the participants. As it was they were pleased to be involved in discussion about the successes and failures, write feedback about their feelings and show me their scrapbooks. Informal conversation was also important.

Validation of results was established through the use of triangulation, with data collected from both those involved in initiating the project and those participating. There was little other research in museums available at that time to be used as part of comparative studies. However, the key outcomes were discussed with both project workers and the participants themselves. Involving those taking part in the process is a key form of validation in this type of project.

Ethically, data was collected with permission, anonymity used where appropriate and respect held for all responses. The report was placed on the West Midlands Regional Museums Council's website and is still available on my own website. Data from this was then published in a comparative report (Hawthorne and Pontin, 2001) making key learning factors available to all. The original report included a reflection on the evaluation itself and considered the limitations of the research, which included the need for more time to attend workshops and activities.

A More Rigorous Approach to Evaluation

Work so far with generic learning outcomes and other new initiatives is the first step along a path of trying to represent the museum experience more accurately. After all, such approaches are only as useful and 'truthful' as the data is valid and reliable. Thus there is also a need for increased training in evaluation and research methodologies, not just for those using the tools but also for managers and other museum staff so that they can assess the reports they read with greater skill.

There is also a need for further funding, but it also essential that funding bodies recognize the importance of rigorous qualitative evaluation and research, and the need for independence. We should be actively involved and should not leave evaluation and research to the universities but include it in our own remit. Including practitioners in research projects and offering grant aid for further work in learning and training in museums are essential to the future development of evaluation and best practice in general. In suggesting the key factors above, I intend to offer guidance to the profession and highlight the need for studies of a higher standard.

Conclusion

This chapter has tried to show that rigour is a central element in our evaluation work. We need to consider the planning, the reliability of data, the use of validation and how we write it. It also means being reflexive about our work, acknowledging our background and epistemological stances in our reports. This reflexive practice should also help practitioners consider the ethical aspects of consulting with visitors, resulting in their empowerment in the process to improve museum experience.

The collaboration and sharing of experience, knowledge and best practice is the only way forward. All too frequently we work within a void and do not use the knowledge around us. Joining organizations such as the Visitor Studies Group can help access advice and support when it is needed, and offer opportunities to learn about improved practice.

We should not be apprehensive to use qualitative data and appreciate what it can add to an evaluation, finding ways of showing its richness in our reporting, in addition to techniques such as generic learning outcomes or models which illustrate key findings. We also need to inform those not familiar with its approach so that they will believe in its capacity to reach new levels of authenticity.

References

Arts about Manchester (1998), *Visitor Responses, Questionnaire and Observation Results of Me and You: An interactive exhibition for children aged 3 to 103!*, Manchester: Arts about Manchester.

Becker, H. (1963), *Outsiders: Studies in the Sociology of Deviance*, New York: Free Press.

CLMG (Campaign for Learning in Museums and Galleries) (2004), *Where Are They Now? The Impact of the Museums and Galleries Lifelong Learning Initiative (MGLI)*, London: DfES.

Clarke, A. and Erickson, G. (eds) (2003), *Teacher Inquiry*, London: RoutledgeFalmer.

Cox, A., Lamb, S., Orbach, C. and Wilson, G. (2000), *A Shared Experience – A Qualitative Evaluation of Family Activities at Three Tate Sites*, unpublished report.

Dadds, M. and Hart, S. (2001), *Doing Practitioner Research Differently*, London: RoutledgeFalmer.

Denzin, N.K. and Lincoln, Y.S. (2003), *Strategies of Qualitative Inquiry*, London: Sage.

Ely, M. *et al.* (1994), *Doing Qualitative Research: Circles within Circles*, London: Falmer Press.

Falk, J., Moussouri, T. and Coulson, R. (1998), 'The Effect of Visitors' Agendas on Museum Learning', *Curator* **41**: 2, 107–120.

Goffman, E. (1968), *Asylums: Essays on the Social Situation of Mental Patients and other Inmates*, Harmondsworth: Penguin.

Hawthorne, E. and Pontin, K. (2001), *'Museum Fever' and 'Represent': Lessons for Working with Young People in Museums*, Birmingham: WMRMC.

Kent, P. (Helix Partners) (2002), *Evidence Change: Quality of Life as a Measure of Distance Travelled (Final Report)*, Fairbridge and Foyer Federation.

Loughran, J. (2003), 'Knowledge Creation in Educational Leadership and Administration through Teacher Research', in A. Clarke and G. Erickson (eds) (2003).

Matarasso, F. (1999), 'Culture makes Communities', *Briefing from the Voluntary Arts*, No. 42, Voluntary Arts Network.

Matarasso, F. (2002), 'Value and Values in the Voluntary Arts', *Briefing from the Voluntary Arts*, No. 59, Voluntary Arts Network.

Merli, P. (2002), 'Evaluating the Social Impact of Participation in Arts Activities', *International Journal of Cultural Policy* **8**: 1, 107–118.

Miles, M.B. and Huberman, A.M. (1994), *Qualitative Data Analysis,* 2nd ed., London: Sage.

MA (Museums Association) (2002), *Code of Ethics for Museums: Ethical Principles for All who Work for or Govern Museums*, London: MA.

Pontin, K. (2001), *'Represent': An Evaluation Report for an Inclusion Project run by Birmingham Museum Service*, unpublished report at <www.katepontin.co.uk>.

Pontin, K. (n.d.), *A Common Treasury – An Evaluation of a Secondary School Programme at Bruce Castle Museum*, unpublished report at <www.katepontin.co.uk>.

Potter, J. (2001), 'Visualisation in Research and Data Analysis' in M. Dadds and S. Hart (2001), pp 27–46.

RCMG (Research Centre for Museums and Galleries) (2001) *Making Meaning in Art Galleries 2 – Visitors' Interpretive Strategies at Nottingham Castle Museum and Art Gallery*, Leicester: RCMG.

Scheurich, J.J. (1997), *Research Method in the Postmodern, Qualitative Studies Series 3*, London: Falmer Press.

Selwood, S. (2002), 'Measuring Culture', article from < www.spiked-online.com>.

Silverman, D. (1993), *Interpreting Qualitative Data, Methods for Analysing Talk, Text and Interaction*, London: Sage.

Tripp, D. (1993), *Critical Incidents in Teaching, Developing Professional Judgement*, London: RoutledgeFalmer.

Willig, C. (2001), *Introducing Qualitative Research in Psychology*, Buckingham: Open University Press.

Useful Websites

<www.soc.surrey.ac.uk/sru> – the social research update for details on a range of qualitative tools
<www.inspiringlearningforall.gov.uk>
<www.mla.gov.uk>
<www.gem.org.uk>
<www.theasa.org/applications/ethics/index.htm> for information on ethics in research
<www.visitors.org.uk> – Visitor Studies Group

Response to Chapter 8

Children and Young People in Museum Evaluation

Susan Potter

In Chapter 8, Kate Pontin comments that there is still considerable progress needed in the technique, use and understanding of museum evaluation. I should like to suggest that progress would undoubtedly be made more rapidly if museums chose to consult with their users at the earliest stages of development – encouraging active engagement with all parts of the community as a means of front-end evaluation.

There is often an assumption that the analysis of young people is, in part, achieved by examining the attitudes among their parents (Costantoura, 2000). This view of the capacity of children to contribute meaningfully to discussions of issues that impinge directly on their lives has been challenged by studies that have sought to interrogate children's experiences and perspectives (Eder and Corsaro, 1999). The issue is less one of the capacity to deal with complex issues and more one of developing an evaluation methodology that is sensitive to and values children's voices.

When educators and academics speak of young people as researchers, however, they usually have something more radical in mind than consulting the children in their care about the issues they would like to be taught to understand better. They usually have in mind the very transformation of the relationships between the organization and the young people.

Priscilla Alderson at London University believes that training young people to become researchers has the potential to address power imbalances. Respect for children's participation recognizes them as subjects rather than objects of research, who 'speak' in their own right and report valid views and experiences, she suggests. To involve children more directly in research can rescue them from silence and exclusion, and from being represented, by default, as passive objects.

The kinds of research that children can do are almost limitless as long as they have been appropriately trained and have access to supportive staff. Child researchers use a wide variety of methods, from selecting topics, questions, samples and observation sites through data collection to analysis and reporting, dissemination and policy discussions. Research reports by young groups range from long typed reports to a simple poster or a wall newspaper, a video or photographic exhibition.

Evaluation methods and techniques tried and tested with very young researchers include:

- visual diaries using drawings, collage, photographs
- model-making to express and illustrate three-dimensional ideas and suggestions
- role-play and puppet-play to act out thoughts and feelings
- conducting small group or one-to-one open-ended ethnographic interviews
- recording findings using digital audio and/or video equipment
- artefact elicitation techniques to facilitate individual discussion
- photo elicitation techniques to facilitate discussion in paired interviews.

The omission of children's voices from museum evaluation holds a number of serious implications. Firstly, children's views on the arts are ignored through the assumption that they hold and mirror the views held by their parents. Increasingly researchers recognize that children are a group apart (largely from adults) with their own cultural lenses and so deserving of attention in their own right. (Matthews, Limb and Taylor, 1998).

Secondly, developments in the sociology of childhood highlight the ways in which children are not only attendant to the cultural practices of others (adults) but also active as cultural producers (Corsaro, 2000; Prout and James, 1997; James, Jenks and Prout, 1998).

Thirdly, the omission of children's voices discourages them from taking

authority in the ways in which they engage with and use the arts in meaningful ways in their lives. In this, we are reminded that 'a society that avoids knowing about its children has already made an ominous decision about its priorities' (Graue and Walsh, 1998).

Consequently, the aims of any museum evaluation should be both discipline-oriented and methodological. We should seek not only to explore the meaning, value and purpose of the museum in the participants' lives, including their descriptions of participation, but also to develop research methods and techniques sensitive to children's ways of communicating and constructing meaning.

Evaluation methodologies should be designed to explore children's perspectives and provide opportunities for their construction of meaning. Special consideration should be given to the most appropriate and sensitive ways of generating data with this group and of acknowledging their expertise and unique position on the subject of inquiry, the museum.

The process should seek to build on children's knowledge and experience, and to value their engagement as co-researchers in exploring their own research questions. Through the lens of narrative inquiry we might therefore become more informed and able to access children's stories concerning their wider engagement with our collections and our communities.

References

Alderson, P. (2001), 'Research by Children', International Journal of Social Research Methodology 4: 2 (London: Routledge).

Corsaro, W. (2000), 'Early Childhood Education, Children's Peer Cultures, and the Future of Childhood', *European Early Childhood Education Research Journal* **8**: 2, 89–102.

Costantoura, W. (2000), 'Australians and the Arts', *International Journal of Education & the Arts* **4**: 4 (Sydney: Australia Council).

Eder, D. and Corsaro, W. (1999), 'Ethnographic Studies of Children and Youth: Theoretical and Ethical Issues', *International Journal of Education & the Arts* **4**: 4 (Sydney: Australia Council).

Fielding, M. (2004), 'Transformative Approaches to Student Voice: Theoretical Underpinnings, Recalcitrant Realities', British Educational Research Journal 30: 2 (London: BERA).

Fielding, M. and Bragg, S. (2003), Students as Researchers: Making a Difference, London: Pearson.

Graue, E. and Walsh, D. (1998), *Studying Children in Context: Theories, Methods, and Ethics*, Thousand Oaks CA: Sage.

James, A., Jenks, C. and Prout, A. (1998), *Theorising Childhood*, Cambridge: Polity Press.

James, A. and Prout, A. (1997), *Constructing and Reconstructing Childhood: Contemporary Issues in the Sociological Study of Childhood*, London: Falmer Press.

Kellett, M. (2005), How to Develop Children as Researchers, Thousand Oaks CA: Sage.

Matthews, H., Limb, M. and Taylor, M. (1998), 'The Geography of Children: Some Ethical and Methodological Considerations for Project and Dissertation Work', *International Journal of Education & the Arts* **4**: 4 (Sydney: Australia Council).

Prout, A. and James, A. (1997), 'A New Paradigm for the Sociology of Childhood? Provenance, Promise and Problems', in A. James and A. Prout (1997).

Strauss, A. and Corbin, C. (1998), Basics of Qualitative Research: Techniques and Procedures for Developing Grounded Theory, Thousand Oaks CA: Sage.

PART 3
Managing the Responsive Museum

Introduction to Part 3

Ensuring that museums respond effectively to their audiences and provide creative learning opportunities within and beyond the museum requires supportive leadership and well-developed management structures. This part of the book highlights several aspects of management and looks at its role in ensuring that all the necessary elements are in place to optimize the learning potential for its visitors and users. These might include policies, organizational structures and management of staff and resources, in particular budgets and spaces.

Primarily, the positioning of audience development within the museum's mission and management structure is crucial, as is the manner in which that role is fully integrated into the other roles and functions of the museum. Chapter 11, in describing a large museum service, highlights the need to reflect upon and evaluate current practice in order to decide on future action and priorities. This holistic view of the museum as an accessible learning environment requires a policy that incorporates all the activities across the organization, so that all staff are aware of their contribution to creating, delivering and supporting learning facilities, environments and programmes which are appropriate for their users (see Chapter 9). Authors of both Chapters 11 and 13 argue that museum managers should consult and involve learning and access staff in decision-making and that they should be represented on senior management teams. The role of audience and learning advocates, on projects such as galleries and exhibitions, is discussed in Chapter 12.

The importance of staff training and development is a key point taken up by several authors: from capacity-building, by including visitor service staff and gallery assistants in the delivery of education programmes and services (Chapters 9 and 11), to recruiting specialist staff to secure additional funds from government and charitable trusts as in Chapter 10. A theme that is taken up by Chapters 9, 11, 12 and 13 is the need for regularly creating cross-specialist teams for planning exhibitions and public learning spaces, and developing outreach projects. Chapter 14 looks more specifically at museum education practitioners and the need to identify areas where new areas of skills and knowledge are required, especially when engaging with new audiences. However, Chapter 14 offers a cautionary note: to what extent should museum practitioners be totally 'absorbed' by the museum and its culture? This can lead to being 'institutionalized' and so weaken the direct link with the very publics that museums wish to serve.

Funding is crucial for any project, programme or service. Chapter 10 looks at this issue in depth, in particular how the method of funding itself can shape the content of the project, choice of target group, and the desired outcomes. Chapters 9 to 13 stress

the importance of consultation with communities, stakeholders and colleagues, and of building partnerships, in order to implement projects and to create the long-term relationships necessary for sustainability.

All six authors argue strongly that leaders and senior managers in particular have to listen carefully to their visitors and stakeholders and respond by transforming policies, practices, systems and structures, not only to attract funding but in order to gain the loyalty, support and involvement of the audiences they serve.

Chapter 9

Where Does the Museum End?

Michael Tooby

What Museums Are – Places or Experiences?

There is a recurrent theme in the discussion of institutional innovation and relationships with audiences. Its first statement is that positive outreach, education, learning and access programmes do exist, but often seem to sit at the periphery of organizations' activities. The theme's development is that museums must address a paradox: relationships with groups or individuals not already involved with museums and galleries are hampered by some basic obstacles, which are often the very things which define a museum. Innovative projects intended to engage audiences, therefore, often do not happen in precisely the settings which define museums. The theme states a fundamental tension in planning the overall direction of an institution – that being the question of what defines a museum anyway: is it collections, buildings or experiences?

The process of addressing audiences often begins with museums recognizing the consequences of not seeing themselves – including their strengths – as others do. All museum professionals can cite anecdotes to illustrate this. A personal favourite from my own experience runs as follows:

(Visitor with two small children) 'Do you have a dinosaur exhibition on?'

(Person on desk) 'I am very sorry – no, we don't' [family leaves, disappointed].

(Colleague, overhearing) 'You could have told them about the dinosaurs in the permanent collection galleries'.

More complex lessons learned deal with the museum as a signifier of authority. For example, an outreach worker explains to a group of refugees and asylum seekers that their local museum is free, caters for young people and families, and, having an easily located central hall, would make a good place to meet each other. A few weeks later she discovers that they have not been inside. The neo-classical exterior implies for them that they will be watched and monitored by the authorities, as they are at other similar buildings where there are staff at the door in security guard uniforms, with walkie-talkies and CCTV cameras.

The acknowledgement that buildings with powerful identities, value-laden objects, staff in uniforms, daytime opening hours and so on, can be givens of the

very existence of museums is important. Without that acknowledgement, external perceptions can never be addressed. Important, too, is the recognition that some of the most exciting and successful work with groups such as young people, people from minority cultures, people economically or educationally excluded from participation in museums, or indeed groups whom museums may regard as their traditional audience, has taken museums away from those traditional signifiers. Without recognizing that, the contrast cannot be made between the physical signifiers of a 'museum' and the nature of activity and experience within them (Anderson, 2000).

Recent literature on this subject has considered how we debate or document organizational change which demonstrates progress.[1] Some of the best ways that this literature is shared and debated is through broad, cross-disciplinary and specialist networks of expertise. In Britain, the current online resource *Inspiring Learning for All*, for example, offers a methodology for considering museums and galleries as learning resources. Among museum professionals, the Group for Education in Museums (GEM) debates and responds to many of the ideas set out in *Inspiring Learning for All*.[2] The specialist visual arts education body, *engage*, leads the way in creating networks of understanding good practice, using action-based research to test ideas and innovation both in the UK and internationally. One example is by leading the creation of *Collect and Share*, a European web-based resource. Practitioners 'on the ground' in a variety of contexts share case studies and ideas in order to understand good practice, but also to raise questions about ideas as they become orthodoxy.[3]

Less frequently discussed are projects which have informed change within mainstream institutions. Given that mainstream institutions are often also large organisations, some of the key directorial challenges are to ensure that small teams or committed individuals who develop innovative projects can understand how and whether their work fits in to the organizational culture. I would therefore like to compare how two large, collections-based institutions – one in the UK, one not – have addressed the questions of planning audience initiatives within the core strategies of their work as museums through projects involving target groups, and discuss whether such projects have led to developments within the wider organization. The examples are the National Museum & Gallery in Cardiff, where I am site director and lead director for access, learning and public programmes; and the Art Gallery of Ontario, which for over 20 years I have enjoyed as an occasional visiting researcher and contributor to outreach work.

1 See, for example, Waterfield (2004); in comparison with the case studies in Dodd and Sandell (2001).

2 See, for example, *GEM Newsletter* 13, with particularly valuable discussions of professional issues by a variety of authors.

3 Sources of web-based support can be found at the following: <www.inspiringlearningforall>; <www.collectandshare.eu.org>; <www.engage.org>.

Speaking to People: Wales

National Museums and Galleries of Wales (NMGW) has a long history of generating projects within a continuing programme of education work.[4] Over the last four to five years this has been linked to audience research and the evolution of a policy of learning activity within the organization's corporate planning. A decision was taken to focus on innovative techniques which addressed specific target audiences. The removal of the necessity of a museum visit as a component of the project would test attitudes to the museum as the provider of learning experiences.

The methodology for the project – *Tir Cyffriddin/On Common Ground* – established a clear route from initial audience research, through project design and fund-raising, to the project's delivery and final evaluation.

The project's origins were in the period immediately following the re-introduction of free admission at NMGW. Visitor profiles – as opposed to numbers – were a broad concern at all levels of the museum. Visitor surveys, and surveys of groups who had not visited the various NMGW sites, showed that the 16- to 24-year-old age group was a particular concern, with a notably low level of awareness of museums and galleries.[5]

To respond to this concern, the *Tir Cyffriddin/On Common Ground* (OCG) initiative began in 2003. National Lottery and charitable trust-funding created a dedicated post and a coordinated range of projects. A full-time project manager was supported by an advisory steering group to bring about an overarching strategy for them. Selected groups in target communities were set up through negotiation with organizations at varied geographical distances from the capital city, from NMGW sites, and from other forms of museum and gallery provision: Denbigh, Rhondda Cynon Taff, Pembrokeshire and Swansea.

The aim was to create tools for 16- to 24-year-olds to communicate their own ideas about museums and galleries, the perceived roles and content of such institutions, and how this related to their own localities. The range of museum disciplines – from art through natural history to social and cultural history and archaeology – underpinned the content. In 11 individual community-based projects young people were offered the opportunity to devise their own approach to project work and the end product, responding to the question 'Why not museums?'. The objectives were:

- to increase access to Welsh heritage and culture;
- to concentrate on education for sustainable development;
- to develop the skills of young people in, for example, IT, Web design, communication, oral history, interpretative planning, design, research and

4 The National Museums and Galleries of Wales operates seven museums across Wales, and the National Museum and Gallery in Cardiff is one of these museums. See <www.nmgw. ac.uk> or <www.aocc.ac.uk>.

5 Research carried out for the National Museums and Galleries of Wales by the Research Centre for Museums and Galleries (RCMG), Leicester University.

documentation, and boost their confidence in project development and increase interpersonal skills;

* to train trainers in Community Mapping and Participatory Rapid Appraisal techniques,[6] skills which can be used well beyond the lifetime of the project; evaluate process, methodology and results to establish future approaches and techniques.

Much participant comment was about the wider impact of the projects. However, given that the common content to each was 'Why not museums?', there were some direct statements about this. A typical comment from one participant was: 'It's not that I was against going to a museum, I just thought that I wouldn't enjoy it …', while professional staff involved in running projects said: 'The young people have been surprised and pleased that they were asked their opinions with regards to museums and really enjoyed the creative process in creating their own piece of art'.

Tir Cyffriddin/On Common Ground demonstrated that, although geographical distance and perceptions of museums were seen as being barriers to participation, it was clarified that the perception of the accessibility of museums and the potential for museum experiences were as remote in terms of intellectual and emotional access for groups from nearby as from further away. This is particularly important in a context where much of the wider debate about cultural provision in Wales is to do with how to find the right balance across diverse geographical regions, given that major institutions are situated around the urban centres of the south-east. In a museum which is defined as 'national', the importance of recognizing the 'local' had to be brought to bear. Equally, in a project that was about breaking down barriers to the perception of museums, the participants needed to understand not simply the relevance of museums and galleries, but their own entitlement to expect to be comfortable with, and find value in, the experiences offered by museums. Whether or not a 'visit to a museum' should be defined as a hard outcome of the project was debated within the steering group and project staff. The conclusion was that experience was most important; though 'museum visiting' – any museum – would remain a positive outcome. The project demonstrated both to NMGW and the participants the value of acquisition of skills and experiences, ranging from learning how to schedule a project through to discovering how to work with different people in a team – the crucial 'soft outcomes' – through creative interaction around a core subject; and that these should be confidently expressed as the core goals of such projects. In other words, NMGW staff learned that the task should not be simply expressed as being to introduce new audiences to the museum experience. Instead,

6 Community mapping techniques include ways that faciltators of youth work can use the structured study of localities as tools to empower people and to allow them to develop and apply new skills.

the task was to meet the learning goals of that new audience by using the museum experience, whether or not an actual visit was made.[7]

The methodology to reach target groups such as those involved in *Tir Cyfriddin/ On Common Ground* has now become relatively structured in NMGW's programmes, as it has in many other institutions. Renewed funding has enabled the *Tir Cyfriddin/ On Common Ground* project worker to become a member of staff alongside other learning and curatorial staff. As this project develops alongside other museum work, a dialogue can therefore evolve between this methodology and other methodologies, both well-established and innovatory. Ideas and experiences can be exchanged in a variety of directions. In turn this dialogue generates input into the development of departmental strategies and the planning of projects within the museum across different subject and functional departments, as different templates for audience-centred approaches to projects emerge.

Elements of the templates that are typically used for projects which aim to build audience development are:

- identify a target group and its 'match' against the design of in-house projects;
- consider whether the in-house project is already in existence or needs to be created in order to reach that group;
- build a consultative group, with a variable levels of formality and size, whose members are well placed to advise both the museum and the target group;
- plan work away from the museum in a setting comfortable for the group, then bring the group in a structured way into the museum to connect with the in-house project;
- encourage the group to return by again creating a social activity around a celebration of their own work visible in the museum, through a product such as a retrospective book, exhibition or presentation; consider with the group the future of the relationship with the museum – reinforce, move on or dissolve?

7 Through this recognition, NMGW has used, for example, an outreach collection originally conceived as a loan collection for schools and colleges to be a more flexible resource of objects which can leave the building. In one initiative, objects are used in classrooms by teachers of English to new arrivals in Cardiff, such as refugees and asylum seekers, so that the sense of using a museum environment is brought into the teaching methods of the community education team. In that context, 'acculturation' and life-skills issues such as the use of a free museum as a safe environment can be encouraged. As relationships develop, some groups evolve to become selectors of exhibitions such as small-scale displays of ceramic and glass objects in a programme entitled *You Choose*. In contrast, the *Llybrau Lafar* project uses a series of learning tools and teaching aids to give learners of Welsh an informal programme of activities as they visit the Museum of Welsh Life. Staff such as museum assistants in first-line contact with visitors are trained to recognize and respond to the questions and exercises in the pack.

For example, in a project about NMGW's part in the UK tour of a famous work of art, Raphael's *Madonna of the Pinks*, an education curator, having identified a match between a target group and the potential of the touring exhibition, led an in-house team working with a group of young mothers in the particularly deprived areas of the Rhondda and Cynon valleys, the relationship facilitated by a local support group. The project focused on the experience of understanding imagery of mothers with small babies. Artists and interpreters worked together with the participants to articulate how imagery of women with small children is created and consumed. In this case a visit to the exhibition was planned as an outcome of the project. However, it was crucial that participants' motivation for the visit was to see their own work shown in a separate space with its own separate identity, not simply as a further method of 'interpreting' the Raphael itself.[8]

It is the point at which such projects return the participants to the question of a museum visit – perhaps to see their own work – that brings the real challenge. How do museums understand the kind of high-quality, often deeply felt, experiences that the participants know to be possible from their 'off-site' projects? How do these compare with the 'real' museum experience? What if, discovering the experiences created by museums or galleries through their own cultural settings – their community centre, their local drop-in 'club', their own homes – they then seek to find them again independently through visiting museums and galleries in their own time – will it be their museum?

NMGW, like many other museum services, is therefore seeking to replicate these off-site practices and experiences through new facilities within its core spaces. It is introducing flexible spaces and zones in its renewal of displays and presentation of exhibitions. Handling areas and interactive resources (people-based not IT-based) are being developed in new galleries and exhibitions. As it develops new projects, it is looking at how consultation can help form the product and the audience in a mutually beneficial way. This often allows a confidence towards the range of activity a museum undertakes. What may seem simple, straightforward, and not terribly 'innovative' projects, such as making drawing materials available in the collections galleries, are recognized by the staff involved as the product of listening to visitors and audiences. It is supported not only by specialist educators, but also by invigilation staff. They are in a more relaxed uniform, and, equally crucially, part of a training programme which ranges from talks and discussions on exhibition content, through to co-mentoring: the aim is to enable them to feel confident about interacting with audiences when dealing with self-directed activity or facilities without the presence of a specialist educator or curator.

8 Draft interim report by Jocelyn Dodd, RCMG Leicester, distributed through Museum Monitor website, <info@mccastle.com>, March 2006 (subscribers only).

Learning to Experiment: Canada

The Art Gallery of Ontario (AGO) in Toronto has one of the most firmly established education functions of any major public art gallery. Throughout its history it has considered the potential of, and the issues arising from, reflexivity with audiences. At the heart of its building is a traditional gallery learning space, which for most UK institutions, is of an unimaginably large and well-equipped scale.[9] However, one of the key ways the AGO has sought to put into practice its learning agenda is to test how the concept of learning and engagement moves beyond this dedicated space. The AGO has questioned how learning and audience-centred initiatives relate across museum functions, and how these allow long-term organizational development to be informed by the experience. In particular, it has sought to learn lessons about those audiences which were reached through outside projects, thus enabling an understanding of their presence within the museum building and the organization itself.

To take a benchmark in the recent past, the 1996 project *Oh! Canada* brought a variety of different programme and outreach initiatives together. A substantial touring exhibition about the Canadian artists known as the Group of Seven[10] was mediated by a series of projects about concepts the Group of Seven signify: nationalism, identity, and images of the land. In order to permeate the issues through the entire relationship network of the institution, projects in different Ontario communities came 'back in' to the museum. In connected gallery spaces six groups created their own exhibitions which documented year-long projects. Each project took the way 'landscape' was a vehicle for creating culturally specific meanings. Alongside First Nation, Chinese and groups from culturally specific backgrounds were an environment awareness group and a group of recent immigrants drawn from an English-as-a-second-language class. Much of the impact of the project came from the design work of Bruce Mau.

The project included combining merchandising, staff uniforms and learning activity, connected in a component using the phrase 'My Canada includes ...'. T-shirts were made for the shop using a variety of images from the exhibition; but visitors could order different versions, whereby alternative images of what 'my Canada includes' could be screenprinted in. These were in turn then used by gallery staff to reflect their own personal imagery alongside the brand identity of the exhibition.

Following this project, the AGO has addressed a number of outcomes of *Oh! Canada.* Despite the long commitment to addressing diverse audiences, the organization still had many lessons to learn. One was its ability to collect the material generated by the communities with which they were in dialogue. Another was the perception that community groups were, by definition, seen as not core

9 A particularly rich way of appreciating the development of the Art Gallery of Ontario's education work is by looking at the work of its founding spirit, Arthur Lismer, a member of the Group of Seven, in Nairne Grigor (2002).

10 *Group of Seven: Art for a Nation* exhibition catalogue, National Gallery of Canada, 1996; *Oh Canada!* season leaflet in newspaper format, Art Gallery of Ontario, Toronto, 1996.

to the organization. Whilst curatorial and education departments might address these from the 'inside looking out', task-and-finish advisory committees specific to different cultural minorities were created to provide ideas and comment back in. These provided safe contexts for the museum and the community to discuss what each saw in the other. They also led to natural mechanisms for different organizations to connect with each other's work across different audiences and communities of interest.[11]

The AGO is now 'testing' collection installations in advance of a new phase of major capital redevelopment, and is using such groups to consult over the process. In a recent installation of recent works by Inuit artists, *Art in Motion*, the debate about the spiritual function of an object from a marginalized culture ritual being decontextualized by its ownership by a museum was assertively re-stated in a collection display. Twenty sculptures, by artists of Inuit background, include four raised up on a plinth. This sits in front of a huge video projection and soundtrack. On the projection, historic footage of dancing at Baker Lake is intercut with new footage of a young Inuit woman in traditional dress, who slowly turns while gently beating a drum. This is not simply a demonstration that the object is intimately bound up with a ritual dance. It also combines what might be seen as 'interpretation' with 'exhibit', blurring the experience in a way that re-balances the status of the museum object dislocated by the institution from its social and spiritual origins.

As the AGO continues to develop collection and temporary displays, in continues such integrated and consultation base approaches. This sometimes forms into 'seasons' such as Tauqsiijiit, a residency-based programme, or follow up work around Inuit material entitled 'Llitarivingaa / Can you recognise me?'; others involve new consultation processes around specific interventions, such as approaches to labelling or sound interpretation. The process whereby a series of consultative groups via collecting moves on from the 'one-off' project liaison group and becomes established with each AGO collection display with a particular target audience is invisible to the general visitor. To that target audience it is a fundamental component of the institution's credibility.[12]

The key organizational lesson demonstrated by the project, however, is not so much the exhibit, but the capability of the organization to present it. The woman on the video turns out to be a member of gallery staff. Following the decision to establish the installation, not merely was she able to offer the understanding of the ritual dance, but she is able to continue the impact made in its presentation through interaction with colleagues in the normal course of her work. This is a small but

11 There are a variety of projects which reflect the different ways in which the AGO has addressed its work in this area. A contrasting example is the season of *All Things are Connected: A City-wide Celebration of Aboriginal Perspectives*, Toronto, February/March 2003; and a comparator historical collection installation, *No Escapin' This: Confronting Images of Aboriginal Leadership*, in April 2003.

12 Programme leaflets and background documentation available through Art Gallery of Ontario, or via www.ago.net.

vivid illustration of the power of addressing diversity within the organization, rather than seeing a minority cultural group as securely beyond it and needing 'outreach'.

The Centrality of Experience

How traditional organizations reach audiences is today set in a complex political and managerial atmosphere in the UK. A wide community of individuals and institutions are taking on an audience-centred approach, learning from common and particular experience. Many of the organizations which emerged in the early years of lottery funding as alternative learning experiences to museums have failed for lack of well-established content, such as the Sheffield Popular Music Centre or the Faith Centre in Bradford. More recent lottery-funded refurbishments have celebrated the founding principles of museums, such as that at Manchester Museum. However this has led to new tensions about the 'core' functions' of museums being defined as those traditional signifiers – authority; static, historically defined collections – being connoted with traditional museological and pedagogical behaviours.

At the same time, a complex reaction against using audience responsive projects is taking place. Some feel that it is time to recognize the 'down side' of using learning activities, emphasizing the perception that these are *audience-led* initiatives, seeing them as social engineering. They feel the need to reassert the value of what is seen as core activity. This is exacerbated by the continuing lack of investment in some museum functions and the 'tagging' of funding to selected initiatives. A confused reaction is created to the promotion of access, which is exploited by conservative forces when choices are made and decisions taken in the allocation of budgets and staff time.[13] Whether 'responsiveness to audience' is simply a gesture to gain credibility with political stakeholders and funders can be a genuine question, a self-reflective act, demanding an honest approach within institutions when professionals assess the successes of projects. The question of how much museum and gallery practice necessarily resides in their core identities as buildings and collections of objects might therefore be posed in a different way: what can museums and galleries do to embed the experiences of learning, outreach and audience-centred activity in the entire range of settings available to it, from the core structures of the traditional institution to its various non-traditional settings, beyond its buildings? How does

13 References to the 'backlash against inclusion' are covered in *Engage Review* **11**, subtitled *Inclusion Under Pressure*, particularly the essays by Bernadette Lynch (Lynch, 2002) and Liz Ellis (Ellis, 2002). This issue was in part prompted by the Institute of Ideas programme and booklet called *Museums for 'The People'?* (2001), particularly contributions by Mark Ryan and Charles Saumarez-Smith. Mark Ryan also challenged the utilization of cultural institutions in the social inclusion agenda in 'Manipulation Without End', in M. Wallinger and M. Warnock (eds) (2000). Further comment on these statements appear in Dodd and Sandell (2001). In comparing these articles, and the measurement of institutional change in providing access, see an example from another museums discipline area in Harvey (2005).

the institution as a whole understand all these available settings and practices in a consistent manner? And how can a definition of quality be reasserted in this consistent approach, whether people experience museum work in their local community centre, or in the grandest of galleries?

The challenge for institutions therefore becomes how this sense of generating high-quality experience throughout its work is understood and acted upon by the whole organization. How does the organizational culture create staff teams, structures and systems of consultation so that the lessons gained from the 'added value' are re-embedded as fundamental to all the organization's work? One simple route to this that we have been seeking to apply at NMGW is cross-referencing skills and interests from the different specialist communities within the institution. Within a staff of over 650 across the organization's seven main sites, this obviously ramifies in different ways. If one takes project teams for major exhibitions at NMGW, for example, considering the role of active learning within exhibitions, teams include a range of curatorial, programme and visitor services staff, alongside education and marketing staff, but also, by virtue of the breadth of their contacts with learning projects, those with knowledge of programming and staffing of activity spaces within exhibitions. This means that the range of staff, whether employed in an 'education department' or a 'curatorial department' or indeed in roles such as 'marketing and communications' or 'visitor services and security', must work together at a consistent level to ensure the success of the whole.

The debate is no longer, therefore, whether (or not) to have exhibitions which create activity-based experiences alongside observing and looking experiences; but how they will operate successfully within each project as they develop. Not only do those staff with experience of audience-centred practice have key roles in planning and programming in the first place, they must also develop as internal sources of expertise on how the goals of such a practice cascade into other areas of activity. This increasingly includes understanding of audiences, and the inter-relatedness of different components of museum and gallery practice, from administrative and building management functions to collecting policies. This approach prompts, for example, a genuine approach to diversity in an organization's recruitment policies so that, as at the AGO, the diversity of the collections can be interpreted by diverse voices within – as well as beyond – the museum.

One way in which organizations can do this is through a revised approach to professional development. The non-building-based membership agency, *engage*, works collaboratively to help professionals articulate and improve their role in promoting a responsive approach to audiences.[14] This is founded in research about education staff. 'Education' as a role is still not fully understood by the wider museum and gallery workforce, and does not have a profile as a dedicated career.[15] Equally,

14 *engage* operates across the UK and internationally: information about it can be accessed at <www.engage.org>.

15 In a 2003 members' survey, *engage* found that 89 per cent of those currently working in gallery education roles had had no knowledge that such roles existed in institutions when

such work depends on collaboration between staff with roles outside those formally designated as 'education'. The *Creative Renewal* project, run by *engage* operates in three urban centres (Newcastle-upon-Tyne, London and Liverpool). Artists, institutions and *engage* staff work with schools and teachers to structure and deliver careers advice and placements. Necessarily, this both raises awareness of the range of professional possibilities within museums and galleries as well as the specific area of learning through the visual arts. This kind of work operates alongside *engage*'s programme of action research, such as the *Get it Together* programme, where case studies promote they ways in which multi-disciplinary teams can work together with local communities to generate new insights, learning experiences in museums and libraries, and thereby ownership and understanding of the institutions themselves.[16]

Conclusions

Much of the discussion of museums and galleries has centred on the pressure to commodify; that is, to commercialize and generate high numbers and high business turnover.

It is important that the other side of the coin, engaging people in the small-scale, experiential dimensions of museum work and establishing a strong relationship with meaningful audiences, is understood as equally demanding on museum managers. It is important to understand the potential impact of placing understanding the audience at the heart of a museum or gallery's work, however large or small.

Soon after I had visited the Art Gallery of Ontario and discussed with its staff the importance of its audience-centred work, three relevant articles appeared in the April 2004 issue of the *Museums Journal*. One reported on how an important regional English museum and art gallery, Cartwright Hall in Bradford, had infiltrated itself into a 'layer' of a mass-market computer game (Heal, 2004). Another described the initial evaluation of the education and audience-development related components of the *Renaissance in the Regions* initiative in England (Nightingale, 2004). A third announced the closure of Daventry Museum, a small museum in a small town in Northamptonshire (Heywood, 2004).The project to infiltrate Cartwright Hall into *Unreal Tournament* by the Bradford Museums Service might be said to be precisely the kind of museum project designed to by-pass prejudicial obstacles. It is led by Steve Manthorp, whose personal skills at engaging creative projects are empowered by his designation as 'special projects officer'. The actual experience of visiting one of Britain's definitive Victorian institutions is both encouraged and questioned by creating a wonderfully insidious version of it. Ownership of the museum is vested in virtual visitors; and the awareness that such a possibility exists shifts the sensibility with which the museum is perceived by real visitors. The validity of the game as a strategy to generate ownership, however, only works by being one component

they had left secondary education.

16 *Get it Together* projects report, 2002, London: *engage*.

among many of a museum service committed to a wide range of local and specific projects.

The initial evaluation of the impact of *Renaissance in the Regions* catalogues what many would cite as typically imaginative and resourceful projects, achieving diverse learning outcomes. One of the key findings was encouraging: 'museums build powerful and identity-building learning in children, young people and community members', but its conclusion warns:

> The challenge now is to find the structures and the means to use the power to inspire learning and to build identities more effectively and more consistently. The research found barriers to the realisation of this power in those aspects of museum culture that marginalised educational work, in the capacity of museums to respond to the demands of ambitious educational programmes, and in the limited expectations of museum users and partners who did not know how to maximise the learning potential of museums.[17]

The situation for Daventry Museum was simple but stark. An historic building, the former Moot Hall, housed a small eclectic collection related to the locality. One might have expected this to seem crucial for a community which had been transformed over the second half of the twentieth century. This transformation, from an attractive small market town to a sprawling anonymous new town, was itself a potential subject for a well-run museum. It was announced in 2000 that:

> Daventry Museum [has] been awarded £355,882 by the Heritage Lottery Fund. This grant will part fund a £720,000 overhaul of the museum, to include an extension of the museum, an education room, and new display areas. Work will begin in summer 2001 and is due for completion in summer 2002.

However, announcing the closure of the undeveloped museum and the redundancy of the three professional staff in 2004, the manager with overall responsibility, the head of environment and recreation services at the local council, said 'There was no major outcry, which goes along with the survey we have done.' In other words, why run something for which there was no audience, no 'demand'?[18]

Few senior figures in public museums and galleries would articulate such a stark imperative to reach audiences, where the apparent inability to do so allows their funding and governing bodies to find it impossible to justify their existence. Daventry Council was not looking to present a paternalistic argument for taking a lead, in delivering what a civic community 'should have'. Neither did the council propose that the museum find new ways of meeting an economic need, such as generating visits to the town centre. Instead they determined that a measure of audience response would suggest no one cared if the museum went, therefore it could be closed.

Generational change means that we now are beginning to see personalities in institutions who are confident about audience-centred (as opposed to audience-led)

17 See the report by Hooper-Greenhill (2004).
18 See the *East Midlands Museums Service Newsletter*, November 2000.

strategies, seeing such strategies as more confident and attractive approaches to curating – in contrast to the old cliché that audience-led approaches challenge the authority of the curator. The concept of audience-centricity can counter the cynical view of institutions needing to be 'audience-led'.[19] Museum professionals concerned that practice was being pushed into a combination of numbers against politically correct tick boxes can ask questions of themselves more confidently if the goal of a responsive organization is clear: to ensure that projects are seen as relevant, high-quality and enhancing experiences.

In order to ask the question, 'Where does the museum end?', it is essential that those working within the institution understand the limitations of seeing the museum as the end in itself. The foregrounding of audience-centred approaches in everyday functions is in fact to argue for the centrality of the fundamental definitions of museums in being museums. It is part of a simple recognition. That for museums and galleries to be responsive and visitor-centred, it is the everyday activity of what in its core functions (at all levels of decision-making and spaces) that matter most. Unless museums genuinely espouse this, museums will, indeed, end.

References

Anderson, D. (2000), 'The Shape of Things to Come?', in N. Horlock (ed.) (2000).

Appleton, J. (2001), *Museums for 'The People'?*, London: Academy of Ideas.

Art Gallery of Ontario (1996), *The* Oh! Canada *Project*, project programme document, Toronto: Art Gallery of Ontario.

Dodd, J. and Sandell, R. (eds) (2001), *Including Museums: Perspectives on Museums, Galleries and Social Inclusion*, Leicester: Research Centre for Museums and Galleries.

Ellis, L. (2002), 'The Backlash to Access', in *Engage Review* 11, Summer, 40–42.

engage (2004), 'Museums and Galleries as Learning Places', *Engage Review* 'extra', special issue of papers for LERNMUSE and Collect & Share, London: engage.

Graham, J. and Yasin, S. (2005), 'Reframing Participation in the Museum: An Homage in Three Parts', in G. Pollock and J. Zemans (eds) (2005).

Harvey, M. (2005), 'The Darwin Centre and Beyond – Access to Collections, Access to Ideas', paper presented at the Politics and Positioning Museums Australia National Conference, 1–4 May 2005, Sydney.

Heal, S. (2004), 'Weapons of Mass Destruction meet Masterpieces of a Municipal Gallery in a New Level of the Computing Game Unreal Tournament', Museum Journal, April, 22–3.

Heywood, F. (2004), 'Daventry Museum Closes Doors', Museums Journal, April, 9.

Hill, R. (2005), 'Meeting Ground: The Reinstallation of the AGO's McLaughlin Gallery', in L.A. Martin (ed.) (2005).

19 For the confidence generated by an 'audience-centred' approach, see the approach of the New Art Gallery Walsall, as reported in, for example, Jenkinson (1997) and Tooby in C. McDade with H. Curnow (eds) (2000).

Hooper-Greenhill, E. *et al.* (2004), *Inspiration, Identity, Learning: The Value of Museums*, Leicester: DfES.

Horlock, N. (ed.), (2000), *Testing the Water: Young People and Galleries*, Liverpool: University of Liverpool and Tate Liverpool.

Jenkinson, P. (1997), 'Custom-made: Making', *Engage Review* 2, Spring, 3–7.

Lynch, B. (2002), 'If the Museum is the Gateway, Who is the Gatekeeper?', *Engage Review* 11, Summer, 12–21.

McDade, C. with Curnow, H. (eds) (2000), *Building the Audience: Audience Development and the Development of the New Art Gallery Walsall*, London: ACE.

Martin, L.A. (ed.) (2005), *Making a Noise*, Banff: Walter Phillips Gallery/Banff Centre Press.

Nairne Grigor, A. (2002), *Arthur Lismer, Visionary Art Educator*, Montreal: McGill-Queens University Press.

Nightingale, J. (2004), 'Lessons in Learning', *Museums Journal*, April, 24–7.

Pollock, G. and Zemans, J. (eds) (2005), *Museums after Modernism*, Oxford: Blackwell.

Resource (2001), Renaissance in the Regions: A New Vision for England's Museums, London: Resource.

Ryan, M. (2001), 'Introduction', in J. Appleton (2001), pp 8–9.

Ryan, M. (2000), 'Manipulation Without End', in M. Wallinger and M. Warnock (2000).

Saumarez-Smith, C. (2001), 'A Challenge to the New Orthodoxy', in J. Appleton (2001), pp 39–41.

Tooby, M. (2000), ' "Blue" in the New Art Gallery, Walsall', in C. McDade with H. Curnow (eds) (2000).

Wallinger, M. and Warnock, M. (2000), Art for All: Their Policies and Our Culture, London: Peer.

Waterfield, G. (ed.) (2004), Opening Doors: Learning in the Historic Environment, London: Attingham Trust.

'… and there is no new thing under the sun'

Alec Coles

In the light of the apparent debate articulated here, over the hallowed buildings (and collections and displays and stores and conservation studios …), it is perhaps appropriate to introduce this piece with a quote from Ecclesiastes. The real reason I use this, however, is because this hackneyed argument should have run its course many years ago.

It never ceases to make me smile at our sector's self-congratulation at its radical practice: our recent engagement with new and young audiences; our work with people with disabilities. I then refer to committee reports from the early 1900s which log the hundreds of young children who turned up at the Hancock Museum in Newcastle upon Tyne on Saturday mornings, or to the photographs of the Curator in Sunderland Museum, in 1910, working with blind children, allowing them to touch the Museum's 'star' exhibit – Wallace the lion. In both cases, I am confident that the socio-demographics of those audiences would have matched anything we achieve today, perhaps with the exception of BME (black and minority ethnic) communities.

In-depth engagement with wide and diverse audiences, driven by the underlying philosophy and policies of the museum, is not new, although perhaps it is still being re-discovered.

Audiences, or as I prefer, 'users' have always been at the centre of the public museums movement in the UK. I am pleased that it is a tradition that we have maintained in policy and practice, but I still wince when some suggest that our core business is looking after collections. There is no question that collections are our USP (unique selling point), but our core business is surely using them for the good of society, and to enrich people's lives?

I am proud that the organization that I lead, Tyne & Wear Museums (TWM), has the largest learning team of any culture and heritage organization that I know in the UK. But I am more proud that the desire to communicate and engage with audiences, I believe, permeates our whole staff, our volunteers and our governing committee. *All* staff, for instance, receive 'Welcome Host' training: a small point perhaps, but it recognizes that *all* staff are engaged with users in some way or another.

Our mission is 'To help people determine their place in the world and define their identities, so enhancing

their self-respect and their respect for others'. We have had this for some seven years, or a version of it, and it still attracts an interesting combination of admiration and derision, although much more of the former. Criticism is usually along the lines of 'But it doesn't mention collections or museums'. This is quite deliberate: collections and museums are the tools of our trade, but our mission articulates *why* we do what we do and why we have, I think, a justifiable call on the public purse.

I am not so naïve as to suggest that all staff could quote our mission verbatim; however, most, I think, understand that it sets the tone and philosophy for our organization and makes TWM what it is. It is also the reason why all our staff, regardless of their title or team, have a responsibility to deliver learning, just as they have a responsibility to our collections, and to advocate our work.

This year we are taking our mission and planning process a stage further. Not only will the principles of the *Inspiring Learning for All Framework* cross-cut all our activities, but we will also be organizing our plans and policies under the following headings:

- Children and young people
- Economy, enterprise and regeneration
- Safer, stronger and healthier communities
- Lifelong learning
- Modernization and performance
- Stewardship of our collections and buildings.

This is a deliberate effort to map our activity to the environment in which we operate. It is absolutely *not* about changing our behaviour to respond to government agendas but absolutely *is* about being responsive to the needs of our users and, to put it baldly, the people to whom we are accountable.

The Funding Challenge

Phyllida Shaw

Introduction

This chapter looks at the recent explosion in funding opportunities for museum and gallery education and audience development, and at the challenges faced by those whose job it is to convert those opportunities into cash. While the focus is on museums and galleries in England, their experience should be of interest to any society where museums rely on a combination of public, private and charitable funding sources.

The chapter begins with an illustration of the complexity of the contemporary museum fundraiser's role. It considers the impact, on funding patterns, of the museum sector's lobbying in the 1980s and 1990s and of the election of a Labour government in 1997. The government's interest in the potential of the cultural sector to achieve social, economic and educational objectives and its willingness to pay for results have led to the creation of entirely new government funding programmes for museum education and audience development, broadly defined. The evaluation of the first of these informed the development of their successor programmes and, to the regret of some museum education professionals, resulted in too strong an emphasis on learning outcomes.

The National Lottery has become an important, if time-limited, source of funds, but this too is increasingly linked to government priorities. Grant-making trusts are more likely to take risks and less likely to ask applicants to predict the outcome, while the corporate sector remains a loyal supporter of museum education programmes. The chapter concludes with the author's view of the main funding challenges for museum education and audience development.

The Funding Challenge

The task of financing the quantity, quality and diversity of education and audience development activity now being delivered by Britain's museums and galleries is demanding unprecedented levels of knowledge and skill. While in many smaller museums the director is still chief fundraiser and in others, the education programme depends on the fundraising abilities of the education officer, there are more fundraising professionals in the sector than ever before. Twenty years ago, it was

rare for a national museum to be employing more than a handful of fundraisers. Today, most have development departments dedicated to securing grants, donations, sponsorship and support in kind from public, private and charitable sources.

Every museum or gallery with an educational remit (whether national, local authority, university or independent) is looking for funding to support their education and audience development work. While museum directors insist that they are part of their core purpose, core budgets cover only part of the cost. There may be a permanent post or two supported by a recurring grant, but the work for which Britain's museum and gallery education departments receive such applause, from their peers in other countries, is almost always dependent on the necessary funds being raised.

The funding challenge has several dimensions. One is the expertise to research potential sources. Another is the time to apply the expertise. A third is the capacity to respond, often at lightning speed, to unexpected opportunities (usually towards the end of the financial year). A fourth is the willingness to work in partnership, perhaps with another museum on a joint proposal, or with a funding body keen to be involved in the development of a project.

The growth in funding opportunities for museum and gallery education, since the late 1990s, has caught the imagination of museums' governing bodies and senior managers. It is enabling them to put on more programmes and to attract new audiences and, in some cases, it is making a net contribution in financial terms. The competition for funding is, not surprisingly, intense.

Specialist Fundraisers Wanted

In response to these opportunities, the museum fundraising profession has become more specialized. Some fundraisers have become experts in European, national government and other public sector schemes. Others have a detailed knowledge of grant-making trusts. Some concentrate on commercial sponsorship, donations, corporate social responsibility and support in kind, while others specialize in individual giving through donations, legacies, friends' and patrons' schemes.

The jobs pages tell their own story, highlighting the diversity of skills and experience required of museum and gallery fundraisers. The emphases in the following paragraphs are mine.

In the summer of 2005, the National Museum of Photography, Film and Television (NMPFT) was looking for a Development Director. The advertisement began:

> Already operating in a senior fundraising role, ideally within the cultural and heritage arena, you will have a track record of securing *creative funding solutions* from both *public and private sector partners*. As a strong *advocate* for the museum, your *exceptional influencing skills* will enable you to enthuse potential sponsors and *engage them* with the delivery of the cultural and educational remit.

Museums and galleries are popular with sponsors. While blockbuster shows in the national and major regional museums attract the lion's share of the money, some

of the smaller, architecturally interesting museums and galleries are finding that they can attract sponsors in search of an unusual venue. Museums are also securing donations from corporate foundations and community affairs budgets (as distinct from sponsorship from the marketing budget) and involving staff through corporate social responsibility programmes.[1]

While the NMPFT was looking for a Development Director, the National Museums and Galleries in Wales was advertising two posts. One was for 'a Development Officer (Statutory Sources) ... to be responsible for securing funding from *European and other statutory sources* and for *managing the reporting and recording requirements* of new and existing funders'. The other was for 'a Development Officer (Individual Giving) ... to coordinate and manage *donor recruitment and development*, primarily through *individual giving* schemes such as the Patrons'.

European programmes have been a significant source of funding for capital projects and employment-based programmes since the 1980s. The recent expansion of the European Union is bad news for museums and galleries in areas of the UK that are poor by British standards but affluent by comparison with the new member states. New EU programmes come into force in 2006 and fundraisers looking to Europe will need to be more resourceful than ever.

Individual giving is still relatively undeveloped in Britain, although Gift Aid has made it more attractive to both givers and receivers.[2] As the number of affluent people grows, so too does the hope that more of them will donate to museums and galleries but, with a few high profile exceptions, this is not yet the case and UK-based fundraisers continued to look enviously to the US and the long tradition of individual giving to local and national cultural institutions. What museum directors on the other side of the Atlantic know, and their British counterparts may be reluctant to accept, is that it takes years to build relationships with donors. There are few 'quick wins'.

The launch of the National Lottery, in November 1994, created a demand for fundraisers with experience of capital fundraising campaigns. In the early years, Lottery grants were almost all for new buildings and refurbishment schemes. The Heritage Lottery Fund (HLF) and Arts Council England awarded millions of pounds to museums and galleries, all of which needed to be matched from other sources (usually at least 10 per cent of the total). Although the Lottery distributors have since broadened their focus and the building boom is over, museums are still looking for capital funding. In June 2005, the National Museums Liverpool was advertising for a head of development 'whose success on major capital campaigns will be supported by extensive experience in corporate fundraising, sponsorship and development'. In the same week, the Tank Museum, in Dorset, was advertising for 'an energetic,

1 <www.aandb.org.uk>

2 Gift Aid enables the receiving charity (the museum, in this case) to claim back from the Inland Revenue the tax that the donor will have paid on the money donated (currently 28 pence for every pound donated). Higher rate taxpayers are able to claim back the difference between basic and higher rate tax (up to 23 pence in the pound).

professional, experienced fundraising manager, able to lead and execute a fundraising and public relations strategy to raise over £5 million of capital partnership funding to match [a] major HLF grant towards a £16 million redevelopment scheme'.

The Assertive Museum

During the 1980s and 1990s, the UK's museums sector asserted itself as never before. It campaigned against cuts in public funding and learned to articulate the contribution that museums make (and with more resources *could* make) to society, in cultural and educational terms. The resources now available for museum education and audience development are a direct result of the way the sector has promoted itself to government and the way in which public and other funders have responded.

Other chapters look in more detail at the structural and policy developments that have affected the relationship between government and museums and galleries and this discussion of funding challenges takes place in that context. The loudest wake-up call came from *A Common Wealth: Museums and Learning in the United Kingdom* (Anderson, 1997). This report considered the role of museums as 'centres for formal and informal learning' and argued for a greater investment of resources (by government and by museums themselves) in that historic role. There were references to lifelong learning and cultural exclusion, the scope for schools to make more use of museums as 'a learning resource', the need for evaluation and for training for museum professionals, the benefits of working with partners, and the potential of the National Lottery (then just over two years old) as a source of funding.

A New Relationship with Government

Who knows what course the funding of museum education and audience development might have taken, had the Conservative government remained in power, but at the General Election of May 1997, the Labour Party won with a large majority. The Department of National Heritage (DNH) was replaced by the Department for Culture, Media and Sport (DCMS) and Chris Smith, a politician with an evident enthusiasm for his portfolio, was appointed Secretary of State for Culture.

It soon became clear that the new government would expect cultural organizations in receipt of government funding to help it to achieve its objectives. The directly funded national museums and galleries would find those objectives reflected in their funding agreements, university museums would be financed to engage with the wider community, and galleries supported by the Arts Council, that included education, audience development, increasing public access and tackling social exclusion among their objectives, were likely to have more funding at their disposal.

Opportunities or Threats?

For some museums and galleries, the Labour government's proactive interest in the cultural sector has been a breath of fresh air and its support for education and audience development has been warmly welcomed. For others, it has been an unacceptable challenge to the arm's-length principle.

Museums and galleries of course accept that funders have objectives. Government departments, grant-making trusts, sponsors and private patrons are all seeking to achieve something in return for their money. Organizations that succeed in raising funds from a variety of sources do so because they are doing something that funders want them to do. For most museums, the objections to the government's funding programmes seem to have less to do with the fact that the government is expecting something in return and more to do with *what* they expect the funding to achieve.

Two funds for museum education were launched in 1999, one sponsored by the Department for Education and Employment (DfEE) and the other by DCMS, in partnership with the Museums and Galleries Commission (MGC). The DCMS/MGC Education Challenge Fund was worth half a million pounds and was designed to help local and regional museums develop their education services. The programme was a response to a need identified by the MGC and was a forerunner of the much larger and more wide-ranging programme, *Renaissance in the Regions*.

The DfEE's *Museums and Galleries Education Programme* (MGEP) aimed to provide 'effective learning opportunities' for five- to sixteen-year-olds, using museum collections and facilities'. [3] MGEP1, as it came to be known, ran until 2001 and spent £3 million on 63 projects. The evaluation of the programme by Leicester University's Research Centre for Museums and Galleries (RCMG) helped to secure a second round of funding (£1 million) from the renamed Department for Education and Skills (DfES) and a more effective method of allocation. This time the money was distributed through the nine regional offices of the Museums, Libraries and Archives Council (MLA, the successor to Resource which earlier replaced the MGC) and engage, the national association for gallery education. Each of the ten distributors had £100,000 to award to museums and galleries with proposals that aimed to achieve specific learning outcomes[4] and access objectives. Between 2002 and 2004, MGEP2 supported 130 projects.

3 The following year, 2000, the DfES launched the *Museums and Galleries Lifelong Learning Initiative* (MGLI), a three-year programme designed to identify and develop good practice in designing and delivering lifelong learning projects 'with new groups' in museums and galleries (Gould, 2004).

4 The learning outcomes for pupils were:
- fulfilment and satisfaction from achievement
- increased learning within the subject area
- increased understanding of connections between subjects
- increased learning across subjects
- increased self-confidence and self-esteem
- increased cultural understanding and respect and tolerance of others

The DfES was keen to ensure that the lessons learned from MGEP1 would inform the practice of other museums and galleries and it commissioned the RCMG to produce a set of examples of good practice (Clarke *et al.*, 2002). MGEP2 was evaluated by Warwick University's Centre for Education and Industry. This evaluation focused on the impact of working with museums and galleries on students' and teachers' learning, and on young people's access to museums and galleries (Stanley *et al.*, 2004). While the attempt to measure the changes (or outcomes) induced by the MGEP is interesting, it will be of only limited value unless provision is made for the measurement of the long-term impact of such activities. If, in 15 years' time, a team from Leicester or Warwick were commissioned to report on the use made of museums and galleries by young adults who were participants in the MGEP, we would perhaps learn something new.

While museum education teams have been enjoying this funding bonanza, their work has never been so closely scrutinized. The government makes regular references to the need for 'evidence-based policy' and publicly funded organizations, in every sector, have been encouraged to demonstrate that they are achieving what they anticipate they will and that they are offering 'value for money'.[5]

The evaluation of the MGEP has had a direct bearing on the education plans now being implemented by the nine regional museum hubs supported by *Renaissance in the Regions* (2003–06). This programme, which includes £12.2 million for education services, achieved in its first year a 28 per cent increase in the number of schools taking part in educational activities with the hub museums and, to the evident satisfaction of Secretary of State for Culture, Tessa Jowell, 'nearly half of all visits [came] from areas rated as among the most deprived in England'.

The preoccupation with numbers continues to irritate museum professionals who argue, rightly, that numbers mean little if the quality of the experience is not also taken into account. Another concern has been the short-term nature of these programmes. Why is it that they run for only two or three years? The government has been funding similar kinds of education activity for more than six years but in planning, evaluation and budgetary terms, the museums participating in the different programmes have had to work to much shorter timescales. The sponsoring departments might argue that they cannot guarantee to support anything longer term, yet in 2003, DCMS and DfES launched a three-year *Strategic Commissioning Museum Education Partnerships Programme*. It was inevitable that a general election would interrupt it at some point, but they were prepared to take the risk.

- increased ability to work with others
- increased involvement in class, school and community events
- the ability to make informed choices within and beyond the planned experience
- positive attitudes to the experience and a desire for further experiences.

5 The government also contracts voluntary sector organizations to deliver services. The management of a funding programme by engage, on behalf of the DfES or DCMS, is a small-scale example of this practice.

The *Strategic Commissioning* programme continues with the theme of 'learning projects' involving partnerships between national and regional museums. In the first year, 12 projects received between £50,000 and £350,000 each. The project budgets were larger but the programme came in for heavy criticism, from the museums and the evaluators, for offering a lead-in time of only a few weeks. The programme was announced in February 2003 and bids had to be in by March. The departments argued that this was an opportunity 'to develop long-held ambitions, to move forward with strategic plans at a faster pace, to review and change current programmes and to extend existing work in new ways', but it was, by any measure, a crazy timescale (Hooper-Greenhill *et al.*, 2004).

The museums, galleries and collections run by universities have been given rather more notice of the introduction of a new single scheme, administered by the Arts and Humanities Research Council (AHRC). One of the aims of this is to improve access to university museums for 'the wider community'. Just over £9 million has been set aside for each of three years, from August 2006.

The National Lottery

For museums and galleries that are uncomfortable with such prescription, or that are not eligible for the government's programmes, the National Lottery has been a major new source of funding. It has financed new facilities, the digitization of collections and their presentation online, the purchase of objects, the creation of new posts and the expansion of education programmes. An unpublished survey by engage shows that museums seeking Lottery funding look first to the Heritage Lottery Fund (HLF) while galleries (without collections) look to Arts Council England.

By the beginning of 2005, HLF had helped to fund 150 education posts, 100 spaces for learning in museums and numerous audience development projects. Its *Young Roots* programme supports partnership projects involving youth and heritage organizations working with young people aged 13–20. HLF's definition of what constitutes heritage makes *Young Roots* one of the more creative schemes available to museum and gallery education departments.

The Arts Council invests in museum and gallery education work through its regularly funded organizations (RFOs); through an open application scheme, *Grants for the Arts*; and through a small amount of 'managed funds' with which it can take the initiative. RFOs may not receive funds specifically for their education work, but most still expect to have an education programme. Lottery funding is intended to be for work that is not supported by statutory sources. This means that Grants for the Arts does not fund 'activities that begin in a formal education setting for statutory educational purposes' but work that takes place in the gallery or in any location other than a school.

For all its strengths the Lottery offers only time-limited support and the total amount of money available for distribution is diminishing. In 2004, the Community Fund and the New Opportunities Fund were merged to create the Big Lottery Fund

(BLF). The BLF is now responsible for the distribution of 50 per cent of all Lottery funds and there is concern among supporters of the Lottery and potential applicants about the proximity of BLF criteria to government priorities, especially in relation to young people.

Grant-making Trusts – Experiments and Risks

As disillusion with the focus of public and quasi-public funding bodies grows, the role of grant-making trusts as promoters of risk and experiment has become more important. In cash terms, the charitable sector is a much smaller player than either the government or the National Lottery. There are about 8,000 grant-making trusts in the UK, but only 60 or so have significant sums to spend and only some of these are interested in supporting museums and galleries. That said, their independent status means that when they identify a need, they can respond in whatever way they think appropriate.

One of the ambitions of the Wellcome Trust is to increase the volume and quality of public engagement with biomedical science. It looks for projects that are accessible and that prompt the public to think about the philosophical and ethical issues raised by this branch of science. It designs its own programmes (for example, *Pulse* and *Sciart*) and works in partnership with other funders. *Rediscover* was a £33 million programme supported by the Millennium Commission, the Wolfson Foundation and the Wellcome Trust to support science education and engagement with the public through museums and science centres. The Wellcome Trust has also invested millions in state of the art exhibition spaces, including the Wellcome Wing of the Science Museum, the Wellcome Gallery (promoting the study of world cultures) at the British Museum and the Darwin Centre at the Natural History Museum.

Dame Vivien Duffield, chair of the Clore Duffield Foundation, founded a museum for children in Halifax called Eureka! The Foundation has subsequently spent some £20 million on education spaces and interactive environments in museums and galleries (including Manchester Art Gallery, Tate Modern and the British Museum) and the lessons learned were published in a handbook on creating an effective education space (Bacon, 2004). Over three years (2002–04), the Foundation's small grants programmes also supported educational activity in 27 regional museums and galleries. The Foundation continues to fund museums and galleries from its main grants programme.

The Paul Hamlyn Foundation has a long-standing interest in museum education, audience development and cultural diversity. In the early 1990s, it funded the post of Paul Hamlyn South Asian Arts Education Officer at the V&A. In 2002, it funded National Museums Liverpool (NML) for two years, to experiment with different ways of attracting new (and often hard to reach) audiences to its museums and galleries. The grant gave NML the freedom to work with different partners on Merseyside and to take risks, without the pressure of having to produce predetermined results. The

Hamlyn Foundation is currently funding the V&A and five regional museums, over two years, to work on ways to attract disadvantaged young people of school age.

The Baring Foundation is currently funding three museums – one public, one private and one university museum – to develop their work with volunteers and to diversify their volunteer base. The projects are being evaluated by the Institute for Volunteering Research. One of the beneficiaries is the Egypt Centre at the University of Swansea, one of whose priorities is the encouragement of young volunteers. A report of the research will be available in 2006.

The National Endowment for Science, Technology and the Arts (NESTA) is a different kind of foundation, endowed with a grant from the National Lottery. While NESTA is alert to government priorities, it is experimental by inclination. In October 2004, NESTA launched a £1m fund called Illuminate (as part of its *Learning Programme*) to enable museums to apply for grants of between £2,000 and £80,000 each, 'to take imaginative approaches to presenting existing collections which will promote learning, engagement and dialogue with visitors'.

Historically, most grant-making trusts have accepted applications only from registered charities. This has excluded local authority, university and other museums (unless they have a charitable arm through which an application may be made). There have always been exceptions to this rule and more grant-making trusts are now changing their guidelines to include applications from organizations that are charitable in purpose, whether or not they are registered as charities.

Thanks to our Sponsors

Museums and galleries remain one of the major beneficiaries of business sponsorship. Much of the money goes to blockbuster shows at the national museums and galleries and in the late 1990s, the corporate sector was a vital source of funding for capital projects supported by the Lottery.[6] The quality of premises and exhibitions enabled by corporate sponsorship is almost certainly helping museums to attract new audiences.

While education and audience development programmes are less obviously attractive to sponsors, there are some interesting examples. The shortlist for the Arts & Business Awards 2005 included the *Unilever International Schools Art Project*, a partnership between Unilever and Tate promoting the teaching and creation of contemporary art and in which 41,000 children from 21 countries have taken part, over the past three years. The Newcastle branch of Gerrard Ltd sponsored four exhibitions at the Laing Gallery and encouraged its staff to attend talks about the paintings and the techniques involved in producing them.

6 Figures published by Arts & Business for the period 1996/97 to 2002/03 confirm that museums and galleries have consistently received more commercial sponsorship than any other sector.

The relationship between museums and galleries and the corporate sector is more sophisticated and broadly based than it was even five years ago, but it is as vulnerable as ever to changes in a company's fortunes and priorities.

Conclusion

There is an imbalance between the profile of museums and galleries as centres for learning and the financial insecurity of much of their education and audience development work. Museums and galleries with different remits and in different parts of the country view the opportunities described in this chapter with very different eyes. While the total amount of funding available for museum education has grown in the past decade, it is not the case that there is more money for every museum or gallery that is doing good work. The winners are the national museums and galleries, the regional museums participating in *Renaissance in the Regions* and museums serving deprived communities.

Museums that are not in priority areas need to work harder to increase funders' awareness of their needs. Funders, in turn, need to ensure that their application forms ask for the information they need in order to make good decisions. The most abundant sources – the special programmes sponsored at different times by the DfES and DCMS – are too tightly tied to the department's desired outcomes, but HLF and the Arts Council are both still ready to encourage and support unusual proposals.

The best applications are usually those that have been discussed with the funder, prior to submission. This has been a long tradition among grant-making trusts, but it is relatively new in the public sector, mainly because of the volume of applications received. Reviewing draft applications to *Grants for the Arts* is now common practice for the Arts Council and for applicants to the *Arts & Business New Partners* scheme. Those who understand what a funder is looking for are much more likely to be able to describe their work in the right terms.

It is appropriate for funders to have priorities (how else could they make a decision or achieve what they want to achieve?) but there is a risk that the monitoring of outputs and the evaluation of an activity against its objectives will overshadow the project itself. It is hard to be creative when you feel a funder at your shoulder, and it is vitally important that museums' education and audience development professionals have the freedom to improvise when a project takes an unexpected turn.

Evaluation is an important management tool but only if the brief accurately describes what is needed and the evaluators have the skills to carry it out.

A final observation: more funders are asking organizations how they will sustain a post or a programme when the short-term funding they are offering comes to an end. 'What is your exit strategy?' they ask. More often than not, there isn't one. The activity will either come to an end, or the museum will go back to the beginning and start the fundraising game all over again.

References

Anderson, D. (1997), *A Common Wealth: Museums in the Learning Age*, London: DNH. (2nd ed. 1999, published as *A Common Wealth: Museums and Learning in the United Kingdom*, London: Stationery Office.)

Bacon, S. *et al.* (2004), *Space for Learning: A Handbook for Education Spaces in Museums, Heritage Sites and Discovery Centres*, London: Clore Duffield Foundation.

Clarke, A. *et al.* (2002), *Learning Through Culture. The DfES Museums and Galleries Education Programme: A guide to good practice*, Leicester: RCMG.

Gould, H. (2004), *What Did We Learn This Time? The Museums and Galleries Lifelong Learning Initiative (MGLI) 2002–2003*, London: CLMG/DfES.

Hooper-Greenhill, E. *et al.* (2004), *Inspiration, Identity, Learning: The Value of Museums. The evaluation of the impact of DCMS/DfES Strategic Commissioning 2003-2004: National/Regional Museum Education Partnerships*. Leicester: RCMG.

Resource (2000), *Resource Manifesto*, London: Resource.

Stanley, J. *et al.* (2004), *The Impact of Phase 2 of the Museums and Galleries Education Programme*. Coventry: Centre for Education and Industry, University of Warwick, available at <www.teachernet.gov.uk.uk/mgep2>.

'What is your Exit Strategy?'

Antonia Byatt

I spent six years at the Arts Council of England so I understand a funding body's need not to get tied down with a particular group of organizations, unable to remain open to new initiatives. That would be stagnation. But there is a rub. A learning programme takes a long time to develop, and even longer to monitor its success, as Chapter 10 points out. It is about building relationships over a long time and watching what happens.

It is very rare that museum learners are tracked for any consistent period beyond the life of particular projects. Even within a project's framework a demand for an exit strategy can be premature; a project needs to be evaluated for its success before the right kind of decisions can be taken about how it should be developed. While some funders are happy to have a more organic relationship with an organization many are not in a position to do this. Governments have to work within their term of office and trusts are subject to the vagaries of the stock market.

The other problem is finding the cash. The Women's Library at London Metropolitan University is in Tower Hamlets, an inner London borough with a deprived and ethnically diverse population. We are working hard to provide learning programmes for these audiences. In our experience we are not always the direct beneficiaries of the funding we have raised for such work. It often goes straight to our partnership organizations and on paying people and paying for materials. Who else is going to pay for these costs? It is unlikely to be the partnership organizations who are also playing the funding game and are often less secure than ourselves. We are a university museum located in a local authority with a very limited cultural budget. So our options for funding exit strategies are:

- obtaining more money from the university
- other statutory funders such as Research Councils, Heritage Lottery Fund, Arts Council of England, DfES
- other trusts
- corporations such as law firms and banks with social responsibility budgets, British Telecom and other locally situated companies.

London Metropolitan University is our core funder. Its mission is to the

higher education community and although it takes widening participation seriously we would have to negotiate a considerable budgetary increase to pay for our learning work with external communities, perhaps at the expense of another department. Other statutory funders such as the Arts and Humanities Research Council will make a huge difference to our capabilities through core funding and research funding streams but they are not going to pick up a lot of our learning work with communities. Though they applaud us for widening access their funding tends to be for collection care, display and research. We are lucky to have found several trusts very supportive to The Women's Library, but understandably they are interested in kick-starting projects.

We have only just started accessing funding for statutory education (for example, the *Aim Higher* programmes) and there is some possibility for more work with young people using these streams, especially as the chapter points out, in the kind of area where there has been a lot of investment. The Lottery should be a source of funding for our learning work in the future, but it cannot be a revenue funder.

Should we only work with partners who can afford to take things forward themselves? Or where there is another statutory agency that might step in? That might mean always choosing to work with, say, The Women's Institutes rather than a local group of migrant women from the East End of London.

The trick is to be highly inventive and to make each development of our learning work into a 'new' funded project. A viable exit strategy is to continually find agile ways to describe our work so that we can make steady progress in developing longer-term relationships with people learning through our collections.

Learning, Leadership and Applied Research

Nick Winterbotham

There is no blueprint for gallery learning excellence. There is no one style for learning delivery any more than there is one style of learning. What matters is to get to know the learning process as well as possible and then constantly to improve the museum 'offer' in the light of that understanding. What follows relates primarily to schools visiting museums, but many of the lessons are equally applicable to lifelong learning in general and to enhancing access in particular.

My enthusiasm for the learning agenda in museums stems from my background as a school teacher, from my experience as a museum education officer in Norfolk and Nottingham, and from conducting longitudinal research into the relationship between schools and museums from 1988 to 2005.

Tullie House, Carlisle, 1989–98

In 1989 I was appointed as Director of Tullie House, the City Museum and Art Gallery of Carlisle. The brief from the City Council was to develop a small local authority service of 11 staff into a regional museum service that would act as a 'tourism, learning and cultural focus for the border city' (Carlisle City Council, 1989) employing 63 staff.

The redevelopment of the buildings was completed in 18 months. During a 15-month closure to the public, the newly formed museum management spawned a new education team. Its guiding principles were founded in part on my research into teacher expectations over the previous two years. In particular, I was keen to meet the generic operational requests made by more than 200 teachers in a postal survey conducted in 1988. At the same time, the management team would assemble gallery exhibits and create displays to match collection strengths on one side and public enthusiasm on the other.

Further requests and ideas had emerged from discussions with Cumbria LEA and a specially convened teachers' group in Carlisle. So, for example, a loans service was established to enable hands-on activity in the classroom, while an education officer was appointed to provide direct liaison with teachers planning visits and to develop learning materials to match their express needs. To facilitate even closer

dialogue, a programme of in-service training for teachers was drawn up, publicized and initiated before the new museum opened.

In January 1991 Tullie House reopened to the public and simultaneously launched a schools' subscription scheme. Schools in the region paid an annual fee based on their capitation (and thereby their ability to subscribe) in return for which they would receive particular benefits and services:

- free access to the Border galleries (the charged-for part of the museum)
- free loans on demand – depending on availability
- two free 'Inset' teacher training places each year
- prioritization in booking – by virtue of pre-release of programme booking details
- commentary on the appropriateness of the galleries and exhibitions to particular areas of study (and, later, a listing of gallery learning opportunities allied to National Curriculum learning targets).

Over 100 schools took up the scheme in the first year, raising a subscription income in excess of £10,000 and subsidizing the museum education service to the tune of 30 per cent per annum. The scheme uptake exceeded the expectations of the management team. Its success in netting 31 per cent of the schools in Cumbria and 90 per cent in the city area was attributed to the close match of museum education services to teacher needs.

These new developments in museum education served as a springboard for a second postal survey to teachers and a number of simultaneous Museum Education Officer (MEO) interviews. The service had established a reputation for the learning agenda and it did not prove difficult to acquire volunteers in the research process. One explanation for the immediate popularity of the museum as a learning destination and for the sign-up to the subscription scheme related to a finding of the 1988 research project – the request from teachers for museum staff to be trained appropriately to support school visits. Prior to opening, there had been a six-month period of recruitment and training for the front-of-house staff. They were dubbed 'gallery assistants' rather than 'warders' or 'attendants' and were given the opportunity to develop information and operational skills matched to the teacher needs of the survey.

Thus the learning 'offer' of the museum ran through the job descriptions, recruitment, inter-personal skills and demeanour of the majority of the museum staff. Further, all the front-of-house staff were trained in reception and telephone skills, staffing the shop, escorting schools and other learning groups and in interpreting the galleries for all visitors. Several were ex-teachers. A few months later, the service became the focus of a new ICT programme for schools dubbed *Frontier 2000*, which enabled schoolchildren across the nation to explore the multi-layered history of the region through the medium of Acorn computers and Cambridge Software House ingenuity.

The astonishing popularity of the museum as a whole stemmed from the ambition of the local authority to receive admissions income from visitors to the city while providing free access to the local residents. The result was the 'Tullie Card' that carried a photograph of the resident, had to be acquired on the first visit and conferred free access for life. A lively pre-opening marketing programme had resulted in 9 per cent of the population purchasing the museum card (which cost £1 for processing) before the doors reopened. Within five years over 50 per cent carried the card – some 52,000 people. This by any standards is unprecedented in the museum world. The card has since been relaunched with new electronic attributes.

By starting almost from scratch with a major project and its staff complement, it was a great deal easier to embed a learning ethos in a museum service than it would have been to change a pre-existing team. Sustaining it and developing the educational offer further was made much easier by including the head of learning in the management team.

Eureka!, Halifax, 1998–99

In 1998 I was appointed Director of Eureka!, the museum for children, in Halifax. The challenge in this service was very different. Eureka! was the brainchild of the Clore Foundation and had been opened to the public in the same year as Tullie House (1991). It was modelled on children's museums in the US and Canada, was targeted specifically at 3- to 12-year-olds and offered some 400 interactive exhibits, grouped under four different themes.

Despite frequent changes in leadership and management since its inception, the formula for attracting schools and families in Yorkshire and further afield was highly effective. Eureka! drew 300,000 visitors per annum and was competing well with the many new and revitalized museums that were currently benefiting from the new resources coming on stream from the Heritage Lottery Fund. The theoretical underpinning of Eureka! was that play and exhibit interaction offer a powerful engagement for young minds and enable individuals, families and school parties to overcome traditional museum inhibitions and to learn in a highly stimulating environment.

Applying the same logic and research platform that had proved so effective in Carlisle, the teacher expectations and requirements were once more addressed by the management team. There were 45 front-of-house staff rostered to greet and manage the many young people arriving during school terms and over holidays. The museum's marketing to schools was explicit and described good practice, safety arrangements and practical considerations. Further, an explanation of some exhibits was published for teachers linking these to the National Curriculum 'key stages' and learning objectives.

However, a quick investigation of staff experience and training revealed an astonishing weakness at this otherwise well-known, unique and established children's museum. The average staff retention period was running at a little over eight months.

Typically the front-of-house staff were exiting the organization within six months of starting. Through line management and exit interviews, the senior team investigated this phenomenon. We concluded that while some of the turnover could be accounted for by seasonal working, much of this skills wastage could be stemmed by adopting a more supportive role in the recruitment and training of staff. In particular, we had to address the personal 'burn-out' experienced by the staff and managers charged with receiving 300,000 small, cheerful and noisy students each year. Further, we developed staff involvement in and ownership of all practical improvements to the service from that point onward.

Then, drawing on the lessons from the earlier research in Nottinghamshire and Cumbria – two teacher surveys and six in-depth MEO interviews – the senior staff embarked on:

- a training programme for those not experienced with dealing with young children
- another to provide the support, advice and management the teachers required
- a stepped competency scheme to develop hosting and teaching skills amongst all front-of-house staff
- regular staff meetings to introduce the museum staff to each other and to the organizational issues that affected them and to which they contributed
- regular appraisal and pastoral meetings with their line manager.

Tied to these developments was a full staff review to improve all aspects of learning and access. Regular training sessions were developed to discuss the school visit predicament; that is, what it was that teachers hoped to get out of learning excursions; and how the visit might be enhanced by particular activities and materials.

It would be convenient to conclude that all these measures resulted in wholesale changes at Eureka! and a dramatic improvement in the learning environment. However, trust board upheavals and differences in approach to leadership made the post of Deputy Head of the National Railway Museum in York ever more attractive to me and I moved on.

With hindsight, the most effective Eureka! development at a pre-existing and relatively well-established museum had been the involvement of all the staff in the core business of the museum. This was based on a 'supply and demand' appreciation of what it was that teachers might expect and might be persuaded to expect. However convinced the management team of Eureka! may have been of the appropriateness of this approach, the outcome remained unproven as the team changed once more and never had the opportunity to review either effectiveness or outcome. An important lesson here was the need for consistent leadership and for establishing from the outset those areas of responsibility where it is appropriate to have trustee involvement and those where it is not.

The National Railway Museum (NRM), York, 1999–2001

The relaunch of an education department at the NRM was almost simultaneous with my third teacher survey in 2000/01. My start at the NRM in 1999 was almost coincidental with the appointment of a new Head of Education. Together we considered a further research method in the form of an action research focus group. We envisaged that a group would engage in the analysis of the operational outcomes of the education department with a view to regular upgrading and learning from experience. However, in discussion it became clear that this approach would be problematical for the following reasons:

- The scale and speed of innovation in the newly formed Public Services department made lengthy and painstaking analysis by key individuals virtually impossible.
- The Head of Education had to introduce new working methods to a team that was sometimes resistant to research but glad of straightforward instruction.
- I was keen not to influence the process of regeneration in an obtrusive way and sought to give the Head of Education as much professional latitude as possible to achieve his task – which he undertook with great energy and broad consultation with all the available and potential providers of learning services.

It was thus more appropriate to make sure that the outcomes of surveys were made available to the Head of Education in the writing of a new education policy but not to burden the new section with any more feedback than was strictly appropriate.•

The new Public Services department for which I was responsible embraced five principal functions – visitor services, marketing, education, displays and programmes – each with a section leader. To support the development of learning, an operational budget of £60,000 was made available – some 200 per cent greater than before. The new Head of Education brought much organizational and managerial experience in the field, having been in his time a senior tutor at a teacher training college, a head teacher of a primary school and, of immediate relevance, the leader of Platform 4. This five-handed theatre company uses railways in general and the NRM in particular as the theme and backdrop for their 'theatre in education' activities. The company is highly effective and regarded by other museums and theatre groups as something of a leader in the field.

As the Head of Education's line manager, I was concerned to be both supportive and non-interventionist. We negotiated a role for me to act less as line manager in the creation of new learning services and more as critical friend and sounding board. The result was a new Education Policy that responded well to teacher need and gave many learning opportunities prior to, during and after a visit. Teachers were enabled to present, handle and discuss the subject matter with students.

As at Tullie House and Eureka!, staff support across the NRM was critical to success. The NRM front-of-house staff were inducted and trained in school support

and teaching roles, were identified by different clothing, and a new employment 'competency scheme' was discussed whereby preferment in the organization would attach to those that had acquired new interpretive skills. The learning and access function at the NRM thereby acquired 22 more staff in the direct delivery of learning events and opportunities.

Leeds Museums & Galleries, 2001–2004

Appointed as Head of Museums and Galleries in Leeds in 2001, I set up a new management team to tackle the 'Best Value' review that was at that time required of local government services. There was not a great enthusiasm for the review from within the service. It would require management time, analysis and soul-searching. If properly pursued, it might facilitate significant decisions about the future of the service – not a formula universally welcomed by many organizations. In the event it proved to be a lengthy but thorough introduction to the service for me, and, in its impact on museum learning, another opportunity to apply the lessons of research acquired over the previous 12 years.

As local authority auditing processes go, Best Value in Leeds proved fairly effective for analysing the contribution and rationale of the museums and gallery services. Without requiring compulsory competitive tendering of services, it placed a close scrutiny on value for money and effective outcomes. The Education Findings from this Best Value review of the whole service ran as follows:

Key findings where action must be taken:

- There is a quality product available for many more people than currently use it.
- Education is not currently central to museum planning, and it should be.
- Some colleagues do not see their own work as being involved in interpretation.
- We could perform much better with more: staff, programmes, project budget money, facilities.
- Education should be far broader: Lifelong Learning, Sure Start, Learning Support, etc., not just school visits.

Key findings which affect our current capability:

- Education staff are not senior enough in the organization – if education is genuinely a core function.
- We fail to market ourselves adequately.
- Education staff are not paid well *vis-à-vis* teachers – this is a recruitment and retention issue.

Other findings which affect our service:

- Some museums and galleries colleagues do not value education as much as they might; there is limited buy-in.
- Teachers and other groups want to use museums and galleries more than they can.
- Supply is almost always outstripped by demand.
- Education may have lost its specific focus on the great stories that the service can tell in all its different sites and disciplines. The government's 'Education, education, education ...' agenda may have stymied [hindered] what museums can contribute to schools by straitjacketing teachers into particular activities. The service must attempt to redress this tendency.

This last injunction in particular, and the conclusions in general, have imparted to the Leeds service a momentum that will see a major response to *Renaissance in the Regions* (2001), a report published by Resource which is having a multimillion pound impact on services across England.

One conclusion from the Best Value review was to return once more to the 'customer focus' that my teacher research had promoted and to reorganize the nine-centred museum service in such a way as to allocate each museum to a named education officer. Initially this envisaged each officer having a responsibility for three museums. As the development programme progressed more appointments would be made and more funds directed to marketing these services across Leeds and throughout West Yorkshire.

While in the planning stage, it became obvious that *Renaissance in the Regions* would have an even greater impact than any review based on resources available only in Leeds. In the meantime, the existing learning and access team had volunteered to pilot the planning framework of *Inspiring Learning for All* and to test its 'generic learning outcomes' (GLOs) as a means of assessing the learning impact of the Leeds Museums.

As before, the key to success would lie in developing the staff and in particular to deliver against ten precepts for museum-school collaboration (see conclusion). The change is recent; the outcomes are as yet unproven. However, the philosophy of developing museum learning has been adopted by the City Council; *Yorkshire Renaissance*, the Yorkshire 'hub' (confederacy of the five cities in Yorkshire) is following a coordinated approach to learning, training and marketing. Museum staff devoted to the learning agenda doubled and the learning programme budget, with the help of *Renaissance* resources increased tenfold over its levels in 2001. While an uncertainty as to the future of *Renaissance* funding persists, there can be little doubt as to the impact it has had in the last three years.

Common to all hub services was the obligation for each hub to create an Education Programme Delivery Plan (EPDP). This described how the services would spend their resources on learning provision, how the impact would be measured and what the visitation benchmarks were. The data required by Resource – now the

Museums, Libraries and Archives Council (MLA) – was fairly daunting for those museum services that had collected data in the past, but were not geared up for the sophistication now insisted upon.

Other management issues became apparent. Many services encountered difficulties in attempting to recruit high-quality practitioners to new strategic learning positions when the new funding was at best guaranteed for three years, and with future initiatives depending on the triennial Treasury spending rounds. Recruiting problems were further exacerbated by the fact that all nine 'hubs' across England were attempting to recruit at the same time.

Recruiting and retaining museum education staff has always been an issue. Generally speaking, museum teachers are paid poorly by comparison with school staff. Some receive as little as half the pay that schoolteachers with equivalent experience might expect. The obvious difference in role lies in a schoolteacher's obligations in pastoral care and in the delivery of the national curriculum. That museums recruit successfully relates to the environment of the work, the comparatively difficult professional environment in schools and the fact that museum education tends to entail a very pure form of teaching. Whether teaching students, instructing teachers or developing learning programmes, there can be few other didactic realms where there are opportunities to develop particular lessons, repeating them and honing them to perfection. Similarly, the learning environment itself is conducive to attention. Whereas in classroom learning familiarity may breed contempt – the one-off nature of museum lessons and learning often prompts 'engaged behaviour' on the part of the recipients.

Managing the Responsive Museum

As a museum manager I have had to take account not only of initiatives such as Best Value but also new policies for audiences and learning. In 2002 Resource launched a cross-sectoral initiative called *Inspiring Learning for All* (ILfA) which was piloted in a number of museum services and at the time of writing is being rolled out as a national standard for learning provision, complete with specific generic learning outcomes (GLOs) (see Appendix 2). In their breadth and detail, it is encouraging to see that there is no longer a focus simply on the cognitive domain. Learning, ILfA suggests explicitly, happens in many different ways depending on circumstance, experience, environment and, of course, the individual.

For many practitioners involved in the pilot scheme, the question remained unanswered as to what might be the prime purpose of focusing on these GLOs. When challenged for suggestions, officers charged with delivering these outcomes reported variously:

• to plan specific activities in the museum
• to plan exhibitions
• to justify activities currently and retrospectively

- to wean colleagues off the notion that only information matters
- to wean teachers on to more effective practice in museums
- to counter the strict adherence to National Curriculum objectives
- to recruit staff more effectively
- to attract schools that might already embrace such working objectives.

When asked which of these the GLOs could be most useful for, a whimsical but telling response from one was 'oh, … *definitely* retrospective justification!'.

The MLA introduction concludes with the assertion: '*Inspiring Learning for All* will help you to demonstrate that you are meeting these outcomes'. Time will tell as to the uses and effectiveness of the ILfA initiative – and so will research; for this, too, will surely be the subject of future scrutiny.

The Campaign for Learning and MLA both use the following definition of learning that is healthily broad and inclusive:

> Learning is a process of active engagement with experience. It is what people do when they want to make sense of the world. It may involve increase in or deepening of skills, knowledge, understanding, values, feelings, attitudes and the capacity to reflect. Effective learning leads to change, development and the desire to learn more (<www.campaign.for. learning.org.uk>.

The underpinning of the personal and generic learning outcomes in ILfA resides in Eilean Hooper-Greenhill's *Learning Impact Research Project* of 2002. Moving from goal-oriented evaluation to personal and generic learning outcomes Hooper-Greenhill summarizes:

> Goal-oriented evaluation was based on a view of learning that was rooted in behavioural psychology, and the failure to find evidence of what was then seen as learning (i.e. the correct assimilation of the curatorial message) was interpreted as meaning that learning was not taking place. Social learning theory suggests that even though exhibition visitors may not wish to learn the facts the exhibitions may wish to communicate, other forms of learning will be taking place.

> In thinking about what might be a useful way of conceptualising learning outcomes in libraries, archives or museums a number of basic challenges can be now identified:

> 1. Learning is very broad in scope and approaches may vary in each of these organizations.

> 2. Specific learning outcomes which are written against a baseline in relation to a programme of study are not normally appropriate for drop-in users, although intended learning outcomes could be devised in respect of specific projects/workshops.

> 3. Defining specific requirements in relation to changes in the condition or behaviour of users is not appropriate, although experience of specific skills may be identified as potential learning outcomes for particular activities.

4. The formal assessment of the levels of attainment or achievement of users from an external (i.e. institutional) viewpoint is not appropriate.

5. Defining a moment in time when an outcome might be identified is problematic, as the end of any visit is not necessarily the end of any learning.

6. In discussing drop-in users (the main focus of this study) it will be the user who defines the objective of the visit and the successful achievement of those objectives (Hooper-Greenhill, 2002, pp 6–7).

Clearly, items 2 and 6 do not relate to directed school visiting, but these definitions nonetheless describe a breadth to the learning predicament in museums that is healthy, inevitable and problematic if the learning outcomes, even for a structured school visit, are to be measured. Hooper-Greenhill roots individual learning strategies in four different strategies – experience-based, creative, intellectual and social interaction. Each of these would prove valuable to both teachers and Museum Education Officers. They now form a part of the evaluation of the learning opportunity of galleries, so there is a chance that the opportunity may present itself in the future, where museum services are obliged to demonstrate their learning credentials.

Taking learning outcomes a little further, Leicester University's *Learning Impact Research Project* has suggested how to develop generic learning outcomes in museums, libraries and archives (see Appendix 2). These are not primarily aimed at schools, but nonetheless allow a reflection on the potential richness of a museum visit.

Learning Environments

In addition to policy directives and new educational research I have also been influenced by a number of educational thinkers in my approach to museums and their audiences. Most significant among these are George Hein and Howard Gardner. George Hein's (1998) discussion of evaluation methods and teaching and learning theory led him to his 'inevitability of constructivism' (p 34) – the notion that whatever stimulus a learner may have, he or she will construct his or her own interpretation of it. The constructivist exhibition, he believed, would provide opportunities for visitors to construct knowledge. So, a constructivist exhibition will:

* have many entry points, no specific path, no beginning and end
* will provide a wide range of learning modes
* will provide a range of points of view
* will enable visitors to connect with objects, through a range of activities and experiences that utilize their life experiences
* will provide experiences and materials that allow students in school programmes to experiment, conjecture and draw conclusions (Hein, 1998, p 35).

This is a charter for a learner-centred experience where the pedagogy is neither linear nor overtly didactic. His picture of 'the constructivist museum' (Hein 1998, Ch. 8) fits very well with those teachers who seek an open-ended experience for their students. Hein admits that there are no absolute standards for his constructivist museum, but that it represents the summation of a family of ideas.

Orientation must be sufficient to enable visitors to overcome fears and uncertainties since anxiety will hinder any learning process. Hein points to extensive signage and well-trained staff to complete a confused picture. Orientation should start before even entering the museum environment.

Conceptual access, Hein argues, is conferred through the inclusion of familiar objects amongst the unfamiliar to give visual and even tactile clues to meaning and purpose. Exhibiting known concepts and themes is an extension of the last and confers meaning where it might prove elusive.

In his analysis of learning styles, Howard Gardner (1983), identifies at least seven different ways to engage thinking, which he terms 'multiple intelligences'. The significance of Gardner's analysis for museums is its multiplicity: the fact that no two people are likely to have the same learning needs, preferences, baselines or capabilities. The 'constructivist museum', Hein concludes, 'will provide opportunities for learning using maximum possible modalities both for visitor interaction with exhibitions and for processing information' (Hein 1998, p 165).

The museum designer could take this further to create spaces that have a 'universal design' that may appeal to all visitors regardless of their learning modalities. Inclusivity in design will have different levels of exhibit, different levels of text complexity, different appeals of the same subject matter, a range of AV opportunities, a mixture of contemplative and non-contemplative spaces. Paulette McManus (1994) would add to this the maximizing of opportunities for discussing the experience with family or friends.

There are many examples of specific applications of these ideas. The use of drama and of theatrical techniques can clearly broaden the appeal of a particular subject matter and has been adopted for particular events such as the *Newstead 1883* reconstruction at Newstead Abbey, near Nottingham, which explored domestic service themes or the Platform 4 theatre company at the National Railway Museum, York, whose exploration of social and engineering themes are as engaging as they are highly researched (Ford, 1998).

Computers and touch-screen technology are also relevant to the 'constructivist museum'. The international ENRICO EU-backed exploration of railway histories enabled Hungary, Sweden, Finland and the UK to share railway histories and narratives in each of their own languages and is sufficiently attractive to draw in the non-specialist. The permanent difficulty with computers is their exclusivity, and the fact that the technology advances at the sort of rate that makes gallery strategies dated almost before they are made available.

Hein also lists open storage for galleries and the availability of a well and appropriately stocked shop to appeal to the gallery learner. In concluding, Hein adds to his constructivist mix the notions of social interaction, developmental

appropriateness and intellectual challenge as being core to an effective exhibition strategy (Hein, 1998). The constructivist focus on the individual and their learning modalities dovetails well with the increasingly 'customer-orientated' nature of museum marketing and the 'pupil-centred' dictates of parts of the National Curriculum and QCA guidelines.

Litigation, Risk Assessment and School Visits

New challenges for the museum manager include shifting patterns of school visits as a result of recent highly-publicized problems with school field trips. On the *Law in Action* programme (BBC Radio 4, 12 November 2004) several teachers voiced regret over the litigious nature of parent/LEA relations. They cited in particular the recent insistence by LEAs on overcomplicated risk assessment procedures and the resultant reduction in school trips. They gave three reasons for the reluctance of teachers to lead trips 'even to museums':

- the reluctance to take on the extra burden of the paperwork and the processes of investigation they necessitated;
- the growing awareness of teachers as to the personal and corporate risks – albeit very remote – that 'in loco parentis' implies;
- the lack of support from senior staff for any risk-taking to be even suggested to parents.

The programme concluded that, through excessive recourse to law, the chief losers were, of course, the children. This gives us a picture of a far more restrictive practice in the planning and execution of school visits. Clearly the museum that wishes teachers to overcome this sort of hurdle will have to work hard to sustain visiting in the future.

Conclusion

There is no blueprint for gallery learning excellence. However, from user research there may yet be a robust enough picture emerging to be defined as the 'holy grail' of school–museum collaboration. This might include:

- understanding what the teachers in your catchment area want and need.
- aligning all services and activities to meet and exceed teacher needs.
- making all services easy to use.
- marketing the services to all potential leaders of visits;
- designing displays and galleries to enable learning in all its forms;
- enabling teachers to overcome any particular obstacles to visiting;
- communicating with teachers so that they can access and use the services available;

- underpinning gallery learning and site practice with a sound theoretical basis and injecting this into the planning, publicity and negotiation of activities;
- avoiding excessive theoretical language and jargon in the negotiation process and clarifying all operational methodology;
- aligning all museum staff to achieve the above through organizational structure, briefing, training and recruitment.

It is also worth paying attention to schemes and systems that can assist any of the above to happen, sustaining staff effort and ownership of the process and working with new initiatives and frameworks that may become vehicles of funding, good practice or both.

This finally boils down to leadership. In this context, leadership is something everyone can learn and is something almost everyone does in the work environment at one point or another. It is not, as some suspect, a series of tricks to manipulate people. Any effective leadership technique acquired by any member of the team can and should be handed on to the other members of the team at the first opportunity. Good leadership creates leaders and not followers. Thus leadership becomes a way of operating and even a value system rather than management sleight of hand. Effective leadership in museums should probably be an amalgam of skills and behaviours:

- clarity, honesty, thoughtfulness
- sharing power, ideas and process
- nurturing teams and individuals
- using difference of opinion as a springboard for consensus and closer working
- trust, lack of defensiveness, self-scrutiny
- self discipline and sticking to plans
- using crisis to demonstrate leadership
- modelling in ourselves what we expect of others
- persuasion and consultation
- and, finally, building a community of planning and progress.

All of these apply to the leadership of learning in museums. If the experience of the last 16 years is a guide, there is much to be said for setting up learning services on the basis of user research and community need. We are increasingly operating in a customer-centred world and many museums compete for that custom. If we fail to embark on research and continual improvement in our provision of museum learning opportunities, we will not just disappoint the auditors who require performance, but the communities of today and tomorrow for whom we must be a key source of identity, self-respect, inspiration and fulfilment.

References

Carlisle City Council (1989), *Tullie House sub-committee minute,* Leisure Services, Carlisle City Council, December 1989.

Caulton, T. (2003), *Yorkshire Renaissance EPDP: Proposed Structure*, unpublished strategy for *Yorkshire Renaissance*, Leeds.

Ford, C.M. (1998), 'The "Theatre-in-Museum Movement" in the British Isles', PhD thesis, University of Leeds, 1998.

Gardner, H. (1983), *Frames of Mind: The Theory of Multiple Intelligences*, London: Fontana.

Halsey, A.H. (1972), *Educational Priority Volume 1: Education Priority Area Problems and Policies*, London: HMSO.

Hein, G.E. (1998), *Learning in the Museum*, London: Routledge.

Hooper-Greenhill, E. (2002), *Developing a Scheme for Finding Evidence of the Outcomes and Impact of Learning in Museums, Archives and Libraries: The Conceptual Framework*, Leicester: Learning Impact Research Project (LIRP), Leicester University, on behalf of Resource, April 2002, available at <http/www.le.ac.uk/museumstudies/rcmg>.

Leeds City Council (2002), *Best Value – The User Experience: Education Findings*, unpublished report of Leeds Museums & Galleries, Leeds City Council.

McManus, P. (1994), 'Families in Museums', in R. Miles and L. Savala (eds) (1994), pp 81–97.

Miles, R. and Savala, L. (eds) (1994), *Towards the Museum of the Future: New European Perspectives*, London: Routledge.

Resource (2001), *Renaissance in the Regions: A New Vision for England's Museums*, London: Resource for DCMS.

Resource (2002), *Inspiring Learning for All: A Framework for Museums, Archives and Libraries*, London: Resource.

Winterbotham, D.N. (2005), 'Museums and Schools: Developing Services in Three English Counties, 1988–2004', PhD thesis, University of Nottingham, 2005.

Response to Chapter 11

Developing Integrated Museum Management

Janet Vitmayer

In Nick's chapter, the points that had a particular resonance for me were:

- how research influences planning
- how teachers are special
- how education (or learning) in it broadest sense is at the heart of the museum experience and
- how success in providing the best possible opportunities for visitors as a whole lies in a holistic and integrated approach to managing the museum.

I began my career running the information desk at the Imperial War Museum. Here I was brought face to face with the huge variety of human experiences, needs and expectations that walk through a museum door each day. Visiting a museum is an intensely individual and, at the same time, social experience. When I moved behind the scenes to exhibition work, I learnt a bit about the dangers of orthodoxy. I conducted the first piece of exhibition visitor research at IWM by cobbling together a questionnaire to find out what visitors thought of our new gallery. I had an ulterior motive – I felt guilty about my long captions

in the light of the work then being done on exhibition copy. Despite very unprofessional probing and repeated trips to the gallery ('Really, don't you think the text is far too long to have to read standing up?'), members of public refused to play ball: no, overwhelmingly they thought it was rather interesting.

At a more strategic level, visitor and non-visitor research is critical in helping link the visitor to management and planning. 'On-the-ground' staff may often have a better idea of how people are experiencing the museum and they can provide excellent feedback. The problem with research, however, is making it relevant and useable. Personally I have found a mixture of approaches useful – the academic as a thoughtful backdrop to the bigger picture – and for this I share Nick's list of Hein, Gardner and Hooper-Greenhill as my particular favourites. The basic quantitative approach (numbers, ages, backgrounds, satisfaction levels) provides a year-on-year backdrop; 'one-off' innovative visitor response projects provide a feel for what is going on; formative evaluation via focus groups is great for testing things out when developing

projects and – the bit that fast-moving museums perhaps find most difficult – the kind of evaluation work based on 'So how has it worked on the ground?' and 'What can we learn from it?'.

The quantity of research now being undertaken is overwhelming; the quality is at times questionable but the need to know and understand more about our visitors and their experience is real. This therefore presents a considerable challenge to all of us who are interested in understanding our current and potential visitors and in creating a clear and politically appealing picture of the great work museums do. We need to exercise good judgement and focus in order not to be overwhelmed by quantity and not to be misled by poor quality work. 'One size fits all' will not work for those trying to move an organization forward on the ground, as Nick nicely shows in his analysis. Organizations of different types and at different stages of development will need to know about and concentrate on different things. In a tiny venue, like the Livesey Museum in South London (where as Director I taught, sat at the reception desk, curated exhibitions, etc., and where my knowledge of audience was finely tuned), research was ad hoc, intimate and small-scale. The broader picture was provided by membership of organisations like GEM. In contrast, as Director of the Horniman I benefit from a wide range of research that we are able to commission: without it I would feel out of touch and adrift.

So, what about schools, and teachers in particular? All my experience – whether actually teaching in galleries, managing an education service, or as a museum director – tells me that schools and teachers have very particular needs and requirements. This is well reflected in Nick's chapter. Good research is therefore critical in shaping the future of these services. The time has thankfully passed when very few museums offered anything approaching a dedicated service for schools and when teachers were grateful for anything they could get. There have been massive improvements across the country in terms of quality and quantity of provision.

We currently face a period where recruitment of education staff is difficult, and in some areas demand for education services no longer outstrips supply. There is the need to market more effectively to schools, to provide a more streamlined, easy-to-access, safe and supportive experience. Good research will help enormously in getting this right. The concept of 'customer care' now often aimed at the general museum visitor is more complex, costly and difficult to achieve when applied to teachers, and presents a challenge to management and those on the ground.

The culture of a museum will out. If the whole experience does not hang together for the visitor – with inspirational, accurate and stimulating content, enthusiastic and well-informed staff, good space, comfort, good facilities, accessible opening times; if the museum is not in it broadest sense responsive – all the research in the world will not rescue it from a gradual slide into neglect by the public, be they teachers or general visitors. Museums need to be loved and we need to understand and love our public.

Chapter 12

Audience Advocates in Museums[1]

John Reeve

This chapter examines one of the most challenging roles for the responsive museum: how to represent the interests of varied audiences and types of learner in terms of policies, services and programmes, and particularly in one especially contested area, interpretation through 'temporary' exhibitions and 'permanent' galleries. It looks at the evidence for what makes some projects successful and others acrimonious, and at the shifting boundaries between traditional 'educator' and 'curator' roles.

A Shared Role

Advocacy is a crucial concept in developing responsive museums and their audiences. It works in many directions and at different levels. Advocacy for museums and galleries at national and regional level aimed at the media and public opinion, government, other funders and policy-makers, is a major function of organizations such as the Museums Association, the Museums, Libraries and Archives Council (MLA), and the National Museum Directors' Conference (NMDC). Pressure groups such as engage and the Group for Education in Museums (GEM) advocate the educational value of galleries and museums to the educational world as well as to fellow professionals, policy-makers and funders. At whatever level, advocating the value of a museum or gallery to new audiences is an entrepreneurial and diplomatic role, requiring vigilance and tact.

Other forms of advocacy can be seen in programmes generated in partnership with pressure groups representing particular audiences or activities: Black History Month, Science Week, Women's History Week, Family Learning Weekend, Big Draw, Carnival, Chinese New Year, Eid and other religious festivals. Museums Month, the national advocacy of museums to a wide public, has different themes each year for exploring collections and connections in new ways, and attracting local publicity.

Boundaries and responsibilities within museums and galleries are shifting rapidly, and the role of educators as audience advocates is now more often shared

1 This chapter is based partly on a paper given at a symposium at the National Gallery of Ireland (NGI) in November 2003 and published in M. Bourke (ed.) (2004), *Effective Presentation and Interpretation in Museums*, Dublin: NGI.

than in the past, when representing many specific audience needs was often left to educators alone. Today, with high expectations for audience development and delivery especially, all museum and gallery staff need to see themselves as audience advocates, or at the very least to sound convincingly like one in public.

At Tate Liverpool Lewis Biggs has described how education and exhibition curators have worked together successfully in pairs (Biggs, 2000, pp 108–115). An audience development officer played an important role in the radical redisplay of the Hunterian Museum in London, working with curators and expert consultants. There are also new role for educators and curators working together behind the scenes, as in the Conservation Centre in Liverpool, and in providing access to study collections, as in the Darwin Centre at the Natural History Museum, in order to enhance and provide depth for the core displays and programmes.

Writing in 2000, Eilean Hooper-Greenhill found much evidence for changing values in the UK art museum, including a change in professional roles: 'In the past, curatorial authority, scholarship and professional judgement have been the drivers of the museum; today the driving position is shared with ... the educator, the marketing officer, the interpretive planner and the outreach officer ...' (Hooper-Greenhill, 2000). Too many drivers can also be a problem as we will see.

The Educator as Audience Advocate

Audience advocacy may now take the form of creating specific museums or galleries expressly for children, such as Clarke Hall, Wakefield (a seventeenth-century experience in West Yorkshire normally open only for school groups), the new Centres for Discovery and Imagination (aimed at young children and families) as at Stratford (East London) and Eureka!, the children's museum in Halifax, Yorkshire. Audiences are often strongly prioritized elsewhere: examples include children under the age of five in Walsall, near Birmingham; (see Cox and Cox, 1995); young children generally in the Museum of Childhood, Bethnal Green (East London) and at the Roald Dahl Museum in Aylesbury; and local communities in Newcastle and Glasgow. Historic heritage organizations have also become more widely audience-focused, notably English Heritage and the National Trust (see Waterfield, 2004).

There will now usually be specific advocacy posts in a medium-sized or large museum or gallery Learning and Access Department. Such posts may be organized by audience (Schools, Youth, Lifelong Learning), by media (online or interactive learning) or type of service (outreach, volunteers). As an example of this change, the British Museum Education Department in 1980 was structured by collections area knowledge, shadowing the curatorial departments; but by 2005 the renamed Learning and Information Department was almost entirely audience-focused, with the addition of audience development posts, librarians and online learning project teams. The first audience advocates here from the 1980s were for disabled people and then in the 1990s for schools and families. Mostly with sponsorship, a range of posts were then developed for a mix of audiences (primary education, families),

for collections and curriculum areas (Arab World, Asia, archaeology, science); and for access as a museum-wide function shared with the Visitor Services Department. Many museums now have access officers, who work with both children and adults, and help to implement the Disability Discrimination Act (DDA) and to build on its legal requirements and growing audience expectations.

The role of 'audience advocates' has been developed for example at the Science Museum since the mid-1990s and on project teams for exhibitions, events and websites. Their impact can be seen in the targeted facilities and programmes for different school age groups, as in the work of their 'early years' audience advocate (Graham, 1998). Some of these functions may sit with a visitor services team, such as access, visitor research or dealing with tourist groups, often neglected. The advocates may themselves be from outside the organization, representing disability groups, teachers or communities in focus groups or user committees. A museum may itself be run by volunteers, as with many open-air, industrial, rural craft, folk-life and eco museums.

Working in Gallery and Exhibition Teams

Exhibitions, galleries and the whole interpretive agenda are still too often 'contested terrain' (Karp and Levine, 1991, p 15; also Luke, 2002), where the vigilant audience and learning advocate will always need to be involved. The Learning and Access Department at the Museum of London, for example, lists 'audience advocacy for galleries and exhibitions' among its 13 key roles. In this role much effort and time may be spent in a frustrating attempt to influence policy, timing and pricing, layout, content and language of exhibits; and, if unsuccessful, in remedial activity such as comprehensive explanatory materials and orientation programmes. At the root of the problem usually is the power structure of the museum or gallery. The real acid test is where the head of learning and access sits in the hierarchy and how involved they are in making key decisions. Interpretation is too often seen as primarily, even exclusively, the responsibility of curators working with a design or presentation department. Directors and curators still too often jealously guard their exhibition programmes and do not consult or discuss early or widely enough.

Curatorial and directorial attitudes have changed enormously, but not inevitably everywhere and forever. A 'young fogey' curator may be quite as lethal as an old one: 'I am terribly against targeting ... I would define targeting as what is done by someone who has given a lot of thought to what visitors might want to see or need to know ... I am against spoon-feeding in these galleries'. That was Nicholas Penny (a leading art historian and former curator at the National Gallery in London, now at the National Gallery of Art in Washington DC), taking part in a seminar on display at the British Museum. In response to comments about the need for focus groups in gallery planning, Penny concluded: 'I am very sceptical about all this ... I do wonder whether a really wonderful, captivating display is going to be put on by people who

have an in-depth research analysis of the potential visitor profile'.[2] And here is a curator from the Prado: 'We must not say that we are going to adapt the museum to the public. No, it is the public that must adapt to the museum' (quoted in Sandell, 2002, p 37).

This is of course part of a much wider debate discussed throughout this book. We can hope that these are rather extreme examples, and counter with more constructive examples of the many curators who see themselves as audience as well as collections advocates. But we should not assume all is well with curators in making display and exhibition policy, devising exhibits, or working in gallery and exhibition teams. Part of the problem remains one of training: many curators in UK national museums and galleries have academic qualifications but little or no professional museum training in communication, and do not read or value the kind of sources referred to in this book. Art museums and galleries – especially those with contemporary art – are still too often a frustrating assault course for the visitor because of their limited interpretation. Some successful display techniques of the past, such as contextual recreations for ethnographic exhibits, have even been abandoned, at least in Britain (see Durrans in Lumley, 1988). So new galleries are not inevitably better than what they replaced, reflecting partly the attitudes of successive directors to the public and to display. At an institutional level we are still not learning sufficiently from our own practice and that of others.

Whatever transformation the museum might undergo, there will always be a need for audience advocates as part of the chemistry of interpretation. As Elaine Gurian observes, exhibition production in particular is 'more like the production of a theatre piece than any other form' (Gurian in Durbin, 1996, p 5). There are still plenty of dramas, as we should expect if team players argue their respective corners as they should. Audience is just one of these, and even here there may be differences of opinion among the advocates about which audience matters most. There is, however, growing articulation of specific roles in such a team, and more emphasis on the need to change – and for everyone to behave professionally.

The Victoria and Albert Museum (V&A) and the Science and Imperial War Museums are among those that have developed the role of the exhibitions officer to adjudicate and to take some of the executive strain – and power – away from the designer or curator. Roger Miles and others have made clear whom they think should be in control in creating the science exhibit, and it is the professional interpreter and not collection curators or designers (Miles *et al.*, 2001). Exhibit designer James Bradburne, working on the new Metropolis science and technology centre in Amsterdam, also warns against the designer as diva but remains firmly in control of the project. The designer must be 'a team member ... not the main act ... (and) must allow the user to shape the experience ... '. His ideal multi-disciplinary team for such a science centre would consist of 'a 3D designer, a computer programmer,

2 Penny's comments as cited in Cherry and Walker (eds), 1996, pp 43, 56, 58; and see Michael Spock's rejoinder to this still all-too-prevalent attitude, in Spock in Falk and Dierking, 2000, p ix.

a scientist/researcher, and a media or graphic designer. Each team would be led by a team leader, who would report directly to the Head of Design' (Bradburne, 1999, p 171).

The Educator's Role

Many different and demanding roles may be expected from the educator in this process, presupposing greater training, managerial support and more time than is often feasible or available. Archaeology curator Piotr Bienkowski describes an exhibition project in Liverpool that adopted 'soft systems methodology', addressing the needs of different 'stakeholders' (including trustees, government and sponsors as well as audiences), working out the organization mapping and precisely defining the roles. The key educator role for him is to 'know what the audience wants' (Bienkowski, 1994).

Within a US context, Lisa Roberts lists educator roles in exhibit teams. These include audience advocacy; evaluation (especially in the early stages in defining the brief, and after opening, when the team has probably disbanded); and articulating how learning and communication theory can help to build the brief. The educator on the exhibit team, Roberts rightly says, must be able to operate in a framework of flexibility and respect that still cannot be assumed (Roberts in Durbin, 1996, pp 10–15).

The educator's role may also be that of exhibition curator or team leader, as with exhibitions at the National Gallery and National Portrait Gallery, London, which both have specifically educational display areas; or as museums in Israel and Germany, for example (as described in ICOM CECA, 1991). The curator may also not be a permanent member of staff, but an artist, or an outside academic, a celebrity, or a community, as in People's Shows and the Open Museum in Glasgow. Another approach might be to get schoolchildren to be the interpreters, as in Southampton and Cardiff, and at the National and National Portrait Galleries. Here the educator acts as entrepreneur or facilitator.

Allocating Staff and Resources to Exhibition and Gallery Projects

Another issue here is the educator's grasp of the key subject matter as well as audience data and understanding. This is crucial if educators are to have credibility with curators and audiences, to make a useful impact (for example, on text or the selection of objects) and to programme creatively. Being a service manager or communications expert alone is not enough. The question of course is 'how much is enough?' and where the cut-off point should be for the freelance or temporary staff member to take over on the detailed research for materials and programmes, after the core educator has fought the major battles. Or it may be a curator with specialist collections knowledge who also takes on the advocacy role, and develops programmes and educational materials, working closely with the educators, as was

the case with the HSBC Money Gallery at the British Museum (BM) (see Burnett and Reeve, 2001 Orna-Ornstein, 2001).

There are several examples now showing the benefits of allocating substantial blocks of education staff time to gallery and exhibit projects. For the BM's Mexico Gallery an educator with a curatorial background in that area, Penny Bateman, worked in a small team developing not just the gallery but the accompanying adult and children's books, the teachers' resource packs (linked to the Aztec option in the National Curriculum) and the gallery guide, which looked at the gallery conceptually alongside its main structure of cultures and geography. An evaluation found the presence of a full-time educator and audience advocate in the team to be one of the key reasons for the gallery's success (Winter, 1995).

On a much larger scale project at the V&A, Gail Durbin, deputy head of education, was seconded almost full-time for five years to the British Art and Design Galleries Project virtually from the beginning, working with two curators in developing the key concepts and travelling with them to look at new installations in other museums.[3] Further members of the V&A Learning Department joined this massive project at a later stage. This considerable allocation of staff resources is not usually possible; nor has it been possible in all subsequent gallery projects at the V&A, or on most exhibitions.

In the case of the British Galleries, this educational investment clearly paid off. The gallery team was informed by the best practice, such as the active use of relevant learning theory, particularly on learning styles. In all, eight audiences were identified for the British Art and Design Galleries, including families. As a result of successful audience advocacy by the educators, and effective partnership with outside expertise and focus groups, different audiences and learning styles can choose from a richly varied menu that includes over 160 activities, all of which have been prototyped and evaluated: replica costume and objects, quizzes, backpacks, resource areas, and so on. Special needs were integrated from the beginning (Judd, 2000). The computer interactives are now online, as is the evaluation of the galleries, some of which was carried out by volunteers from the Museum Friends. Not everyone of course is happy with such a strong audience focus. Voices in the press have complained about 'the downgrading of the individual object 'in these galleries.[4] One could equally argue that there are still too many objects. That is a recurrent problem: saying more with less, 'the art of leaving out'as Schouten and Houtgraaf put it, in explaining their design approach for the new Dutch National Natural History Museum (Schouten and Houtgraaf, 1995, 303).

V&A curators also sought visitors' views while planning the earlier T.T. Tsui Gallery of Chinese Art. They set up a desk captioned 'Curator on duty. Enquiries – Please ask'. Themes replaced the chronology of the earlier installation as a result of specific public views, reflected also in the gallery's themes: living, ruling, collecting,

3 Wilk and Humphrey (eds), 2005: Chapter 9. For comparison with the BM's galleries for such material, see Cherry and Walker (eds), 1996.

4 James Fenton in *The Guardian*, 1 February 2003.

eating and drinking, temple and worship and burial. Key questions were also identified from this process (Hardie, 1991). A similar thematic approach following audience research is part of the new Jameel Islamic Art Gallery at the V&A due to open in 2006. Again, a full-time gallery educator specializing in this area has been appointed to the core team from the outset.

Team development takes time, especially if the team is to learn together. For the Hotung Gallery for Asian Art at the BM, as at the V&A, there was quite a long incubation period and a lot of informal discussion involving the team, which included educators (not full-time on the project) from the start, and curators from other departments and other museums experienced in gallery and exhibition development. Curators and educators had both taught in the old gallery and had a shared sense of what was wrong with it. Modest visitor surveys conducted by the education department, using students and volunteers, showed that many visitors abandoned the old gallery after only a few seconds. Information and gallery staff shared the kind of questions and confusion shown by the public. Orientation to faiths, to timespans and narratives of history, meeting the needs of very different audiences, as well as physically opening up vistas, were clearly priorities. Multi-modal learning makes a modest appearance here with texts that include poems as well as photos of objects in use in contexts such as temples. The introductory panels suggest a Big Idea for each half of the gallery but these are not reinforced – posing them as questions might have helped. Former curator Peter Hardie rightly worries also about the danger of reinforcing stereotypes about cultures like China if they are not identified and addressed in the display itself (Hardie, 1991, 23).

Existing and projected audiences were identified for the Hotung Gallery and their likely patterns of use plotted in the layering of star objects in the central spine. This was reinforced through two printed gallery guides and by the first of what are called 'eye-opener tours' led by volunteers. They are vetted, trained, and reviewed regularly by educators and curators (Burnett and Reeve, 2001, p 90). Volunteers are closer to the public than either curator or educator: they become an audience themselves for trialling materials and programmes; they provide in-depth feedback from visitors and become advocates for the museum or gallery as well as for learning.

Advocates for Learning Styles

As audience advocates we need also to consider our own learning styles and preferences. Research for the British and the earlier Silver Galleries at the V&A found that most educators tended to be what David Kolb calls 'common-sense learners' who prefer to test theories for themselves and find solutions. Most curators and conservators, however, tended to be 'analytical learners' who like facts and logical theories; and are less focused on people (Judd, 2000).

As Chandler Screven observes, 'museum learning is self-paced, self-directed, nonlinear and visually oriented' (Screven quoted in Durbin, 1996, p 4). Exhibitions (and guides in all media) often ignore this; sound guides and virtual tours can be

more flexible in the right hands. Attention spans are short and fragile; the need for coffee, fresh air or a seat may be overwhelming. Very few people work their way chronologically round a gallery, so strong section headings and concepts are especially important for re-orientation, and layering of text and objects is crucial. In the BM's Hotung Gallery different audiences and learning styles can co-exist: a large tourist group in a hurry can march through while young children draw dragons in the side bays, a volunteer leads a tour or handling, and a university class studies bronzes. The presence of educators as audience advocates led to features such as the performance areas at each end, used for Indian dance, Chinese calligraphy, storytelling and Beijing Theatre.

Learning from Experience

Published exhibition evaluations and reports can help a museum not only to learn from its own experience (often surprisingly not the case), but to share it (Wilk and Humphrey, 2005). Visitor studies help reveal what our audiences are thinking and how they are reacting to new and old displays. However, exhaustive evaluation implies a follow-up budget: the Science Museum in London reserves as much as 10 per cent of the budget for work after opening. What is needed from the outset is a more experimental approach to display, perhaps developing a concept as an online or small temporary display first, as in preparing the redisplay of The Museum of the American West and Autry Center in Los Angeles.[5] It is often difficult to experiment in face of pressure from fundraisers, sponsors and directors for a finished product on the night. Too often the team then disbands and is promptly submerged in the next project, which some will have been working on already.

The HSBC Money Gallery is another BM gallery that has been kept very much alive in the years since it opened. The gallery curator, having worked on the initial project including the accompanying children's book, then organized the evaluation of the gallery, which found that the average visit was only five minutes (to this corridor gallery often found near the end of the Museum visit). One successful innovation made as a result, to try and sustain longer attention from visitors, was to train volunteers with a handling table of objects in the gallery. This has now been adopted in other galleries. Handling sessions for children both in school and family groups also happen in the nearby Coins and Medals Department Study Room. The BM has since shared its experience on this project with The Manchester Museum (one of its regional partners) in developing its new Money Gallery. Evaluations and reports on other major exhibition projects have been published at the request of the main sponsors.

Other ways to refresh galleries, keep them alive and develop their audiences include making their programmes as multi-voiced as possible. In this context

5 This process enables educators to test out programmes, and get to know audiences and collections. For BM examples of exhibitions before galleries (Korea, Africa, Cyprus and Money), see Burnett and Reeve, 2001, pp 20–29.

a museum may act as host and forum: The Museum of London, for example, provided a platform for London's communities to represent themselves and their cultures during the *Peopling of London* exhibition. At the BM, filmmakers and actors, novelists and doctors, Indian dancers and Chinese calligraphers, storytellers, Indonesian and Japanese craftspeople, potters and Roman soldiers have turned gallery and exhibition spaces at the BM into events (Merriman, 1997; Burnett and Reeve, 2001, p 95, 114–115).

Conclusions

The major issues discussed here have included:

> the audience advocate having a defined role, including researching accurate and detailed audience information;
> the commitment of sufficient staff time of the right calibre;
> the need to be alert to specific needs on all aspects of access.

Long-term team-building across the institution as well as with outside audience advocates, focus groups and experts,will all bear fruit when the team begins to negotiate priorities and approaches.

All too often advocacy can be frustrating, especially on exhibit projects wheremuseum politics dominate. Hilke calls his account of developing science exhibits 'a tragic-comedy in four acts' (Hilke in Durbin, 1996, pp 236–41). There are rarely sufficient resources to do the job really properly or amicably. Yet, as American children's museum pioneer Michael Spock reminds us, this is not rocket science, or magic: 'There still seems to be a stubborn streak running through our profession that treats museum exhibitry and programming as a mysterious art ... rather than built on a growing common body of knowledge ... few of us seem to be paying attention to what we already collectively know' (Spock in Falk and Dierking, 2000, p ix). That was a view from Chicago in 2000 – how different is it now, where you are?

References

Bienkowski, P. (1994), 'Soft System in Museums: A Case Study of Exhibition Planning and Implementation Processes', *Museum Management and Curatorship* **13**, 245–9.

Biggs, L. (2000), 'Opening Up the Curatorial Space', in N. Horlock (ed.) (2000).

Bradburne, J. (1999), 'Changing Designership: The Role of the Designer in the Informal Learning Environment', *Museum Management and Curatorship* **18** (2).

Burnett, A. and Reeve, J. (eds) (2001), *Behind the Scenes at the British Museum*, London: British Museum Press.

Cherry, J. and Walker, S. (eds) (1996), *Delight in Diversity: Display in the British Museum*, seminar proceedings March 1995, British Museum Occasional Paper 118, London: British Museum Press.

Cox, A. and Cox, M. (1995), 'Under-5s at Walsall', *JEM* (*Journal of Education in Museums*).

Durbin, G. (ed.) (1996), *Developing Museum Exhibitions for Lifelong Learning*, London: The Stationery Office.

Durrans, B. (1988), 'The Future of the Other', in R. Lumley (ed.) (1988).

Falk, J. and Dierking, L. (2000), *Learning from Museums*, Walnut Creek CA: AltaMira Press.

Graham, J. (1998), 'Planning for Early Learning in Museums and Galleries', *JEM* (*Journal for Education in Museums*) **19**, 12–15.

Gurian, E.H. (1996), 'Noodling Around with Exhibition Opportunities', in G. Durbin (1996).

Hardie, P. (1991), 'Chinese Whispers', *Museums Journal*, October.

Hilke, D.D. (1996), 'Quest for the Perfect Methodology: A Tragi-comedy in Four Acts', in G. Durbin (1996).

Hooper-Greenhill, E. (2000), 'Changing Values in the Art Museum: Rethinking Communication and Learning', *International Journal of Heritage Studies* **6** (1). (Reprinted in B.M. Carbonell (ed.) (2004), *Museum Studies: An Anthology of Contexts*, Oxford: Blackwell.)

Hooper-Greenhill, E. (ed.) (1997) *Cultural Diversity: Developing Museum Audiences in Britain*, Leicester: Leicester University Press.

Horlock, N. (ed.) (2000), *Testing the Water*, Liverpool: Liverpool University Press/ Tate Liverpool.

ICOM CECA (International Committee of Museums, Committee on Education and Cultural Affairs) (1992), *The Museum and the Needs of People*, A. Zemer (ed.), report of the 1991 Annual Conference in Jerusalem, ICOM CECA: Haifa.

Judd, D. (2000), 'Designed for Different Audiences and Different Learning Styles. The New British Galleries at the V&A', *GEM News* 2000, 83–9.

Karp, I. and Lavine, S. (eds) (1991), *Exhibiting Cultures: The Poetics and Politics of Museum Display*, Washington DC: Smithsonian Press.

Lord, B. and Lord, G.D. (eds) (1999), *Manual of Museum Planning*, 2nd ed., London: The Stationery Office. (See chapters by McManus on audience needs and Spencer on exhibition planning.)

Luke, T. (2002), *Museum Politics: Power Plays at the Exhibition*, Minnesota: Minnesota University Press.

Lumley, R. (ed.) (1988), *The Museum Time-Machine*, London: Routledge.

Merriman, N. (1997), 'The Peopling of London Project', in E. Hooper-Greenhill (1997).

Miles, R. *et al.* (2001), *The Design of Educational Exhibits*, 2nd ed., London: Routledge.

Orna-Ornstein, J. (ed.), *The Development and Evaluation of the HSBC Money Gallery at the British Museum*, British Museum Occasional Paper 140, London: British Museum Press.

Roberts, L. (1996), 'Educators on Exhibit Teams', in G. Durbin (1996).

Sandell, R. (ed.) (2002), *Museums, Society, Inequality*, London: Routledge.

Schouten, F. and Houtgraaf, D. (1995), 'The Management of Communication: a Systematic Approach to the Design of Museum Displays', *Museum Management and Curatorship* **14** (3).

Waterfield, G. (2004), *Opening Doors: Learning in the Historic Environment*, London: Attingham Trust.

Wilk, C. and Humphrey, N. (eds) (2005), *Creating the British Galleries at the V&A: A Study in Museology*, London: V&A Publications.

Winter, C. (1995), 'The Mexican Gallery at the British Museum: An Evaluation of its Impact as an Educational Resource', unpublished MA dissertation, Institute of Education, London.

A Collective Responsibility: Making Museums Accessible for Deaf and Disabled People

Jane Samuels

Nowadays, national museums recognize the centrality of audience diversity to their purpose. In order to satisfy this increasingly important objective, audience advocacy has grown in strength. Since the 1995 Disability Discrimination Act (DDA), advocacy for disabled people has become a greater priority in most institutions. Inevitably, this is principally due to the legal onus placed on museums by the DDA, but is also a consequence of increased awareness of the needs of disabled people that has followed in the wake of the Act.

Successful inclusion for disabled visitors to museums is multi-layered and for most committed institutions a continually ongoing process. Responsibility for disabled access cuts across all areas of museum services, from the physical environment, to commercial services, to learning and information, marketing, exhibitions and galleries, Human Resources and visitor services. Principal accountability for disabled access, however, usually rests with one individual, namely the museum's appointed manager of Access, often placed in the Learning Department. However, for audience advocacy in this area to be sustainable

there needs to exist a museum-wide commitment to Access which recognizes the institution's collective responsibility towards its deaf and disabled visitors.

Historically, Access services have all too often slipped through the net when budgets are first apportioned. Therefore, the greater a museum's commitment to disabled audiences, the greater the likelihood that appropriate funds will be apportioned to this target audience from the outset of all new exhibitions or gallery refurbishments.

Mummy: the Inside Story, a recent exhibition at the British Museum, provides an example of successful intellectual, sensory and physical disabled access. This notable case of advocating for disabled audiences was the result of direct teamwork across the museum between several departments, including the Department of Learning and Information, the Department of Presentation, the Marketing Department, the Visitor Services Department and the Buildings Department. *Mummy: the Inside Story* was an extraordinary virtual reality film, narrated by Sir Ian McKellen and supported by an accompanying exhibition, the whole giving a

remarkable opportunity to learn about Ancient Egypt. During the film, the unopened 3000-year-old mummy of Nesperennub, priest of Karnak, is revealed using a CT scanner. The audience is taken on a journey through the mummy-case, under the wrappings and inside the body. This exhibition provided superb intellectual and sensory access for disabled visitors, in particular for visually impaired audiences. All the written information in the exhibition was produced in large print, including the text of the film. A large-print booklet and flyer introduced the exhibition, provided information about the visual elements of the film and located what was on display in each room. This information was also produced in Braille and audio CD and, where possible, all materials were made freely available at the Museum's Information Desk and from the Museum's website.

Additionally, a handling collection of replicas reflecting those objects highlighted in the film was available on request, and trained gallery assistants were on hand to assist visually impaired visitors' enjoyment of and access to the exhibition. Finally, a handling session, led by the lead curator of the exhibition, also took place, ensuring a thorough provision for the Museum's visually impaired audiences. For deaf audiences, all three exhibition rooms had a loop system and monthly sign-interpreted talks were programmed for the general public. Sign-interpreted talks were also available for deaf school groups. Visitors with mobility difficulties were also appropriately considered. There was lift access to the exhibition, two permanent wheelchair spaces in the auditorium and seats to sit and rest in the first exhibition room. All the displays were at a height suitable for people using wheelchairs.

Guided by the Museum's Access specialist, the exhibition's impressive provision for disabled visitors owed its success to the cooperation and commitment of many departments. It is an illustration of the high access standards attainable – and not necessarily at great expense. Having provided resources for disabled visitors, it is essential to emphasize the importance of a marketing strategy. In order for this necessary service to be effective and well utilized, disabled people need to know it exists. Here, inclusive publicity becomes critical in reaching new audiences. Alternative promotional formats, including Braille, large-print and audio CD are important requirements. Other methods of advertising might also include relevant websites, teletext pages for deaf people, radio for visually impaired audiences, audiotape and talking newspapers.

With a UK estimated disabled population of approximately 20 per cent (Disability Rights Commission, 2005), the importance of intellectual, sensory and physical Access for this target audience is considerable. Furthermore, by continuously enhancing Access provision for disabled people, Museums will also noticeably expand the quality of their services for all audiences.

Chapter 13

Whose Space? Creating the Environments for Learning

Rick Rogers

Introduction

Many new museums and galleries across the world have become iconic buildings, both within the cultural sector and to the general public. Architects, designers, graphic and video artists have also greatly improved the display of art works and exhibits, and the overall surroundings in which visitors experience those displays. The use of new technologies and re-assessments of more traditional ways of experiencing objects and art works are helping to meet visitors' needs more effectively, as well as engaging and inspiring young visitors. We all know more about what museums and galleries can be like in the twenty-first century.

Another significant change going on inside these cultural sites, iconic or otherwise, is a greater focus on people's learning needs. This is being driven largely by a combination of government funding criteria, and by such major policy initiatives as the Museums, Libraries and Archives Council's *Inspiring Learning for All*. And yet, while museum and gallery professionals set about fulfilling these learning criteria, and install what are perceived to be more exciting ways for people to engage with art works, and while sociologists and cultural entrepreneurs survey, analyse and categorize visitors or users in equally exciting ways, the locations, or spaces, for learning within museums and galleries are being overlooked.

The Evidence on Learning Spaces

Many of our cultural sites have inadequate learning spaces. They are too small, or in the wrong place, poorly fitted out, or with unsuitable equipment. They are too dark, or too cold. Some work only because of the ingenuity and enthusiasm of the site's education team. Too many spaces fail to realize the potential of the learning opportunities that the site can offer. Too many senior management teams fail to appreciate the central role that education should play in the site's vision, work and future development. Too few architects take account of the needs of education teams and their learning clients.

We know all this from research carried out by the Clore Duffield Foundation between 2002 and 2004 under the general heading of *Space for Learning.*[11] This formed part of the Foundation's long-term *Artworks* programme and looked at art education spaces in schools as well as in galleries, museums and other cultural sites. The Foundation's involvement in supporting education in the visual arts, and its substantial investment in funding new buildings and internal areas of galleries and museums, led it to the conclusion that too little was being done to provide practical guidance on best practice in the design, construction, rethinking, refurbishing, resourcing and management of learning spaces – large or small, old or new – across a range of cultural sites.

The location, design and build quality of learning spaces in museum, discovery, environmental and heritage sites tend to reflect the general lack of status of education as a discipline within such sites. Too often, education is regarded as a marketing tool rather than a core service. Too often, education is used as leverage to obtain additional funding for developments rather than being seen as intrinsic to the site's overall purpose. Too often, the head of education is not a member of a site's management team, and therefore on the margins of the decision-making process.

Certainly, cultural sites need to see themselves as an entire learning space, where education takes place in the galleries and exhibition areas as well as in designated learning spaces. But without dedicated spaces, education remains at risk from marginalization with no clear reference point for users or staff. Creating a successful, dedicated learning space helps both to raise the status of education across the site as a whole, and to make education users feel valued by the organization. Before all else, sites must have an education policy in order even to attempt the creation of a learning space. They must know in advance what they want the space *for* and the learners for whom they intend to provide.

It is not surprising that the UK has so few centres of excellence in these types of learning space. Many education staff say they have little or no access to proper guidance and support in devising, negotiating, analysing and managing learning spaces. Crucially, too few are brought into the collaborations and partnerships – internally with senior management and curatorial staff, and externally between management, architects and contractors – that determine the sort of learning space in which they have to work.

The Imperative of Partnership

The concept of partnership is central to government policy on resourcing the education and cultural sectors – alongside the concept of learning. 'Partnership'

1 The three Clore Duffield Foundation reports on developing learning spaces and the importance of creating a partnership across sectors – *The Big Sink* (2002), *Space for Art* (2003) and *Space for Learning* (2004) – are all available on the following websites: <www. cloreduffield.org.uk> and <www.art-works.org.uk>. For hard copy versions, access under S. Bacon (ed.) *et al.* in the Bibliography.

opens up more funding streams than any other approach to the development of a cultural site. The same approach is determining how the arts are being developed in schools. Indeed, the arts curriculum cannot be successfully delivered without significant participation by the arts or cultural sector – be it an artist-in-residence or a long-term, all-embracing programme like Creative Partnerships. This creates the need for two-way traffic between school and cultural site, with both being seen as locations for learning.

Partnership also highlights the need for effective joint decision-making, both within a cultural site and between the site and its users. Why collaborate in this way? Why form partnerships beyond the professional networks that sustain and have responsibility for the cultural site? Just getting on with it can be much more efficient and convenient. There are four good starting points, however, for exploring such issues: the potential in collaborations; the gaining of public trust by museums and galleries; the promotion of 'cultural engagement and aspiration' across society, characterized by the concept of people's 'right to art'; and the Clore Duffield Foundation's approach to spaces for art and for learning.

The book *Organizing Genius: The Secrets of Creative Collaboration*, by Warren Bennis and Patricia Ward Biederman (1997), is based on the premise that 'none of us is as smart as all of us'. The book documents significant companies or social and economic developments which succeeded because of what is called 'collective magic'. Examples cited include Walt Disney, Apple, the 1992 Clinton campaign for the American presidency, the Manhattan Project to build the atom bomb and the arts school Black Mountain College. Bennis and Biederman refer to 'great groups' – great because of their ability to collaborate and be greater than they are individually. Crucially, they do not fear change or the future. A group, they say, can be a goad, a check, a sounding board, and a source of inspiration and support. Songwriter Jules Styne said he always had to have a collaborator because: 'In the theatre you need someone to talk to. You can't sit by yourself in a room and write.' It is the same when planning learning spaces in a museum or gallery.

Such issues are also discussed, albeit from a different perspective, in a series of essays, *Whose Muse? Art Museums and the Public Trust*, edited by James Cuno (2004). Six directors of leading UK and American galleries consider how to maintain public trust in such cultural sites. Their answer is that they must continue to build collections that reflect the nation's artistic legacy, and provide informed and unfettered access to them. However, they stop short of trusting either the public or those outside senior management enough to be part of the decision-making process about what a gallery and its spaces should be like. It is a debate that goes on between curators rather than between curators and educationalists and, subsequently, learners themselves. Experiencing what these six directors term the 'spiritual' aspect of a gallery is seen to be sufficient for the user. The Clore Duffield Foundation's approach is to ensure greater accessibility to the practical (or nuts-and-bolts) aspects of developing galleries – a stage as vital as gaining trust for the curatorial role of what is exhibited, why and how.

The cultural entitlement advocated in the Demos/VAGA report *The Right to Art: Making Aspirations Reality* (Hewison and Holden, 2004) embraces the need for governments to put into practice the principle of universal access to visual art, and for the public to support that aim by 'giving something in return' – not just money in the form of taxes, but time to enjoy the arts and to a readiness to see educational resources devoted to ensuring access to, and understanding of, visual art. The overall aim is to encourage and spread visual literacy. Once again, this polemic does not go as far as addressing the right to a more practical engagement with the development of cultural sites and, particularly, spaces in which to learn.

So while these elements of the potential of collaborations, gaining public trust, and promoting cultural engagement and aspiration (the right to art) are clearly inter-related, they currently tend to be promoted by different sets of stakeholders in the cultural sector, whose perceptions and professional interests do not always readily match. The *Space for Learning* approach can offer one way of resolving, at least in part, this dichotomy by bringing these stakeholders together to discuss and agree on practical, as well as philosophical, issues of what to do with a cultural site or institution, both as a structure and as a collection of art, heritage, science, or archival material.

The Partnership in Spaces

The process of creating and running learning spaces in cultural venues is a microcosm of the relationship between the education and cultural sector, and between the cultural sector and the public. It reflects the key issues of partnership in terms of hierarchies, access to knowledge and access to decision-making. The Clore Duffield Foundation's work quickly became a collaborative venture, involving key organizations concerned with education in the arts, cultural, environmental and heritage sectors: Arts Council England, Arts Council of Northern Ireland and the Scottish Arts Council, the Commission for Architecture and the Built Environment (CABE) and the Design Commission for Wales (DCFW), the Department for Culture, Media and Sport (DCMS) and the Department for Education and Skills (DfES), the Heritage Lottery Fund (HLF) and the Museums, Libraries and Archives Council (MLA, formerly Resource). They came together because of mutual concerns about, and ambitions for, education and for learning spaces in the sites for which they are responsible or which they fund.

The State of Learning Spaces

The *Space for Learning* findings are based on a survey of 91 non-national sites and 21 national sites, such as those receiving funding from central government. These sites comprise museums, historic houses and other architectural and industrial heritage locations, environmental centres, including nature and wetland reserves and parks, galleries and sculpture parks. The survey asked about the main elements of

their learning spaces and how they rated them across a range of practical criteria. Eleven in-depth case studies of learning spaces at small- and large-scale sites across the UK were also carried out. They are in a mix of city, urban and rural locations, and run by commercial companies, private trusts or local authorities. They are:

- Bishops Wood environmental centre in the Worcestershire countryside
- two science/discovery centres – Techniquest in Cardiff and @Bristol in that city's harbourside redevelopment
- The Lighthouse, Scotland's Centre for Architecture, Design and the City, in Glasgow
- The National Trust historic house Dyrham Park near Bath
- The Women's Library in London's East End
- the Bagshaw Museum in the small Yorkshire town of Batley
- the larger-scale Bolton Museum & Art Gallery
- the Horniman Museum in South-east London.
- the River & Rowing Museum at Henley-on-Thames
- the Ulster Folk & Transport Museum in Holywood, near Belfast.

A series of focus groups at each site drew on the views and experience, enthusiasms and criticisms of key stakeholders of the spaces, including educators, senior management and other staff, teachers and other users of the space. In some cases, the architects who designed the learning space also attended the focus groups. The groups also identified the key factors that determined the outcomes of their project to rethink, refurbish or build a learning space. Altogether, the *Space for Learning* team consulted hundreds of educators working within museums, archives and libraries, historic houses and buildings, heritage sites (industrial, archaeological and natural), architecture and science centres, children's museums and discovery centres across the UK.

From the survey of cultural sites, three-quarters are housed in listed buildings – a significant factor in the redevelopment of sites or internal spaces. The annual number of visitors ranges from 6,000 to six million, and educational participants from a hundred to half a million. The responses therefore highlight the diverse nature of learning activities and contexts, as well as the common factors in what makes a successful learning space. For example, while most of the national sites are satisfied with the size of their learning space, half of the non-nationals definitely are not. Only a third has space that is exclusively for educational uses.

Most spaces in national and non-national sites resemble a classroom, followed by a gallery or exhibition area. Critically, only a minority of spaces seem a sufficient size to accommodate a whole class of 30 children. The majority are located on the ground floor and accessed through the main gallery or exhibition area. However, access out of opening hours can be limited and, more seriously, is often inadequate for learners with physical disabilities. Nationals tend to hide their learning spaces away from the general visitor by locating them where they cannot readily be seen, whereas non-nationals do the opposite. However, non-nationals tend to dislike more

the look and feel of their spaces, and half of both types of site have problems keeping spaces clean and tidy.

Learning space facilities must be able to manage efficiently the movement and physical needs of large groups of people, especially children. Yet, only a minority of sites consider their toilet facilities good enough in terms of numbers, accessibility and child-friendliness. Adequate space for lunch is a chronic problem, as is cloakroom provision – whether lockers, hooks, cloakrooms, wheelie bins or crates are used. Over half of sites regard such provision as poor and just 13 per cent as good. Storage space generally is a problem for most sites, and solving it is seen as a priority by many education staff. Over three-quarters of responders are not satisfied with their storage space for work, resources and materials. That cornerstone of services – the sink – continues to vex most education staff, and no doubt those who use them as well. Forty-two per cent said provision is poor, and 13 per cent of non-national sites have no sink at all. Alarmingly, almost three-quarters of nationals report that their sink situation is not good.

While access to power points is satisfactory, the location of other services such as water and lighting is less pleasing for two-thirds of the non-nationals. The quality of natural and artificial light is also better for nationals than non-nationals, as are black-out facilities – not good enough for 60 per cent of them. Other important aspects of a well-designed and fitted learning space include acoustics and soundproofing, temperature control and floor covering. Of these, soundproofing and temperature control are particularly problematic for the majority of sites, being good in just one in five and one in four respectively. By contrast, almost half are satisfied with a space's acoustics and its floor covering.

Factors to take into account when deciding on furniture and equipment include the quantity you need, the type and size, and the design. Most regard their table and chairs as adequate rather than good. But such items must suit different ages and size of users, and be easy to move and store. There is less satisfaction with furniture's adaptability, with only one in four saying this is good. One in five has moving and storing problems with furniture and one in four with equipment.

Finally, one of the most worrying findings is the limited access to ICT equipment and the Internet. Over half of non-nationals say access is poor; 15 per cent say they have no access at all. Even three-quarters of nationals do not have good access. Only a minority benefit from effective technical assistance.

The Process for Developing Learning Spaces

The process of developing a learning space is as vital to get right as its location and what goes inside it. Who helps to make the decisions and how those decisions are made determine the kind of space you end up with. If the education team is not properly involved in this, the odds are – and the evidence shows – that they will not get the space they want nor the fittings, furnishing and equipment needed to run effective learning programmes. To succeed requires well-informed and empowered

education staff who can, in turn, engage and persuade their directors, trustees, funders, architects and contractors, when the time comes to rethink, refurbish or rebuild. Overall, a successful development process requires communication, collaboration and consultation, including consultation with children and young people.

Forming a 'project team' sends the message that you mean business. The more ambitious the project, the larger the team, and in a listed building, the team should include a conservation officer. The head of education should always have a central role in any team's decision-making process. Certainly with new build or major refurbishment, the team should appoint a project leader who can:

- act as the main conduit for all information and documentation between architect and the site;
- establish and manage effective liaison and consultation internally, including with building and conservation staff;
- manage the different lines of decision-making with external bodies such as trustees, owners and funders;
- maintain continuity through a project especially when there are staff changes;
- agree timetables to suit the demands on staff as well as architects;
- ensure all staff, including education or curatorial staff, have access to and can negotiate those elements of a development directly affecting their work.

The project team should set up straightforward and transparent arrangements for keeping all staff up to date, having consultation sessions at key points, and ensuring staff work together rather than in isolation. The project leader's role will sometimes be that of a referee ensuring fair play and bringing new players onto the field. At one site, different teams, such as education, were asked to specify what they wanted in terms of spaces and what should be in them. Drawings and descriptions were circulated for comment and amendment at the two key stages of applying for planning permission and agreeing the detailed designs. The teams were also brought in to discuss specific aspects of the development that affected their future work.

No team can embrace all the professional and practical know-how that is required to create a successful learning space. The project team, and the different teams such as education, should therefore draw on the knowledge, experience and expertise of particular individuals either internally or from outside. Sub-groups need to be set up to research and develop specific aspects such as access. The stronger the team, the better that education staff can discuss issues on equal terms with other senior management, architects and contractors. That will help in steering the direction of the new space according to learning imperatives rather than be driven by non-education imperatives.

It is also vital to consult with the users of the learning space, and the site as a whole. The education team should ensure that its actual and potential users are consulted in some effective way. This, of course, includes children and young people. Ways to do this can be worked at, based on practical involvement in developing the

space. For example, children can help to work out whether the proposed space is the right size for the numbers and activities envisaged. One site got each education team member to act as an advocate for the different audiences it served, and consulted informally with local contacts and community networks.

The difficulty is how to carry out a successful, meaningful and useful consultation. It is not simply a question of asking young people what they want from a space – how can they know what is possible? There is also the issue of managing expectations – young people may make creative suggestions that cannot be implemented because of budget or staffing restrictions. Many museums and other sites may feel that they cannot afford to consult children and young people using specialist researchers. However, those that do suggest:

- talking to architects about their experience of consulting users;
- collaborating with teachers and tutors of educational groups who regularly use spaces, and who may have ideas about how to research the potential of the space with the young people with whom they work;
- researching websites and other documentation on recent examples of consultations for projects, such as the development of the New Art Gallery in Walsall, the Discover Centre in East London, and the MacRobert Arts Centre at Stirling University.

Working with Architects

> When it came to briefing the architectural team, we knew what we wanted from the building but not what it might look like. That's the architect's job (John Rhymer, Director, Bishops Wood Environmental Centre, Worcestershire).

Communication, consultation and collaboration apply equally to working with architects. The most successful learning spaces have come about from a close understanding between client and architect of what is needed. That means talking and listening, as well as designing. However, there is often little contact between architect and education team – and sometimes a lack of understanding of, or regard for, their needs. It is the individuals involved, and their ability to collaborate effectively, who determine the success of the client/architect relationship. That means understanding each other's approach and needs in terms of designing and fitting out the space; and identifying and acknowledging gaps in expertise or knowledge of client and architect. Our case studies show that it is best to have one person to act as the main link between staff and architects.

> Designing a useable, versatile space needs the sort of architect who will come in, spend time, listen, look, listen again, go back, and keep working until you come to the point where everybody is confident in the brief not just the architect or not just the client (Chris Adams, Property Manager, River & Rowing Museum, Henley-on-Thames).

Three crucial points emerged. First, the professional hierarchies of an institution should not restrict the involvement of the education team in the consultation and decision-making processes. The head of education should always be part of the senior management team, and be seen as a key player in planning any learning space project. Second, the consultation process should be effective, transparent and trusting. Finally, everyone should be helped to understand what is being proposed, with technical terms, architectural drawings and jargon all explained. Too many gallery staff are afraid to say when they do not understand what is being said or proposed.

> One difficulty was interpreting complex drawings. So we always tried to ensure that they were understood. Even so, people sometimes didn't take things seriously until they saw it in reality. That didn't really happen with the education team because they crawled all over the plans! (Finbarr Whooley, Horniman Museum's Head of Curatorial and Public Services).

Looking Ahead

The *Space for Learning* case studies show how learning no longer has age limits. Cultural sites see their education work as territory for a wide range of learners, from groups of Key Stage 2 pupils to higher education students, and from early years groups to adult learners. Such diversity has obvious implications for the design of learning spaces. Much more can go on in them – making, investigating and exploring, listening and discussion – and with a wide range of equipment, from the traditional to new technologies. A space may also need to be compatible both with sitting still and with being active. As a result, learning spaces can take many different forms in order to meet the needs of the diverse groups and individuals who come, or could come, to them. The key is flexibility.

These changes also require a re-evaluation of the nature of learning in cultural sites. This is an opportunity to raise the status of education and learning within the site; ensure that education staff are involved in the process of developing or rethinking learning spaces, as well as managing them; and encourage a 'creative pedagogy' that can enhance the learning potential of site visits, establish creative connections to the curriculum and provide opportunities for teachers' professional development.

Learning also takes place beyond the boundaries of dedicated learning spaces, alongside artefacts, collections, exhibits and internal and external environments, such as outdoor discovery and heritage areas. However, across the various sites involved in the research, education staff stressed the importance of having a dedicated space for learning, which (properly located) can give education work visibility and status in the site and spark interest and participation among visitors.

Designing and running learning spaces enable sites to incorporate principles of sustainability, particularly in the use of natural resources, energy, waste management and recycling. An environmental centre would make sustainability a top priority, but there is a growing commitment by other types of site to adopt such solutions. An

education team is in a good position to press for a sustainable approach, especially as most schoolchildren and teachers are very aware of these issues.

The long-term objective of the *Space for Learning* initiative is to encourage all types of cultural sites to create high-quality, flexible and sustainable learning spaces for the future. As such, the initiative is aimed not only at site staff, but policy-makers and funders, architects and designers – and, of course, the interested user.

The *Space for Learning* research enabled the team to devise a set of guidelines to cover the key factors to consider in designing and equipping a learning space:

- the development process and working with architects
- the location and dimensions of spaces
- the activities that would go on in them
- the use of new technologies
- fittings, furniture and equipment
- storage and equipment
- services and costs
- usage, management and maintenance
- planning for the future.

This guidance is based on the principles that:

- there is value in learning from experience rather than theory or ideology
- spaces should cater for learners of all ages
- success can be achieved whatever the size of the budget
- spaces should embrace the wider learning environment and support both economic and environmental sustainability
- the guidelines can be relevant to all types of spaces.

The initiative found only a minority of examples of excellent practice. Where spaces had 'gone wrong', many education staff often knew why – and what was needed to turn a poor space into one that worked. Crucially, the Foundation's research also found many thoughtful, and sometimes inspirational, solutions to rethinking and managing spaces where resources are limited and locations far from ideal – sometimes far more exciting than a 'flagship' space or site.

Evaluating spaces after they have been up and running for some time also highlighted a key point: even successful spaces require rethinking at regular intervals as needs and priorities change, and building and equipment innovations become available. A space that is right now will not be right forever.

The one simple but vital imperative is ensuring that all learning spaces can realize their full potential for users, and be the best possible space within the constraints of a particular set of circumstances or resources. The common factor is the success of the collaborative process combined with the presence of motivated, imaginative and talkative individuals within that process.

We are grateful to the Clore Duffield Foundation director Sally Bacon for permission to draw extensively on the Spaces for Learning *research and report. The research was project managed by Siobhan Edwards.*

References

Bennis, W. and Biederman, P. W. (1997), *Organizing Genius: The Secrets of Creative Collaboration*, London: Nicholas Brearley Publishing.

Cuno, J. (ed.) (2004), *Whose Muse? Art Museums and the Public Trust*, Princeton NJ: Princeton University Press and Harvard University Art Museums.

Hewison. R. and Holden, J. (2004), *The Right to Art: Making Aspirations Reality*, London: Demos/VAGA.

Response to Chapter 13

The Importance of the Museum's Built Environment

Christopher Bagot

The collections of many museums would merit study however they were housed, but the enjoyment of a visit to the museum can be greatly enhanced by the quality and variety of the architectural spaces which support the experience. This principle should apply not only to the galleries, but must also be an ambition in the creation of other public spaces, particularly learning centres at museums. If the educational spaces can be uplifting and memorable, as well as functional and well built, then the chances of the facilities being successful in achieving their purpose will be very much increased. Alongside the main spaces for teaching and learning, those areas given over to arrival and orientation, to relaxation and break out, can be just as important in establishing the overall quality of a learning centre. They offer less constrained opportunities to innovate and inspire, with the aim of the design being to encourage informal and unplanned interaction.

It is unlikely, though, that an architect, no matter how grand, will come up with the best solution without consulting with those who are going to use the spaces. Understanding the needs and aspirations of users benefits the project at every level.

In developing our designs for the Education Centre at the Victoria and Albert Museum, (V&A) we have been able to interact with end users in several ways. Working with the Sorrell Foundation, we were involved with a series of visits and workshops with groups of schoolchildren from Birmingham, London and Newcastle at a very early stage in the design process. Encouraged to act as clients, the pupils drew upon the observations they made while visiting a series of cultural buildings to set out what some of their ambitions for the project would be. It was really interesting to see the amount of common sense and instinctive thinking that they brought to design details that one might assume would be overlooked. They were harsh critics of lazy thinking and understood well the importance of function as well as stimulation.

Observing some of the V&A's current courses and events and talking with their programmers and tutors also helped us to understand which decisions would be perceived to have the biggest impact on the ultimate usability of a space. Often the failings

of current facilities made it easier to highlight what their preferred solution would be. Also, the many discussions that have taken place between the architects and the museum have been very useful in finalizing the brief. In a museum with such a wide-ranging provision of educational services as the V&A, it has given us confidence to know that we are taking on board the sometimes contradictory requirements of as many different stakeholders as possible.

Invariably a number of learning facilities in museums will be housed in existing buildings, of varying quality. The challenge then is to create forward-looking and stimulating environments from structures designed for a different purpose and with different priorities. Re-using an existing building is an inherently sustainable approach to design and one that also has the potential to create a more richly layered design than would have been the case if a project had been built from scratch. The V&A's new Education Centre will be housed in the nineteenth-century Henry Cole Wing. With generous ceiling heights, it has been possible to insert new elements that are clearly distinct from the original structure, allowing the visitor to read how the design has been built up. Given the strong character of the existing building, a degree of spatial compromise was inevitable. However, with all those old bricks comes character and memory and the capacity to provide contrast and context to the new technologies and materials required for the building's future role.

Chapter 14

An Unsettled Profession

Vicky Woollard

This book looks at the relationship between museums and their audiences particularly from the perspective of the museum education practitioner. This chapter examines the professional development of practitioners and suggests that perhaps the relationship between practitioner and audience has become strained.

> During the 1980s and 1990s, museum training courses like museums themselves have proliferated all over the world, producing more qualified students than museums can employ ... Whether they and other innovations have succeeded in creating anything that could be accurately described as a 'museum profession' remains an open question (Hudson, 2004, p 89).

Rise of a Profession?

By the end of the nineteenth century, museums were beginning to separate out their audience from being one homogenous group (the public) into groups with identifiable needs, such as researchers and schoolchildren. The US established children's museums such as Brooklyn Children's Museum (1899), while the UK and Europe concentrated on relationships with the formal education sector, schoolchildren and their teachers, by providing loan services, teaching and guided tours (Hooper-Greenhill, 1991). These services required dedicated staff who had an understanding of the needs of their audiences and so during the first half of the twentieth century there was a gradual rise in the employment of teachers in UK museums. This history of the birth of a 'profession' has been well documented by Winstanley (1980), Hooper-Greenhill (1991) and Woollard (1998). By the 1950s professional bodies or organizations had been established to promote the status and development of museum education and to provide educators, both at national level (in the UK Group for Children's Activities in Museums) and international level (ICOM's Subcommittee/Section F on Children's Activities) (see Woollard, 1998).

With the global increase of new museums during the following decades, one assumes that some of these included education specialists on the staff. Museums which employed such specialists would see a change in the roles and responsibilities of other staff; for example, curators who had previously been the public face of

museums, through giving lectures, handling sessions and guided tours,[1] were freed to carry out further research on their collections in the stores, leaving the galleries and other public spaces to the educators. However, the increased educational services were evenly distributed, as Anderson noted in his groundbreaking report *A Common Wealth: Museums and Learning in the United Kingdom* (1997) – in the mid-1990s, 50 per cent of UK museums made no deliberate provision for education, let alone had employed staff to deliver these services. With the change to the New Labour government in 1997, there has been a substantial amount of government funding – through the Department for Culture, Media and Sport (DCMS) and the Department for Education and Skills (DfES) – put into museum education projects, such as the Museums and Galleries Education Programme and the Education Challenge Fund. The figure, a conservative estimate, has been over £17 million. This sum excludes the Heritage Lottery Fund (HLF), which has explicit criteria that educational benefits are an integral part of the amount awarded to museums and galleries in the UK. So we are talking about considerable sums of money. The main thrust of these grants has gone towards increasing audiences, either directly through funding school visits or engaging with new community groups, or indirectly by building capacity through training, developing education policies and creating support networks.

Health of the Profession

When considering the professionalization of museum education practitioners, one needs to define the group. Demos (2003) encourages the inclusion of freelancers and consultants alongside volunteers, and paid staff who may hold permanent or short-term contract posts. The term 'practitioner' is used to distinguish individuals from academics and perhaps managers, as those who are 'actively engaged in an art, discipline or profession' (Oxford Dictionary of English, 2003), thus bringing 'practitioner' and 'professional' together in the one definition. The Dictionary continues by giving the example of a doctor as a practitioner. One takes the term 'actively engaged' for museum educators to mean those organizing and delivering events, activities and materials for audiences and participants as a part of their engagement with museums and their collections. The terms 'professional', 'professionalism' and 'professionalization' have been debated in the past by a number of authors (see Burrage and Torstendahl, 1990; Eraut, 1994; Freidson, 1973 and 2001; Laffin, 1986 and 1998; and Larson, 1977). In the context of museums there are a number of sources to consult (see Teather, 1990;[2] Van Mensch, 1989; and Kavanagh, 1991 and 1994). Other more pragmatic sources include the work carried out by professionals in agreeing the National Occupational Standards for the Cultural Heritage Sector

1 See back copies of the *Museums Journal* between the First and Second World Wars for examples of letters, notices and articles by curators on aspects of delivering public programmes.

2 This is an excellent summary of the debate on the museum profession discussing the rise of professional bodies and training up to 1990: it can be found in Shapiro (1990).

(under CHNTO) and ICTOP (The International Committee on Training of Personnel (for Museums)). There is however some debate whether there is such a thing as a museum profession (see Teather, 1990; Sola, 1991; Kavanagh, 1991 and 1994; Hudson, 2004; Weill, 1988). Kavanagh suggests that there is not enough evidence to claim that there is a museum profession as a whole, but what she calls 'a (very) loosely held together occupational group'. However, she goes on to say that there are particular characteristics that identify professional behaviour and attitudes, which can be summarized as:

- high degree of specialization and general knowledge
- high degree of specialist and general knowledge about museums, via pre-entry and in-service postgraduate training
- considerable personal commitment to the ideals of museum provision and place in society
- strong sense of public duty; that is, serving people
- willingness to monitor and control standards of behaviour and performance for the common good
- peer group control and collective responsibility exercised through professional groups or bodies (Kavanagh, 1994, p 8).

Here we can note that the public are acknowledged explicitly in terms of public duty and implicitly when setting standards for the 'common good'. The notion of public service is inextricably linked to professional standards and conduct. As Hudson (2004) noted, when discussing the change in relationship between museums and their audiences over time, it has been partly due to 'the development of professionalism among those who work in museums and a corresponding inclination to say, "There must be a better way", defining "better" in terms that will be approved both by other museum people and by the authorities that may have to meet the costs' (Hudson, 2004, p 87).

The Status of the Museum Educator

Kavanagh's list above does not include the possible benefits for the individual gained from such professional conduct and attitudes. As with the major professional groups, such as law, medicine and architecture, one of the results may well be status, within the sector and in society as a whole (Larson, 1977). For museum educators the notion of status and professional standing has been a contentious one and remains so today. In 1986, Elliot Eisner and Stephen Dobbs investigated the status of museum education in America in *The Uncertain Profession* and came to the conclusion that its overall 'health' was poor (Eisner and Dobbs, 1986). It could be said that the list of their 20 findings demonstrated that there were multiple understandings of the purpose of education, and there was a direct correlation between the views held by directors, trustees and curators and the perception museum educators had of themselves. The former appeared to have a general lack of understanding and respect of the role of education and education practitioners' work within museums;

as a result museum educators felt powerless and lacked the opportunities to develop innovative programmes, due to poor funding and support from senior management.

More than ten years later, this troubled area is found to be central by Owens in *Creative Tensions* (1998), in which he found that staff within cultural organizations fell into three distinct groups, each having different views as to what the role/purpose of education had for the organization: the artistic/collections focus, the individual focus and the institutional focus. These alternative understandings/misunderstandings cause confusion and tension when certain education projects bring about results not necessarily anticipated by one group, yet welcomed by another. This is due to each group assuming the project is set to achieve different aims and objectives, which have not been discussed or agreed. This describes organizations which have little integration or sharing of common goals.

Perhaps one of the reasons for the lack of respect shown by senior managers for museum educators mentioned above is raised by Heyburn in his article 'The Educator as Museum Professional' (1992). He proposed that this lack of respect may be caused by education practitioners being associated with children and school parties, which 'acts in a subtle way to devalue educators as full grown museum professionals and conditions the way they are perceived: the ones that deal with the kids'. Could one suggest that this has been extended in the last five or six years to those working with groups of disaffected youths, prisoners and the elderly in care homes – the socially excluded and the 'institutionally' excluded – and by 'contagion' to those staff members in close contact?

New Demands upon the Museum Educator

Not only is it the type of audience that may separate museum education practitioners from their colleagues, but also the structure of programmes in which these audiences participate. In the past few years in the UK the recent increase in project-funded initiatives for audience development has exacerbated the lack of professional integration. These short-term projects can have high status as the funding partner is the government – the Department for Culture, Media and Sport (DCMS) and the Department for Education and Skills (DfES).

Yet the components that make up the project are all, or almost all, external to the organization: funding partners, project partners (such as social services/community workers), and those that deliver the project, such as freelance artists/educators and the evaluators. There are some obvious reasons for this, such as identifying new audiences to the museum, and the appointment of an outside 'objective' evaluator. However, this 'externality' needs attention, time and energy, thus overshadowing the need to maintain internal connections and communications. A consequence of this may well be that there is difficulty at the end of the project to 'return' to the organization and hence a feeling of isolation may occur. Yet the involvement in such projects may highlight the reverse, that the individual had become institutionalized to fully understand the needs of the particular audience group. This was observed in Hooper-Greenhill's 2002 evaluation report, where she quotes a practitioner saying,

'I realised how much I didn't know ... how much I needed to see things from a visitor's viewpoint' (Hooper-Greenhill and Dodd, 2002, p 24).

Training Needs

Other reports include observations of practitioners' competencies and professional development (Gould, 2003 and 2004; ACE, 2004). Management issues are frequently discussed and emphasize the need for planning; for improved communication skills and systems; and for sustaining partnerships through establishing clear roles and expectations. The focus is more on project planning and delivery (the method and quality of management) rather than the use of professional skills in working pedagogically/museologically with various audiences. Yet it has been reported that new professional skills, such as interpreting and utilizing demographic information, have been developed through the projects, as well as increased confidence (Hooper-Greenhill and Dodd, 2002; CHNTO, 1997; CLMG, 2001).

The implication is that there has been a lot of self-training on the job. This is a key factor of project-funded (short-term) programmes; in the applications for funding no budget is set aside for training needs. This omission is understandable to some extent, as it requires individuals to be able to assess their current capabilities and match these to the possible demands of the project which may not be fully realized until the project is underway. But it could be argued that a professional should be aware of the currency and appropriateness of their skills and understanding.

This lack of self-awareness in terms of professional competency was highlighted in a research exercise carried out with museum and heritage educators, which revealed that at all levels of the sector there was a lack of 'skills literacy'.[3] Such literacy is defined in the report as 'a low basic awareness of how to maximise the potential of skills already possessed and how to access training already available' (CHNTO, 1997; CLMG, 2001, p 3). This observation makes it clear that the individual is responsible for reflecting on their practice, benchmarking themselves alongside others and predicting future needs. There is the recognition, however, that individuals need education and training to be skills-literate.

CHNTO also acknowledges that it is the sector's responsibility to plan a professional, well-trained staff for the future. CHNTO, the Museums, Libraries and Archives Council (MLA) and the Heritage Lottery Fund (HLF) have commissioned a number of reports on skills forecasting. The 2002 ABL report, based on a range of commissioned papers and interviews, noted that in areas to do with access and

3 The report *Fast Track to Improving Skills in the Museum, Galleries and Heritage Education Sector* (2001) was commissioned by The Cultural Heritage National Training Organisation (CHNTO) in collaboration with the Campaign for Learning in Museums and Galleries (CLMG). The three programmes involved in the evaluation were the *Education Challenge Fund* (capacity training through the training of education educators), the *Museums and Galleries Education Programme* (60 projects placed throughout the country, working with schools) and the *Museums and Galleries Lifelong Learning Initiative* (a small number of projects working outside the formal education sector (see Gould, 2003 and 2004; ACE, 2004).

inclusion, 'further work is required to recruit and train suitably skilled staff, to rethink the usage of collections and to enable museums to maximise their impact on the social and economic development of their communities …' (ABL, 2002, p 1). Again, when looking at education and learning, 'The sector has distinct capacity building needs if it is to enable museums to fulfil their potential as centres of education and lifelong learning … [and] capacity building programmes need to be put in place to enable them [museums] to deliver education and lifelong learning programmes more effectively' (p 1). Yet little is said about the need to understand the public in greater depth and to consider in more detail the intended outcomes of the projects from the visitors'/participants' perspective rather than that of the institutions.

Capacity-building is primarily to achieve performance targets (such as those set by DCMS for *Renaissance in the Regions* and the Hub Museums) and is solved by recruiting new education staff who are (on the whole) straight from the formal education sector, as the target audience for the funding is schools. But this does question the integration of such staff into the museum's methodologies (pedagogical and museological). Heyburn's comments from 1992 could still be relevant today in that many education staff come to museums to teach children and 'if this is the preferred role then we, as educators, will never be professionals but remain professional teachers working in a museum context. In this case we must be prepared to remain on the fringe, vulnerable to changes'. What is beginning to appear from data being collected on the recent recruitment for Education/Learning posts for *Renaissance in the Regions* and the Regional Agencies is that staff being recruited have a mix of professional experiences. A significant number have an MA in museum studies while others have teaching experience or are artists.[4] The information did not go into detail about their expertise in working with particular groups such as adult learners, families or identifiable community groups. But knowledge of an actual or potential audience group does not necessarily prepare one for the specific context of the museum. Hooper-Greenhill noted that:

> One of the difficulties for museum educators is that their practices reach on the one hand into the world of museums and on the other into the world of education. Neither of these worlds knows much about each other, with the consequence that neither fully understands the work of the museum educator (Hooper-Greenhill, 1987, cited in Heyburn, 1992).

The consequence of this is a 'weakening of both personal and professional identity'.

Professional Development and Qualifications

The Uncertain Profession offered a number of solutions which provoked a wide-ranging and heated debate, some of which was recorded in the *Journal of Museum*

4 Data was collected by the author from the Regional Agencies and the Regional Hubs in May 2005.

Education (JEM, 1996). The debates included the continuing professional development (CPD) believed necessary to enable museum educators to advance their professional skills and knowledge. The authors made a number of recommendations which included a summer school set up by the Getty Center for Education in the Arts (the research funders); a handbook on theories and practices of museum education; conferences and seminars; visiting fellowships collaborative programme development; and research studies. Thus there were both short- and medium-term opportunities (the seminar and the course) for CPD. Several practitioners at the time argued for other forms of professional development including year-long courses. Since then a few countries, including the UK and the US, have established postgraduate programmes specifically on museum education.[5] Otherwise most MA courses tend to include museum education either as an optional part of the course or have it integrated as one the core areas for study. However, the existence of such courses does not necessarily mean that standards improve across the board.

Degrees do not necessarily indicate the level at which individuals will demonstrate their professional abilities, if at all. For the past 20 years there has been an increase in the use of vocational awards (national vocational qualifications in Canada, Australia and the UK) that acknowledge competencies – showing what you can do rather than what you have learnt. What are the current core competencies of a museum educator? To use the word 'currently' implies that it is possible to get a clear snapshot of the roles and responsibilities required of education practitioners. However, given the speed at which museums are having to identify the needs of, and effectively work with, various audiences, it is increasingly difficult to capture that view completely. Perhaps one can make attempts by looking at job advertisements, at recommendations from reports of museum education projects (such as Hooper-Greenhill and Dodd, 2002) or of government bodies with the task of raising workforce standards (such as the Cultural Heritage National Training Organisation, or CHNTO[6]), and by referring to the International Committee on Museums (ICOM) International Committee on the Training of Professionals (ICTOP).[7] CHNTO and ICTOP have both outlined specific competencies needed which could be said to give descriptions of the ideal, whereas reports and job adverts relate to the actual needs of organizations.

5 For example, in the UK the Institute of Education, in partnership with the Victoria and Albert Museum (and until recently the British Museum), runs an MA in Museums and Galleries in Education. In the US, Bank Street College of Education runs four programmes, including an MA in Leadership in Museum Education.

6 This was one of many employer-led organizations set up by government to increase the quality of the workforce though gaining recognition of competencies. In 2004 CHNTO was closed down and museums and heritage sites have joined the visual and performing arts, craftspeople and designer-makers to become the Sector Skills Council for the Creative and Cultural Industries (CCSSC).

7 < http://www.city.ac.uk/ictop>.

Responsibilities of the Employer

Museums need to become more strategic in their medium- to long-term thinking as to how the whole organization is involved in working towards the needs of the visitors, rather then simply employing more frontline staff. To achieve this it is suggested that museum educators are integrated into the senior management teams and that learning is confirmed as central to the main aims and purposes of the museum. This is not revolutionary, but was recognized in the 1980s by Eisner and Dobbs: education staff felt powerless and lacked the opportunities to develop innovative programmes due to poor funding (as they were not at the correct management level to allocate funds). They had no support from senior management and so lacked political power, were at the bottom of the status hierarchy in museums and were limited in gaining any career progression.

This lack of career progression has been also identified in a more recent report by Demos (2003) for Resource (now the Museums, Libraries and Archives Council) which commented that there is still the 'culture of professionals' in museums (and libraries and archives) – a term they borrowed from the Holland Report (CHNTO, 1997). The 'culture of professionals' within museums only allowed partial integration of new disciplines, such those for learning and access to progress into senior management positions, as appointments still favoured the more established professional groups such as curators (Demos, 2003, p 31). However, in some larger museums, education staff are members of the senior management team – they enter into what are referred to as the ranks of the professional managerial class (Ehrenreichs, 1977a and 1997b, as cited by Freidson, 1986), or the managerial professionals (Freidson, 1986) or the elite professionals (Laffin, 1998). These individuals have chosen to develop key skills in management and leadership and are at senior management level, bringing status and the power to organize staff and budgets and to influence policy. This career shift has disrupted the 'culture of professionalism' (mentioned above), in which certain individuals 'remain focused on their particular subject professionalism, such as curatorship, conservation or education and are resistant to acquiring management skills or taking on management responsibilities' (Demos, 2003, p 31).

There are issues with taking on management roles, and in particular when an individual in a larger organization joins the management team, which create a distancing of the individual from the audience, due to time spent in meetings and preparing documents/reports. This change in job responsibilities will inevitably increase the reliance on others, who choose to remain 'professional' and to deliver audience programmes. In certain organizations this delegating can lead to the creation of a 'chain': junior staff collaborate with non-museum key workers who have been brought in for their expertise in understanding of and acceptance by particular targeted groups (such as the socially excluded); teachers may manage and lead the school trips themselves. This chain creates an 'arm's-length' delivery and a reduction in the direct relationship between senior managers and the museum's audiences.

New Approaches

So there is a tight balance required: between being professional, up-to-date and well-informed about audience needs and being able to deliver projects successfully for all involved, with a voice at management level that ensures that the organizational framework offers the best environment for projects to be created, realized and integrated. To help individuals strike this balance, the Museums Association has developed its professional development scheme known as the Associateship of the Museums Association (AMA). This was revitalized in 1996 with three main activities: having the support of a mentor; creating a plan which identifies areas and activities for professional and personal development; and attending a review at the end of the two-year process. If all goes well, the individual receives the letters AMA after their name to indicate they have demonstrated to their peers and senior colleagues that they act and think professionally. This scheme has been well received by the profession and has become a model for other professional groups. The combination of having a mentor and an action plan provides several benefits for the mentee, the mentor, the organization and the profession, as it states in the Mentoring Toolkit Handbook.[8] The mentee gains 'focused career development, improved self-confidence, advice and guidance, access to networks and contacts and management development'. The benefit for the profession as a whole is the passing on and implementation of standards and thus the creation of a greater critical mass of professionals.

It is hoped that such schemes will be incorporated into the planning and budgeting of the new UK Creative and Cultural Sector Skills Council (CCSSC), established in 2005. Yet figures from the Museums Association show that only 13 per cent of those who have passed their AMA since 1996 have become education practitioners.[9] It is not clear why this is the case. Perhaps many feel that they have already shown their competence by gaining other relevant qualifications, such as a teaching certificate, but it is perhaps also the view that the AMA is for curators, although the Museums Association would wish to discourage this. Or perhaps it is that through the literature there is a strong emphasis on creating a career path and education practitioners do not necessarily see themselves having a 'career' in museums with its implications of management: 'I don't want to be a manager. I came into museum education because I enjoyed supporting others [to] learn'.[10]

One could argue that education practitioners need to be continually learning if they are to support and encourage audiences and participants to do so too; therefore they should become involved with such schemes as the AMA discussed above. One of the recommendations from *What Did We Learn This Time?* is: 'Do as you say, not

8 This document is undated and without page numbers. It was produced by the Museums Association in partnership with the Yorkshire Museums, Libraries and Archives Council.

9 Data given to May 2005: 310 museum staff gained their AMA while only 41 people had Education/Access/Learning in their job title. The number could be more or less depending whether individuals have changed jobs since gaining their AMA.

10 From a personal e-mail sent to the author by a museum education practitioner in 2000.

as you do. Apply everything you know about learning to yourselves: listen more than you than you talk; network; communicate; suppress your ego; stifle your prejudices; stop "doing" long enough to start thinking; open your mind' (Gould, 2004, p 26). For this to work, the organization as a whole needs to appreciate, encourage and invigorate both individual and collaborative learning. It needs to discuss and evaluate practice, to communicate lessons learnt to others and ensure that resources (time and funding) are set aside to enable further improvement through training, appraisals and regular cross-department/team meetings.

This sharing of information, policy and practice across the organization is key to the concept of learning organizations, as it is to the Investors in People Award (see Chapter 2).[11] Unfortunately only a few museums in the UK have taken up this programme. What may become a more successful initiative in creating learning organizations is the *Inspiring Learning for All* (ILfA) framework, set up by the MLA (see Appendix 2).[12] There are four principles on which the framework is based: people, places, partnerships and (finally) policies, plans and performance. This final group (policies, plans and performance) requires learning to be placed at the heart of the organisation and thus (through staff development and evaluation) help demonstrate that the museum is a learning organization.[13] ILfA acknowledges that although education practitioners are crucial in creating museums for learning, it is the establishment of integrated museum-wide learning policies and practices which allow all staff, volunteers and resources to contribute in some way to the planning and delivery of learning opportunities. The belief is that for visitors to gain the most from meaningful learning experiences, all staff will need to be aware of how their skills and knowledge can play a part; from developing a website through to selecting items for the bookshop to enable access to the reserve collections. It will be interesting to see how many museums take on this challenge as it will no doubt demand changes from the individual, departments and at senior management level. Everyone will have to recognize that they will need to unlearn certain ideologies and practices, restructure systems and strategies and reach new standards.

Where does the museum education practitioner stand within this new ILfA vision? I have argued above that for the last 20 years museum education practitioners constitute an 'unsettled' profession, sitting on the troubled borders between the visitors and the organization. If they lean too much either way (outwards or inwards) it will create a destabilizing effect; either becoming institutionalized or excluded. Will the ILfA framework and other professional development opportunities offered by MLA, CCSSC and the Museums Association help to correct the balance? Education practitioners will also have to create new roles with appropriate skills and knowledge. Learning

11 This term was popularized by Peter Senge in his book *The Fifth Discipline: The Art and Practice of the Learning Organisation* (1990).

12 Though the research and development carried out by the Research Centre for Museums and Galleries, Leicester, under the directorship of Professor Eilean Hooper-Greenhill.

13 See <http://www.inspiringlearningforall.gov.uk/introduction/what_is_ilfa/module/default. aspx>,accessed 11 September 2005.

organizations are certainly the solution, but I suggest that for many museums it will be too great a task for them to transform themselves into such a reality. What therefore will be the implications for the visitors (actual, virtual and potential), the museum education practitioner and, finally, for the museums themselves?

References

ABL (ABL Cultural Consulting) (2002), *UK Museum Needs Assessment 2002*, London: HLF, Resource and ABL.

Anderson, D. (1997), *A Common Wealth: Museums and Learning in the United Kingdom*, London: DNH.

Argyris, C. and Schön, D. (1974), *Theory in Practice: Increasing Professional Effectiveness*, San Francisco: Jossey-Bass.

ACE (Arts Council England) (2004), *New Audiences: Final Report*, London: ACE.

Burrage, M. and Torstendahl, R. (eds) (1990), *Professions in Theory and History*, London: Sage.

CLMG (Campaign for Learning in Museums and Galleries) (2001), *Fast Track to Improving Skills in the Museums, Galleries and Heritage Education Sector*, London: CHNTO.

Carbonell, B. (ed.) (2004), *Museum Studies: An Anthology of Contexts*, Malden MA and Oxford: Blackwell.

CHNTO (Cultural Heritage National Training Organisation) (1997), *Review of Management Training and Development in the Museums, Galleries and Heritage Sector* (The Holland Report), London: CHNTO.

Demos (2003), *Towards a Strategy for Workforce Development*, London: Resource.

Eisner, E. and Dobbs, S. (1986), *The Uncertain Profession: Observations on the State of Museum Education in Twenty American Art Museums*, Los Angeles: Getty Center for Education in the Arts.

Eraut, M. (1994), *Developing Professional Knowledge and Competence*, London: Falmer Press.

Freidson, E. (ed.) (1973), *The Professions and Their Prospects*, Beverly Hills CA: Sage.

Freidson, E. (1986), *Professional Powers: A Study of the Institutionalisation of Formal Knowledge*, Chicago IL: University of Chicago Press.

Freidson, E. (2001), *Professionalism: The Third Logic*, Cambridge: Polity Press.

Gould, H. (2003), *What Did We Learn? Museums and Galleries Lifelong Learning Initiative 2000–2*, London: DfES.

Gould, H. (2004), *What Did We Learn This Time? Museums and Galleries Lifelong Learning Initiative 2002–3*, London: DfES.

Heyburn, T. (1992), 'The Educator as Museum Professional', *JEM* 13, 15–18.

Hooper-Greenhill, E. (1991), *Museum and Gallery Education*, Leicester: Leicester University Press.

Hooper-Greenhill, E. (1987), 'Museum Education Comes of Age', *JEM* 8, 6; cited in Heyburn (1992).

Hooper-Greenhill, E. and Dodd, J. (2002), *Seeing the Museum through the Visitors' Eyes – The Evaluation of the Education Challenge Fund*, Leicester: RCMG.

Hudson, K. (2004), 'The Museum Refuses to Stand Still', in B. Carbonell (ed.) (2004), pp 85–91. (Originally published in *Museum International* 1998.)

JEM (Journal of Education in Museums) (1996), 'The Uncertain Profession – Perceptions and Directions', in *Patterns in Practice: Selections from the Journal of Education in Museums*, pp 48–57.

Kavanagh, G. (ed.) (1994), *Museum Provision and Professionalism*, London: Routledge.

Kavanagh, G. (ed.) (1991), *The Museum's Profession*, Leicester: Leicester University Press.

Laffin, M. (1986), *Professionalism and Policy: The Role of Professions in the Central–Local Government Relationship*, Aldershot: Gower.

Laffin, M. (ed.) (1998), *Beyond Bureaucracy? The Profession in Contemporary Public Life*, Aldershot: Ashgate.

Larson, M. (1977), *The Rise of Professionalism: A Sociological Analysis*, Berkeley CA: University of California Press.

Moffatt, H. and Woollard, V. (1999), *Museum and Gallery Education – A Manual of Good Practice*, London: The Stationery Office.

MA (Museums Association) (no date), *Museums Association Mentoring Toolkit Handbook*, London: MA.

Owens, P. (1998), *Creative Tensions*, Washington DC: British American Arts Association.

Oxford Dictionary of English (2003), 2nd ed., Oxford: Oxford University Press.

Shapiro, S. (ed.) with Kemp, L.W. (1990), *The Museum – A Reference Guide*, New York: Greenwood Press.

Senge, P. (1990), *The Fifth Discipline: The Art and Practice of the Learning Organisation*, London: Random House.

Sola, T. (1991), 'Museums and Curatorship: The Role of Theory', in G. Kavanagh (ed.) (1991).

Teather, L. (1990), 'Professionalism and the Museum', in S. Shapiro (ed.) with L.W. Kemp (1990), pp 299–327.

Van Mensch, P. (ed.) (1989), *Professionalising the Muses: The Museum Profession in Motion*, Amsterdam: AHA Books.

Weill, S. (1988), 'The Ongoing Pursuit of Professional Status', *Museum News* **62**: 2, 20–34, reprinted in G. Kavanagh (1994), pp 251–6.

Winstanley, B. (1980), 'Museum Education 1948–1963', in *JEM* **1**.

Woollard, V. (1998), '50 Years: The Development of a Profession', in *JEM* **19**: 1–4.

Woollard, V. (1999), 'Developing Museum and Gallery Education Staff', in H. Moffat and V. Woollard (1999), pp 136–147.

Websites

Museums, Libraries and Archives Council, *Inspiring Learning for All Framework* at <http://www.inspiringlearningforall.gov.uk/default.aspx?flash=true>.

Response to Chapter 14

Specialism versus Generalism

Caitlin Griffiths

The chapter highlights an interesting trend that is occurring across the museum profession, and not just in the area of education. In order to progress within the sector and move into the senior ranks, professionals are required to take on more managerial responsibility, which leads to a distancing from their own specialisms and the public they serve. Those who choose to remain rooted in their specialisms, staying at the delivery end, often find career advancement reduced if they are not willing to build up skills in management and leadership.

This has repercussions for the profession, a key one being the loss of specialist knowledge across the sector. As more people focus on developing generic management skills in order to gain advancement, they focus less on their specialist areas. A recent report published by The Museums Association highlighted this concern over the growing lack of specialist knowledge across the sector, where time spent maintaining and developing specialist knowledge is seen as a luxury and not a necessity (MA, 2005). While the report focused mainly on those working within collections, concern was also raised over the need to develop the specialist skills of those who communicate the collections to the public, including museum educators.

What then is the answer? One thing that needs to happen first is a change in the sector's attitude towards professional development. The 2003 Demos report pointed to the existence of a 'negative or reluctant workforce development culture' within the sector (Demos, 2003). The profession needs to develop a culture that recognizes the need of those at all levels to maintain and enhance their specialist knowledge and skills. In other professions, like medicine, one is required to carry out professional development in order to maintain one's status as a professional: this should be the same for all professions. If those within the museum sector want to be viewed as professionals then they must adopt a similar approach that encourages and values the importance of updating and developing skills and knowledge.

One way to address this need for professional development is through schemes like the Associateship of The Museums Association (AMA), referred to in Woollard's chapter, whose strength lies in encouraging all those within the sector, regardless of their position

or specialism, to continually address a broad range of development needs.

However, while professional development has a key role to play in addressing the development of specialist knowledge, we need to begin the process earlier – in the entry-level training for those in the sector. This is an area where the Creative and Cultural Skills section of the new Sector Skills Council for the cultural heritage industry will have a part to play. Their role is to ensure that the training available meets the needs of the sector, and to give the employer greater control and direction over the content and provision of training. It is hoped that they will take on the challenge of finding ways to develop specialist skills and knowledge, and it is anticipated that this may be done by the promotion of more accredited work-based training in specialist areas.

One last approach to dealing with this issue has been provided by the museum traineeship model. A two-year traineeship includes a combination of postgraduate study and paid work experience. The extensive period of paid work experience results in participants not only having a good grounding in a wide variety of museum work, but it allows them to undertake significant projects developing a deeper, more specialized knowledge.

The Museums Association has used these traineeships over the last six years as part of their *Diversify* scheme, which aims to increase the number of minority ethnic museum professionals, but they are now being used by the sector to address specialist knowledge gaps. Traineeships in natural history curation are currently being developed so there is no reason why traineeships focusing on educational specialisms cannot follow.

It is to be hoped that, with a growing awareness of this issue and by implementing various approaches to dealing with it, we will be able to make some significant steps towards ensuring we have the specialist knowledge needed across the sector.

References

Demos (2003), *Towards a Strategy for Workforce Development*, London: Demos for Resource.

MA (Museums Association) (2005), *Collections for the Future, Report of a Museums Association Inquiry*, London: MA.

PART 4
Conclusion

Chapter 15

So Where Do We Go From Here?

Caroline Lang, John Reeve and Vicky Woollard

This book will inevitably be read from many different perspectives, both from within the UK and, we hope, from outside it. Clearly its overall message is that the responsive, audience-focused museum is here to stay in the UK, and we hope this will be an encouragement to museums everywhere that are rethinking their role. We began by looking back at how museums have changed and why so many have become so much more responsive. Not surprisingly, these conclusions, as well as pulling together the preceding chapters, also look forward. What does a responsive museum now look like and what is the professional practice that is necessary to make and sustain one? When we have looked at some of the features of a responsive museum we then carry out a SWOT analysis (strengths, weaknesses, opportunities and threats) to evaluate progress and to assess the future prospects for responsive museums in the UK.

Features of the Responsive Museum

- *Audience-centred across the whole organization*, as seen through leadership, integrated policies, management structures, core funding, staff development and the regular and responsive use of evaluation (Chapters 5, 6, 9, 11 and 14).
- *In dialogue with its audiences and potential audiences*, not simply consulting but seriously listening, and offering opportunities for communities to take greater control. As a result the museum becomes multi-voiced, using the voices of different classes and ethnic groups as well as those of artists and performers (Chapters 6, 8, 9, 11 and 12).
- *Accessible* – physically, socially, culturally and intellectually – with implications for everything from marketing, pricing, catering, staff training and exhibitions policy to the kind of language used in guidebooks and labels (Chapters 3, 4, 6, 9 and 12).
- *Learning-focused*, with learning represented in the senior management team, and as a significant area of resourcing and staffing. The need to create rich and appropriate learning environments is argued in Chapter 13. Although the focus is still often on schools, the main trend and the larger audience is for informal lifelong learning.

- *Innovative in exhibition programmes, design and interpretation*, to meet the needs of different audiences and learning styles. As Chapter 12 points out, this is not a battle that is won once and for all – it is one of the most contentious areas of museum policy-making, where marketing as well as curatorial values may collide with learning and access.
- *Innovative in focused programming, targeting priority audiences*. As Chapter 4 demonstrates, there has been an explosion of ingenuity in meeting the needs of specific audience groups, from the under-5s to the Third Age. The key signifier is the ability to offer progression for the learner, either within the museum or through identifying other resources.
- *Creatively using ICT*, not only to create the virtual museum but also to engage the virtual visitor in participating in a variety of ways to interpret the collections for themselves; in other words, being a medium for learning rather than an end in itself (Chapters 4 and 7).
- *Securing sustained and varied funding*: more often varied than sustained. In some countries, like the UK, museums are blessed with individual sponsors and foundations as well as commercial sponsors with an interest in children, learning and social responsibility (Chapters 10 and 13).
- *Promoting professionalism*: by becoming learning organizations in their own right as well as places for learning, where staff are encouraged to experiment, to learn positively and supportively, to reflect on practice and to take up training and further continuing professional development across all departments and roles or responsibilities (Chapters 8, 9, 11 and 14).

A SWOT Analysis of Current Practice in UK Museums

How responsive have UK museums become? Below we have carried out a SWOT analysis to help identify some of the key factors, which we hope will generate further discussion about the prospects for responsive museums worldwide.

Strengths

Transformation

Museums in the UK have been through a rite of passage in transforming themselves. They now feel different to their audiences, and have a different relationship from before with government, society and culture. They have seen phenomenal change, expressed not only in new policies, political interest and funding, but in the ambitions of all involved. There are new and renewed buildings (though these can bring with them problems of sustainability), and services where before there had often been neglect and indifference.

This book has been imbued with the language of aspiration: 'excellence and equity',' 'a common wealth', 'arts for all', 'the open museum'; of active engagement,

and nurturing; whereas the leisure industry uses the language of consumption. We have seen also the language of cultural entitlement, equality and rights – for disabled people, gays, ethnic groups, the under-5s, and so on (Hewison and Holden, 2004; Holden 2004a and 2004b).

Demand

There is a new benchmark for what audiences expect. Audiences will not accept back-pedalling, nor will campaigners who make good use of the growing media attention. Users will increasingly expect to be involved not only in learning and as volunteers, but increasingly in developing policy (as with the ghost shirt issue in Glasgow – see Hooper-Greenhill, 2000) or by participating in exhibitions, for example with their own collections, as in People's Shows (see RCMG 2000 (the GLLAM Report) and Dodd and Sandell, 2001, for other examples).

A Responsive Profession

Leaders of the profession have advocated change and many professionals have responded energetically to its challenges, showing flair, stamina and flexibility (Anderson 1999; see also Appendix 2 and Chapter 4 in this volume). Pressure groups have included the Campaign for Learning in Museums and Galleries (CLMG) and organizations such as the Group for Education in Museums (GEM) and engage, which are also providing a range of training and continuing professional development programmes to ensure best practice is disseminated. Sometimes top-down change has seemed brutal, and often leadership and management skills have not been up to the task. So we have to ask how committed the profession really is to responsiveness (see Chapter 3).

Government Policy

This has been a catalyst in raising the stakes dramatically and focusing the minds of museum managers and governing bodies nationwide. The emphasis on education, access and social inclusion has been strong and effective in that all are working towards the same end. Performance indicators may initially have been rather crudely used (for example, in using only quantitative measures such as visitor figures) but there has been a concerted effort by the Museums Libraries and Archives Council (MLA) and museum educators to develop the *Inspiring Learning for All* (ILfA) framework as a useful tool for qualitative evaluation in understanding the benefits of museum visiting and working with artefacts. ILfA now provides a common language for the profession as a whole to understand what had previously often been a very separate activity in education departments (see Coles' Response to Chapter 9, and Appendix 3 to this volume).

Reassessment of the Use and Purpose of Collections and Other Aspects of Museum and Gallery Operations

From registrar to front-of-house, from marketing manager to development officer, the centrality of the visitor has become a reality in many organizations. In particular, the role of curators and the purpose of collections have been reviewed, led by the Museums Association, and with some significant leadership from reforming directors, as to how these can be best used to inform and be more accessible to the public (Chapter 9).

Greater Rewards for Enterprise

The funding situation has changed out of all recognition (but is still precarious): not only are millions available from the HLF for big building projects but also there are much-needed smaller sums from the Clore Duffield and other foundations, and prizes such as the Gulbenkian Award of £100,000 a year (see Chapters 10, 13 and 14).

Weaknesses

Pressure

First among these must be the ability of museums to deliver and respond to (often conflicting) demands: these pressures have increased considerably both in scale and range under the Labour government. Managers writing in this book express these concerns (Chapters 9 and 11). Curatorial training has not yet caught up with these demands (Chapter 14) and that shortfall also applies to the training of educators and community outreach workers inside and outside museums and galleries.

Sustainability

In a context of declining visitor numbers (Appendix 1) and a mixed economy of funding and staffing, this will continue to be a problem. Bradburne warns how 'new buildings often bring substantially increased operating costs ...[which], combined with drastically reduced visitor revenue, can injure – or even kill – a new institution, and paralyse an older one' (Bradburne, 2001, p 76). Estimates for the additional operating costs of HLF-funded museum projects alone start at £29 million (Selwood, 2001; Babbidge, 2000). The problem of resourcing museums is of course a worldwide phenomenon. Closed museums and the several failed Lottery projects show what happens where an engaged and articulate audience was either not there or optimistically predicted (see Chapters 9, 10 and 14).

Uneven Distribution

Deciding strategically what will be the core offer, and for whom, will also continue to be a knotty problem, regionally as well as within a particular museum, as Chapter 4 explored. Poor facilities, admission charges, location, and other disincentives (Selwood, 2001, p 7) are still a major factor for those not part of a Hub (receiving support from *Renaissance in the Regions*) or blessed with new funding. The current structure does not provide a consistent framework, support or outcomes across the regions.

A balance has to be struck between new and old audiences, free and charging, in determining the degree of inclusion and access. Who delivers and to whom and how much? 'Some programmes can sustain themselves through charging if key posts are already funded (schools, teachers, tourists, adult education); others need to be free if a museum is to be inclusive as well as responsive (under-5s, families, communities, youth, outreach)' (Chapter 4).

Government Direction

Museums may appear to be directly implementing state policy and cultural authority – except that the script is different from that of the past in the UK or the communist bloc, for example. What can be demanded for one political agenda can be shifted to another, as with the emphasis on traditional values and civic engagement from current UK and US governments, and with respect and citizenship in the UK. (See Horne, 1984 and 1986, on state use of museums and also Luke, 2002, on the political use of exhibitions; and Chapters 1, 2 and 3.)

Lack of Coordination

This may well become apparent in some areas, notably in data-gathering, and also in ICT policy, purpose and provision. Coordination of museums nationally has made some progress, thanks to *Renaissance in the Regions*, and to the national museums' regional initiatives, which will hopefully become more two-way. However there is a need for better links between Regional Hubs, the regional agencies for museums, libraries and archives, and the regional cultural forums, to support the smaller individual and often independent museums and to ensure that they have adequate learning provision.

Lack of Reliable Data

This is particularly apparent with regard to performance indicators and audience analysis. (See Appendix 1 on data problems, and Appendix 3 for GLOs, which aim to provide better qualitative data.) This lack of detailed and long-term research means that governments will continue to make policy decisions based on limited and less

than robust evidence, placing museums in the difficult position of being unable to achieve the unachievable (Chapter 2).

The Use of Quantitative Audience Data for Advocacy

Although this kind of advocacy is needed for the press, government and other funders, it does not allow the sector to have a mature, reflective debate with government on how to move forward, or to develop their relationship with particular groups of users. Quick wins can mean long-term losses, and can all too easily create a blame culture which does not support innovation.

Limited Cultural Democracy

There has certainly been great progress in democratizing culture and in cultural empowerment (see Simpson, 1996, p 72 *seq.*) but very little progress in cultural democracy (see Chapter 1). The Black History Archives, which recently won a Lottery grant to provide greater access, are an unusual example in this respect.

Opportunities

As Learning Advocates

Museums and galleries can make a real difference at every age and level of interest, and we now have conclusive hard evidence of this. They can, and often do, offer a different and less restrictive kind of learning from what is currently provided in too many UK schools: learning that is enjoyable by being innately multi-modal, and fostered in learning cities (such as Birmingham) and learning organizations (whether companies or communities), and lifelong in character, which is especially important when non-vocational lifelong learning is starved of resources but not of users.

Continuity as Civic Institutions

Museums and galleries offer continuity as civic institutions – to be revisited as and when, throughout the visitor's life. This continuity may be compared with libraries, or with schools and universities, which are changing out of all recognition from 20 years ago. Museums have a potential role therefore as a public forum and safe space (see Gurian, 2005, on the museum as 'a new town square') for a rapidly changing society and culture, on a basis of trust (although contributors to Cuno, 2004, think that is being eroded too).

Identities

A recent evaluation report by the RCMG in Leicester is entitled *Inspiration, Identity, Learning: The Value of Museums.* Sharon Macdonald believes that 'the museum medium is well capable of articulating postnational, transcultural identities ...' and shows how responsive museums have been to the changing needs of the state as well as, more recently, its users and their hybrid identities (Macdonald, 2003, p 10). This is especially relevant now, when the nature of identity and civic engagement are part of a process of quickening evolution across Europe and Asia in particular. Also, museums are being offered as forums where concerns about diversity, other beliefs and the links and tensions between cultures (see Chapter 3) can be addressed or at the very least articulated.

Audience Development

This is a constant process of seizing opportunities as priorities and demands change (cf. Middleton, 1991, with Selwood, 2001, *passim*). Chapter 4 concludes that 'Among the least well served of audiences are people living in rural areas; those without the money or mobility to travel into inner cities or heritage sites; most tourists; those who have fallen through the educational net; or belong to communities with no tradition of museum-visiting and see no point in doing so' or who are not online – so there are plenty of opportunities there.

Maximizing Marketing and Customer Services

In 1999 these were the factors that museums thought made a significant impact on audience figures: more or better marketing (30 per cent); more special events (18 per cent); longer opening hours (16 per cent); extra attractions or facilities (10 per cent) (Selwood, 2001, p 6). To these factors should now be added free admission for national museums and galleries. Bradburne is emphatic that museums 'must offer facilities which can be used, rather than just visited' if they are to attract repeat visitors, citing not only user-friendly staff and opening hours, family-friendly cafés and play facilities but 'reading tables, portable stools and ladders for children to see into high display cases' (Bradburne, 2001, p 79; and see Chapters 1 and 5).

Threats

Competition

Other leisure opportunities present a huge choice, including Sunday shopping and other heritage attractions. 'There simply aren't enough visitors to go round', one director observed in 2000. The vast majority of museums attract fewer than 20,000 visits annually (Selwood, 2001, p 6; Middleton, 1991). This may mean that small

and especially independent museums (often embedded in a community) will have to close down or amalgamate with others; for example, to maximize storage areas and rotate exhibitions, or because they are located in the wrong place, thus diminishing the uniqueness of locality.

Funding

This will continue to be a problem, especially if the Lottery is rethought or its income decreases appreciably. Within the DCMS, funding for the 2012 Olympics will probably elbow aside museums. 'Compassion fatigue' and impatience at the slow burn of change may also affect funding, especially when government may be able to demonstrate quicker results in other areas of public services (Chapter 10).

Government

Governments continually itch to announce new initiatives, to micro-manage and to have a Culture Ministry comparable to France or (if one is unsympathetic) the old communist bloc. This sits uneasily with the independence of trustee museums and of locally controlled regional and local museums, which promote multiple rather than fixed national identities. An additional challenge comes from the revival of regional identities throughout Europe (Chapter 2).

Culture as a Commodity and Policy Tool

This is often characterized as a conflict between what some see as 'social engineering' and the valuing of culture and learning themselves, as with non-vocational adult learning. There is nothing new here, as the nineteenth-century example of Henry Cole of the V&A shows, or the arguments for the economic benefits of museums advanced also by the founding fathers of American museums (see Coles' Response to Chapter 9). DCMS (with its eye on the Treasury) talks of 'investment in culture', and of 'putting a new emphasis on the public rather than the producer' (DCMS, 1998).

'Art matters' in its own right, however (and not just because it meets a government's educational, social or economic targets), as we are reminded by John Tusa, Managing Director of the Barbican Arts Centre in London (Tusa, 2000 and 2002). Two commentators have queried *Art for All?*, subtitling their anthology of texts *Their Policies and Our Culture* (Wallinger and Warnock, 2000). (See also Garnham on the tensions between access and excellence, in Selwood, 2001, and Carey, 2005).

Backlash

This new ambition to contribute to society has not been uncontroversial (Chapters 3 and 9). The trajectory of museum development in the past has been compared to a roller-coaster and this may continue to be the case. There is always a likely loss

of interest or funding with changes in government or government priorities. Data suggests that the over-optimistic expectations of the DCMS in changing audience composition radically and then sustaining it will not be met (see Appendix 1).

Consumer Expectations

Consumers are accustomed not only to novelty, mobility and rising standards, but also to increasingly personalized provision, with opportunities for progression for adult learners, and for varied forms of family and social learning (Chapter 3).

ICT

Should this be viewed as a threat? Why go to an interactive downtown science centre if you can access it in your own home? (See Hawkey, 2004, on the virtual museum of the future.) However, the renewed appreciation of multi-modal learning suggests otherwise (Kress and Van Leeuwen, 2001).

A Case Study

A final example of responsiveness deserves mention: it comes from Bradford in West Yorkshire. Sharon Macdonald (2003, p 6) chooses this to illustrate her thesis on museums as an arena for 'national, postnational and transcultural identities', in particular the transcultural galleries opened in 1997 at Cartwright Hall. Like a domed icon of imperialism in New Delhi or Whitehall, this art gallery sits magisterially in its Edwardian park, and was created as a monument to an industrial past that has now conclusively died, in a city that has seen considerable racial tension. The substantial and varied South Asian community can now see itself reflected alongside the Gainsboroughs and the Victorian classical fantasies. These galleries are part of a city-wide policy promoting intercultural understanding and expression, built on consultation and advocacy. Their original curator, Nima Poovaya-Smith, is South Asian herself, steeped in the post-colonial writing of Said, Bhabha, Spivak and others (see also Merriman and Poovaya-Smith, 1996). This project is an example of inclusive staffing and of the marriage of theory, advocacy and professionalism, curatorial and educational. The display is thematic, non-hierarchical, non-linear. Only eight years later these galleries are being replaced, in response partly to declining audience interest, and the whole main floor of the gallery is being re-conceived as an integrated, thematic series of displays bringing European and Asian art together rather than showing them in their separate compartments. This carries to a wider conclusion the practice of other re-conceived local galleries, in York and Leicester for example. Learning, access and diversity are at the core of this project and of the team creating it.

A Final Thought

Responsiveness to their users and audience development are, of course, an issue not just for museums but across all the creative industries: theatres, orchestras and opera companies worry along the same lines, and are using education, popularization, hybrid programming and outreach to address the challenge. Conductor Simon Rattle has introduced this approach to Berlin (after Birmingham; see Morton Smyth, 2004) where it was a radically new idea, as it would have been in many of their museums and galleries until quite recently. Like the best museum directors, Rattle has weathered criticism about lack of respect for culture or 'dumbing down' through popularization. Such directors know that, without supportive and engaged audiences, all cultural forms may die.

References

Anderson, D. (1999), *A Common Wealth: Museums in the Learning Age*, London: Stationery Office.

Babbidge, A. (2000), 'UK Museums, Safe and Sound?', *Cultural Trends* **37**.

Bradburne, J. (2001). 'A New Strategic Approach to the Museum and its Relationship to Society', *Museum Management and Curatorship* **19**: 1.

Carey, J. (2005), *What Good Are the Arts?*, London: Faber.

Cuno, J. (ed.) (2004), *Whose Muse? Art Museums and the Public Trust*, Princeton NJ: Princeton University Press.

DCMS (Department for Culture, Media and Sport) (1998), *A New Cultural Framework*, London: DCMS.

Dodd, J. and Sandell, R. (eds), (2001) *Including Museums: Perspectives on Museums, Galleries and Social Inclusion*, Leicester: RCMG.

Gurian, E.H. (2005), 'Threshold Fear', in S. MacLeod (ed.) (2005).

Hawkey, R. (2004), *Learning with Digital Technologies in Museums, Science Centres and Galleries*, NESTA Futurelab (also available online).

Hewison, R. and Holden, J. (2004), *The Right to Art – Making Aspirations Reality*, London: Demos.

Holden, J. (2004a), *Capturing Cultural Value*, London: Demos.

Holden, J. (2004b), *Challenge and Change: HLF and Cultural Value*, London: Demos.

Hooper-Greenhill, E. *et al.*, (2004), *Inspiration, Identity, Learning: The Value of Museums*, Leicester: DfES.

Hooper-Greenhill, E. (2000), *Museums and the Interpretation of Visual Culture*, London: Routledge.

Horne, D. (1986), *The Public Culture. The Triumph of Industrialism*, London: Pluto.

Horne, D. (1984), *The Great Museum. The Re-presentation of History*, London: Pluto.

Kavanagh, G. (ed.) (1996), *Making Histories in Museums*, Leicester, Leicester University Press.

Kavanagh, G. (ed.) (1991), *The Museums Profession*, Leicester: Leicester University Press.

Kress, G. and Van Leeuwen, T. (2001), *Multimodal Discourse: The Modes and Media of Contemporary Communication, Cheltenham:* Arnold.

Luke, T. (2002), *Museum Politics: Power Plays at the Exhibition*, Minnesota: Minnesota University Press.

Macdonald, S.J. (2003), 'Museums, National, Postnational and Transcultural Identities', *Museum and Society* **1**: 1, 1–16.

MacLeod, S. (ed.) (2005), *Reshaping Museum Space*, London: Routledge.

Merriman, N. and Poovaya-Smith, N. (1996), 'Making Culturally Diverse Histories', in G. Kavanagh (ed.) (1996).

Middleton , V. (1991) 'The Future Demand for Museums 1990–2001', in G. Kavanagh (ed.) (1991).

Morton Smyth Limited (2004), 'Not for The Likes of You', at <www.artscouncil. org.uk>.

RCMG (Research Centre for Museums and Galleries) (2000), *Museums and Social Inclusion: The GLLAM Report*, Leicester: RCMG.

Sandell, R. (ed.) (2002), *Museums, Society, Inequality*, London: Routledge.

Selwood, S. (ed.) (2001), *The UK Cultural Sector: Profile and Policy Issues*, London: Policy Studies Institute.

Simpson, M.G. (1996), *Making Representations: Museums in the Post-Colonial Era*, London: Routledge.

Tusa, J. (2000), *Art Matters. Reflecting on Culture*, London: Methuen.

Tusa, J. (2002), 'Thou Shalt Worship the Arts for What They Are', at <www.spiked-online.com/Articles/00000006DA07.htm>.

Wallinger, M. and Warnock, M. (2000), *Art for All? Their Policies and Our Culture*, London: Peer.

Kavanagh, G. (ed.) (1994) *Museum Provision and Professionalism*, Leicester: Leicester University Press.

Kotler, N. and Kotler, P. (1998) *Museum Strategy and Marketing*, San Francisco: Jossey-Bass.

Kotler, G. and Scott, J. (2001) *Whitechapel Diary*, London: Black Dog Publishing.

Lord, B. and Lord, G.D. (1997) *The Manual of Museum Management*, London: The Stationery Office.

McDonald, S. (2002) *Behind the Scenes at the Science Museum*, Oxford: Berg.

Merriman, N. and Poovaya-Smith, N. (1996) 'Making culturally diverse histories', in G. Kavanagh (ed.) (1996).

Middleton, V. (1991) 'The future demand for museums 1990–2001', in G. Kavanagh (ed.) (1991).

Moore, K. (1997) *Museums and Popular Culture*, London: Leicester University Press.

Prentice, R. (1994) 'Perceptual deterrents to visiting museums and other heritage attractions', in *Museum Management and Curatorship*.

Sandell, R. (ed.) (2002) *Museums, Society, Inequality*, London: Routledge.

Selwood, S. (ed.) (2001) *The UK Cultural Sector: Profile and Policy Issues*, London: Policy Studies Institute.

Stephen, A. (1994) 'Museum management', in *Journal of Arts Management*, London: Routledge.

Tusa, J. (2000) *Art Matters: Reflecting on Culture*, London: Methuen.

Tusa, J. (2002) 'Does Britain care about the arts, or for what they are?', in *Cultural Trends*.

Wallinger, M. and Warnock, M. (2000) *Art for All? Their Policies and Our Culture*, London: Peer.

Appendix 1

UK Museum and Gallery Visitor Figures

Vicky Woollard[1]

There is no consistency in what information is collected, where it is gathered from and for how many years. Consequently the picture of the current visiting public in the UK is blurred and with distinct empty spaces. As these figures show, government, funders and museum professionals all need data that is more reliable and that also assesses the quality as well as the volume of visits, and their long-term impact.

We are grateful to the Museums, Libraries and Archives Council for permission to reprint sections from the document *Overview of Data in the Museums, Libraries and Archives Sector* (2004)[2] for the period 1992/93 to 2002/3. The data varies, in that it relates to Great Britain (GB), the United Kingdom[3] (UK) or England.

General Visitor Numbers

The total number of visitors to museums and galleries per year is falling in the UK, despite government initiatives and other policy changes (see Table A1.1). The total population of Great Britain in 2002/03 was 47,255,000, out of which 22 per cent (10,359,000) of *adults* visited museums: in 1992 this figure was 28 per cent.

Table A1.1 The trend of museum visiting, over ten years as a percentage of the adult population in GB, 1992/93 and 1998/99 to 2002/03

1992/93	1998/99	1999/00	2000/01	2001/02	2002/03
28%	24%	24%	26%	22%	22%

Source: Target Group Index (TGI), ©BMRB 1993–2003, cited in Creaser, 2003.

Another source (MORI, 2001, p 4) has different percentages (for the UK) that also show a decline in visitors to museums: from 42 per cent in 1991 to 28 per cent

1 The editors would like to thank Marina Economidou for her help with this appendix.

2 This can be obtained on the web at <http://www.mla.gov.uk/documents/ev_stats_overview.doc>. See under Matty (2004) in the References section.

3 Great Britain consists of the island of England, Scotland and Wales, whereas the UK is a political unit that also includes Northern Ireland.

in 1999. This reduction in visitors comes from a particular age band, those aged between 15 and 34 years old, while the number of visitors over 35 has increased over the last ten years (Table A1.2).

Table A1.2 Proportion of museum visitors in each age group for GB as a whole, 1992/93 and 1998/99 to 2002/03

	15–19	20–24	25–34	35–44	45–54	55–64	65+
1992/93	8%	9%	21%	21%	16%	11%	14%
1998/99	8%	7%	20%	22%	17%	11%	14%
1999/00	9%	7%	19%	22%	17%	13%	15%
2000/01	8%	7%	21%	22%	17%	11%	13%
2001/02	6%	7%	19%	25%	16%	12%	14%
2002/03	7%	6%	18%	24%	18%	13%	14%

Source: Target Group Index (TGI), ©BMRB 1993–2003, cited in Creaser, 2003.

While the percentage of the population visiting museums appears to be in decline, the *number* of visits is increasing (Table A1.3). This implies that fewer people are making more visits: 74.6 million visits in 2003 (Matty, 2004, p 31).

Table A1.3 Trend in the number of visits to museums, 1992 and 1998 to 2002

1992	1998	1999	2000	2001	2002
110	112	111	108	110	118

Source: VisitBritain, 2003.
Note: Based on a constant sample (one year to the next: index 1989 = 100).

Social Inclusion

The UK defines social class in terms of occupation.[4]

By social class the increase nationally in number of visits is not by working-class visitors and others seen as socially excluded: proportionately their numbers are falling (Table A1.4).

4 A: Professional, etc., occupations B:Managerial and technical occupations C1: Skilled occupations – non-manual C2: Skilled occupations – manual D: Partly-skilled occupations E: Unskilled occupations.

Table A1.4 **Proportion of museum visitors in each social grade, GB total, 1992/93 and 1998/99 to 2002/03**

	A	B	C1	C2	D	E	Total
1992/93	5%	23%	30%	21%	12%	9%	100%
1998/99	4%	28%	32%	17%	12%	6%	100%
1999/00	5%	29%	32%	17%	11%	6%	100%
2000/01	6%	33%	30%	17%	10%	5%	100%
2001/02	6%	32%	31%	16%	11%	5%	100%
2002/03	6%	33%	31%	16%	10%	5%	100%

Source: Target Group Index (TGI), ©BMRB 1993–2003, cited in Creaser, 2003.

Thus we can see the overall trend of more A–C1 visitors, despite the government's aim for museums and galleries to attract more socially excluded visitors; C2DEs make up 51 per cent of the population yet are only 31 per cent of the visitors (Matty, 2004, p 23; DCMS, 2001).

However, this is not the case for DCMS-sponsored museums, including the nationals (see Table A1.5).

Table A1.5 **Visits made by C2, D and E socio-economic groups, 1998/99 to 2002/03, to the DCMS-sponsored museums**

	1998/99	1999/00	2000/01	2001/02	2002/03
No. of visits by C2s, Ds and Es	3.52m	3.33m	4.55m	4.52m	4.77m
Total no. of visits to DCMS museums, excluding Tyne & Wear Museum Service	22.8m	24.18m	27.89m	28.85m	29.52m
% of visits by C2s, Ds and Es	15.44%	13.77%	16.31%	15.67%	16.16%

Source: Matty, 2004, correspondence with Richard Hartman, DCMS, 17 July 2003.
Note: 'DCMS-sponsored museums' includes nationals and other but excludes those within the Tyne & Wear Museums Service.

The success shown in Table A1.5 may be due to stringent performance targets as part of funding agreements with government since 1997.

Age of Visitors

Museum visitors reflect the overall UK demographic profile, but with a wider margin when it comes to families with under-4s, young parents and those over 65 (Table A1.6).

Table A1.6 UK visitors to museums, by life stages, 1999

	% UK population	% visitors to museums
Adults		
65+	19%	15%
55–64	11%	14%
45–54	11%	13%
25–34*	9%	10%
35–44	5%	7%
16–24	9%	9%
Adults with children		
Adults 25–44 with children aged 5–10	14%	14%
Adults 25–44 with children aged 4 and under	12%	9%
Adults 25–44 with children aged 10+	8%	7%
Adults 16–24 with children	7%	4%

*The sequence of ages is as printed by MLA direct from the source.
Source: MORI, 2001, p 9.

It is interesting to note that since the late 1990s many audience development projects have been specifically targeted at young people (which would include the 16–24 band shown in Table A1.6). Perhaps attention needs to be drawn to the over-65s as part of lifelong learning, the often-espoused belief of both the DCMS and DfES.

Significance of Length of Full-time Education

The figures below (Table A1.7) could be seen to support the arguments made by Bourdieu (see Chapter 1) that cultural capital is inextricably linked with the length of full-time education. Also the decrease of younger individuals visiting museums is linked to the reduction of museums visits made by secondary schools as a part of the curriculum.

Table A1.7 Proportion of museum visitors by terminal education age, GB total, 1992/93 and 1998/99 to 2002/03

	Up to 14	15	16	17–18	19 +	Still studying	Total
1992/93	9%	15%	25%	19%	23%	9%	100%
1998/99	5%	12%	23%	18%	31%	11%	100%
1999/00	5%	12%	23%	19%	29%	12%	100%
2000/01	4%	11%	22%	18%	32%	12%	100%
2001/02	4%	11%	23%	19%	34%	9%	100%
2002/03	4%	8%	29%	21%	30%	8%	100%

Source: Target Group Index (TGI), ©BMRB 1993–2003, cited in Creaser, 2003.

Ethnic Minorities

'Bridgwood *et al.* (2003) suggests that Asians under the age of 45 (28%) were significantly more likely to visit a museum or gallery than those aged over 45 (18%)' (Matty, 2004, p 18; see also Desai and Thomas, 1998). Tables A1.8 and A1.9 present the findings referred to.

Table A1.8 Percentage of ethnic minorities visiting museums/art galleries by ethnic group, England, 2002–03

	White	36%
	Dual heritage	44%
Asian or British Asian	Indian	27%
	Pakistani. Bangladeshi	21%
	Asian all [a]	25%
Black or British Black	Black Caribbean	32%
	Black African	32%
	Black all [b]	32%
	Chinese and other ethnic groups	32%
	All	34%

Source: Bridgwood *et al.*, 2003, Table 2.4.
Note: [a] including other Asian groups not shown separately; [b] including other Black groups not shown separately.

Table A1.9 UK visits to museums by ethnicity, 1999

	% of UK population	% of visitors to museums
White European	92	94
Black – African/Caribbean	1	*
Asian	2	2

Source: MORI, 2001, p 16.
Note: * indicates numbers too insignificant to derive a percentage for comparison.

No trends are shown over ten years as such data was not collected until recently, similarly for those with disabilities, as seen below.

People with Disabilities

The only known information is shown in Table A1.10.

Table A1.10 Percentage of the English population visiting a museum, by nature of illness

	Limiting longstanding illness	Non-limiting longstanding illness	No longstanding illness	All
	26%	33%	39%	35%
Base	1,455	695	3,871	6,021

Source: Skelton *et al.*, 2002, Table 8.4.

Young People

The definition of young people can be '7- to 19-year-olds' (Youth TGI),[5] '15 and under' (DCMS), while MORI (2001) uses the age range 16–24 but has the group 'student' separately.

For the year 2002 the number of visits in GB by 7- to 19-year-olds was 9,586,000 (Creaser, 2003).

The DCMS for 2002/3 puts the figure for visits by under-15s to national museums at 7,470,000.

5 Target Group Index – a continuous survey carried out by British Market Research Bureau (BMRB) International (see Matty, 2004, p 9).

London and the major regional museums are, not surprisingly, drawing in the majority of young people.

Tourists

According to The Office for National Statistics,[6] 20 million tourists from abroad came to the UK in 1993 and 24.7 million in 2003, but at present there is no clear information what percentage visit museums and galleries across the UK. Tourists from abroad are a majority of, for example, British Museum visitors.

References

Bridgwood, A., Fenn, C., Dust, K., Hutton, L., Skelton, A. and Skinner, M. (2003), *Focus on Cultural Diversity: The Arts in England: Attendance, Participation and Activities* (Research Report 34), London: ACE.

Creaser, C. (2003), *Target Group Index Data*, unpublished analyses prepared for Resource.

Creaser, C. and White, S. (2003), *Arts Council England: Omnibus Survey 2001*, analysis for Resource.

DCMS (Department for Culture, Media and Sport) (2000), Centres for Social Change: Museums, Galleries and Archives for All, London: DCMS.

Desai, P. and Thomas, A. (1998), *Cultural Diversity: Attitudes of Ethnic Minority Populations towards Museums and Galleries*, London: MGC.

Hooper-Greenhill, E. (1994), *Museums and their Visitors*, London: Routledge.

Matty, S. (ed.) (2004), *Overview of Data in the Museums, Libraries and Archives Sector*, London: MLA.

MORI (Market & Opinion Research International) (2001), *Visitors to Museums & Galleries in the UK: Report for Resource*, London: Resource.

Selwood, S. (ed.) (2001), *The UK Cultural Sector: Profile and Policy Issues*, London: PSI.

Skelton, A., Bridgwood, A., Duckworth, K., Hutton, L., Fenn, C., Creaser, C. and Babbidge, A. (2002), *Arts in England: Attendance, Participation and Attitudes in 2001* (Research Report 27), London: ACE.

VisitBritain (2002), *Sightseeing in the UK*, London: VisitBritain.

Wright, M., Selwood, S., Creaser, C. and Davies, J.E. (2001), *UK Museums Retrospective Statistics Projects*, Loughborough: LISU.

6 <http://www.statistics.gov.uk/cci/nugget_print.asp?ID=178>.

Appendix 2

The *Inspiring Learning for All* Framework

Vicky Woollard[1]

The Museums Libraries and Archives Council (MLA), under its previous title of Resource, initiated a project to establish a learning framework for museums, libraries and archives. It has two concerns which are interlinked: to develop rich learning environments for the visitor; and to evaluate the actual learning experience gained by the visitor. These together are to encourage museums, libraries and archives to place the learner at the centre.

The framework is made up of a number of components which include a methodology for capturing the evidence of learning (learning generic outcomes) and a set of principles which enable organisations to engage all their staff in the creation of stimulating and diverse learning opportunities.

The principles are:

- people – providing more effective learning opportunities;
- places – creating inspiring and accessible learning environments;
- partnership – building creative learning partnerships;
- policies, plans and performance – placing learning at the heart of the museum, archive or library (<http://www.mla.gov.uk/action/learnacc/00insplearn. asp>, accessed 12 December 2005).

Generic learning outcomes (abbreviated to GLOs) are the criteria by which a practitioner is able to demonstrate that a visitor has had some form of learning experience. These outcomes fall into five groups:[2]

- knowledge and understanding – for example, giving specific information, naming things, people, places;
- skills – which may be social, emotional, physical or intellectual, or a mixture of these;

1 Thanks to Sue Wilkinson, Director: Learning, Access, Renaissance, Regions & International Team for her advice on this text.

2 The website for the Generic Leaning Outcomes is as follows: <http://www. inspiringlearningforall.gov.uk/uploads/More%20about%20the%20GLO's.doc>, accessed 12 November 2005.

- attitudes and values – opinions about oneself and other people, empathy;
- enjoyment, inspiration and creativity – such as experimentation, or just having fun;
- action, behaviour, progression – change in behaviour, follow-up activities.

The GLOs were tested through a pilot project involving over 45 museums, archives and libraries across England. After some refining, the *Inspiring Learning for All* (ILfA) toolkit was launched nationally in 2004 as a web resource, and used by organisations such as the National Trust, the Arts Council England and the BBC.

It is perhaps early days yet to be able to say what effect the toolkit has had on the sector. Comments already gleaned from those involved[3] suggest that the impact of establishing the ILfA framework has been felt more within the museums and galleries themselves, as staff discuss and agree how to improve learning opportunities, programmes and places. Visitors, on the other hand, may find it difficult to remember, reflect and compare one learning experience with another over time in the same museum, thus making assessment of possible improved visitor impact more difficult.

3 See the various quotes on the mla website: <www.inspiringlearningforall.gov.uk>.

A Common Wealth: Twelve Targets for Development of Museums Learning

Caroline Lang

In his comprehensive and influential report on museum and gallery education in the UK, first published in 1997, and updated in 1999, David Anderson proposed twelve targets for development of museums learning. They are referred to by a number of the contributors throughout this book. Many of the ideas articulated here have since been adopted by government, museums and other bodies, but not all. At the time of writing (Spring 2006), the Museums, Libraries and Archives Council (MLA) has just completed a Museum Learning survey, this data should allow comparisons with the original survey which provided much of the data for Anderson's report and allow an assessment of the extent of change over the past ten years.

Anderson's twelve targets for development of museums learning are listed below.

The Institution

Target 1: The Museum's Educational Mission

Few museums include education in their mission statements. To become centres for learning, museums themselves need to become learning organizations with education central to their purpose. This requires the leadership of museum management and their governing bodies, who have direct responsibility for educational development.

Target 2: The Museum as a Learning Resource

Three main types of provision for learning – exhibits, programmes and facilities for self-directed learning – define a museum. All three must be engaged if museums are to develop their whole public dimension for learning, using new technologies where appropriate. Increasingly, museums are involving the public as partners as well as targets in development of services.

Target 3: A Skilled Workforce

All staff contribute in some way to a museum's educational work, but only one in four of the museum staff who deliver education services is a specialist educator. The report recommends that each museum or group of museums should employ a specialist to lead its educational development, and should foster the educational capabilities of staff, volunteers and all who work in or for them, both those who are trained educators and those who help to deliver services. A much greater investment is required if museums are to be as effective as they should be as educational institutions. In addition, the report proposes that the Cultural Heritage National Training Organisation, when reviewing its standards of competence and qualifications, should include a unit or units on museum education in the mandatory framework of all museum qualifications.

Target 4: Research and Evaluation

Research and evaluation of public learning needs to become an integral part of museum practice. Few museums evaluate the educational effectiveness of their galleries or other services, conduct learning research, or study the educational work of other museums, yet investment in these activities could significantly enhance the effectiveness of museums. The report recommends that museums should make educational research and evaluation a high priority and that they should be supported in this by an independent research committee which sets a national research agenda; in addition, one or more higher education institutions should establish centres for museum learning to encourage the development of research and training in the field.

The Public

Target 5: Lifelong Learning

Museums can contribute to every stage of educational development. They should support lifelong learning through both informal learning and formal education, from early childhood, through families, at work and in the Third Age. The community provides an important framework for lifelong learning, and must now be the focus for audience development. The report recommends that museums should identify their audience priorities and direct educational provision where it can be most effective at reaching target groups.

Target 6: Open Museums

Museums can open themselves to the widest possible audience by using strategies for access, participation and for progression of learning. At present, half the population of the UK rarely or never use museums, but the levels of participation vary greatly

from area to area, depending in part upon the efforts made by individual museums to encourage participation. Provision for learning is the most effective strategy for reaching new audiences, and the report proposes that it should be deployed more effectively to overcome barriers to inclusion.

Target 7: Engaging Other Educators

The effective use of museums as a learning resource by educational institutions depends in part on teachers and other educators as well as museums themselves. Developing of their skills would significantly enhance student learning, yet very few receive training in learning through museums. Initiatives are needed at both local and national levels. Therefore, the report recommends that the government should ask public bodies with responsibility for curricula and assessment, for teacher and lecturer training and for the inspection of schools and other educational institutions to encourage, enhance and monitor the use of museums as a learning resource.

Target 8: Partnerships

Partnerships extend the boundaries of what is possible, and local authorities in particular can play an enabling role in helping museums to collaborate with different agencies and institutions which share museum objectives. The report recommends that museums should seek partnerships with other agencies and institutions, especially libraries, archives and broadcasting media, as well as formal education institutions.

National Development

Target 9: Adequate Provision throughout the UK

Participation in museums should be an entitlement of citizenship. If museum learning is to be available in every area of the country, museums will need support from Area Museum Councils (AMCs) and from museums with well-established education services. Each museum or group of museums needs an education specialist to lead development, but in addition there is an urgent requirement for AMCs to provide more expert educational advice, training programmes, grants and other support. To do so effectively, they need to employ their own specialist advisory staff, and should develop their own educational policies and plans.

Target 10: A National Framework

If education is to be established as a central purpose of museums of all sizes and types, an infrastructure is required to support development at a national level. The government and the new Museums, Libraries and Archives Council (MLAC) can

take a lead in this, with the support of other agencies. For this it is vital that MLAC should employ a full-time educator at a senior level with support to develop and implement a new educational policy and plan. In addition, the government should establish a Standing Committee on museum and gallery education or on education through the cultural sector.

Target 11: Investment

Museums need to commit the resources to education that are required for growth. Such investment will help to attract additional resources of expertise and funding, as well as a complementary investment of time and support from the public, voluntary organizations, trusts and foundations. But this alone will not be sufficient to achieve the scale of change in quality and level of public provision. The report recommends that Lottery funding should be used to establish a national and regional infrastructure of support and to expand services at a local level.

Target 12: Advocacy

Museums have the potential to enrich many aspects of national life. They need to articulate their value to society as educational institutions, to local and national government, to other sectors, and to independent policy and research bodies, if they are to play a more effective part in society. In addition the report recommends that the Museums Association (MA), the Association of Independent Museums (AIM), the Group for Education in Museums (GEM) and the National Association for Gallery Education (engage) should promote the value of museums as educational institutions inside and outside the museum sector.

Reference

Anderson, D. (1997), *A Common Wealth: Museums in the Learning Age*, London, DNH. (2nd ed., 1999, *A Common Wealth: Museums and Learning in the United Kingdom*, London: Stationery Office.)

Bibliography

ABL (ABL Cultural Consulting) (2002), *UK Museum Needs Assessment 2002*, London: HLF, Resource and ABL.

Adorno, T. and Horkheimer, M. (1993) [1944], *The Culture Industry: Enlightenment as Mass Deception in 'Dialectic of Enlightenment'*, New York: Continuum. Originally published as *Dialektik der Aufklarung*, 1944.

Alderson, P. (2001), 'Research by Children', International Journal of Social Research Methodology 4: 2 (London: Routledge).

Anderson, D. (1997), *A Common Wealth: Museums in the Learning Age*, London: DNH. (2nd ed. 1999, published as *A Common Wealth: Museums and Learning in the United Kingdom*, London: Stationery Office.)

Anderson, D. (2000), 'The Shape of Things to Come?', in N. Horlock (ed.) (2000).

Appleton, J. (2001), *Museums for 'The People'?*, London: Academy of Ideas.

Araeen, R., Cubitt, S. and Sardar, Z. (eds) (2002), *The Third Text Reader on Art, Culture and Theory*, London: Continuum.

Argyris, C. and Schön, D. (1974), *Theory in Practice: Increasing Professional Effectiveness*, San Francisco: Jossey-Bass.

Arnheim, R. (1954), *Art and Visual Perception*, Berkeley CA: University of California Press.

Arnheim, R. (1969), *Visual Thinking*, Berkeley CA: University of California Press.

Art Gallery of Ontario (1996), *The* Oh! Canada *Project*, project programme document, Toronto: Art Gallery of Ontario.

Arts about Manchester (1998), *Visitor Responses, Questionnaire and Observation Results of Me and You: An interactive exhibition for children aged 3 to 103!*, Manchester: Arts about Manchester.

Arts Council England (ACE) (2000), *Whose Heritage? The Impact of Cultural Diversity on Britain's Living Heritage*, London: ACE. (Proceedings of the 1999 conference.)

Arts Council England (ACE) (2001), *Towards 2010: New Times, New Challenges for the Arts*, London: ACE.

Arts Council England (ACE) (2003), 'Focus on Cultural Diversity – The Changing Face of Arts Attendance and Participation in England', <www.artscouncil.org.uk>.

Arts Council England (ACE) (2004), *New Audiences: Final Report*, London: ACE.

Arts Council England (ACE) (2004), *Spotlight on Diversity: Decibel Projects in the NE*, London: ACE.

Arts Council England (ACE) (2004), *Towards a Greater Diversity*, <ww.artscouncil.org.uk>.

Ashcroft, B. and Ahluwalia, P. (1999), *Edward Said*, London: Routledge.
Babbidge, A. (2000), 'UK Museums, Safe and Sound?', *Cultural Trends* 37.
Babbidge, A. (2005), '40 Years On', *Cultural Trends* 53, 14: 1, 3–66.
Bacon, S. *et al.* (2004), *Space for Learning: A Handbook for Education Spaces in Museums, Heritage Sites and Discovery Centres*, London: Clore Duffield Foundation.
Bacon, S. *et al.* (2003), *Space for Art*, London: Clore Duffield Foundation.
Bacon, S. *et al.* (2002), *The Big Sink*, London: Clore Duffield Foundation.
Baudrillard, J. (1968), 'The System of Collecting', in J. Elsner and R. Cardinal (eds) (1994).
Becker, H. (1963), *Outsiders: Studies in the Sociology of Deviance*, New York: Free Press.
Bennett, T. (1988), 'Useful Culture', in D. Boswell and J. Evans (eds) (1999).
Bennett, T. (1995), *The Birth of the Museum*, London: Routledge.
Bennis, W. and Biederman, P.W. (1997), *Organizing Genius: The Secrets of Creative Collaboration*, London: Nicholas Brearley Publishing.
Bienkowski, P. (1994), 'Soft System in Museums: A Case Study of Exhibition Planning and Implementation Processes', *Museum Management and Curatorship* 13, 245–9.
Biggs, L. (2000), 'Opening Up the Curatorial Space', in N. Horlock (ed.) (2000).
Birmingham City Archives, Black Pasts and Birmingham Futures, and HLF, 'Connecting Histories', online at <www.birmingham.gov.uk/GenerateContent?CONTENT_ITEM_ID=58944&CONTENT_ITEM_TYPE=0&MENU_ID=10468>.
Bochynek, B. (2004), 'Cultural Treasures as Gateways to the "Treasure Within": The Role of Museums in Lifelong Learning', in engage (2004a).
Borun, M. and Korn, R. (eds) (1999), *Introduction to Museum Evaluation*, Washington DC: American Association of Museums.
Boswell, D. and Evans, J. (eds) (1999), *Representing the Nation: A Reader in Heritage and Museums*, London: Routledge.
Bourdieu, P. and Darbel, A. (1990) [1969], *The Love of Art – European Art Museums and their Publics*, translated by C. Beattie and N. Merriman (1990), Cambridge: Polity Press.
Bourdillon, H. (1994), *Teaching History*, London: Routledge.
Bourke, M. (ed.) (2004), *Effective Presentation and Interpretation in Museums*, Dublin: National Gallery of Ireland.
Bradburne, J. (1999), 'Changing Designership: The Role of the Designer in the Informal Learning Environment', *Museum Management and Curatorship* 18 (2).
Bradburne, J. (2001). 'A New Strategic Approach to the Museum and its Relationship to Society', *Museum Management and Curatorship* 19: 1, 75–84.
Bradburne, J.M. (2005), 'Between a Rock and a Hard Place' (date of original publication unknown) from Doors of Perception at <http://www.doorsofperception.com/Features/details/83/?page=5>, accessed 13 June 2005.
Bridal, T. (2004), *Exploring Museum Theatre*, Walnut Creek CA: AltaMira Press.

Bridges, D. and McBride, R. (1993), *London Museums Education Unit: An Evaluation*, London: LMEU.

Bridgwood, A., Fenn, C., Dust, K., Hutton, L., Skelton, A. and Skinner, M. (2003), *Focus on Cultural Diversity: The Arts in England: Attendance, Participation and Activities* (Research Report 34), London: ACE.

Burnett, A. and Reeve, J. (eds) (2001), *Behind the Scenes at the British Museum*, London: British Museum Press.

Burrage, M. and Torstendahl, R. (eds) (1990), *Professions in Theory and History*, London: Sage.

Byrnes, W. J. (2003), *Management and the Arts*, 3rd ed., Oxford: Focal Press.

Cabinet Office (1999), *Bringing Britain Together*, London: Cabinet Office.

Campaign for Learning in Museums and Galleries (CLMG) (2001), *Fast Track to Improving Skills in the Museums, Galleries and Heritage Education Sector*, London: CHNTO.

Campaign for Learning in Museums and Galleries (CLMG) (2004), *Where Are They Now? The Impact of the Museums and Galleries Lifelong Learning Initiative (MGLI)*, London: DfES.

Carbonell, B. (ed.) (2004), *Museum Studies: An Anthology of Contexts*, Malden MA and Oxford: Blackwell.

Carey, J. (2005), *What Good Are the Arts?*, London: Faber.

Carlisle City Council (1989), *Tullie House sub-committee minute*, Leisure Services, Carlisle City Council, December 1989.

Carnegie, E. (1996), 'Trying to be an Honest Woman', in G. Kavanagh (ed.) (1996).

Caulton, T. (2003), *Yorkshire Renaissance EPDP: Proposed Structure*, unpublished strategy for *Yorkshire Renaissance*, Leeds.

Chadwick, A. (2004), 'Lifelong Learning in Museums: An Overview with Reference to Museums and the Post-School Sector', in engage (2004a).

Chadwick, A. and Stannett, A. (eds) (2000), *Museums and Adults Learning: Perspectives from Europe*, Leicester: NIACE.

Chakrabarty, D. (2002), 'Museums in Late Democracies', *Humanities Research* **IX**: 1.

Cherry, J. and Walker, S. (eds) (1996), *Delight in Diversity: Display in the British Museum*, seminar proceedings March 1995, British Museum Occasional Paper 118, London: British Museum Press.

Clarke, A. and Erickson, G. (eds) (2003), *Teacher Inquiry*, London: RoutledgeFalmer.

Clarke, A. et al. (2002), *Learning Through Culture. The DfES Museums and Galleries Education Programme: A guide to good practice*, Leicester: RCMG.

Corsaro, W. (2000), 'Early Childhood Education, Children's Peer Cultures, and the Future of Childhood', *European Early Childhood Education Research Journal* **8**: 2, 89–102.

Costantoura, W. (2000), 'Australians and the Arts', *International Journal of Education & the Arts* **4**: 4 (Sydney: Australia Council).

Council of Europe (1997), *In from the Margins*, Strasbourg: Council of Europe.

Cox, A. and Cox, M. (1995), 'Under-5s at Walsall', *JEM* (*Journal of Education in Museums*).

Cox, A., Lamb, S., Orbach, C. and Wilson, G. (2000), *A Shared Experience – A Qualitative Evaluation of Family Activities at Three Tate Sites*, unpublished report.

Creaser, C. (2003), *Target Group Index Data*, unpublished analyses prepared for Resource.

Creaser, C. and White, S. (2003), *Arts Council England: Omnibus Survey 2001*, analysis for Resource.

Csikszentmihalyi, M. (1991), 'Notes on Art Museum Experiences', in A. Walsh (ed.) (1991).

Csikszentmihalyi, M. (1997), *Finding Flow: The Psychology of Engagement with Everyday Life*, New York: Basic Books.

Csikszentmihalyi, M. and Robinson, R.E. (1990), *The Art of Seeing: An Interpretation of the Aesthetic Encounter*, Los Angeles: J. Paul Getty Museum.

Cultural Heritage National Training Organisation (CHNTO) (1997), *Review of Management Training and Development in the Museums, Galleries and Heritage Sector* (The Holland Report), London: CHNTO.

Cuno, J. (ed.) (2004), *Whose Muse? Art Museums and the Public Trust*, Princeton NJ: Princeton University Press and Harvard University Art Museums.

Curry, A. and Stanier, R. (2002), 'Filling the Disappointment Gap', paper presented at the *Changing Worlds* 2002 Conference of the Arts Marketing Association, Cambridge: AMA.

Dadds, M. and Hart, S. (2001), *Doing Practitioner Research Differently*, London: RoutledgeFalmer.

Davies, S. (1994), *By Popular Demand: A Strategic Analysis of the Market Potential for Museums and Art Galleries in the UK*, London: MGC. Reproduced in Resource (2001), pp 43–4.

Davies, S. (2005), 'Still Popular – Museums and their Visitors 1994–2004', *Cultural Trends* **53**, 14: 1, 67–106.

Demos (2003), *Towards a Strategy for Workforce Development*, London: Resource.

Denzin, N.K. and Lincoln, Y.S. (2003), *Strategies of Qualitative Inquiry*, London: Sage.

Department for Culture, Media and Sport (DCMS) (1998), *A New Cultural Framework*, London: DCMS.

Department for Culture Media and Sport (DCMS) (1999), *Museums for the Many: Standards for Museums and Galleries to Use When Developing Access Policies*, London: DCMS. See also <www.culture.gov.uk>

Department for Culture, Media and Sport (DCMS) (1999), *Policy Action Team (PAT) 10 – Report on Social Exclusion*, London: DCMS.

Department for Culture, Media and Sport (DCMS) (2000), *Centres for Social Change: Museums, Galleries and Archives for All: Policy guidance on social inclusion for DCMS-funded and local authority museums, galleries and archives in England*, London: DCMS.

Department for Culture, Media and Sport (DCMS) (2001), *Building on PAT10: A Progress Report on Social Inclus*ion, London: DCMS.

Department for Culture, Media and Sport (DCMS) (2004), *Culture at the Heart of Regeneration*, London: DCMS.

Department for Culture, Media and Sport (DCMS) (2005), *Understanding the Future: Museums and 21st Century Life*, DCMS consultation document, <www.culture.gov.uk>.

Department for Education and Skills (DfES) (2002), *Learning Through Culture. The DfES Museums and Galleries Education Programme: A Guide to Good Practice*, Leicester: RCMG.

Department for Education and Skills (DfES) (2005), *Harnessing Technology: Transforming Learning and Children's Services*, London: DfES.

Department of National Heritage (DNH) (1996a), *Treasures in Trust*, London: DNH.

Department of National Heritage (DNH) (1996b), *People taking Part*, London: DNH.

Desai, P. and Thomas, A. (1998), *Cultural Diversity: Attitudes of Ethnic Minority Populations towards Museums and Galleries*, London: MGC.

Detheridge, A. (2000), 'Les Musées, le Public, Les Medias', in *L'Avenir des Musées*, proceedings of a conference at the Musée du Louvre, Paris, 2000.

Dewey, J. (1934), *Art as Experience*, New York: Capricorn.

Dewey, J. (1938), *Experience and Education*, New York: Macmillan.

Dicks, B. (2003), *Culture on Display – The Production of Contemporary Visibility*, Buckingham: Open University Press.

Dierking, L. (1992), 'Historical Survey of Theories of Learning' and 'Contemporary Theories of Learning', in G. Durbin (ed.) (1996).

DigiCULT Consortium (2003), *Learning Objects from Cultural and Scientific Heritage Resources*, Salzburg: DigiCULT Consortium. (Available at <www.digicult.info>.)

Dodd, J. and Sandell, R. (1998), *Building Bridges: Guidance for Museums and Galleries on Developing New Audiences*, London: MGC (Reprinted 2000).

Dodd, J. and Sandell, R. (2001), *Including Museums: Perspectives on Museums, Galleries and Social Inclusion*, Leicester: RCMG.

Dufresne-Tassé, C. (ed.) (1998), *Evaluation and Museum Education: New Trends*, Paris: ICOM-CECA.

Dufresne-Tassé, C. (ed.) (2002), *Evaluation: Multi-purpose Applied Research*, Paris: ICOM-CECA.

Duncan, C. (1995), *Civilizing Rituals – Inside Public Art Museums*, London: Routledge.

Durbin, G. (ed.) (1996), *Developing Museums for Lifelong Learning*, London: Group for Education in Museums (GEM), Stationery Office.

Durrans, B. (1988), 'The Future of the Other', in R. Lumley (ed.) (1988).

Eder, D. and Corsaro, W. (1999), 'Ethnographic Studies of Children and Youth: Theoretical and Ethical Issues', *International Journal of Education & the Arts* **4**: 4 (Sydney: Australia Council).

Eisner, E. (1998), *The Enlightened Eye: Qualitative Inquiry and the Enhancement of Educational Practice*, Englewood Cliffs NJ: Merrill.

Eisner, E. and Dobbs, S. (1986), *The Uncertain Profession: Observations on the State of Museum Education in Twenty American Art Museums*, Los Angeles: Getty Center for Education in the Arts.

Ellis, A. and Mishra, S. (2004), *Managing the Creative – Engaging New Audience: A dialogue between for-profit and non-profit leaders in the arts and creative sectors*, Background note for a seminar at the J. Paul Getty Trust, 15–16 June 2004, at <www.getty.edu/leadership/downloads/ellis_mishra.pdf>, accessed 20 April 2005.

Ellis, L. (2002), 'The Backlash to Access', in *Engage Review* **11**, Summer, 40–42.

Elsner, J. and Cardinal, R. (eds) (1994), *The Cultures of Collecting*, London: Reaktion.

Ely, M. *et al.* (1994), *Doing Qualitative Research: Circles within Circles*, London: Falmer Press.

engage (2004), 'Museums and Galleries as Learning Places', *Engage Review* 'extra', special issue of papers for LERNMUSE and Collect & Share, London: engage.

engage (2004a), *Museums and Galleries as Learning Places*, London: engage.

engage (2004b), *Encounters with Contemporary Art – Schools, Galleries and the Curriculum*, London: engage.

Eraut, M. (1994), *Developing Professional Knowledge and Competence*, London: Falmer Press.

Evans, G. and Shaw, P. (2004), *The Contribution of Culture to Regeneration in the UK: A Report to the Department for Culture, Media and Sport*, London: Metropolitan University.

Falk, J. and Dierking, L. (1992), *The Museum Experience*, Washington DC: Whalesback.

Falk, J. and Dierking, L. (2000), *Learning from Museums: Visitor Experiences and the Making of Meaning*, Walnut Creek CA: AltaMira.

Falk, J. and Dierking, L. (2002), *Lessons without Limit: How Free-Choice Learning is Transforming Education*, Walnut Creek CA: AltaMira.

Falk, J., Moussouri, T. and Coulson, R. (1998), 'The Effect of Visitors' Agendas on Museum Learning', *Curator* **41**: 2, 107–120.

Fielding, M. (2004), 'Transformative Approaches to Student Voice: Theoretical Underpinnings, Recalcitrant Realities', British Educational Research Journal 30: 2 (London: BERA).

Fielding, M. and Bragg, S. (2003), Students as Researchers: Making a Difference, London: Pearson.

Fleming, D. (2000), *Notes on Tyne and Wear Museums Service*, Royal Academy Seminar 2000. Reproduced in Resource (2001), p 43.

Fleming, D. (2002), 'Positioning the Museum for Social Inclusion', in R. Sandell (ed.) (2002).

Ford, C.M. (1998), 'The "Theatre-in-Museum" Movement in the British Isles', PhD thesis, University of Leeds, 1998.

Foster, H. (ed.) (1985), *Postmodern Culture*, London: Pluto.

Freidson, E. (ed.) (1973), *The Professions and Their Prospects*, Beverly Hills CA: Sage.

Freidson, E. (1986), *Professional Powers: A Study of the Institutionalisation of Formal Knowledge*, Chicago IL: University of Chicago Press.

Freidson, E. (2001), *Professionalism: The Third Logic*, Cambridge: Polity Press.

Freire, P. (1972), *Pedagogy of the Oppressed*, Harmondsworth: Penguin.

Gardner, H. (1983), *Frames of Mind: The Theory of Multiple Intelligences*, London: Fontana.

GEM News – quarterly newsletter of the Group for Education in Museums, published by GEM, UK.

Geser, G. (2003), 'Introduction and Overview', in DigiCULT Consortium (2003).

Goffman, E. (1968), *Asylums: Essays on the Social Situation of Mental Patients and other Inmates*, Harmondsworth: Penguin.

Gould, H. (2003), *What Did We Learn? Museums and Galleries Lifelong Learning Initiative 2000–2*, London: DfES.

Gould, H. (2004), *What Did We Learn This Time? The Museums and Galleries Lifelong Learning Initiative (MGLI) 2002–2003*, London: CLMG/DfES.

Graham, J. (1998), 'Planning for Early Learning in Museums and Galleries', *JEM (Journal for Education in Museums)* **19**, 12–15.

Graham, J. and Yasin, S. (2005), 'Reframing Participation in the Museum: An Homage in Three Parts', in G. Pollock and J. Zemans (eds) (2005).

Graue, E. and Walsh, D. (1998), *Studying Children in Context: Theories, Methods, and Ethics*, Thousand Oaks CA: Sage.

Greater London Authority (2004), *The Mayor's Cultural Strategy – London: Cultural Capital – Realising the potential of a world-class city*, London: GLA.

Greater London Authority, The Mayor's Commission on African and Asian Heritage (2005), *Delivering Shared Heritage*, London: GLA.

Greene, M. (2003), 'Sacred Spaces', 'Museer for Alle', *Museumformidlere* [Denmark], issue 9, September.

Gregory, R. (1997), *Eye and Brain: The Psychology of Seeing*, 5th ed., Oxford: Oxford University Press.

Group for Larger Local Authority Museums (GLLAM) (2004), *Enriching Lives*, London: NMDC/GLLAM.

Gurian, E.H. (1996), 'Noodling Around with Exhibition Opportunities', in G. Durbin (1996).

Gurian, E.H. (2005), 'Threshold Fear', paper presented at a conference at the University of Leicester 2004, proceedings published in S. MacLeod (ed.) (2005).

Haas, C. (2002), 'ZOOM Kindermuseum, Austria', in W. Wolf and A. Salaman (eds) (2002).

Hall, S. (ed.) (1997), *Representation: Cultural Representations and Signifying Practices*, London: Sage.

Halsey, A.H. (1972), *Educational Priority Volume 1: Education Priority Area Problems and Policies*, London: HMSO.

Hardie, P. (1991), 'Chinese Whispers', *Museums Journal*, October.

Harvey, M. (2005), 'The Darwin Centre and Beyond – Access to Collections, Access to Ideas', paper presented at the *Politics and Positioning* Museums Australia National Conference, 1–4 May 2005, Sydney.

Hawkey, R. (2004), *Learning with Digital Technologies in Museums, Science Centres and Galleries*, Bristol: NESTA Futurelab (also available online).

Hawthorne, E. and Pontin, K. (2001), *'Museum Fever' and 'Represent': Lessons for Working with Young People in Museums*, Birmingham: WMRMC.

Heal, S. (2004), 'Weapons of Mass Destruction meet Masterpieces of a Municipal Gallery in a New Level of the Computing Game *Unreal Tournament*', *Museum Journal*, April, 22–3.

Hein, G. (1992), 'Constructivist Learning Theory', in G. Durbin (ed.) (1996).

Hein, G. (1998), *Learning in the Museum*, London: Routledge.

Helen Denniston Associates (2003), *Holding up the Mirror: Addressing Cultural Diversity in London's Museums (A report by HDA for the LMA)*, London: London Museums Agency 2003.

Hemsley, J. (ed.) (2005), *Digital Applications for Cultural and Heritage Institutions*, Aldershot: Ashgate.

Heppell, S. (2001), 'Preface', in A. Loveless and V. Ellis (eds) (2001).

Her Majesty's Government (1976), Race Relations Act, London: HMSO.

Her Majesty's Government (1995), Disability Discrimination Act, London: HMSO.

Hewison. R. and Holden, J. (2004), *The Right to Art: Making Aspirations Reality*, London: Demos/VAGA.

Heyburn, T. (1992), 'The Educator as Museum Professional', *JEM* **13**, 15–18.

Heywood, F. (2004), 'Daventry Museum Closes Doors', *Museums Journal*, April, 9.

Hilke, D.D. (1996), 'Quest for the Perfect Metholodogy: A Tragi-comedy in Four Acts', in G. Durbin (1996).

Hill, R. (2005), 'Meeting Ground: The Reinstallation of the AGO's McLaughlin Gallery', in L.A. Martin (ed.) (2005).

Hinton, M. (1998), 'The Victoria and Albert Museum Silver Galleries II: Learning Style and Preference in the Discovery Area', *Journal of Museum Management and Curatorship* **17**: 3.

Holden, J. (2004a), *Capturing Cultural Value*, London: Demos.

Holden, J. (2004b), *Challenge and Change: HLF and Cultural Value*, London: Demos.

Holo, S. (2000), *Beyond the Prado: Museums and Identity in Democratic Spain*, Liverpool: Liverpool University Press.

Holt, J. (1976), *Instead of Education*, Harmondsworth: Pelican.

Hooper-Greenhill, E. (1987), 'Museum Education Comes of Age', *JEM* **8**, 6; cited in Heyburn (1992).

Hooper-Greenhill, E. (1991), *Museum and Gallery Education*, Leicester: Leicester University Press.

Hooper-Greenhill, E. (1992), *Museums and the Shaping of Knowledge*, London: Routledge.

Hooper-Greenhill, E. (1994), *Museums and their Visitors*, London and New York: Routledge.

Hooper-Greenhill, E. (2000), 'Changing Values in the Art Museum: Rethinking Communication and Learning', *International Journal of Heritage Studies* **6** (1). (Reprinted in B.M. Carbonell (ed.) (2004), *Museum Studies: An Anthology of Contexts*, Oxford: Blackwell.)

Hooper-Greenhill, E. (2000), *Museums and the Interpretation of Visual Culture*, London: Routledge.

Hooper-Greenhill, E. (2002), *Developing a Scheme for Finding Evidence of the Outcomes and Impact of Learning in Museums, Archives and Libraries: The Conceptual Framework*, Leicester: Learning Impact Research Project (LIRP), Leicester University, on behalf of Resource, April 2002, available at <http/www.le.ac.uk/museumstudies/rcmg>.

Hooper-Greenhill, E. (ed.) (1997) *Cultural Diversity: Developing Museum Audiences in Britain*, Leicester: Leicester University Press.

Hooper-Greenhill, E. (ed.) (1999), *The Educational Role of the Museum*, London: Routledge.

Hooper-Greenhill, E. and Dodd, J. (2002), *Seeing the Museum through the Visitors' Eyes – The Evaluation of the Education Challenge Fund*, Leicester: RCMG.

Hooper-Greenhill, E. and Moussouri, T. (2002), *Researching Learning in Museums and Galleries, 1990–1999: A Bibliographic Review*, Leicester: RCMG.

Hooper-Greenhill, E. *et al.* (2004), *Inspiration, Identity, Learning: The Value of Museums. The evaluation of the impact of DCMS/DfES Strategic Commissioning 2003-2004: National/Regional Museum Education Partnerships*. Leicester: RCMG.

Horlock, N. (ed.), (2000), *Testing the Water: Young People and Galleries*, Liverpool: University of Liverpool and Tate Liverpool.

Horne, D. (1984), *The Great Museum – The Re-presentation of History*, London: Pluto.

Horne, D. (1986), *The Public Culture – The Triumph of Industrialism*, London: Pluto.

Hudson, K. (2004), 'The Museum Refuses to Stand Still', in B. Carbonell (ed.) (2004), pp 85–91. (Originally published in *Museum International* 1998.)

Hughes, C. (2002), 'Telling the Untold Story', keynote address at *Raising the Curtain: First National Forum on Performance in Cultural Institutions*, National Museums of Australia, available at <www.nma.gov.au/events/past_events/2002_raising_the_curtain/print_index.html>.

Illich, I. (1973), *Deschooling Society*, Harmondsworth: Penguin. Republished by Marion Boyars.

Illich, I. *et al.* (1977), *Disabling Professions*, London: Marion Boyars.

Ings, R. (2001), *Funky on your Flyer*, London: ACE.

International Committee of Museums (ICOM) (2002), *Code of Ethics*, <www.icom.org>

International Committee of Museums, Committee on Education and Cultural Affairs (ICOM CECA) (1992), *The Museum and the Needs of People*, A. Zemer (ed.), report of the 1991 Annual Conference in Jerusalem, ICOM CECA: Haifa.

Investors in People (2002), *Investors in People – What does it mean for me?*, London: Stationery Office.

James, A. and Prout, A. (1997), *Constructing and Reconstructing Childhood: Contemporary Issues in the Sociological Study of Childhood*, London: Falmer Press.

James, A., Jenks, C. and Prout, A. (1998), *Theorising Childhood*, Cambridge: Polity Press.

JCORE, Jewish Forum, Parkes Institute for the Study of Jewish/Non-Jewish Relations at Southampton University, 'Connections Exhibition', online at <www.connections-exhibition.org/index.php?xml=the_project/_/partnerssponsors.xml>.

JEM – Journal of Education in Museums, published annually by GEM, UK.

JEM (*Journal of Education in Museums*) (1996), 'The Uncertain Profession – Perceptions and Directions', in *Patterns in Practice: Selections from the Journal of Education in Museums*, pp 48–57.

Jenkins, T. (2004), 'A Lesson to be Learned', *Blueprint*, May.

Jenkinson, A. (2004), 'Who *are* the Interpreters?', *Interpretation Journal* **9**: 1 (Spring), 22–5.

Jenkinson, P. (1997), 'Custom-made Making', *Engage Review* **2**, Spring, 3–7.

Jones, M. (2005), 'Show and Tell', *Museums Journal*, June.

Jones-Garmil, K. (1997), *The Wired Museum: Emerging Technology and Changing Paradigms*, Washington DC: American Association of Museums.

Judd, D. (2000), 'Designed for Different Audiences and Different Learning Styles. The New British Galleries at the V&A', *GEM News* 2000, 83–9.

Karp, I. and Lavine, S. (eds) (1991), *Exhibiting Cultures: The Poetics and Politics of Museum Display*, Washington DC: Smithsonian Press.

Kavanagh, G. (ed.) (1991), *The Museums Profession*, Leicester: Leicester University Press.

Kavanagh, G. (ed.) (1994), *Museum Provision and Professionalism*, London: Routledge.

Kavanagh, G. (ed.) (1996), *Making Histories in Museums*, Leicester: Leicester University Press.

Kellett, M. (2005), How to Develop Children as Researchers, Thousand Oaks CA: Sage.

Kent, P. (Helix Partners) (2002), *Evidence Change: Quality of Life as a Measure of Distance Travelled (Final Report)*, Fairbridge and Foyer Federation.

Khan, N. (ed.) (2006), *Connections Disconnections – Museums, Cultural Heritage and Diverse Cultures*, proceedings from a conference at the V&A, 22 June 2002, London: V&A.

Knell, S. (2003), 'The Shape of Things to Come: Museums in the Technological Landscape', *Museum and Society* **1**: 3.

Kolb, D. (1984), *Experiential Learning: Experience as the Source of Learning and Development*, Englewood Cliffs NJ: Prentice-Hall.

Kotler, N. and Kotler, P. (1998), *Museum Strategy and Marketing*, San Francisco: Jossey-Bass.

Kotler, P. and Scheff, J. (1998), *Standing Room Only: Strategies for Marketing the Performing Arts*, Boston MA: Harvard Business School.

Kreps, C. (2003), *Liberating Culture – Cross-cultural Perspectives on Museums, Curation and Heritage Preservation*, London: Routledge.

Kress, G. (2003), *Literacy in the New Media Age,* London: Routledge.

Kress, G. and Van Leeuwen, T. (2001), *Multimodal Discourse: The Modes and Media of Contemporary Communication, Cheltenham:* Arnold.

Laffin, M. (1986), *Professionalism and Policy: The Role of Professions in the Central–Local Government Relationship*, Aldershot: Gower.

Laffin, M. (ed.) (1998), *Beyond Bureaucracy? The Profession in Contemporary Public Life*, Aldershot: Ashgate.

Lammy, D. (2005), Keynote address to Museums Association Conference, 26 October 2005. (Available at <www.culture.gov.uk/global/press_notices/archive_ 2005/lammy_ma_speech.htm>.

Larson, M. (1977), *The Rise of Professionalism: A Sociological Analysis*, Berkeley CA: University of California Press.

Leeds City Council (2002), *Best Value – The User Experience: Education Findings*, unpublished report of Leeds Museums & Galleries, Leeds City Council.

Littler, N. (2005), *The Politics of Heritage: The Legacies of Race*, London: Routledge.

Loomba, A. (1998), *Colonialism/Postcolonialism*, London: Routledge.

Lord, B. and Lord, G.D. (eds) (1999), *Manual of Museum Planning*, 2nd ed., London: The Stationery Office.

Loughran, J. (2003), 'Knowledge Creation in Educational Leadership and Administration through Teacher Research', in A. Clarke and G. Erickson (eds) (2003).

Loveless, A. and Ellis, V. (eds) (2001), *ICT, Pedagogy and the Curriculum: Subject to Change*, London: Routledge/Falmer.

Luke, T. (2002), *Museum Politics: Power Plays at the Exhibition*, Minnesota: Minnesota University Press.

Lumley, R. (ed.) (1988), *The Museum Time-Machine*, London: Routledge.

Lynch, B. (2002), 'If the Museum is the Gateway, Who is the Gatekeeper?', *Engage Review* **11**, Summer, 12–21.

Macdonald, S. and Fyfe, G. (eds) (1996), *Theorizing Museums*, Oxford: Blackwell.

Macdonald, S.J. (2003), 'Museums, National, Postnational and Transcultural Identities', *Museum and Society* **1**: 1, 1–16.

MacLeod, S. (ed.) (2005), *Reshaping Museum Space*, London: Routledge.

Maitland, H. (1997), *A Guide to Audience Development*, 2nd ed., London: ACE. (3rd ed. 2000.)

Manchester Museums, Community Advisory Panel (CAP), online at <http://museum. man.ac.uk/communities/communities.htm>.

Marks, G. (ed.) (2004), *Information Technology in Childhood Education Annual*. Norfolk VA: Association for the Advancement of Computers in Education.

Martin, L.A. (ed.) (2005), *Making a Noise*, Banff: Walter Phillips Gallery/Banff Centre Press.

Matarasso, F. (1997), *Use or Ornament? The Social Impact of Participation in the Arts*, Stroud: Comedia.

Matarasso, F. (1999), 'Culture makes Communities', *Briefing from the Voluntary Arts*, No. 42, Voluntary Arts Network.

Matarasso, F. (2002), 'Value and Values in the Voluntary Arts', *Briefing from the Voluntary Arts*, No. 59, Voluntary Arts Network.

Matarasso, F. and Landry, C. (1999), *Balancing Act: 21 Strategic Dilemmas in Cultural Policy (Cultural Policy Note 4)*, Strasbourg: Council of Europe.

Mathers, K. and Selwood, S. (1996), *Museums, Galleries and New Audiences*, London: Art & Society.

Matthews, H., Limb, M. and Taylor, M. (1998), 'The Geography of Children: Some Ethical and Methodological Considerations for Project and Dissertation Work', *International Journal of Education & the Arts* **4**: 4 (Sydney: Australia Council).

Matty, S. (ed.) (2004), *Overview of Data in the Museums, Libraries and Archives Sector*, London: MLA.

McDade, C. with Curnow, H. (eds) (2000), *Building the Audience: Audience Development and the Development of the New Art Gallery Walsall*, London: ACE.

Mclean, F. (1997), *Marketing the Museum, London:* Routledge.

McManus, P.M. (1994), 'Families in Museums', in R. Miles and L. Zavala (eds) (1994), pp 81–97.

McManus, P.M. (1998), 'Preferred Pedestrian Flow: A tool for designing optimum interpretive conditions and visitor pressure management', *Journal of Tourism Studies* **9**: 1, 40–50.

McManus, P.M. (ed.) (2000a), *Archaeological Displays and the Public*, 2nd ed., London: Archtype Books.

McManus, P.M. (2000b), 'Written Communications for Museums and Heritage Sites', in P.M. McManus (2000a), pp 97–114.

Merli, P. (2002), 'Evaluating the Social Impact of Participation in Arts Activities', *International Journal of Cultural Policy* **8**: 1, 107–118.

Merriman, N. (1997), 'The Peopling of London Project', in E. Hooper-Greenhill (1997).

Merriman, N. (ed.) (1993), *The Peopling of London*, London: Museum of London.

Merriman, N. and Poovaya-Smith, N. (1996), 'Making Culturally Diverse Histories', in G. Kavanagh (ed.) (1996).

Middleton , V. (1991) 'The Future Demand for Museums 1990–2001', in G. Kavanagh (ed.) (1991).

Miles, M.B. and Huberman, A.M. (1994), *Qualitative Data Analysis*, 2nd ed., London: Sage.

Miles, R. and Zavala, L. (eds) (1994), *Towards Museums of the Future*, London: Routledge.

Miles, R. *et al.* (2001), *The Design of Educational Exhibits*, 2nd ed., London: Routledge.

Mirzoeff, N. (ed.) (1998), *The Visual Culture Reader*, 2nd ed., London: Routledge.

Moffat, H. and Woollard, V. (eds) (1999), *Museum and Gallery Education – A Manual of Good Practice*, London: Stationery Office.

MORI (Market & Opinion Research International) (2001), *Visitors to Museums & Galleries in the UK: Report for Resource*, London: Resource.

Morris Hargreaves MacIntyre (MHM) (2004) *Learning Journeys: Using Technology to Connect the Four Stages of Meaning-making*, unpublished report, commissioned by Birmingham Museums and Art Gallery. MHM website at <http://www.lateralthinkers.com/>.

Morton Smyth Limited (2004), *Not for the Likes of You*, final report for Arts Council England and Resource, at <www.artscouncil.org.uk> or at <www.newaudiences2.org.uk/downloads/NFTLOY_doc_A.doc>.

Morton, S. (2003), *Gayatri Chakravarty Spivak*, London: Routledge.

Museums Association (MA) (1999), *Ethical Guidelines on Access*, <www.museumsassociation.org.uk>.

Museums Association (MA) (2002), *Code of Ethics for Museums: Ethical Principles for All who Work for or Govern Museums*, London: MA.

Museums Association (MA) (2005), *Collections for the Future, Report of a Museums Association Inquiry*, London: MA.

Museums Association (MA) (no date), *Museums Association Mentoring Toolkit Handbook*, London: MA.

Museums, Libraries and Archives Council (MLA) (2004), *Inspiring Learning for All*, London: MLA. Also at <www.inspiringlearningforall.gov.uk>, accessed September 2005.

Museums, Libraries and Archives Council (MLA) (2004), *Investing in Knowledge: A Five-year Vision for England's Museums, Libraries and Archives*, London: MLA.

Nairne Grigor, A. (2002), *Arthur Lismer, Visionary Art Educator*, Montreal: McGill-Queens University Press.

National Museums Directors' Conference (NMDC) (1999), *A Netful of Jewels: New Museums in the Learning Age*, London: NMDC.

Nightingale, E. and Swallow, D. (2003), 'The Arts of the Sikh Kingdoms: Collaborating with a Community', in L. Peers and A. Brown (eds) (2003).

Nightingale, J. (2004), 'Lessons in Learning', *Museums Journal*, April, 24–7.

O'Neill, M. (2002), 'The Good Enough Visitor', in R. Sandell (ed.) (2002), p 24.

Orna-Ornstein, J. (ed.), *The Development and Evaluation of the HSBC Money Gallery at the British Museum*, British Museum Occasional Paper 140, London: British Museum Press.

Owens, P. (1998), *Creative Tensions*, Washington DC: British American Arts Association.

Pearson, A. and Aloysius, C. (1994), *Museums and Children with Learning Difficulties*, London: British Museum Press.

Peers, L. and Brown, A. (eds) (2003), *Museums and Source Communities*, London: Routledge.

Pollock, G. and Zemans, J. (eds) (2005), *Museums after Modernism*, Oxford: Blackwell.

Pontin, K. (2001), *'Represent': An Evaluation Report for an Inclusion Project run by Birmingham Museum Service*, unpublished report at <www.katepontin.co.uk>.

Pontin, K. (n.d.), *A Common Treasury – An Evaluation of a Secondary School Programme at Bruce Castle Museum*, unpublished report at <www.katepontin. co.uk>.

Porter, G. (1998), 'Seeing through Solidity: Feminist Perspectives on Museums', in S. Macdonald and G. Fyfe (eds) (1996).

Potter, J. (2001), 'Visualisation in Research and Data Analysis', in M. Dadds and S. Hart (2001), pp 27–46.

Preziosi, D. and Farago, C. (eds) (2004), *Grasping the World. The Idea of the Museum*, Aldershot: Ashgate.

Prosser, D. and Eddisford, S. (2004), 'Virtual Museum Learning', in G. Marks (ed.) (2004).

Prout, A. and James, A. (1997), 'A New Paradigm for the Sociology of Childhood? Provenance, Promise and Problems', in A. James and A. Prout (1997).

Rabinow, P. (ed.) (1984), *The Foucault Reader*, London: Peregrine.

Reeve, J. (1996), 'Making the History Curriculum', in G. Kavanagh (ed.) (1996).

Research Centre for Museums and Galleries (RCMG) (2000), *Museums and Social Inclusion: The GLLAM Report*, Leicester: RCMG.

Research Centre for Museums and Galleries (RCMG) (2001), *Making Meaning in Art Galleries 2 – Visitors' Interpretive Strategies at Nottingham Castle Museum and Art Gallery*, Leicester: RCMG.

Resource (2000), *Resource Manifesto*, London: Resource.

Resource (2001), *Renaissance in the Regions: A New Vision for England's Museums*, London: Resource.

Resource (2002), *Inspiring Learning for All: A Framework for Museums, Archives and Libraries*, London: Resource.

Resource (2003), *Disability Portfolio*, London: Resource.

Rider, S. (1999), 'Opening the Doors', *Journal of Education in Museums* 20.

Roberts, L.C. (1996), 'Educators on Exhibit Teams', in G. Durbin (1996).

Rogers, R. (1998), *Audience Development: Collaboration between Education and Marketing*, London: ACE.

Runnymede Trust (2000), *The Parekh Report: The Future of Multi-Ethnic Britain*, London: Profile Books. Also online at <www.runnymedetrust.org.uk>.

Runyard, S. and French, Y. (2000), Marketing and Public Relations Handbook for Museums, Galleries, and Heritage Attractions, Walnut Creek CA: AltaMira Press.

Ryan, M. (2000), 'Manipulation Without End', in M. Wallinger and M. Warnock (2000).

Ryan, M. (2001), 'Introduction', in J. Appleton (2001), pp 8–9.

Sandell, R. (2000), 'The Strategic Significance of Workforce Diversity in Museums', *International Journal of Heritage Studies* **6**: 3, 213–230.

Sandell, R. (ed.) (2002), *Museums, Society, Inequality*, London: Routledge.

Santos, M. S. (2005), 'Representations of Black People in Brazilian Museums', *Museum and Society* **3**: 1.

Saumarez-Smith, C. (2001), 'A Challenge to the New Orthodoxy', in J. Appleton (2001), pp 39–41.

Scheurich, J.J. (1997), *Research Method in the Postmodern, Qualitative Studies Series 3*, London: Falmer Press.

Schouten, F. and Houtgraaf, D. (1995), 'The Management of Communication: a Systematic Approach to the Design of Museum Displays', *Museum Management and Curatorship* **14** (3).

Schuller, T. *et al.*, (2001), *Modelling and Measuring the Wider Benefits of Learning*, London: Institute of Education.

Scottish Museums Council (2000), *Museums and Social Justice*, Edinburgh: SMC.

Selwood, S. (1999), 'Access, Efficiency and Excellence: Measuring Non-economic Performance in the English Subsidised Cultural Sector', Cultural Trends **35**, *87–141.*

Selwood, S. (2001), 'Profile of Museums and Galleries', in S. Selwood (ed.) (2001). Reproduced in Resource (2001), p 44.

Selwood, S. (2001), *Markets and Users*, research paper for MLA, London: MLA. Available at<http://www.mla.gov.uk/webdav/harmonise?Page/@id=73&Document/@id=18601&Section[@stateId_eq_left_hand_root]/@id=4332>.

Selwood, S. (2002), 'Measuring Culture', Spiked-Online, <http://www.spiked-online.com/Printable/00000006DBAF.htm>.

Selwood, S. (ed.) (2001), *The UK Cultural Sector: Profile and Policy Issues*, London: Policy Studies Institute.

Selwood, S. and Clive, S. (1992), *Substance and Shadow*, London: London Arts Board.

Senge, P. (1990), *The Fifth Discipline: The Art and Practice of the Learning Organisation*, London: Random House.

Serota, N. (1995), *Experience or Interpretation: The Dilemma of Museums of Modern Art*, London: Thames and Hudson.

Shapiro, S. (ed.) with Kemp, L.W. (1990), *The Museum – A Reference Guide*, New York: Greenwood Press.

Silva, E. and Edwards, R. (undated), 'Operationalizing Bourdieu on Capitals: A discussion on the "Construction of the Object" ' at <http://www.open.ac.uk/socialsciences/sociology/research/ccse/index.html>, accessed 5 July 2005.

Silverman, D. (1993), *Interpreting Qualitative Data, Methods for Analysing Talk, Text and Interaction*, London: Sage.

Simpson, M.G. (1996), *Making Representations: Museums in the Post-Colonial Era*, London: Routledge.

Skelton, A., Bridgwood, A., Duckworth, K., Hutton, L., Fenn, C., Creaser, C. and Babbidge, A. (2002), *Arts in England: Attendance, Participation and Attitudes in 2001* (Research Report 27), London: ACE.

Smithsonian Institution (2005), *Concern at the Core*, Washington DC: Smithsonian Institution.

Sola, T. (1991), 'Museums and Curatorship: The Role of Theory', in G. Kavanagh (ed.) (1991).

South West Museums, Libraries and Archives Council (SWMLAC) (2004), *South West Diversity Festival, Final Report*, Taunton: SWMLAC.

Stanley, J. *et al.* (2004), *The Impact of Phase 2 of the Museums and Galleries Education Programme*. Coventry: Centre for Education and Industry, University of Warwick, available at <www.teachernet.gov.uk.uk/mgep2>.

Stanley, N. (1998), *Being Ourselves for You: The Global Display of Cultures*, London: Middlesex University Press.

Strauss, A. and Corbin, C. (1998), Basics of Qualitative Research: Techniques and Procedures for Developing Grounded Theory, Thousand Oaks CA: Sage.

Taylor, P. (1993), *The Texts of Paulo Freire*, Buckingham: Open University Press.

Teather, L. (1990), 'Professionalism and the Museum', in S. Shapiro (ed.) with L.W. Kemp (1990), pp 299–327.

Tooby, M. (2000), ' "Blue" in the New Art Gallery, Walsall', in C. McDade with H. Curnow (eds) (2000).

Trevelyan, V. (ed.) (1991), *Dingy Places with Different Kinds of Bits: An Attitudes Survey of London Museums amongst Non-visitors*, London: London Museums Service.

Tripp, D. (1993), *Critical Incidents in Teaching, Developing Professional Judgement*, London: RoutledgeFalmer.

Tulloch, C. (ed.) (2004), *Black Style: Origins, Evolution and Politics*, London: V&A.

Tusa, J. (2000), *Art Matters. Reflecting on Culture*, London: Methuen.

Tusa, J. (2002), 'Thou Shalt Worship the Arts for What They Are', at <www.spiked-online.com/Articles/00000006DA07.htm>.

Van Mensch, P. (ed.) (1989), *Professionalising the Muses: The Museum Profession in Motion*, Amsterdam: AHA Books.

Victoria and Albert Museum (V&A) (2003), 'Access, Inclusion and Diversity Strategy at the V&A', at <www.vam.ac.uk>

VisitBritain (2002), *Sightseeing in the UK*, London: VisitBritain.

Visram, R. (1994), 'British History: Whose History? Black Perspectives on British History', in H. Bourdillon (1994).

Vygotsky, L.S. (1971), *The Psychology of Art*, Cambridge MA: The MIT Press.

Vygotsky, L.S. (1978), 'Mind in Society: The Development of Higher Psychological Processes', in H. Gardner (1983).

Wadeson, I. (2003), 'Audience Development – Unpacking the Baggage', paper presented at the November 2003 London Conference of the Arts Marketing Association, Cambridge: AMA.

Walker Art Center Museum Management Consultants (1999), *Artists and Communities at the Crossroads*, Minneapolis: Walker Art Center.

Walker, S. (1997), 'Black Cultural Museums in Britain: What Questions Do They Answer?', in E. Hooper-Greenhill (ed.) (1997)

Wallinger, M. and Warnock, M. (2000), *Art for All: Their Policies and Our Culture*, London: Peer.

Walsh, A. (ed.) (1991), *Insights: Museums, Visitors, Attitudes, Expectations: A Focus Group Experiment*, Santa Monica CA: Getty Center for Education in The Arts and J. Paul Getty Museum.

Ward, A. and Lawrence, J. (1991), 'The T.T. Tsui Gallery of Chinese Art', *Orientations*, July [Asian art journal published in Hong Kong].

Ward, C. and Fyson, A. (1973), *Streetwork. The Exploding School*, London: Routledge and Kegan Paul.

Wartna, F. (2002), 'Wereldmuseum, The Netherlands', in W. Wolf and A. Salaman (eds) (2002).

Waterfield, G. (ed.) (2004), *Opening Doors: Learning in the Historic Environment*, London: Attingham Trust.

Weil, S. (1995), *A Cabinet of Curiosities. Inquiries into Museums and their Prospects*, Washington DC: Smithsonian Institution Press.

Weil, S. (1988), 'The Ongoing Pursuit of Professional Status', *Museum News* **62**: 2, 20–34, reprinted in G. Kavanagh (1994), pp 251–6.

West, W.R. (2002), 'American Museums in the 21st Century', *Humanities Research* **IX**: 1.

Wilk, C. and Humphrey, N. (eds) (2005), *Creating the British Galleries at the V&A: A Study in Museology*, London: V&A Publications.

Willig, C. (2001), *Introducing Qualitative Research in Psychology*, Buckingham: Open University Press.

Winch, D. (2005), 'Hidden Histories: Black History in the V&A', in N. Khan (ed.) (2006). Winstanley, B. (1980), 'Museum Education 1948–1963', in *JEM* **1**.

Winter, C. (1995), 'The Mexican Gallery at the British Museum: An Evaluation of its Impact as an Educational Resource', unpublished MA dissertation, Institute of Education, London.

Winterbotham, D.N. (2005), 'Museums and Schools: Developing Services in Three English Counties, 1988–2004', PhD thesis, University of Nottingham, 2005.

Wolf, W. and Salaman, A. (eds) (2002), *Playing to Learn? The Educational Role of Children's Museums* (papers from the *Hands On!* Europe conference, 2001), London: Discover.

Woollard, V. (1998), '50 Years: The Development of a Profession', in *JEM* **19**: 1–4.

Woollard, V. (1999), 'Developing Museum and Gallery Education Staff', in H. Moffat and V. Woollard (1999), pp 136–147.

Wright, M., Selwood, S., Cresser, C. and Davies, J.E. (2001), *UK Museums Retrospective Statistics Projects*, Loughborough: Library and Information Statistics Unit.

List of Websites

All accessed during November 2005

24 Hour Museum <www.24hourmuseum.org.uk>

American Association of Museums (AAM) <www.aam-us.org>

Arts Council England (ACE) <www.artscouncil.org.uk>

Audience development plans of the Heritage Lottery Fund <http://www.hlf.org.uk/English/PublicationsAndInfo/AccessingPublications/GuidanceNotes.htm>

Campaign for Learning in Museums and Galleries (CLMG) <www.campaign-for-learning.org.uk>

City University, London: Department of Arts Policy and Management <www.city.ac.uk/cpm/artspol>

Culture Online <www.cultureonline.gov.uk>

Curriculum Online <www.curriculumonline.gov.uk>

Department of Culture, Media and Sport (DCMS) <www.culture.gov.uk>

Department for Education and Skills (DfES) <www.dfes.gov.uk>

engage (National Association for Gallery Education) <www.engage.org>

Generic learning outcomes (GLOs) <http://www.inspiringlearningforall.gov.uk/uploads/More%20about%20the%20GLO's.doc>

Group for Education in Museums (GEM) <www.gem.org.uk>

Heritage Lottery Fund (HLF) <www.hlf.org.uk>

mak.frankfurt, at <www.museumfuerangewandtekunst.frankfurt.de>

Moving Here (collaborative site on immigration) <www.movinghere.org.uk>

Museum and Society (online journal from Leicester University's Department of Museum Studies) <www.le.ac.uk/ms/m&s/m&sframeset.html>

Museums Association (MA) <www.museumsassociation.org>

Museums, Libraries and Archives Council (MLA) <www.mla.gov.uk>

'Not for the Likes of You', Arts Council/MLA/ English Heritage report on new audiences, 2004 <www.newaudiences.org.uk/feature.php?news>

Qualifications and Curriculum Authority (QCA) <www.qca.org.uk>

Reinwardt Academy <www.mus.ahk.nl>

Research Centre for Museums and Galleries (RCMG), Leicester University <www.le.ac.uk/museumstudies/rcmg>

Social research update for details on a range of qualitative tools <www.soc.surrey.ac.uk/sru>

Victoria & Albert Museum (V&A) <www.vam.ac.uk> Visitor Studies Group <www.visitors.org.uk>

Visual Arts and Galleries Association (VAGA) <www.vaga.co.uk>

Index